MacDonald Gill

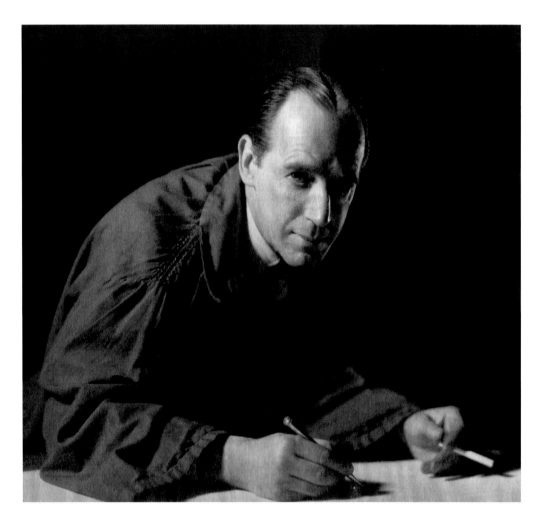

MacDonald Gill
1884–1947

MacDonald Gill

Charting a Life

Caroline Walker

UNICORN

First published by Unicorn
an imprint of Unicorn Publishing Group LLP, 2020
5 Newburgh Street
London W1F 7RG
www.unicornpublishing.org

ISBN 978-1-912690-89-3
10 9 8 7 6 5 4 3 2 1

Designed by Felicity Price-Smith
Printed in Europe by Fine Tone Ltd

CONTENTS

FOREWORD

Today Leslie MacDonald Gill is regarded as one of the most original British map-makers working in the twentieth century. His maps display a distinctive, idiosyncratic vision of the world which has been much imitated but rarely equalled. But his stock has not always been so high. For example, not all of his cartographic output was routinely accessioned by the national map collection at the British Library, the principal reason being that such artistic, pictorial pieces did not meet the pervading twentieth-century criteria of maps as scientific communication models.

MacDonald Gill's absence from the cartographic canon was an unfortunate by-product of a narrow perception of maps that downgraded art in favour of science. He fell between the cracks in other ways too, being seen primarily as a commercial artist rather than an apparently nobler painter or sculptor and working in the shadow of his more famous elder brother Eric. But the twenty-first century has seen a resurgence of interest in him: the British Library's subsequent efforts to plug the Gill-shaped gaps in its holdings are an important indication.

Of course, MacDonald Gill was far more than just a map-maker. He was a mural painter, architect, letterer and a prominent figure in the Arts and Crafts movement. He was the go-to designer for some of the major advertising campaigns of the early twentieth century including work for the Empire Marketing Board and the rejuvenation of the London Underground. His alphabet is used on every Imperial War Graves Commission headstone produced since the First World War.

Caroline Walker's biography is finally able to do true justice to the many aspects of this remarkable career, and there really is nobody better to write his story. When I first saw a MacDonald Gill map – *The Wonderground Map of London Town* – in an antique map gallery on New Bond Street in 2001, I was struck by the seemingly impenetrable colours, motifs and strong dark lines. But features gradually began to emerge: the Serpentine, little tube station buildings, figures with speech bubbles containing phrases and in-jokes, the majority of which were terribly obscure. Caroline, who is MacDonald Gill's great niece, understands them all, and brings them to life with as much vigour as she does in person, for

example when pointing out, with obvious delight, tiny portraits of family members among daffodils in his map of the Surrey Hills.

It is this personal affinity that enhances this book's ability to fully celebrate MacDonald Gill after over half a century in the relative wilderness. Perhaps this intervening time-out has allowed for a more considered perspective on an artist who was so enmeshed in the social, political and visual contexts of his time.

For me there are two things that shine forth from Gill's work. First, there is his sheer quality as a draughtsman, able to produce lines and designs of supreme confidence, achieved – as we can see in surviving preparatory sketches – with virtually no underdrawing. It is a powerful antidote to the increasingly machine-automated methods of map production then being developed. Secondly, MacDonald Gill's work shows not only a great awareness of the visual heritage of Britain, but an understanding of how its nostalgic power could be harnessed. Yes, it was very much of the Arts and Crafts movement: medieval, antiquated, nostalgic, but in other ways it was modern – 'medieval modernism' as historian Michael Saler termed it. Using the past to reinforce the present is one of the oldest tricks in the book, but few mapmaker-artists since the medieval period utilised it as effectively as Leslie MacDonald Gill.

Tom Harper
Curator for Antiquarian Mapping
The British Library

INTRODUCTION

O<small>N</small> N<small>EW</small> Y<small>EAR</small>'<small>S</small> D<small>AY</small> 1927 an enormous pictorial poster called *Highways of Empire* was unveiled on a giant billboard in the Charing Cross Road. It caused a sensation. Traffic came to a halt, and police were called as crowds gathered to gape at this extraordinary depiction of the British Empire. This poster was designed by 'the inimitable Mr Gill', as one article called my great-uncle MacDonald 'Max' Gill, the younger brother of the sculptor and typographer Eric Gill.

Detail from *Highways of Empire*, poster for the Empire Marketing Board, 1927

Until I began my research, I knew almost nothing about Max – as he was called by friends and family. I was therefore astonished to discover that in his lifetime he had been almost as renowned as his older brother Eric. Max painted decorative maps for such iconic buildings as the Palace of Westminster and Lindisfarne Castle and murals for churches such as St Andrew's in Roker, Sunderland; he designed numerous houses and cottages in Sussex and Dorset and logos for organisations such as the Post Office; and he created the alphabet that is still used on the familiar British military headstone. He was best known, however, for the whimsical pictorial poster maps that he produced for companies such as the London Underground. These were imitated by artists across the world and set a style that continues to influence map-makers today.

My love of Max's maps goes back to childhood. For years his poster of Ceylon (now Sri Lanka) hung on the kitchen wall in our family home. It was a striking map filled with pictures of tea plantations, elephants and crocodiles, landmarks such as the great rock of Sigiriya, and a beautifully decorated compass. Over time, this once-beautiful poster became so tattered, grease-stained and faded that it was eventually tossed into the dustbin.

Detail from fold-out map, *Coricancha: Garden of Gold*, (written by A.T. Tschiffely), 19.3 × 34.5 cm, 1943

I was also captivated by an exquisitely drawn map tucked inside the covers of a book entitled *Coricancha: Garden of Gold* – an account of the conquest of the Inca Empire. This hidden gem was littered with llamas and other exotic animals of the Andes as well as Spanish galleons on seas infested with scaly sea creatures. The world it conjured up was so alluring that years later I undertook my own journey to the land of the Incas. It would be another three decades before I set off on my greatest quest – to learn about the maker of this magical map.

I had always known that Max was an older brother of my grandfather Evan Gill and when researching family history in 2006, I came across his name and was reminded of his beautiful maps. As a keen amateur photographer, I had the idea to compile a small booklet of photographs of the Max maps I knew, but when I began hunting for some information to accompany the images, I could find almost nothing about the artist – even my relations seemed to know little. My appetite whetted, I set out to discover more about this mysterious figure.

A major breakthrough was meeting Max's daughter Mary Corell – an energetic and enthusiastic lady in her late eighties – who was eager to share recollections of her adored father. Shortly after this, a Canadian cousin presented me with his grandfather's large scrapbook of Max-related letters, photos and cuttings, which has proved to be an invaluable source of information.

Then in the autumn of 2007 came a remarkable discovery. Through the Ditchling Museum of Art + Craft in Sussex, I made contact with Andrew Johnston, the nephew of Priscilla Johnston, Max's second wife and, in an enthralling first phone call, he revealed he had inherited a large amount of his uncle's artwork and memorabilia, including such poignant objects as his baby shoes. After Max's death Priscilla had stored everything away in the cottage she had shared with Max, and when she died, Andrew and his wife began to unearth these treasures. A fortnight later I was sitting in Max's old home, surrounded by all manner of personal items including photographs, diaries, love letters, portfolios, sketchbooks, piles of loose artwork and dozens of pristine posters rolled in brown paper. Only now did I truly begin to appreciate the sheer quantity and quality of Max's output in his extraordinary four-decade career.

At that point I realised that Max deserved to be celebrated with a proper biography. This book is therefore intended to provide a long-overdue and much-needed resource for all those seeking to learn about the life, loves and work of this once-acclaimed yet enigmatic artist.

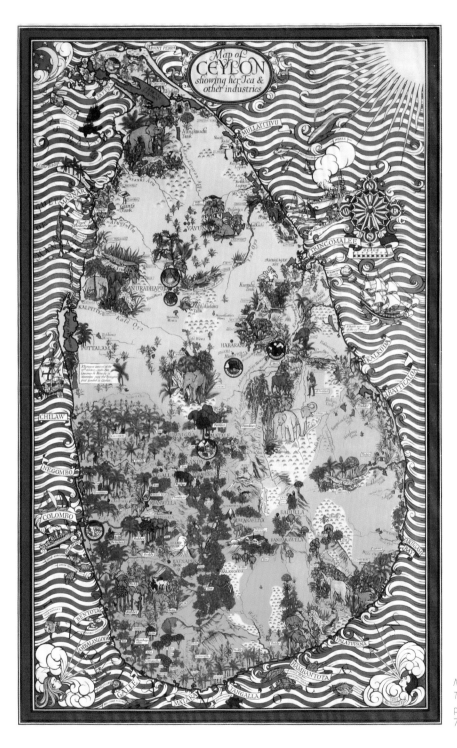

*Map of Ceylon showing her
Tea & other industries,
poster for Ceylon Tea Board,
76.2 × 50.8 cm, 1933*

WHO'S WHO IN MACDONALD GILL'S FAMILY

Grandparents
 George Gill (1820–1880) and Sarah Trego (née Halliday) Gill (1818–1898)
 Gaspar Robert King (1829–1916) and Rose (née Stubings) King (1833–1891)

Parents
 Arthur Tidman Gill (1848–1933)
 Cicely Rose Gill (1854–1929)

Children of Arthur Tidman Gill and Cicely Rose Gill

Enid Rose	12 January 1881 (d.1972)
Arthur Eric Rowton	22 February 1882 (d.1940)
Cicely Eleanor	8 January 1883 (d.1897)
Leslie MacDonald (Max)	6 October 1884 (d.1947)
Stephen Romney Maurice	5 January 1886 (d.1954)
Lilian Irene	16 September 1887 (d.1889)
Madeline Beatrice	27 November 1888 (d.1971)
Gladys Mary	18 September 1890 (d.1978)
Evan Robertson	24 April 1892 (d.1968)
Vernon Kingsley	24 April 1892 (d.1970)
Kenneth Carlyle	9 August 1893 (d.1918)
Margaret Evangeline	29 January 1895 (d.1979)
Cecil Ernest Gaspar	7 May 1897 (d.1981)

MacDonald Gill's Wives
 1. Muriel Bennett (1882–1967)
 2. Priscilla Johnston (1910–1983)

Max and Muriel's Children
 John Gill (1916–1985)
 Mary Gill (1918–2014)
 Anne Gill (1921–2005)

Other Relatives
 Aunt Elizabeth 'Lissie' Osmund – Arthur Tidman Gill's sister
 Uncle Stephen Osmund – husband of Lissie
 Wilfred and Gordon Osmund – sons of Lissie and Stephen
 Frederick 'Fred' Gill – Max's uncle
 Colin Gill – a cousin
 Una Gill – wife of Colin
 Elizabeth 'Lizzie' King (sister of Max's mother)

PART ONE

A Sussex Boyhood

1884 –1903

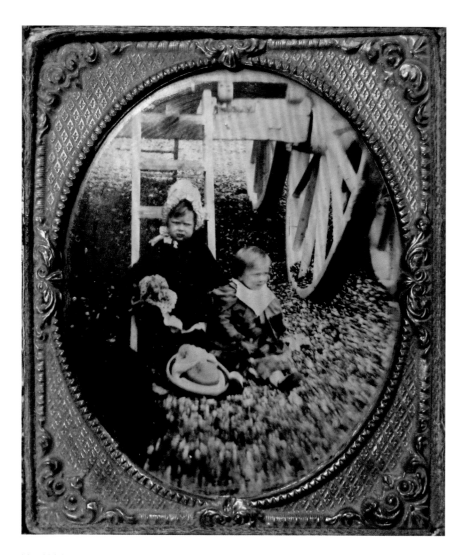

Max (right) and his older sister Cicely on Brighton Beach, 1895

CHAPTER ONE

Brighton
1884–1897

Leslie MacDonald Gill began life in a small but neat terraced suburban villa in Prestonville Road on the northern edge of Brighton, then a rapidly expanding seaside town. Eric had a dim memory of his brother's birth:

> And upstairs … in one of the back bedrooms, the westernmost of the two bedrooms on the first floor, I was in bed one morning. It is quite light. I don't know why I am not up and about. I think things must have been a bit abnormal; for as I sit there someone comes in and says: 'You've got a new baby brother' or words to that effect. I just remember the curious light in the room – as though it were lit by a yellowish skylight, but it can't have been, and me in bed and the person bringing the news. (That was Max, that was. So it must have been October 6th, 1884).[1]

Max was the fourth child and second son of Arthur Tidman Gill, a clergyman, and Cicely Rose (née King), formerly a singer. Arthur had been born to missionaries George and Sarah Gill on Mangaia, one of the Cook Islands. Aged only two Arthur was sent back to England with his mother and two brothers but the family later reunited and moved to Burnley in Lancashire where George Gill had been appointed minister of the Westgate Congregational Chapel.

Arthur also became a clergyman, first a Congregationalist minister in Burnley. Sermons of hellfire and damnation not being in his nature, he found himself at odds with the congregation so in around 1878, he moved to Brighton to work as assistant minister at the North Chapel of the Countess of Huntingdon's Connexion, which followed a Calvinist form of Methodism.

Shortly after arriving in Brighton, Arthur, a tall bearded figure, met Rose, a petite but striking young woman with a forceful personality. Her

Max's birthplace,
2 Prestonville Road, Brighton

Grandfather, George Gill, missionary and minister of Burnley Chapel
Grandmother, Sarah Gill

Baby shoes showing Max's name on one sole with Eric and Vernon's names crossed out

father, Gaspar Robert King, was a London timber yard manager, whom Eric remembered chiefly for his 'complete outfit of teeth which clacked as he spoke and a large library of worthless second-hand books'.[2] Family legend has it that there was French blood on this side of the family with an ancestor who was said to have accompanied Louis XVI on his flight to Varennes.[3] Rose had a fine contralto voice and joined the Alleghanian Bell Ringers, a touring concert party group that performed all over England as well as overseas. Years before she joined, the troupe had encountered George Gill in the South Seas when their ship was inadvertently blown onto the shores of Mangaia. To repay the warm hospitality they had received, they put on an impromptu concert to entertain the mission station – a rare treat. In 1879 Arthur Gill went to see the Bell Ringers performing at the Brighton Aquarium and was captivated by their raven-haired singer 'Rose le Roi'. Determined to meet her, he went backstage after the show introducing himself to the players as 'son of the Rev. George Gill of the South Seas'.[4] A year later he and Rose were married.

Rose and Arthur settled down to a life of domesticity in Brighton. Over the next seventeen years she gave birth to thirteen children, eleven of whom survived to adulthood. A friend on hearing from Mr Gill of the imminent arrival of yet another child, asked if it was not going to make things difficult. Mr Gill, smiling serenely, answered 'the Lord will provide', to which his friend replied, 'yes, of course, but aren't you straining His hospitality a bit?'[5]

Their father had a notion that a well-chosen name would inspire a child in life. Accordingly, the girls were named after romantic heroines, and the boys after heroes or literary greats. Max was named after George MacDonald, the Scottish poet, author and Christian minister, whose writings were much admired by Arthur Gill – but he quickly became known as Mackie or Max.

The family moved to nearby Preston View in Dyke Road Drive,[6] a recently developed area of red-brick and stuccoed terraced houses. Their new home was on top of the high chalk railway embankment and from the back windows there were fine views over to the village of Preston and the downland to the north. Just beyond the back garden was a triangle of land bisected by the Hove branch line, which then plunged into a tunnel running almost under the house. The children would watch the trains through the wooden palings. Eric wrote: 'they came very slowly because it was quite noticeably uphill … snorting and puffing up out of the tunnel.'[7] The Gill boys could identify all the engines and rolling stock on the lines; these were among the first things that Max learnt to draw.

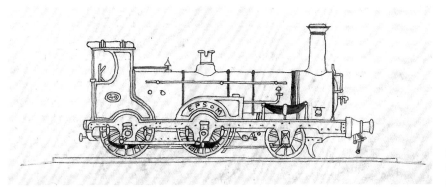

Four-coupled Bogie Engine
No 693, drawn by Max Gill
aged twelve, 4 November 1896

Max shared a bedroom with his younger brother Romney, who recalled thirty years later: 'Do you remember the patterns on the ceiling and wall thrown up by the red stove in our bedroom? Do you remember the red blanket which Max and I each had on our beds? Ah I do, for I have mine here … and it still covers my bed. And it is still without hole or tear.'[8] The household at Preston View was typically Victorian with Father at its head and Mother in charge of all domestic arrangements. The children were taught to obey and respect their elders and were instilled with the moral attitudes of uprightness and honesty. Underpinning every aspect of life was religion, giving their lives meaning and engendering a feeling of security and certainty about the world. Both parents led by example, and seem to have been united in their purpose, although their natures and methods differed.

Eric described their father as 'a very kind man … very sentimental' but also as 'lazy and vain'.[9] Although in his teenage years Eric's combative nature pushed him to argue with his father, he also acknowledged the profound influence of his parents: 'There has never been a time when I have not known or even when I have forgotten that the main lines of their teaching were the main lines of the road to heaven.'[10] Max did not possess his brother's rebellious streak and always looked up to his father for approval; even if he disagreed, he would never have openly criticised him. When his father disapproved of Max's smoking, for example, Max immediately stopped. Two years later his father relented, and Max wrote: 'As regards my smoking – Father has allowed me to freely now. So I am glad I was able to wait.'[11]

The household revolved around their father. When he retreated to his study, Rose Gill protected him: 'Father must not be disturbed; he's writing his sermons. Father must not be wakened: he's very tired after his Sunday work. Father's shoes or slippers must be warmed.' On

Father, Arthur Tidman Gill

Mother, Cicely Rose Gill

the other hand, Rose '… worried and fought and sweated, while she worked her fingers to the bone with sewing and washing and mending and cleaning'.[12] Her pregnancies and constant housework meant she was physically worn out and thus more demanding of her children, but she had an indomitable spirit and would keep the household in good cheer with her singing and dry wit. She could also be mischievous. On one occasion Arthur was in the garden and spotted her cradling a baby at the window above and began lyricising over the pretty sight. She vanished but re-appeared moments later, still 'devotedly nursing her little bundle'. When her husband continued his rhapsody, she cried, 'Catch!' and 'threw the bundle out of the window'. In panic Arthur managed to catch it, but found himself clutching not a baby but a pillow.[13]

'Mackie', as his mother called him, 'was a very special son'[14] and he adored her in return. As a child Max would help her in the house or look after the younger children for her. She had a profound influence on his attitudes and behaviour. Forty years later he recalled one particular incident that had taught him an important lesson. During a musical evening at the Gills' home, Rose:

> signalled to Max & they withdrew to the kitchen. They had set the tray with the greatly prized 'best' teaset, a cherished wedding present, when there was a disasterous [*sic*] accident. Somehow the tray was dropped or knocked off the table. The best teaset lay in ruins at their feet. She looked at it & said 'We'll have to use the ordinary cups then, shan't we?' & proceeded to get them out. If she could have known the effect that incident had on her young son she surely would have thought that the loss of her best teaset had been a small price to pay. For the rest of his life whenever things went wrong, he quietly set to work to put them right or started from the beginning over again. Not a word did he say.[15]

The children were brought up according to a strict Christian moral code and attended chapel at least twice every Sunday. They would sit in the front row of the gallery of the chapel, in full view of the congregation and directly above their father, who – when preaching – would wear 'a special black gown, very noble and voluminous'.[16] The sermons and speeches were not restricted to the confines of the chapel; even at home, their father would quote texts, prayers and poetry to which the children would be expected to pay full attention. Prayers were said before meals

and at bedtime without fail and high up on the breakfast room wall their father affixed a card depicting a large eye, which was supposed to represent the idea that 'Thou God seest me'. Eric recalled his embarrassment at this and said: 'it stared steadily down on us and followed us all round the room.'[17]

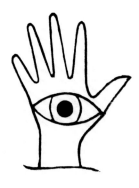

Eric Gill, *Hand and Eye*, wood engraving, 2.2 × 3.5 cm, 1908

By 1896 there were eleven children – a daughter Irene had died 'of nurse's neglect'[18] aged two in 1889 – ranging in age from one to sixteen years old. The older children put together a family newspaper with drawings, jokes and stories and regularly devised entertainments which they called 'Children's Programmes' for the younger members of the family and their friends. These consisted of tableaux of fairy stories or historical events, especially those depicting gruesome death scenes including those of Nelson, King Harold and Mary Queen of Scots. The theatricals would be followed by refreshments and hymn-singing and sometimes one of the boys would dress up in their father's cassock and pretend to preach a sermon. Music too was part of the fabric of their lives. Their mother – who taught all her children to play the piano – would sing popular songs or classic arias from light opera as she scrubbed the floors or prepared a meal in the kitchen.

Outside the home were other entertainments. Just around the corner was the Booth Bird Museum with its dioramas of stuffed owls, gulls and other curiosities and in town there was the Brighton Museum with its collection of fossils. Another attraction was the Brighton Aquarium, the scene of their parents' first meeting, where there was not only a wonderful array of sea creatures in glass tanks to be seen but also concerts and the earliest moving picture shows on an Edison Kinetoscope.[19] In summer there were also the joys of the seaside: paddling in the sea, picnics on the beach and the possibility of a ride on the train that trundled along the promenade. Once Max and Romney were treated to a ride on Magnus Volk's 'Daddy-long-legs' tram,[20] which ran on its seven-metre-high legs along concrete rails through the surf to Rottingdean.

Also within walking distance was the open country of the South Downs, another favourite summer destination. Here the Gill 'clan' – as they called themselves – and their friends would play boisterous adventure games. Eric wrote of the beauty and sense of freedom up here: 'with the harebells blowing in the short turf … and mother and tea waiting for us at home.'[21] For Max too it was the beginning of a life-long passion for the Sussex landscape.

Their father had long been a keen amateur painter of landscapes; indeed, he often said that he 'ought to have been an artist rather than

a clergyman'.[22] He encouraged his children to draw and paint with meticulous attention to accurate perspective and the need to take care of their tools. Even the simple act of sharpening a pencil was given an importance. Both Eric and Max showed a talent for drawing from an early age and would fill their sketchbooks with watercolours of churches and farm buildings when they visited places such as Ditchling.

As he grew older, Max drew closer to his younger brother Romney, who was just fifteen months his junior. Both were sensitive and suffered from a stammer in their earlier years but whereas Max was always popular with his schoolfellows, Romney was shy and ill at ease. Unlike their brother Eric, neither enjoyed conflict, the reason perhaps why the pair became inseparable. Eric would sometimes be the target of Max's impish ruses for which Romney would play stooge. One night Eric woke to find his bedclothes slipping off the bed and discovered the duo outside the door pulling the threads they had fixed to the bottom of the blankets.

Max began his education at Miss Browne's,[23] a nearby preparatory school, before joining Eric at Arnold House School in Hove, where he was a part-time boarder. Romney, for some reason, was sent to Taunton House School, near their home, where he was deeply unhappy. With little money to spare, the Gill girls were all educated at home. Max enjoyed school immensely. He was an intelligent, hardworking and bright pupil who did well in class. His diaries record his triumphs – at the end of his first term at Arnold House, ten-year-old Max announced proudly: 'I am top in my class.'[24]

With his wiry build and boundless energy, he was also a natural sportsman. Max played in the school cricket team and his diary for 1895 is filled with match details such as: 'I scored at a match Arnold House V Merton House, Southwick … I made 11 runs not out "Hum! Hum!".'[25]

Ditchling Church, watercolour in sketchbook, dated 1892 when Max was eight.

Their father would sometimes take the boys to the Sussex County cricket ground in Hove, where they would watch their heroes – Billy Newham, or the legendary Ranji (K.S. Ranjitsinhji), one of the top batsmen of his day.

At the beginning of 1897 the family was shattered by tragedy. A major epidemic of measles laid low most of the Gill children. Thirteen-year-old Cicely did not recover – she died on 8 January. Eric, just one year older, wrote that she was 'the good one in our family and she was strong and happy and intelligent . . . I do not remember the slightest thing wrong

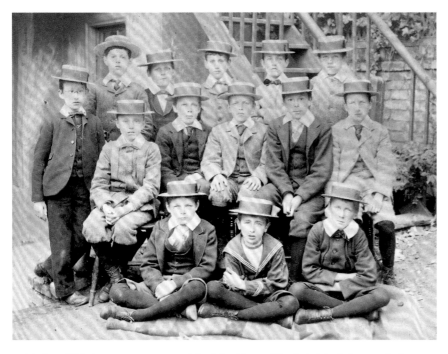

Arnold House School photo, c. 1896. Max front row, far right; Eric seated second from left.

with her.'[26] Max was to record in his diary Cicely's birthday and the age she would have been, well into his adulthood. Her death was especially devastating for their mother, who lost – not just a precious daughter – but also a wonderful 'little mother'. With ten children to look after and another baby on the way, Rose suffered deeply.

The timing could not have been worse. Their father was just about to start a four-month training course at Chichester Theological College, to become an Anglican minister.[27] On his last day at North Chapel, the 'hat' was passed around the congregation, who contributed generously and the money that was raised helped the family, who had no other income, keep afloat until Arthur might be given a curacy. For the next four months Rose was responsible for looking after the family in Brighton. The wife of another minister, Mrs Philson, stepped in to help look after the younger children who still had measles, while Eric returned to school. To ease the burden, it was decided that Max should be sent to stay with his Aunt Lissie and Uncle Stephen Osmund, a wealthy businessman, in Blackheath.

The Osmunds were a solidly middle-class and well-to-do Methodist family with two boys. Also living with them was Max's grandmother Sarah Gill, whose husband George had died some years before. Rose's feelings about the family are stated in a letter to Max a few years later:

Cicely Eleanor Gill, *c.* 1896

> … I can quite understand your not being at all keen about going down – even for the feed – everything is so 'nice and ordinary'. Wilfred is an utter prig though he was very amiable with me and I couldn't 'squash' him as I would like to have done. I'm glad my boys are not like him.[28]

Her dislike may have stemmed partly from her having to accept much-needed charity from Lissie in the form of her boys' cast-off clothes and other handouts.

This separation from his family must have been a major emotional upheaval for twelve-year-old Max. At Blackheath he did not attend school with his cousins and was left to his own devices for much of the day. He made himself useful by running errands for his aunt, accompanied her to the shops and visits to neighbours and would also read to Grandma Sarah Gill and she in turn may well have regaled him with tales of missionary life in the South Seas. His uncle also took the boys to such places as the Crystal Palace, the Tower of London and Madame Tussaud's where Max's favourite exhibit was a tableau of the meeting between Nansen and the British explorer Frederick Jackson in Franz Josef Land.[29] Max would spend countless hours creating programmes or props such as snowshoes for the boys' own tableaux inspired by what they had seen. At Easter Romney joined him and at the end of May, three weeks after Rose gave birth to her thirteenth child, both boys returned to Brighton. Max had been away for three months.

CHAPTER TWO

Chichester
1897 – 1899

O
N HIS ARRIVAL HOME Max was greeted with the news that the family was moving to Chichester. His father had been ordained into the Church of England and appointed curate at the sub-deanery church of St Peter in West Street. On 25 June the family moved into 2 North Walls, a cramped cottage (now demolished) in a cobbled lane which ran along the inner side of the Roman Wall near the West Gate. Its front door opened directly onto the street and the back bedrooms looked out onto the neighbour's backyard and the Roman Wall. Looking east from the broad footpath on top of this ancient structure, there were panoramic views over the city: to the north, the green woods and hills of the Sussex Downs and to the west and south, the lush meadows almost to Chichester Harbour. There was a maze of cobbled medieval lanes and alleys to explore in this compact walled city – such a contrast to Brighton's suburban red-brick sprawl.

Chichester Cathedral, whose impressive spire could be seen from almost every point in the city, was a magnet for the older boys. Eric and Max became so well known to the clergy that they were allowed to explore the hidden corners of the building, including its spire where Max once wrote his name on a beam. The cathedral prebendary Dr Robert Codrington became a close friend of the boys and would invite them for tea. Like Arthur Gill's father, he had been a missionary and had a collection of 'Relics of the South Seas' which he would bring out for their delight.

2 North Walls, second house from the left, beyond the signpost, Chichester, c. 1962

Life since Cicely's death had been a trial for the Gills, especially for Rose. During her husband's training, there had been no income and now his curacy at St Peter's only offered him £90 in contrast to the £150 he had earned as a minister in Brighton. There was so little money, it was sometimes hard to put enough food on the table and clothes were worn until almost threadbare. Eric later wrote of the 'perpetual rumour of bills and summonses and the perpetually hovering suspicion that the attitude of the baker or the butcher … was not as friendly as … would

have seemed natural.'[1] And for Rose coping with eleven children in such a tiny house involved a remarkable feat of organisation. There could no longer be paid help so all the children – especially the older ones – were expected to share the burden of household chores.

As sons of the clergy, Max and Romney were enrolled at the Prebendal School.[2] Despite having missed school for seven months, Max was soon excelling, winning school prizes for Latin, geography, algebra and drawing. He began a Saturday class in wood-chip carving at the Theological College and three evening classes in drawing, designing and wood-carving at the Chichester Technical College and Art School, where Eric was studying full-time. The drawing tutor was Mr George Herbert Catt, who would often invite the boys to his home for tea and croquet on the lawn.

A diary entry for 17 November 1897 is the first indication of a new-found love and talent for map-making: 'dg. [drawing] part of map.'[3] From 3 February the following year map-making becomes a regular pastime, with Max charting every corner of the globe including the East Indies, China, Ireland and Japan. Some maps were for school projects but many were for competitions in *Chums*, a popular boys' magazine and over the next two years these won him numerous prizes and honourable mentions. He also made maps to barter with his friends: 'I exchanged 3 of my maps with Moore, ma [major] for 1 cricket ball & 3 eggs viz 1. Herring Gull 2. Golden Plover 3. Galsway.'[4] None of these early maps seems to have survived.

Another passion was photography. With some of his competition winnings, he bought a Nansen hand camera and darkroom equipment. Undaunted by his early failures, he practised hard and quickly became competent enough to take portraits of his schoolmates to sell to them as visiting cards to supplement his pocket money. The older Gill boys and their friends were allowed to explore beyond the city walls. Favourite destinations were Salt Wood, 'the Devil's Humps past Kingly Vale' and 'the Chalk Pit' where they would spend endless hours 'sledging', fossil-hunting, playing 'bows-and-arrows' or collecting birds' eggs.[5] In the summer Max would go fishing with his schoolmate Charlie Ballard in the canal – one expedition netted over thirty minnows although 'some died on the way home'.[6]

Their horizons expanded dramatically when Eric acquired a bicycle. With Max riding pillion, they would go on sketching expeditions to outlying villages such as Selsey and the Witterings. It was on one such trip, speeding downhill, they had an accident in which Max suffered a

Prebendal School Prize bookplate, pen and ink on card, 1920s

broken nose, an injury that resulted in numerous operations over the years and left him with his distinctive crooked profile.[7]

Despite his rather reticent nature Max had a talent for entertaining. At the age of thirteen he took up conjuring as a hobby after being invited on stage to help at a magic show in Chichester.[8] After practising his card tricks and illusions until perfect, he would perform at events such as his sister Madeline's birthday party where 'Between each act, Rom & I did conjuring tricks under the title of Prof. Hardy & Blackey Arumptoida. All went off very well.'[9]

Max and Romney's *piéce-de-resistance* became *Box and Cox*, a popular farce of the time. The plot revolves around two lodgers who share a room with only one bed – Box the Printer (Romney) uses it by day and Cox the Hatter (Max) by night; the third character is the landlady Mrs Bouncer (first played by schoolfriend Charlie Ballard). Initially their audiences were family and friends but as word spread, they were invited to perform at St Paul's schoolroom in Chichester for a variety of local groups. For years the piece was a regular feature at family events – with a piano accompaniment by their sister Enid and the character of Mrs Bouncer played by whoever was available.

The Gills lived in Chichester for only two years, but this short period had a profound influence, particularly on the two older boys. The college provided their first artistic training and the city shaped their early ideas of architectural beauty, although the pair were to develop totally different feelings about the city. Eric as a teenager began to feel trapped: 'I was very miserable and dissatisfied' and had decided that for him Chichester was 'no abiding city.'[10] Max, by contrast, never stopped loving 'Chi Chi'. He had been extremely happy here, and had developed friendships, skills and confidence, the foundations of a successful life in the years to come.

Max's schoolfriend Thornewell 'sledging' at the Chalk Pit, drawing in letter to Romney Gill, 1923

CHAPTER THREE

Bognor
1899 – 1903

In May 1899 the Reverend Arthur Tidman Gill was offered the curacy at St John's Church in London Road, Bognor.[1] The stipend was a slight improvement on St Peter's but there was no accommodation to go with the job. Max, Romney and their mother found Strathmore in the High Street, and after some haggling, a deal was struck. On 20 June the family left Chichester – parents and children on the train, and all their worldly goods in two horse-drawn vans – for their new life in Bognor.

When the Gills arrived here, Bognor was already a well-known and rapidly expanding holiday destination with a pier, the Assembly Rooms, the Esplanade, the new Victoria Theatre and a golf course.[2] The town also boasted a range of modern facilities, such as piped water, sanitation, regular rubbish collections, a police station and fire brigade. It was an eminently respectable middle-class town.

Although lacking the architectural charms of Chichester, Bognor had at least one major attraction: the sea. Max built a wooden beach hut which became the family's base for picnics, bathing and shrimping. Known as

Strathmore, the Gill family home in Bognor

'The Hut', it was also a place where Max could enjoy a little privacy – to sketch, read, or write his diary in peace, away from the demands of his younger siblings. The Gill boys learnt to sail here – one legendary trip was written up as 'The Log of the Jolly Roger' – and all became strong swimmers sometimes venturing into the deep dark waters under the pier.

Until the end of the summer term Max and Romney continued to attend the Prebendal School in Chichester, cycling the seven miles twice a day on their second-hand Stanley bicycles.[3] In the autumn they started at White's Naval Academy – also known as Holyrood College[4] – in Victoria Drive, although there was no hint that the Gill brothers were destined for naval careers. The pupils would have regular military-style drilling in the schoolyard and after the start of the Transvaal War (Second Boer War) in 1899, the headmaster, Mr Williams-White, ensured

'The Hut' built by Max on Bognor beach – view looking towards Felpham, pen and ink on paper, 1904

they were kept up to date with events. Good news such as 'Pretoria is Practically Captured without any Resistance'[5] was greeted with jubilation by the pupils because it meant they might be awarded a half-day's holiday. Many local men were fighting in the war and on their return there would be noisy parades to welcome them home. Patriotism was also preached at home where Arthur Gill would read out passages from the *Daily Mail* to the rest of the family.

Max's passion for map-making continued unabated. His allegiance to the boys' magazine *Chums* switched to *The Captain* when he discovered that the latter was advertising a map-drawing competition. His first entry, a map of Ireland, won first prize, the princely sum of one guinea (£1 1*s*), good reason to continue his hobby. At school his artistic talents were also put to good use in an emergency as he records: 'I took C class in drawing owing to Monsieur having toothache.'[6]

The household dynamic changed in April 1900 when Eric moved to London, where he was to be a pupil of the architect W.D. Caroë. His absence would have provoked mixed feelings. He was missed and letters were written regularly – Max wrote to his brother most Sunday evenings. However, there must also have been a sense of relief. Eric had been eager to leave as he later admitted: 'I was hateful at home and hated being there.'[7] Romney certainly found him difficult, describing him as 'outstanding in aggressiveness and argumentativeness',[8] but Max, by contrast, he described as 'an extremely attractive person … always the joker of the family, as well as the most thoughtful and kind',[9] an opinion echoed by other siblings.

Max, c. 1901

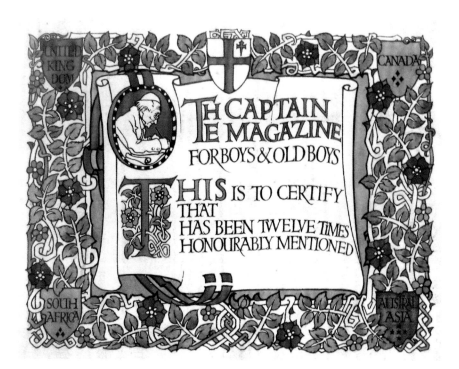

At the end of 1900 Max, just sixteen, left White's Naval Academy. This pivotal moment in young Max's life coincided with an event that shook the nation: the death of Queen Victoria on 22 January 1901. Max travelled to Gosport to witness the historic spectacle of the British fleet paying homage to their late Queen as her body was carried from the Isle of Wight across the Solent to Portsmouth on its journey to London. The teenager was mesmerised at the sights and sounds, later writing: 'At 3 o'clock exactly the 1st minute-gun went off along down the line. Grand it was to see these huge vessels flashing out their guns … at different intervals down the line we heard the thunder – like reports … the "Alberta" with its sacred burden appeared in sight. The standard was flying at half-mast, but one could distinguish the white pall covering the coffin on deck … preceding the boat were six torpedo-boats abreast … long, black & shiny, moving gracefully & quickly through the Harbour … the guns from the land-batteries began & solemn & grand were the sounds … mingled with the bugles & the muffled bells.'[10]

It had been decided that Max should follow in Eric's footsteps into a career in architecture and three days after his trip to Gosport, he was taken on as a pupil of local man Leonard Pilkington –'just to see how I like it for a month'[11] – Max noted in his diary.

Pilkington ran a one-man practice in general architectural work, dealing with everything from surveys of leaking roofs to house design. From the moment Max stepped into the office, he was involved in practical on-the-job training. He quickly became adept at drawing to scale, tracing and painting plans; he discovered the importance of accurate measuring and surveying; he learnt about bricks, stone, timber and tiles; he gained an understanding of stresses and strains, angles and pitches, weights and loads; he acquired the ability to estimate and price up potential jobs; and he learnt how to deal with clients as well as workmen. His diary records his daily tasks: 'Went with Mr and Master Pilkington to Eastergate to see about a new roof on water works' and 'Rode with Mr P to Bertwick House to do surveying and levelling' and at Mrs Dunnett's house on Victoria Drive he 'Tested the drains by explosive let down W.C. Pipe.'[12] Both Max and Romney loved experimenting with an array of recipes using volatile chemicals and glass bottles, most of which would result in earth-shattering bangs.[13]

Within months Pilkington was entrusting Max to man the office in his absence, to cycle out to building sites in outlying villages to check on works-in-progress, and even to distribute the labourers' wages at the end of the week. On his way home from such visits, he would sometimes stop at a village church or picturesque cottage, pull out his small sketchbook and make a quick drawing, later painting it up in watercolour.

During the summers of 1901 and 1902, the Gills let Strathmore to a family for the holiday season and decamped to the village of Slindon, where Arthur Gill assisted the rector, the Reverend Izard. The move not only boosted the Gills' income, it also gave the family the nearest to a holiday that they could expect. These 'Slindonian days', as his sister Angela called them, became the stuff of Max's dreams. For the rest of his life he treasured enchanted memories of long hot lazy days, idyllic family picnics on the downlands, endless games of cricket and tennis, afternoons of painting and sketching, the solitude of reading in shady woods, strolls along dusty lanes hand in hand with Angela or little Cecil, as well as musical evenings with their friends the Izards and once their father took them on a visit to Walberton Rectory 'to see Mr Crawley's baboon'.[14]

Meanwhile the Boer War was still being fought. Patriotic newspaper reports had the effect

The Gill family (without Eric) c. 1899. Back row, standing left to right: Romney, Rose with baby Cecil, Max, Gladys and Enid; front row, standing left to right: Evan and Madeline, sitting, left to right: Vernon, Angela, Kenneth and their father Arthur Gill

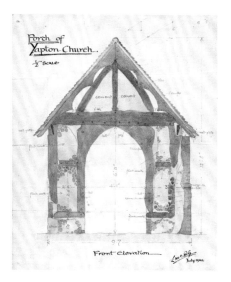

Left: *Porch of Yapton Church,* watercolour on paper, July 1902

Right: *Under Slindon Woods,* watercolour on paper, c. 1902

of boosting recruitment into the forces and in March 1902, Max and five friends signed up to serve as part-time volunteers for three years in the Sussex Yeomanry.[15] With gusto, he threw himself into the weekend drills, shooting exercises and the week-long summer camp at Arundel where the regiment would practise manoeuvres on horseback and engage in mock battles. Max became a crack shot with his Lee-Enfield Marks rifle, winning several yeomanry shooting competitions. He loved the camaraderie of this amateur military life and was soon part of a musical group that performed at the camp 'smoking concerts'.

By this time Max was also enjoying his first romance. Towards the end of the previous year, he had joined the Bognor Amateur Orchestra and been smitten by one of the young lady members. Two years his senior, Mary Brown (later known as Molly) was a sweet-natured and attractive young woman with a mass of dark brown hair swept up in the Victorian manner. Her family home was Leigh-on-Sea in Essex, but she was in Bognor looking after the children of the Radford family who were also from her home town. Their mutual love of music took Max and Mary to concerts at the Assembly Rooms, they lent each other sheet music and books, and Max wooed her with poetry and presents of painted local scenes. They would contrive to meet 'by accident' on their various strolls and errands around town or after church and she soon became a frequent and welcome visitor at Strathmore where she joined in their musical evenings and games of ping-pong. As an honorary family member – Arthur Gill called her 'The Dear One' – she was one of the founder members of the Blubberchops Club, which

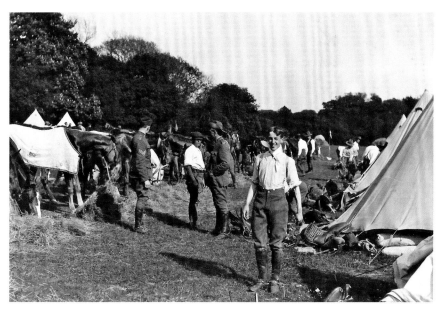

Max at Sussex Yeomanry training camp, c. 1902

was formed by some of the Gill siblings around 1905. There seems to have been no particular point to the club except to create a secret brotherhood which brought them all closer together. They devised a set of humorous rituals, chants and rules (enforced by Romney, the 'Hon. Sec.') and each member had a role and a pseudonym: 'Mr Beelzebub (President [possibly Max]), Redskin (Door Mat), Springer (The Gas Bag), Tenderfoot (Chucker-Out) and 'Stick-in-the-Mud' (Hon. Sec.).' Romney had various names for Max, including Magbelia, Maggles or Baggles, and they both answered to Gorsewell.[16]

Max's diaries are generally factual – revealing little emotion – but just occasionally there is a hint of his feelings with such touching and enigmatic entries as: 'After church saw Miss Brown home – I will not here write any details, but will mention it as a day to be remembered.'[17] And after Max called at the Radfords to see if Mary could come for a cycle ride, he wrote: 'As Mrs Radford was out, however, she was not able to – and I was afterwards very glad … "God fulfills himself in many ways".'[18]

The inevitable day arrived when the Radfords had to return to Leigh-on-Sea, taking Mary with them. But no sooner had Max bade her farewell at Bognor station on 14 June 1902, than he wrote to Eric to ask if he could come and stay. A few days in London could easily be used as an excuse to have a day trip to Leigh. Four days later Eric met Max at London Bridge station and took him to his digs at 16 Old Buildings in Lincoln's Inn.

16 Old Buildings, Lincoln's Inn,
drawn on Max's visit to London,
watercolour on paper,
24 June 1902

Eric was sharing lodgings with the calligrapher Edward Johnston, his teacher at the Central School of Arts and Crafts, who welcomed 'Gill's brother'. Max thought him a 'v. nice fellow'[19] and a friendship began that would last a lifetime. While Eric was at work, Max explored the sights of London, including the Temple Church, and the unfinished Westminster Roman Catholic Cathedral which he thought 'grand'. But of all the places he visited, he was most impressed by the Church of the Holy Trinity in Sloane Street, noting in his diary: 'The Church was fine. Beaten-silver round organ, by Wilson, East Wdw. [window] by Morris, & Ironwork by Corlett [*sic*].'[20]

Max arranged to call on Mary the following Monday. He arrived in Leigh early and spent some time looking around the town and sketching the harbour before arriving at her home at 3 o'clock precisely. After having tea with her mother and sister, he and Mary caught a train to Southend-on-Sea, where they had 'a very jolly time'.[21] But their six hours together was over all too quickly: Max had to get back to London and by the 26th was back in Bognor.

They would not see each other again for some months, but in the meantime, he wrote her long letters, enclosing small tokens such as photographs, hymns, paintings and 'shoes & stockings' flowers picked on the South Downs.[22] There were many other pleasures and diversions in the summer including cricket. Max was now playing for the Bognor first eleven, although if it was hot even he could be enticed by Romney to miss a match to go swimming. There were also local dances and musical evenings – at which Max would play his violin – and outings with his good friends Ronald Rust, Frank Truman and Emile Pilkington. When Eric joined the family in Slindon that August, he and Max spent a great deal of time together. They 'rode over to Bognor', 'had a v. jolly walk to Eastham & sang "Oh haste, oh haste ye to the ferry"', 'helped prepare for the Dance' in Barnham, and one night in company with Romney, they 'walked up on the Downs, as the Moon was so lovely'.[23]

After the holidays Max took on a pupil, a ten-year-old boy, Edward Wilcox, who needed tuition in Latin, giving Max an income of a few shillings a week. Although Max and Mary continued to correspond, she put off Max's proposed visit. Instead it was fifteen-year-old Romney – now working in Shepherd's Bush, London – who began visiting her rather frequently that autumn. A deeper attachment between the two

was formed on 7 November, a date pinpointed by both as their special anniversary.[24] Max, however, knew nothing of this development.

As the year drew to a close, Max's thoughts turned to the future. Although his time with Pilkington had been useful and enjoyable, it is unlikely that Max wanted to be a provincial architect for the rest of his life. Eric seems to have used his connections to help Max find a job in London. In February 1903 Max wrote with great excitement: 'Received letter from Eric this morning – which says that Nicholson & Corlette, Architects, have offered to take me on as an assistant fro [*sic*] 15/- per wk!!!'[25] Whatever the case, Max had good reason to be pleased. Sir Charles Nicholson and Hubert C. Corlette were ecclesiastical architects with an excellent reputation and worked with the top craftsmen of the time – and only a few months before, Max had admired Corlette's work in Holy Trinity Church. Max's acceptance of the offer was signed, sealed and sent by nine o'clock the following morning.

Nine days later, Max left Pilkington's office for the last time. On his last Sunday in Bognor, he presented prizes to the most deserving children in his Sunday School class and in the afternoon he packed his trunk. Eric had come down from London to celebrate his twenty-first birthday and after Evensong, there was a wonderful evening of 'music and singing … till 12o'c – & then talked till about 2.30 (Monday morn)'.[26] After just a few hours' sleep, Eric and Max climbed onto the 8.30 am train to London Bridge. A new chapter in Max's life was about to begin.

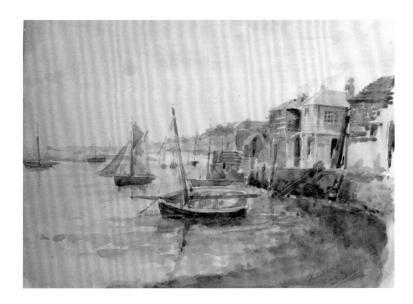

Leigh-on-Sea Boats, painted on the morning Max first visited Mary Brown here, watercolour on paper, 23 June 1902

PART TWO

London

1903 – 1914

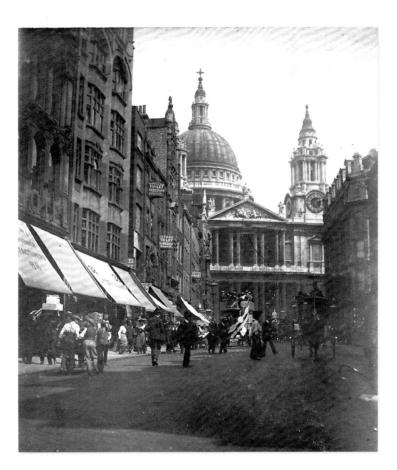

View from Ludgate Hill to St Paul's Cathedral, photo taken by Max, c. 1904

CHAPTER FOUR

The Early Years
1903 – 1908

W<small>HEN</small> M<small>AX</small> <small>ARRIVED IN</small> London, it was the largest city in the world, a thriving centre of world trade with its river and docks packed with merchant ships. Its pavements bustled with bankers in top hats, workers in cloth caps, flower sellers, and ragged urchins begging for coppers, while the streets swarmed with every type of horse-drawn vehicle from beer drays to buses, from milk vans to Hansom cabs.

Max was a sensitive-looking young man of slim build with short light-brown hair parted in the middle, high cheek bones, a distinctive bent nose and a pale complexion with pronounced circles under his pale grey-blue eyes. After the death of two daughters, his mother constantly worried about her children's health, particularly Max's, but she had little need for concern – he was stronger than his delicate looks suggested, and with his boundless reserves of energy and enthusiasm, he was determined to carve out a successful career for himself.

His first act on arriving in London was to leave his trunk at Bloomsbury House – a 'kind of club for young men'[1] – in Queen Square, and hurry down to 2 New Square, Lincoln's Inn, to introduce himself to Hubert Corlette, 'who is my future architect and I the paid assistant',[2] Australian-born Corlette, now in his mid-thirties, had joined Sir Charles Nicholson in 1895, and Max was, in fact, hired to assist both partners. Nicholson had been a pupil of John Dando Sedding, one of the key architects of the early Arts and Crafts movement, who had designed such churches as Holy Trinity in Sloane Street. Sedding instilled in his pupils, including Nicholson, the belief that the architect and craftsmen should all be closely involved with the construction of the building to create a unified whole. After Sedding's premature death in 1891, Nicholson worked with his successor Henry Wilson, later a silversmith, in an office sub-let from the architect Edward S. Prior at 1 Hare Court in the Temple.

One of Nicholson's pupils, the architect H.S. Goodhart-Rendel – a contemporary of Max Gill – said of his master:

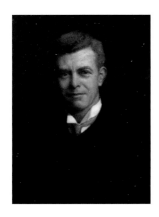

H.A. Olivier, *Sir Charles Nicholson*,
oil on canvas, 80 × 65 cm,
c. 1909

He was the most remarkable architect who ever lived. He had an extraordinary facility for drawing anything. He designed two Cathedrals, Portsmouth and Sheffield, and some forty churches. He did not care much for publicity. The number of things he has done without anyone noticing is simply incredible. His ecclesiastical career kept him rather apart. Also he was violently anti-academic and looked on architecture as an Art.[3]

The influences and ideals of the Arts and Crafts movement were visible in the artwork, fittings and furnishings of Nicholson and Corlette's churches, many of which possess magnificent painted ceilings, organ cases and altars. An early diary entry from this time reveals that their new assistant was in awe of the designs he was seeing in the office: 'All day helped clean up and paint Mr Nicholson's Liverpool Cathedral Plans – which he had brought up to his brother's digs – & have to be sent up by Thursday. Awfully fine – about 15 in all (sheets).'[4]

A typical workday for Max started at ten o'clock and finished at six o'clock with an hour for lunch. Apart from tracing and painting plans in the office, he often had to go out and measure up buildings such as All Soul's Church in Camden, London. Within a year, Max was entrusted to supervise and check work-in-progress in locations as distant as Chester, where Nicholson was enlarging and remodelling Burton Manor for Harry Gladstone, third son of the former Prime Minister William Gladstone. In fact, architects of this era often spent long periods on site monitoring construction, ensuring that no corners were cut, that materials were of the requisite quality and even, on occasion, wielding a trowel themselves.

After Easter Max enrolled on two evening class courses at a cost of 1 shilling each. The first was in leadwork, which took place on Wednesdays at the Westminster Institute, and the second was in architectural design under Sidney Caulfield on Thursdays at the Central School of Arts and Crafts in Regent Street. The first architecture lecture he attended was given by Halsey Ricardo, a leading exponent of glazed bricks and tiles,[5] who was currently building a grand house in Holland Park for Ernest Debenham, sometimes called the Peacock House.

At the end of July Max moved in with his brother in Lincoln's Inn.[6] Eric had recently embraced agnosticism and would argue fiercely with Max about his staunch Anglo-Catholic beliefs. Max would go to great lengths to avoid confrontation with his older brother, leading Eric to say years later that Max is 'so virtuous by nature and so stupid

Eric Gill, 1904

Max (far right) working
at a church, undated

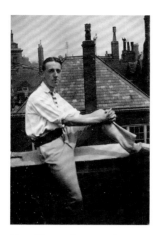

Max sitting on the parapet
at 16 Old Buildings, c.1905

and muddle-headed, also by nature, and he always has been impossible to argue with'.[7] Serious doubts about such a living arrangement had been expressed by Romney some months earlier: 'I can't help feeling rather glad that you won't live with Eric just yet. Good "chap" though he is, he would not encourage yours & my religion.'[8] However, Edward Johnston had vacated the flat prior to his marriage and Eric needed someone to share the rent. The matter was settled after: 'Eric & I discussed with Father & Mother concerning my going into 16 Old Buildings with Eric', wrote Max.[9]

The entrance to 16 Old Buildings was in a cobbled courtyard opposite the Old Hall and to reach their flat they had to climb up to the top of a narrow winding staircase. From his rooms Max could hear the impressive wrought-iron gates across the square clanging shut at night, and from the windows he could look out over New Square – where Nicholson & Corlette's practice was situated – to the magnificent Great Hall and the gatehouse beyond. The sixteenth-century walled Inn of Court was a mix of Georgian and medieval red-brick buildings grouped around green courtyards, giving the place a collegiate character; the community within was expected to abide by the Inn's own set of written, and unwritten, rules and regulations to ensure an atmosphere of dignity and decorum.

The main studio-cum-living room with its groin-vaulted ceiling and built-in bookshelves was fairly spacious and light with windows looking out over New Square and beyond. The shared bedroom was small by

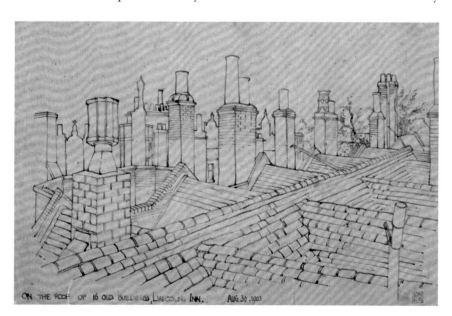

On the Roof of 16 Old Buildings,
pen and ink on tracing paper;
30 August 1903

Max's workspace at 16 Old
Buildings, Lincoln's Inn, *c.* 1908

comparison, furnished simply with a pair of iron bedsteads, two sturdy
chests-of-drawers and an upright chair. There was also a tiny bathroom
with running cold water and a small kitchen with a skylight which
gave access to the roof where Max would sit and read, draw or tend his
collection of plants on summer days.

The day Max moved in Eric was away in Cambridge where he was
carving inscriptions on the Medical Schools for the architect Edward
Prior. His passion for lettering had been sparked by the calligraphy
tutor Edward Johnston whose writing, illuminating and lettering class
at the Central School of Arts and Crafts he had joined in September
1899. Eric wrote: 'He profoundly altered the whole course of my life
and all my ways of thinking.'[10] He became increasingly disillusioned
with architecture as a profession and took up classes in masonry at the
Westminster Technical Institute and was soon sought after as a letter-
cutter. Prior's commission was a pivotal moment, forcing Eric to choose
between architecture or letter-cutting – he chose the latter.

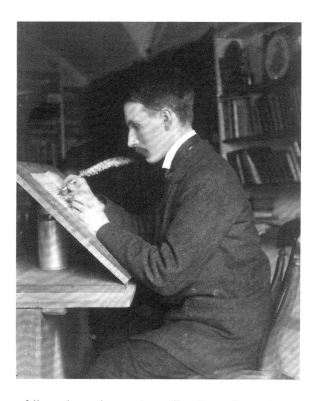

Edward Johnston at 16 Old
Buildings, Lincoln's Inn, 1902

Max too fell under Johnston's spell. The calligrapher was a frail-looking man with high-cheek bones, deep-set eyes and a full moustache, and bore – some said – a strong resemblance to Robert Louis Stevenson.[11] After a sheltered upbringing with no formal education, Johnston taught himself lettering and illuminating, often presenting beautifully crafted texts and cards to his sisters and relatives. After three unsatisfactory years of studying medicine at Edinburgh, he was encouraged by people who had seen his calligraphy to come to London to study art. Within days of his arrival, he met his hero, the calligrapher Harry Cowlishaw, who promptly introduced him to William R. Lethaby, founder and principal of the Central School of Arts and Crafts. To Johnston's astonishment, instead of inviting him to join a class, as he had assumed Lethaby might, he was offered a teaching post. Johnston's first calligraphy classes started in 1899 and spearheaded the revival of this lost art. Amongst his earliest students were Eric Gill, Noel Rooke, Graily Hewitt, Laurence Christie, T.J. Cobden-Sanderson of the Doves Bindery, and Helena Hall (Heddie), who had been nursemaid to the young Gill twins Evan and Vernon. Noel Rooke wrote of Johnston's zest, his humour and wit, of 'the clearness and vigour of his mind' and his 'exceptional courtesy'.[12]

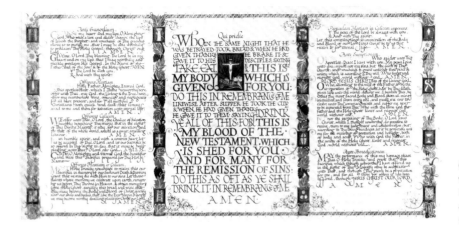

Communion service card written for St Silas' Church, Kentish Town, by Max, pen and ink and watercolour on card, 1911

As the master of the good lettering to which his students aspired, Johnston imparted knowledge of all aspects of his craft: its history, how letters were formed, how the shapes were made, what materials and tools had been used, and what produced the purest and most beautiful results, but most of all, he imbued them all with a passion for lettering. He believed that the three qualities of good writing were 'Readableness, Beauty, Character',[13] and this he taught his students with the study of old Roman lettering, alongside the techniques of cutting and sharpening reeds and quills, and an understanding of papers and vellums, inks and pigments. In true Arts and Crafts tradition he believed in the superiority of the traditional skills and the purity of the old forms. Under Johnston's systematic, careful approach his students came to acquire great skills, a number of them becoming well-known letterers and craftsmen. Max began attending the lettering classes at the Central School in January 1904 and was soon competent enough to be earning extra income from commissions for formal manuscripts and inscription designs for a number of private clients.

On 15 May 1903 Johnston took Max to his first meeting at the Art Workers' Guild where they heard a paper given by Francis W. Troup, the master leadwork craftsman of the day. The guild became the heart of Max's social life and it was here he met many of the architects and craftsmen he would work with over his career.

Founded in 1884 by a group of young architects, amongst whom were Lethaby and Prior, the guild promoted the ideas of the Arts and Crafts movement associated with William Morris and Philip Webb. It was an male-club of architects, artists and craftsmen, who called themselves 'brothers'[14] and respected each other on equal terms and

shared their knowledge and understanding of traditional techniques freely. At the time Max first attended, notable members included – apart from Johnston and Prior – the architects Charles Voysey, Edwin Lutyens, Halsey Ricardo, the silversmith Henry Wilson, Ernest Gimson, better known as a furniture designer, metalworker C.R. Ashbee, and stained-glass maker Christopher Whall.

In 1905 full meetings took place every fortnight at Clifford's Inn Hall (in 1914 the guild moved into its own premises at 6 Queen Square), but there was also a junior guild for younger members which Max also attended. The first part of the evening would consist of a main talk or paper presented by one or more guild brothers, usually accompanied by lantern slides. The titles of the talks Max heard range from the more obvious 'Gilding and Plasterwork' to such oddities as 'Horse-trapping[s]'. Afterwards the Master would lead a formal discussion before closing the meeting and those who wished could then linger for informal conversation over a glass of whisky. Women could only attend as guests on Ladies' Nights when the topics were selected to appeal to the feminine taste – Max took his sister Enid to a talk on lacework which they both thought lamentable.

He often went to guild meetings with the calligrapher Graily Hewitt, who lived at 23 Old Buildings. Johnston said of Hewitt that he was 'one of my 2 best students … He does most beautiful work – giving an extraordinary *proof* the good work *is* being revived and telling me, as mere works could not, that I have not wasted all my days.'[15] Originally a solicitor by profession, Hewitt achieved a degree of excellence in the craft of calligraphy and illumination such that Lethaby asked him to teach a second calligraphy class at the Central School that Max may also have attended. The two became close friends, often breakfasting together, and in the ensuing years they collaborated on a number of decorated formal manuscripts.

Despite Romney's misgivings, Eric was a great support to his younger brother in those first months. After work and at weekends they would go to exhibitions, talks and the theatre and most days they lunched together – often at the ABC in the Strand – and shared simple suppers at 16 Old Buildings. On Sundays the brothers often visited Dr Oliver Codrington, the Chichester Prebendary's brother, who lived in Clapham and could always be relied on to provide an excellent Sunday dinner. A kind and generous man, he took a keen interest in the well-being and careers of the Gill boys, even extending them loans when times were hard. Eric was expected to support Max financially until his first salary was paid: 'I trust

Eric is in funds and able to provide for you … you must tell him we are depending upon his helping you till the 25th,'[16] wrote their mother.

She regularly expressed her motherly concerns about working too late, about keeping warm and not eating properly: 'Don't stint yourself – you won't keep well if you don't eat enough,'[17] she would scold, and hardly a week passed without the Gill brothers receiving bundles of mended clothing or containers of family dinners including stews, sausages, boiled mutton or savoury turnovers. Full of practical advice and family gossip, her frequent letters display her dry wit:

> As the 'Times' has not awarded Father the £1000 prize I have had to come down in my ideas and, instead of sending you a splendid hamper must content myself with the usual mixture … generally the ingredients that 'little boys are made of'. May you enjoy the 'snips and snails'.[18]

These letters were often scribbled hastily during her busy day and reflect the warm and close relationship she enjoyed with her favourite son. Their content also provides a glimpse into the poverty of the Gill family; sometimes there was so little money that Rose could not even afford the postage for a parcel. She missed her boys, especially Max, but consoled herself with the thought that '… I believe in the "young man" himself … I have many hopes for you, and no fears, and for that reason I can cheerfully resign myself to your absence'.[19] Surviving letters from Max's father show the love for his 'dear boy' and a concern for his health and finances. A few weeks after Max's arrival in London, Arthur Gill was moved to write:

> I am grieved at the 'low water mark' at which your funds have arrived & thus send you a chq. for a pound – which I hope will reach you in time to save you from utter starvation – and enable you to put another penny 'in the slot' – I mean plate next Sunday.[20]

He was proud of his children's achievements and would write warm letters of congratulation at any new success but he could also be critical. He deplored Max's habit of strolling along the Embankment late at night, striking up conversations with the odd characters he found there, and would exclaim: 'Oh, my dear, dear son!'[21] but now Max was an adult in London, his father's disapproval had little effect.

Max regularly returned to Bognor to play in town football and cricket matches, sometimes taking his bicycle on the train down and cycling the eighty miles back on Sunday evening. On such long journeys there would inevitably be the occasional mishap as Max records: 'At 5 o'c Eric & I, in the rain, started riding back to London. Owing to my bike-chain giving way at Holmwood, we had to sleep the night there at an Inn – still raining & v. muddy outside: we were drenched already.'[22]

Once every few weeks Max made the journey out to Brentford to have Sunday tea with his Aunt Lizzie and Grandpa King. His mother was grateful, as her 76-year-old father Gaspar King had lost his job as a timber yard manager after breaking his leg. Now he was being cared for by her unmarried sister, who had a small income from giving piano lessons. Rose Gill wrote: 'I am glad you are going to see Aunt Lizzie. She is another who has to "give up" – and I fear her reward will not be here.'[23]

The Osmunds in Blackheath were avoided, but Max enjoyed the company of his Uncle Fred Gill and Aunt Annie in Edmonton. Fred, in his spare time, was in the Ambulance Corps of the London Rifle Brigade and often invited his nephew to Brigade dinners and concerts as well as such theatrical oddities as *A Carriage Accident* and *A Pair of Spectacles*.[24] Fred once came to Lincoln's Inn where he, Eric and Max indulged in the popular Victorian pastime of 'spiritual table-raising',[25] in which the participants sat in a darkened room around a small table which would supposedly be levitated or rotated by some spirit force communicating from the dead.

Eric's letter-cutting business was taking off and when he was particularly busy Max would be paid to help him out with drawing, tracing or laying out inscriptions and painting lettering. In November 1904 he was working on a shopfront for W.H. Smith & Sons. One of the firm's directors was C.H. St John Hornby, a wealthy businessman and founder of the Ashendene Press. In one week in late March 1904 Max logged over nine hours' work for Hornby for which Eric paid him 10 *d* an hour. As his experience grew so did his hourly rate. Three months later the theatre designer Sidney Sprague, for whom Max made a carved table and a painted 'perspective', was paying him 1 *s* 10 *d* and was receiving 2 *s* an hour from the architect Goodhart-Rendel for the work done on the Eton Memorial Competition entry. By October that year Eric too had upped Max's rate: 'Worked late 2 o'c. Book-stall front[26] – Smith & Sons for Eric, 5 hrs: say 10/6 *d*.'[27]

London life was everything Max could have hoped – he was enjoying his work, was stimulated by the meetings at the Art Workers' Guild and

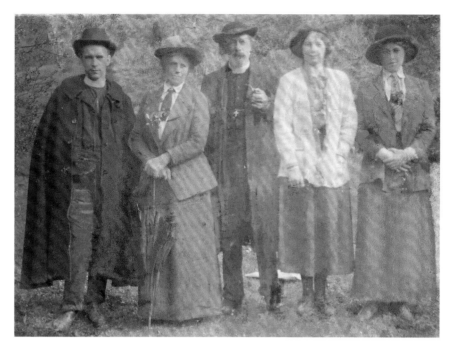

Romney, his parents, sister Angela
and Mary Brown, undated

had made a new set of friends. But his romance with Mary was doomed. A suggested visit to Leigh had been rebuffed by her in April 1903, although Max went to Leigh in June and, for the first time, met her best friend Muriel 'Mu' Bennett. Still unaware of the attraction between Mary and Romney, Max was disconcerted when Romney stayed the night with the Browns in July and invited Mary to Strathmore. On her journey back, Max met her at London Bridge station: '… together we had tea at "16 Old Buildings"'!!! Very jolly time',[28] before escorting her, via St Alban's Church in Holborn, to her aunt's in Stoke Newington. And here – in mid-sentence, with the ink uncharacteristically smeared – his diary for 1903 ends.

Whatever his shock and initial confusion, poor Max could never have borne either his dearest brother Romney or Mary any grudge and she remained a close friend. She now encouraged his friendship with her friend Muriel. He was invited to Muriel's home to meet her family for the first time on 14 March 1904, and went again a fortnight later, on the train home writing: 'All v. well',[29] at the same time making a note of Muriel's birthday under 27 February. On 19 April he wrote his first letter to her, and enclosed a little watercolour of his favourite subject, Dell Quay.

Two years older than Max, Muriel – whose home was in nearby Westcliff-on-Sea – was a demure young woman, with a round homely

Dell Quay, Max's first gift to Muriel, watercolour on paper, 1904

face who wore her thick long curly hair pinned up at the back of her head and usually dressed in plain ankle-length skirts and white blouses buttoned up to the neck. People who knew her have spoken of her placid, undemonstrative nature, her kindness and sweetness. Like Max, she was one of the eldest in a clergyman's large family in which faith, worship and traditional Victorian values were paramount. In August 1904 she went to work as a mother's help for a family living in Great Bedwyn in Wiltshire, although on her occasional brief visits to Essex, Max would go out to see her and Mary. Over the following years many letters were written between them, but none seem to have survived.

By this time Eric had left 16 Old Buildings for a flat in Battersea as he was soon to be married and also needed a space to work on his letter-carving. Now Max needed to find someone to share the rent. A friend called Bownass lodged with him for a short time but in September he was replaced by an acquaintance from Bognor, Ernest Laughton, who has been described as 'a rather rough-neck radical and *louche* free-thinker'.[30] From November a nominal rent was also being paid by Eric, who wanted to keep Lincoln's Inn as his professional address.

Although Max loved his older brother dearly, their relationship was often strained to the limit because of their differing religious beliefs. Eric had rebelled against the rigid faith imposed upon him by his upbringing, and his fierce agnosticism led him to be extremely intolerant of those with differing beliefs, including his own brothers. With their strong faith and love of the Anglo-Catholic traditions, Romney and Max were shocked at Eric's attitude to the church. In 1904 Romney wrote:

Muriel Bennett, undated

> I am very sorry to hear about poor Eric. It seems so extraordinary the blind way some people go on. They pity us who believe, as being poor half-civilized creatures who don't know any better, but in reality it is the other way about … in 9 cases out of 10 conceit is at the bottom of it … He has never looked fairly on both sides, he cannot but help seeing all these truths with the eye of a skeptic … a willingness and readiness to pull it to pieces.[31]

Since his arrival in London Max had worshipped at St Alban's in Holborn, where the Anglican services were High Church. Romney, who was leaning ever closer towards Catholicism, was eager for Max

to follow his example: 'You can't possibly imagine the joy I felt, when I heard that you are thinking of making your "confession" … How thankful I am that He has given you the strength.'[32] Six months later Max was still procrastinating, but Romney continued to hope: 'How lovely it must be to go into St Alban's on a Sunday evening just for private prayer and Confession. You will tell me won't you when you have decided to make yours won't you – if you do …'[33]

Despite Eric and Max's differences, the family bonds were deep, and the two were still close enough for Max to act as Eric's best man at his marriage to Gladys Ethel Moore, the daughter of the sacristan of Chichester Cathedral. Max even spent two-thirds of a week's wages on a top hat for the occasion. The wedding, which took place on Saturday 6 August at St Peter's the subdeanery church, 'went off v well', noted Max, and was followed by a very 'jolly' reception.[34]

Max continued courting Muriel who was back with her family, now living in Walthamstow. On Saturday afternoons, Max – armed with sketchbook and pencil – would cycle out to see her there or in Leigh with Mary. He once diverted his journey to visit the village of Great Warley where he 'saw carving by AERG [Eric] on Spragg's gate' at St Mary's Church, and on another occasion, he left London rather late and when darkness fell, he slept 'ensconced under a hedge',[35] rose at dawn for an early morning swim at Maldon before pedalling on to Leigh.

Football remained a passion: 'I am still "hunting the leather"[36] most Saturday afternoons', he told his brother Vernon as late as 1910. A strong player, he was a top scorer for the Bognor first eleven over the years: after a victory against Chichester, he quips that he 'slithered the globe twixt the willows twice'.[37] In 1906 he joined the Leigh and Shoeburyness team, but his proudest moment came in November that year when he was invited to play for Chelsea Football Club against Crystal Palace in a third round FA Cup match at Stamford Bridge.[38] Due to a match clash, the regular team was playing elsewhere and a team of semi-amateur players was hastily assembled – they lost the match but it was the highlight of Max's footballing career.

Working a full day at the office meant private work had to be done in the evenings. Tight deadlines involved working into the early hours in candle and lantern light.

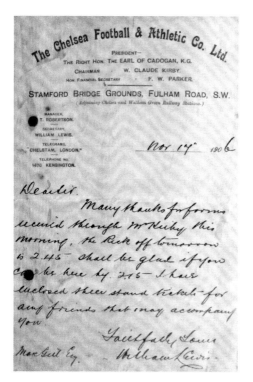

Letter from Chelsea Football Club, 17 November 1906

Eric and MacDonald Gill, engraved plaque to James Howell, St Wilfrid's Church, Bognor, brass with lettering in black with name infilled with red wax, 43.2 × 39.4 cm, 1905

In September 1905 he was working on shop fronts for W.H. Smith until half-past one in the morning. Another early collaboration with Eric was from his old headmaster for a brass plaque[39] to commemorate the death of a fellow Holyrood College pal, James Howell, who had tragically drowned at sea. Romney remembered: 'He was a jolly chap wasn't he – '"Screetch Owl" + "featherd Songster" were his names weren't they. Yes, it seems but a short time ago that we were all larking schoolboys together.'[40]

Max's parents fretted: 'With your work – so sedentary in nature, and with hours so prolonged into the night you are more than ordinarily liable to lung troubles. Remember: you are not robust in constitution … you often find yourself forced to work at high pressure; your hours are necessarily irregular … you must take greater care of yourself … Don't overdo it – that's all.'[41] As usual their son took no heed.

Competition entries took up enormous amounts of time and energy. The Central School of Arts and Crafts, funded by the London County Council (LCC), held annual exhibitions with the best students being awarded LCC scholarships. In the spring of 1904 Max was elated when he won a two-year Junior Artisan Scholarship worth £5 for each year and the following year he gained the LCC architectural studio prize of £7 10 s. These awards entitled the winner to free classes at the Central School. In 1906 he exhibited watercolours of Rouen Cathedral and the Presbytery at Neufchâtel-en-Bray and the parish church of Blewbury, as well as shop front designs, a chess table and a plaster wreath, which won him the Senior Artisans Art Scholarship. His parents were delighted at his success, writing: 'It is very good. You know how Mother & I areespecially glad & thankful – and how proud we are of our dear boy. We congratulate you with all our heart.'[42] Both Eric and Max showed work in the 8th Arts and Crafts Exhibition of 1906 at the Grafton Galleries in London: Max's work was included in the Central School display of 'Calligraphy under Edward Johnston and Graily Hewitt'.[43]

The paintings of French churches were the product of a cycling holiday Max took in June 1905 with Francis Grissell, a pupil of Nicholson and Corlette. Inspired by a talk at the Art Workers' Guild on Amiens, Rheims and Chartres, the pair crossed the Channel, armed with little more than a copy of Baedeker's *Guide to Northern France* and a map. They spent eleven glorious days exploring the countryside – sometimes sleeping out in the open – and sketching 'La Belle France',

including the cathedrals of Rouen, Amiens and Beauvais. After their trip they were glad to get home to a 'hot bath!'[44]

Edward Johnston, now living in a house overlooking the River Thames at 3 Hammersmith Terrace with his young family, continued to be a close friend. He was in good company here as this stretch of the river had attracted some of the great names associated with the Arts and Crafts movement. His neighbours in the terrace included the founders of the Dove's Press: Emery Walker at no. 7 and T.J. Cobden-Sanderson at no. 1; Douglas (later Hilary) Pepler, who ran a working men's club and was experimenting with a printing press, was at no. 14; and at no. 8 was May Morris, the daughter of William Morris, who had himself lived less than 100 metres away on Hammersmith Mall. Others in this community included architect and furniture designer Charles Spooner, and the cabinet-maker Romney Green. In November 1905 they were joined by Eric, his wife Ethel and baby Betty, who moved into a little terraced house in Black Lion Lane.

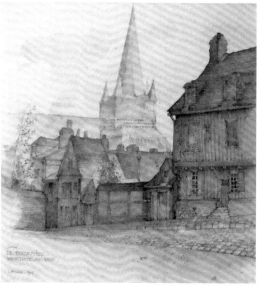

Neuchatel-en-Bray from Le Presbytère, exhibited at the LCC exhibition in 1906, watercolour on paper, 1905

Max often dined with the Eric Gills and also the Johnstons with whom he sometimes stayed the weekend. After undergoing an operation on his nose, they insisted that he come to convalesce with them. Their garden backed onto the Thames and in the spring they always held a Boat Race party – Max as a Cambridge supporter would cheer on the Light Blues. The Johnstons were also renowned in the locality for their 'jolly' firework parties on bonfire night for which each guest would be asked to bring one firework. Always a boy at heart, Max would no doubt have loved entertaining the children with his absurd jokes and magic tricks.

When the Lincoln's Inn lease came up for renewal in 1906, Max was also tempted to move to Hammersmith. Eric and Ethel had offered him a room at Black Lion Lane, but their mother advised strongly against his going:

> You and Eric do not agree upon matters of religion and it would not be helpful for your work if you and he were constantly in danger of argument on the subject! I have in my mind the unprovoked attack made upon your views when I was with you

all in Battersea. I could not bear to think of your Sundays in uncongenial surroundings. I would not say all this to Eric because he would only get offended without seeing that I love him in spite of his views. I always feel, too, that he [is] passing through a phase – and may not be always in the same mind as now.[45]

Max decided – probably wisely – to remain at Lincoln's Inn. His tenant Laughton was replaced in June by Edgar Spon, another Bognor acquaintance, and after him came Muriel's brother Rupert. Despite their many meetings, Max was ambivalent about Muriel and seemed unwilling to commit to an engagement. In Bognor he spent part of his Easter holiday pursuing a flirtatious relationship with a young lady he refers to as 'Ray', possibly a friend of his eldest sister Enid. As with Mary some years before, he and Ray would engineer 'accidental' encounters, as this tongue-in-cheek diary entry suggests: '… went up into Town: Curiously enough at 11.45 met "Ray" by Pier (where I was dawdling about) and we together went westwards to call on Mrs Lowe! Did not find Mrs Lowe on the Aldwyke [sic] Rocks – Mirabile dictu!'[46] It was rash of Max to make such an obvious play for another girl because also staying with the family that Easter was Muriel's brother Rupert.

This may have spurred Muriel to accept an invitation to spend a fortnight at Strathmore in August. Now twenty-four years old, she was of an age at which many women of the time might have felt 'left on the shelf'. She and Max had been courting for well over two years and by agreeing to come to Bognor, she may have been demonstrating that she was firm in her commitment to him. In addition, meeting Max's parents would have been a prerequisite to any chance of a proposal.

Despite his recent dalliance with Ray, Max was thrilled that Muriel – and Mary too – were coming to stay at Strathmore; Romney was also there. The night their sweethearts arrived, Max wrote expectantly: 'Le Rêve – at last!'[47] The foursome enjoyed a fortnight of carefree holidaying: bathing, building sandcastles with the youngest Gills on the beach, boating, picnics, walks to Aldwick Rocks and romantic evening strolls on the pier. At Strathmore there was all the usual family fun and games in the evenings including a fancy-dress supper at which Muriel and Max appeared as 'The Nut Brown Maid and a Cavaliere'.[48] It was a happy fortnight and it seemed as if there was an engagement in the air when – in the final days of the holiday – a series of letters flew between the young couple and Muriel's parents. Max's diary does not record a betrothal although later in life he talked of broken engagements. If

promises were made, then the engagement was short-lived. Max was continuing to see Ray and on 14 November he received a package from Muriel returning his letters to her. However, before Christmas the rift was mended and Max went to see her in Lowestoft in Suffolk, where her father was now minister.

Meanwhile, sharing lodgings with Muriel's brother was proving to be an ordeal. Rupert habitually returned to the flat late, often waking Max with his clattering about. Rose Gill was concerned, and advised: 'You must get rid of Rupert if he does not realize that your work and habits require him to be more considerate … what a disturbing element he might prove.'[49] Carrying this out was impossible as Max hated confrontation, especially if it might cause a breach with Muriel and her family – so Rupert stayed on for another twelve months.

In the spring of 1906 Max embarked on a commission that would take him two years – the writing of a missal for St Paul's Missionary College in Burgh-le-Marsh in Lincolnshire, where Romney was studying. Bound in calfskin by craftswoman Katharine Adam, the volume was finally completed in 1908. Eric had not been considered for the job as Romney explained:

> I don't suppose for one moment that he could have found time to do it, but I wouldn't even offer the most sacred rite that we know of to his irreverent skill great as it may be. I write these words without impetuosity or anything like that, I simply mean them. I had one or two little insights into his ideas during my last vac. from one source or another. And I was shown that he didn't show the consideration, to say nothing of the reverence, for our Holy Faith that I should have expected from one professing to be broad-minded.[50]

By 1907 Max had amassed a number of private clients for whom he had done a diverse range of commissions ranging from an oak table to a cottage. Sir Charles Nicholson was also employing Max privately to edit his book on plates and there was work for his brother Archibald K. Nicholson, the stained-glass designer. Max was also working on his latest exhibition piece *Study of a Chancel*, an interior decoration design for entry in the annual Royal Academy Summer Exhibition.

This was Max's first Academy success and he had no hesitation in agreeing to a request from *The Builder* journal to publish a full-page colour plate of his study in their next edition.[51] His parents were

Page from the *Burgh Missal* for St Paul's Missionary College, Burgh-le-Marsh, Lincolnshire, 1906–08

proud enough to make a special trip to London to see their son's painting at the Academy although his father was a little restrained in his praise:

> It is the first of our family productions to gain that distinction – and though I do not think very highly of the Academy standards of Art – it is a distinction – especially on the architectural side to have got hung on its walls at your first attempt. I trust it will not be your last success in this direction.[52]

By 1907 Max was growing increasingly restless with his position at Nicholson & Corlette. The five-year contract he had signed as an eighteen-year-old in early 1903 had seemed fine at the start, but the salary scale meant that he was now only earning £1 15 *s* a week, a rise of just 10 *s* in four years, rising to £2 in his final year. A diary note about payment for his work on the London County Council Hall plans reflects his irritation at the meagre amount he was paid for overtime: '£4.5.0 *d* cheque Nicholson & Corlette for 85 hrs! overtime on LCC work @ 1/– per hr.!'[53] His private commissions were already earning him nearly twice that rate. Even his mother agreed: '… you deserve more.'[54] With five years' experience as an assistant architect, a small list of private clients and a wide network of contacts within the Arts and Crafts world, Max decided the moment was right to set up his own practice.

A hint of his intention comes in a letter from his mother in April 1908, after Max had received a rise in salary from Nicholson & Corlette. This also reveals that Max and Eric were planning to join forces: 'It is a splendid idea that you and Eric should work together, just what ought to be … I have heard a little from you – and from Eric – and from Ernest Laughton about your future plans – and am anticipating a full account of the final arrangements when you come home at Easter … hope you are coming!'[55] Her stance is now very different from two years before, when she had spoken out so vehemently against Max sharing lodgings with Eric in Hammersmith.

Opposite:
Study of a Chancel, exhibited at the 1907 Royal Academy Summer Exhibition, photo in *Academy Architecture*, Vol 32, 1907 (the original painting was watercolour on paper, approx. 60 × 40 cm, 1907, location now unknown)

CHAPTER FIVE

Independence: The First Year
1908 – 1909

THE DECISION TO EMBARK on an independent career was a natural step. The promise of commissions from Nicholson & Corlette combined with occasional collaboration with Eric gave Max the confidence to launch his own practice. Despite their contrasting characters and disagreements over religion, Max and Eric remained close. Family bonds were strong, they shared a network of friends and acquaintances and their professional interests were inextricably linked by their mutual lettering projects.

Although Max assisted his brother on a number of works, he was never a workshop employee or apprentice. The arrangement between the brothers was loose and reciprocal. If a stone inscription was commissioned from Max, he would design the piece, then subcontract Eric (or later Joseph Cribb) to execute the actual carving. There does not seem to have been a contractual partnership of any kind and they usually worked independently of one another.

The closer relationship also benefited Eric. He and his family had left Hammersmith in 1907 and set up home in the Sussex village of Ditchling, where the Gill boys had stayed as youngsters. Although Eric had continued to use 16 Old Buildings as an office address, he now needed somewhere to stay up for the night on his frequent trips to London where he came to meet friends and clients. So it was that on 4 May 1908, 16 Old Buildings became the 'joint office of Eric & Max'[1] with Eric contributing six shillings a week for rent and rates. The arrangement was that Eric would stay up in town for three nights a week. However, with Ernest Laughton also in residence, this entailed squeezing a third bed into the small bedroom – hardly ideal for three men needing a good night's sleep. A business card was printed with not only the brothers' names, but also that of Eric's wife Ethel, who was a gilder. This generated some parental disapproval: '... a pity ... "Mrs Ethel Gill" looked out of place on it; it seemed to lower the dignity of a Lincoln's Inn address. I said nothing till Father expressed almost the same opinion ... why not have hers printed

The Gills' business card, 1908

Mr. L. McD. GILL, Architect & Decorator.
Colour decoration, Architectural drawing. Writing and Illuminating.

Mr. A. E. R. GILL, Inscription Carver & Caligrapher.
Lettering in stone, marble, and wood. Painted, written, and drawn lettering for title-pages, shop-signs, engraving, etc.

Mrs. ETHEL GILL, Gilder.
Carved and Gilded Frames for pictures, mirrors, etc.

16, Old Buildings, Lincoln's Inn, W.C.
Telephone: 1143 P.O. City

Alternative design by Max Gill for St Martin's Church, Epsom, photo of pen-and-ink drawing, 1908

separately …'[2] Despite the independence she enjoyed as a concert singer, his mother had entrenched conservative views and clearly disapproved of women invading traditional male bastions, such as Lincoln's Inn.

In June 1908 Sir Charles Nicholson persuaded Max to take on an apprentice, Joseph Colebrook, for a month's trial at five shillings a week for the first year.[3] By August, however, he had left and been replaced by a fellow named Hughes. Maintaining good relations with his old employers was vital as in the first few months of independence the bulk of Max's time was spent on work for them. First, there was the completion of plans and drawings for the new parish church of St Martin's in Epsom, Surrey, and then the painting of the interior, immediately followed by the drawing and painting of designs for Romford Parish Hall, as well as a memorial in Kingston, Jamaica.

For A. K. Nicholson there were two plaques including one commemorating the Reverend Aubone Cook in St Mary's Church in Benfleet, Essex. The second was an impressive brass inscribed to the memory of Colonel John Alexander Man-Stuart of the Gordon Highlanders and decorated with a coat of arms in brilliantly coloured enamels. Lawrence

Colonel J.A. Man-Stuart commemorative plaque, St Ternan's Church, Banchory, Aberdeenshire, Scotland, cast bronze with enamelled arms, 25.4 × 73.7 cm, 1909

Weaver, an expert and writer on architectural topics, notably for *Country Life* magazine, featured the brass in his volume *Memorials and Monuments*.

The best-known of Max's collaborations with Eric is the magnificent memorial for Dorothea Beale, Principal of Cheltenham Ladies College for forty-eight years until her death in 1906. She had not only been a vociferous champion of women's education, founding St Hilda's, the first Oxford women's college, but also a powerful and respected proponent of women's suffrage. In July Max was invited to meet her successor, Miss Lilian Faithfull, to discuss a befitting memorial to the remarkable Miss Beale and after lengthy discussions and examination of Max's portfolio, the committee were satisfied that he would create a memorial that would do Miss Beale justice. It was the first major private commission of his career so far.

Before going to Cheltenham Max had determined that he would make the most of the journey home. He had taken his bicycle on the train and after the meeting he collected it from the college cloakroom and set off to cycle the 150 miles back to Bognor, first stopping off at Gloucester to buy provisions, eventually leaving at 9 o'clock in the evening. The first leg of his journey was the hardest: 'Biked over Cotswold Hills – up "Birdlip Hill" – v. steep walking!'[4] But on he pedalled, and after two hours sleep under a hedgerow somewhere north of Swindon, and stops at Stonehenge, Old Sarum and Romsey Abbey, he arrived at his destination at 8 o'clock, in time to join Romney and Mary for a last 'Bognor Saturday Night' walk. The entire family were home to bid Romney farewell before his departure to Papua New Guinea as a missionary. A photograph was taken of this poignant moment – years later Vernon wrote underneath his copy: 'The last time we were all together.'[5]

In the months before this, Romney and Max had spent as much time as possible together. At Easter they had spent a week on retreat with the Cowley Fathers – a male Anglican community in Oxford – where they

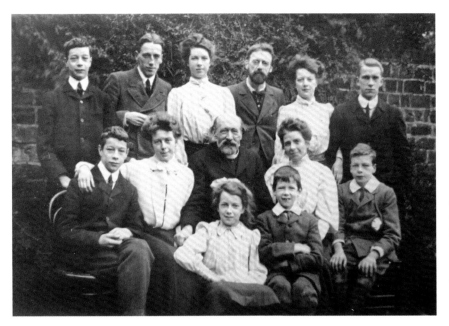

'That last time we were all together.' The Gill family at 2 Denmark Terrace, July 1908. Back row, left to right: Evan, Max, Gladys, Eric, Madeline and Romney; seated, left to right: Vernon, Enid, Father, Mother and Kenneth; in front, left to right: Angela and Cecil

shared the monastic experience of piety and prayer. Of the two, Romney was the more ascetic, and despite his long friendship with Mary, he embraced celibacy, rejecting sex and marriage in favour of a life devoted to serving God. When Cecil, the youngest sibling, went out to Papua as a missionary in the 1920s, he found Romney to be overtly mistrustful and disdainful of women, even Cecil's own wife, yet still believed that he was an excellent missionary, devoted to – and loved by – his Papuan community.

Max's own attitude towards women was rather different – and although he may have thought that celibacy was right for Romney, it is doubtful if he ever considered that lifestyle for himself. He was attracted by women and enjoyed his flirtations and romances, although – if his diary is to be believed – it is unlikely that these dalliances progressed beyond the occasional stolen kiss. More of a conformist than his older brother Eric, Max was highly principled and respectful of women, the result perhaps of the reverence in which he held his mother. His reticence in emotional matters may also have held him back from anything but proper behaviour and he might have been afraid of rejection. A certain level of propriety was expected, particularly when in company, and opportunities to be alone with a young woman were rare.

After Cowley, the two brothers made a nostalgic trip to Brighton 'to visit the haunts of our childhood – see places we had lived in when 9 & 10 yrs old – which we had not seen or been near to since 1895–6 or 7'.[6]

They visited the cemetery where their beloved sister Cicely was buried, then wandered through the streets up to their old home Preston View and called on old school friends before enjoying a picnic lunch in the copse overlooking Preston Park Station. It was a 'lovely day'.[7]

The night before Romney left, he, Max, Eric, Evan, Father and Ernest Laughton all went to the Duke of York's Theatre in London's West End to see the unconventional American dancer Isadora Duncan, who was taking the world by storm with her natural movements and poses based on Greek imagery and costume. Barefoot and dressed in a white Grecian tunic, she danced expressively and spontaneously with great leaps, strides and skips with arms spread wide. Reviews were mixed, but Max was certainly won over: it was 'most splendid', he wrote.[8] Then after supper at The Venice in Soho Square, they made their way to Euston station where Romney, accompanied by their father, climbed onto the night train to Liverpool, where he would embark on the first voyage of his journey to Papua. Just before parting, Romney presented Max with a new pipe so that when he smoked, he could remember his absent brother. After what must have been a sad farewell, Max wrote wistfully: 'Goodbye … till when?'[9]

When Eric was up in town – as he was rather often, despite his desire to live the rural life – he and Max would dine together at such favourite restaurants as Slater's, Roche's, The Venice, or the renowned Gatti's, an Italian restaurant in the Strand.[10] Sometimes the brothers went on to a talk. In November that year Max was so inspired by a lecture given by G.K. Chesterton and Ramsay MacDonald on 'Socialism v. Liberty, Fraternity and Equality' that he took his brother to hear the two men speak again at a Christian Social Union (CSU) meeting at Caxton Hall, Westminster. Eric too was impressed by what he heard. The CSU, which Max had joined earlier that year, was a Church of England group that discussed contemporary social conditions and solutions to poverty and social injustice. Industrialisation was seen as the most important social issue of the new century yet the guiding principle of the CSU was that 'the ultimate solution of this social question is bound to be discovered in the person and life of Christ'.[11] Despite his evident sympathy with the Socialist cause and a general desire to see social injustice righted, only two years after this, Max became a paid-up member of the Conservative Party. In 1908 he was invited to join the masonic lodge of the King's Colonials - the volunteer regiment he had joined after coming to London. The subscription that year was paid but the subject is never referred to in his diaries again.

In his first year of independence, Max accumulated a great deal of experience, especially on the lettering side, with a variety of commissions

and new clients. Among these was German aesthete Count Harry Graf von Kessler, for whom he did nearly sixty hours of work on title pages for a volume of Homer's poems[12] that summer, almost certainly work passed to him by Eric who had already done the titles for volumes of Schiller's works for Insel-Verlag of Leipzig with whom Kessler had a collaboration.

In August while taking a well-deserved break in Bognor after a fortnight's training with the King's Colonials, Max was summoned by Eric to assist on the lettering of a notice board urgently needed at the recently completed King's College Hospital at Denmark Hill. He caught the first available train back to London and began work the following morning. The first step was 'spacing out the board with Eric' after which Max was left to paint the lettering.[13] The job took nearly 160 hours of work and earned him £13 15s 6d, paid by the building's architect William A. Pite.

That August Mary Brown had been staying down with the family in Bognor. She and Max had remained close friends and when they met, often talked of Romney. Meanwhile Max was now romantically involved with her sister Anne, but it was not destined to last. His invitation for her to join Mary in Bognor had been rejected and despite never meeting her, Rose Gill, ever-protective of her favourite son, did not think her suitable and made her feelings plain:

> I am sorry (if you were at all keen on it) that Anne cannot come. But don't be in a hurry dear boy – I've set my heart on your future helpmeet being not only blessed with every domestic virtue that you deserve she should possess – but, on her being musical: – for I cannot imagine you with a wife who could not sing or play – if only well enough to accompany you. You will probably laugh at this and think I am as bad as a friend of mine who being asked why his engagement was broken off replied 'Well, you see, she didn't like cricket.'[14]

At this early stage in his solo career, reliance on commissions alone was risky, so Max applied – with testimonials from Ricardo, Lutyens and Lethaby – for a post as a 'Teacher of Writing' at Clapham School of Art. After his interview, he was very pleased to be informed that he had been appointed – with pay of about £8 a term, starting in September.[15] Unfortunately, he was half-an-hour late for his first class because 'the trams broke down',[16] but he soon settled into his teaching role. He was a conscientious teacher, keen to pass to his students an understanding of the application and effect of their work, impressing on them that poor

lettering can 'spoil an otherwise beautiful object'.[17] He was not loud or strident, in fact his voice was described as 'light and lacking in strength, like the voices of all his brothers', and when he spoke it was 'like a shallow stream over stones'.[18] A natural conversationalist, he could usually keep up a lively, if somewhat unpredictable, flow of words, and this, together with the occasional pun or whimsical aside, must have resulted in many mirthful moments – welcome amusement for his adult students after a hard day's work.

In October he gave his first public lecture. The paper was entitled 'Lettering in Decoration' and was read to an audience of like-minded craftsmen and women at a meeting of the Society of Calligraphers. The talk outlined his thinking about the art. The first essential element to understand was, he said, 'utility' which he likened to 'the trunk of an oak that comes to us through past ages',[19] as opposed to its leaves that provide the decoration which he defined as 'that which is comely and graceful'. He also emphasised adaptability as well as sincerity, saying: 'whatever be the craft, for be the conditions and requirements ever changing – if our tools are handled truthfully and sincerely then that decoration we want – we shall have.'[20] Another pillar of his philosophy, taught him by Edward Johnston, was that 'Calligraphy – the art of good writing – is good – only really good – in as much as being beautifully formed it bears some beautiful thought … without this abstract sense – the concrete result must be a failure … the lettering would not live – it would in fact be a dead-letter!'[21] In other words good technique alone was not enough. His view was that 'lettering, though essentially with us to bear some direction to the reader is also a great power in or as decoration … lettering is decoration'.[22]

Every aspect of this philosophy was being put into action in Max's most prestigious commission, the Beale Memorial. The final drawing – signed and dated August 1908 – shows a grand monument, over 3.5 metres high and 2.75 metres across, with a splendid inscription bordered by a delicate decorative moulding of leaves and chevrons. The work was a collaboration with Eric, who would do the stone-carving. The shaping of the stone was done at Eric's workshop at Sopers, his home in Ditchling, so Max often came down to ensure all was going to plan and also to make the plaster moulding. The cutting of the inscription and paintwork would be done after its installation.

The brothers arrived in Cheltenham on Wednesday 10 February 1909 and set to work the following morning in the Oxford Staircase Hall of the college, fixing the three large Hopton Wood stone panels onto

Opposite:
Dorothea Beale memorial, designed and painted by Max Gill, carved by Eric Gill, Hopton-Wood stone with plaster mouldings and marble base, 1909

the marble base. The lettering and decoration was marked on the stone and the letter-cutting then begun. Above the inscription is a daisy – the emblem of the college – carved in low-relief and beneath that is the scroll bearing the college motto '*Coelesti Luce Crescat*' which translated means 'May she grow in heavenly light'.

The college principal Miss Faithfull was a great admirer of Edward Johnston's work and was anxious for her girls to develop good writing skills and she duly took advantage of the presence of these 'exponents of this revived art'[23] and persuaded them to give talks. So, to an audience of 300 schoolgirls, Eric spoke on 'The Story of the Alphabet', outlining the development of lettering from Roman times to the present day, while Max read a paper on 'The Modern Revival of Handwriting'[24] and also displayed some of his manuscript work in the school library alongside some examples of the best modern printing.

The carving of the memorial took two and a half weeks and then came the painting and gilding. Max added the last brushstrokes at 11 o'clock on the evening of 8 March. It had been a hectic period with commissions for other clients as well as his teaching in Clapham, which entailed rushing up to London on Tuesday afternoons, then hurrying back to Cheltenham as soon as he could. This situation was repeated in April when Miss Faithfull employed Max to design and superintend a complete refurbishment of the hall in which the memorial stood. Before returning, however, he spent Easter week on retreat in Oxford, where he was strongly reminded of his brother Romney and their shared spiritual experiences of the year before. Immediately after this he was 'hurrying about again'[25] to and from Cheltenham, where he was now supervising the installation of new carved stair rails, an iron coronet-style electric chandelier and general decorations while he personally painted a set of corbels with the national emblems: a rose, thistle, leek and shamrock. The finishing touch to the hallway was a simple oak settle that matched the panelling, commissioned from Ernest Gimson, the renowned Arts and Crafts furniture designer.

If Max had thought he would not have enough commissions to sustain him, he was mistaken. Now frantically busy, there was little time for anything but work: his ledger details payments for at least two dozen commissions for 1909, chiefly for lettering, formal manuscripts and mural painting. The most significant commission of the year, however, would come from a new client: the great Arts and Crafts architect Sir Edwin Landseer Lutyens.

Painted corbel above the Oxford Staircase at Cheltenham Ladies College, 1909

CHAPTER SIX

Lutyens and the First Painted Map
1909

Edwin Lutyens had made his name with his red-brick Arts and Crafts houses which frequently featured in *Country Life*, the magazine beloved of the wealthy landowning classes. Around fifteen years Max's senior, Lutyens was an unmistakable figure with his moon-shaped face, small moustache and round tortoiseshell spectacles which gave him an owlish appearance. One of his admiring pupils in 1912, Hubert Worthington, recalled: 'We revelled in the flashing wit of the man, his creative flair, his unfailing imagination. He could memorize everything, and his capacity for work was terrific.'[1] Osbert Sitwell spoke of 'his sense of irreverence, his spontaneity, his hatred of the pompous' and 'his bubbling flow of puns'.[2] He was also described as someone who 'never really grew up'[3] – a description that has also been applied to Max.

William Rothenstein, *Sir Edwin Landseer Lutyens*, red, black and white chalk on paper, 34.6 × 29.2 cm, 1922

Like many eminent architects of the time, Lutyens was a member of the Art Workers' Guild and this is probably where he first met Max Gill. Perhaps one evening they fell into conversation and Max told him of his boyhood love of map-making. Whatever the case, in the summer of 1909 Lutyens commissioned him to design and paint a decorative map panel for Nashdom, a neo-classical villa he was building near Taplow in Buckinghamshire. The client was Princess Dolgorouki, an English heiress, born plain Frances 'Fanny' Fleetwood Wilson. Mrs William Dodge James, one of the Edwardian super-rich and a society hostess, said rather unkindly of her: 'She is no one … vulgar, but kind and very fond of entertaining … style her HH and she will take any amount of it.'[4] Mrs James was certainly right on one point. The Princess and her Russian husband Prince Alexis Dolgorouki, both in their fifties, entertained lavishly in their several residences, and Nashdom had been commissioned specifically to provide a convenient summer venue within easy reach of London for weekend river parties on the Thames. Limited by a small budget, Lutyens nevertheless managed to create a house fit for entertaining the upper echelons of English society as well as Russian aristocrats who would gather here to discuss the politics of their homeland.

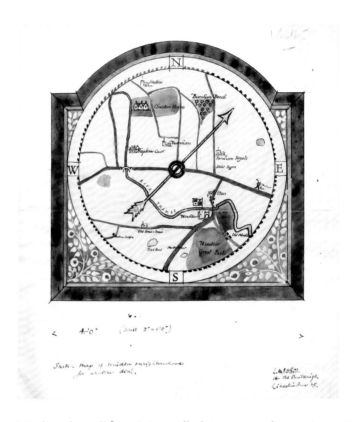

First design for Nashdom wind-dial map (Max's first map commission), pen and ink and watercolour on paper, 1909

The 'Taplow board',[5] as Max called it, was a decorative wind-dial (or wind-indicator) map painted on a wood panel. It shows Nashdom and its surrounds including the Thames encircled by the points of the compass marked in gold leaf and black Roman letters. In the centre a metal indicator (now lost) would once have linked to a system of rods and cogs which ascend the chimney flue to a weather vane on the roof.

Painted wind dials were a fashionable addition to the houses of ship owners and merchants in seventeenth-century Holland, a nation whose wealth depended on its seafaring activities. Here, these devices had a practical use – allowing owners of sea-going vessels to know the prevailing wind direction, vital for decision-making about ship departures without the necessity of stepping outside the front door. Over time, as the wealthy commissioned ever more elaborate wind dials, these became more important as symbols of wealth and status. The Nashdom map shows the eagerness of the Dolgoroukis to align themselves with the area's connections to high society and the aristocracy so visible on the map: Cliveden, home of the Astors, Hedsor House, seat of 7th Baron Boston, and the royal residence of Windsor Castle.

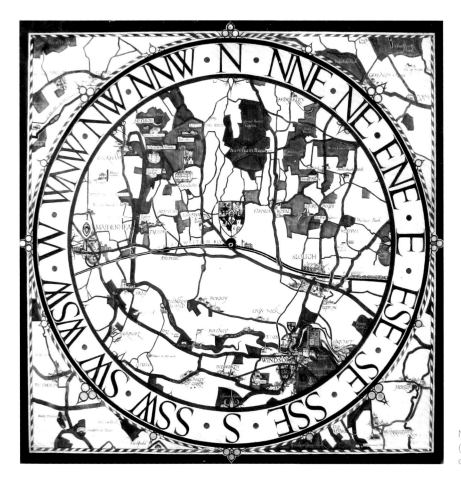

Nashdom wind-dial map
(now missing its metal pointer),
oil on wood, 73.7 x 73.7 cm, 1909

Max began the Nashdom panel in late August 1909, taking it with him to Bognor when he went for a few days break from London. Now that the older siblings had left, the family had relocated to a smaller – and cheaper – terraced house in Denmark Terrace. The trip also gave Max the opportunity to see Eve, the new girl in his life. In June he had done a job at Wyphurst House in Cranleigh, the home of Sir Charles Chadwyck-Healey, whose daughter Evangeline was staying at Cambridge House, a children's convalescent home in Bognor, where she may have been a volunteer. After a morning session on the Nashdom panel, he would usually join her in the afternoons – with her various young charges – down on the beach and in the evenings, they would mingle with other couples on the pier or join his family for 'music and whist'.

Following the completion of the map at the end of September, there began an intense period of activity with Max painting a barometer

for Heathcote, a Lutyens house in Ilkley, then dashing back and forth between the Royal Academy where he was lettering an Honours board and St Luke's Mission Hall in Chelsea where he was painting an altar – a job for which he had been recommended by Halsey Ricardo, his former architecture tutor at the Central School. He interrupted his work to spend a few days in Bognor where he saw Eve every day. After their last evening together, he wrote a coded note in his diary which when deciphered reads enigmatically: 'I know and you know but I will not know till that time when we shall know God knowing so help us both our bodies and our souls.'[6] Just before Christmas she was in London visiting her friend 'Birdie' Lang. He was her frequent companion, accompanying the two young ladies around London including to London Zoo and a concert at the Queen's Hall, but despite their evident attachment at this time, the romance faded out early in the new year.

That autumn Nicholson & Corlette gave Max three important commissions which would take him to distant parts of the country. The first was an eight-day painting job at St John's Church (now demolished) in Uldale in the Lake District, where he was to decorate the walls with painted scrolls and friezes inscribed with the Ten Commandments, the Creed and the Lord's Prayer. After spending his days painting inside the church, Max would explore the surrounding countryside sometimes in the company of the schoolmaster Mr Todd. One evening – perhaps unwisely given the poor conditions – they decided to climb Skiddaw, one of the highest peaks in the Lake District. It was nearing dusk when they set off. Max wrote:

> At 5.45 we started to go up – very cold – fog set in … All frozen. Snow in places – very strong wind – blown about. At last we reached summit 3058ft up at 9o'c – drank a health & wrote a note! Too cold to stop more than 10 mins under a shelter of rocks at top. Got down somehow … various stoppages for whisky.[7]

After his adventures in Uldale, Max's next job was to design and supervise an Arts and Crafts-style scheme of decoration at St Luke's Mission Hall in Chelsea. He had been appointed by a panel which included Lethaby, Prior and Halsey Ricardo, who continued to be influential in shaping Max's architectural ideas. Ricardo's son, the engineer Sir Harry Ricardo, described his father as 'an architect by profession, but an artist by instinct and inclination, he was far more interested in the aesthetic than in the

Harold Speed, *Halsey Ricardo*, oil on canvas, 1910, Art Workers' Guild, London

Section of The Apostles' Creed panelling, St John's Church, Uldale, painted in 1909 (the church was demolished in 1963)

constructional side of architecture … and a great admirer of all forms of skilled craftsmanship'.[8] He added: 'He was also the happiest man I have ever known. He enjoyed every minute of his life, had no regrets, no fears or forebodings … Though not a Bohemian, he was certainly no slave to convention or routine …'[9]

The Mission Hall murals must have astonished the congregation. Every wall was covered with bold and colourful designs: between each of the twelve windows were panels depicting the months of the year in fruits and blossom, each topped with a sign of the zodiac. Over the Holy Table was a fresco of St Luke bordered on either side by symbolic plants and fruits. The panels at the end on the western side, as a reviewer in *The Times* thought, were 'treated with greater freedom and occasional touches of merriment and humour … to be found amongst the birds and frogs and such small deer which figure here and there amidst the foliage'.[10] There was a 'good gathering'[11] at the Private View on Saturday 11 December 1909, and it was applauded in the press:

> An interesting experiment, and one that seems full of promise, has just been very successfully carried out … of the decoration of the interior … under the guidance of Professor Lethaby and Mr Halsey Ricardo. They have completely painted in tempera from their own designs … and they have transformed a somewhat chill, dreary and unattractive building into a bright and delightful place, which one enters with an instant feeling of cheeriness and warmth.[12]

Amongst the talented group of fourteen young painters executing the decorations were Frederick Etchells, Bernard Adeney and his wife Therese,[13] Noel Rooke, Laurence Christie, and Ricardo's daughters Anna and Esther. The artists were not paid for their designs, only for

St Luke's Mission Hall, Chelsea, 1909 (now demolished)

the painting work for which they received the 'Union Rate of Wages for house-painters' work', a total of £52 9 s 0 d, divided between them. Anna, a dark-haired beauty and a student at the Slade School of Art, London caught Max's eye. According to her brother:

> Anna wore her heart on her sleeve and was frequently falling in love with one or other of her many suitors. She did not take herself, her heart, or her emotions seriously, and was always prepared to laugh about them, for she had a keen sense of humour.[14]

Although Anna may have flirted with Max and he was enamoured of her for some months, no romance developed. Instead they became firm friends and she acted as his painting assistant on a number of occasions.

The arrangement at 16 Old Buildings had become untenable with sometimes as many as four sleeping there, including Edgar Spon, Laughton's replacement, Eric and Max's younger brother Evan. It had

become impossible to use the place as a studio and since the previous September Max had been incurring the extra expense of renting a workshop. With so many using the communal space, it was also impractical for Eric to use the place as an office. It was decided, therefore, that Eric would take on the lease of a set of chambers across the courtyard. Max notes on 20 December 1909: 'Moved into 21 Old Sq. Lincoln's Inn – new office with Eric.'[15] He set it up as a studio that very evening and began painting a set of statues for an altarpiece destined for St John the Baptist Church in Newcastle – another job for Nicholson.

Max's first full year as a freelance artist was coming to a close. Any concerns he might have had about his earnings could be laid to rest – his payment ledger for 1909 shows an income of £178, nearly five times the salary he had received from Nicholson & Corlette. And there was a succession of commissions in the pipeline.

Reredos, designed by Sir Charles Nicholson, painted and gilded by Max Gill, St John the Baptist Church, Newcastle, 1909

CHAPTER SEVEN

From Justice to Punch and Judy
1909 – 1911

T OWARDS THE END OF 1909 Max had been contacted by Harley Granville-Barker, the theatre manager and producer, to design the sets for his latest production, set in the confines of a prison. Barker, an ex-actor, had taken over the Duke of York's Theatre with the intention of running a repertory season with a core company of actors performing in a series of plays. One of these was *Justice*, a new work by John Galsworthy. Max had been recommended to Barker by the artist and writer William Rothenstein, who had been critical of Barker's productions of Shaw's plays at the Court Theatre:

> In the stage scenes, which represented commonplace rooms, there was none of the fun of Shaw's dialogue; they were just unintelligently dull. I told Barker what I felt: that irony should be shown in scenes as it was in dialogue; that there were plenty of young artists who could design scenes and dresses with point and meaning, even for realistic plays. When Barker got Frohman's support for a Repertory Theatre he consulted me about the staging – could I now find some young artists? He was prepared to give them a trial. Whereupon I recommended MacDonald Gill who planned the scenes and staging for Galsworthy's 'Justice' with which play the Repertory Theatre opened.[1]

William Rothenstein, *John Galsworthy*, chalk on paper, 1917

Rothenstein was one of an influential group that included the artist and writer Roger Fry and the avant-garde sculptor Jacob Epstein, who were shaking up the art world. Eric, beginning to find the ethos of the Arts and Crafts movement less to his liking, was being drawn into this circle. Max also rubbed shoulders with his brother's new friends from time to time, sometimes at private views and talks or at the Café Royal in Piccadilly, London. After Rothenstein's lecture at the Art Workers' Guild in November 1908 on 'Difficulties of the Modern Artist', Epstein and the

artist Ambrose McEvoy returned with Max to Old Buildings to continue their animated discussion on the subject.

Justice was Galsworthy's attempt at showing the public the devastating effects of solitary confinement in the British prison system. The play follows Falder, a bank clerk, who commits a minor crime and is subjected to prolonged solitary confinement in prison until he ends up deranged. Galsworthy, whose plays and novels generally highlighted social injustice, had seen at first hand the conditions that prisoners suffered in Lewes Gaol and was appalled, particularly at the effects of long-term solitary confinement, a common punishment in those days. *Justice* included five stage sets, three of which depicted prison interiors. Unlike the playwright, however, Max had never set foot in a prison. So two days before Christmas, after a pleasant morning escorting his sister Madeline around the Mission Hall in Chelsea followed by lunch in South Kensington, Max made his way to East Acton where he 'joined Granville-Barker at Wormwood Scrubs prison & were shown over prison re: scenic painting of Galsworthy play "Justice", which I'm to design'.[2] What Max saw was translated directly into the sets he designed. Although there are no photographs or artwork of the sets, there is a vivid description of the place in which the main character is incarcerated:

Justice theatre programme, 15 March 1910

> Part of the ground corridor of the prison. The walls are coloured with greenish distemper up to a stripe of deeper green about the height of a man's shoulder, and above this line are whitewashed. The floor is of blackened stones. Daylight is filtering through a heavily barred window at the end. The doors of four cells are visible. Each cell door has a little round peep-hole at the level of a man's eye, covered by a little round disc, which, raised upwards, affords a view of the cell. On the wall, close to each cell door, hangs a little square board with the prisoner's name, number, and record. Overhead can be seen the iron structures of the first-floor and second-floor corridors.[3]

These naturalistic prison scenes were shocking to an audience more used to seeing plays set in country houses. Few, if any, of the middle- and upper-class audience would ever have seen inside a prison, and this glimpse into the world and life of a prisoner in solitary confinement appalled them.

When the curtain fell on its opening night on 21 February 1910, there was silence – the audience so stunned at its shocking conclusion.

Uproar followed, with many members of the gallery refusing to leave without seeing the playwright until at last, they were persuaded that he had left the building. Reviews were mixed with one critic writing:

> It was so good as to raise the whole question of dramatic realism. One might just as well have been in a court of law; and, some will say, when we go out after dinner for pleasure we had sooner go elsewhere. Just so in the prison scene, with that greenish distemper on the walls. It even turned one a little sick … However, it is not given to every dramatist to draw Judges of the High Court to his theatre, nor to turn Home Secretaries sick. Such effect, seemingly, had *Justice*, since it is a play of so much effect … can hardly be regarded as other than an opening of distinction for The Repertory Theatre.[4]

The realism of the sets was clearly an element in the overall effect as the writer Max Beerbohm commented:

> We really do … have the sensation of seeing reproduced exactly things that have happened in real life … In the first act … we do not feel that we are seeing an accurate presentment of the humdrum of a lawyer's office: we are *in* a lawyer's office. The curtain rises on the second act; and presently, we have forgotten the footlights, and are *in* a court of law … In the third act we arrive at a prison … we are shown round the interior … we are haunted by it all … [5]

Beerbohm also made a prophetic comment about the play's impact on the solitary confinement issue: 'I shall be surprised if Mr Galsworthy has not delivered its death-blow.'[6] He was right. The recently appointed home secretary of the time, Winston Churchill, who saw the play early in its run, was also shocked at the terrible consequences this punishment could wreak on the mental state of a person, and he quickly took steps to bring about penal reform. By July that same year, it had been 'announced that the Falders of the future are to be condemned to a maximum of one month of solitary confinement, and that no longer are they to be pursued and broken by the inquisitorial system of ticket-of-leave'.[7]

The play, perhaps the most successful of the series, inevitably became the talk of the town. Count Harry Kessler, a well-known patron of the arts, was so moved by the production, he felt compelled to stage the play

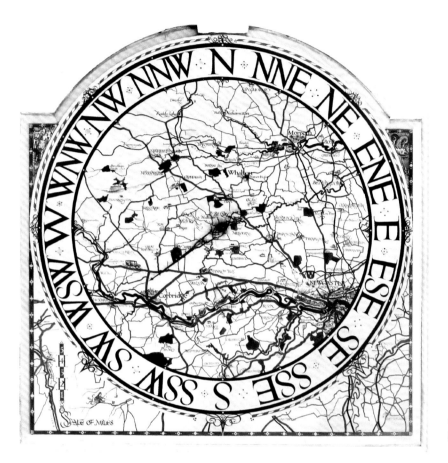

Wind dial at Whalton Manor,
Northumberland, oil on wood,
134.62 × 134.62 cm, 1910

in his German homeland and employed Max to adapt the set designs for a German theatre. And 'So pleased was Barker with the result …'[8] that Max was asked to design the sets for another of that season's productions, *Misalliance*, a one-act play by Barker's friend, George Bernard Shaw.

During the run of *Justice*, Max was contacted by Lutyens who wanted another wind-dial map, this time for Whalton Manor, near Morpeth, Northumberland, the home of Mrs Eustace Smith, widow of a Newcastle industrialist. Originally a row of 17th- and 18th-century stone cottages and houses, this was being was remodelled by Lutyens into one building that now enjoys the reputation of being the longest manor house in England. The map, which is above a fireplace in a first-floor sitting room, is similar to the one at Nashdom. It depicts Whalton Manor as well as all the main geographical features of the surrounding area, including the city of Newcastle, where Max had recently finished gilding and painting the Nicholson reredos. In the map, he was allowed, if not encouraged, to

Detail from Whalton Manor wind dial showing a broken-down car with the chauffeur lying beneath and his mistress (Mrs Eustace Smith?) sitting inside, 1910

incorporate a few humorous vignettes, one of which depicts a lady – perhaps Mrs Smith herself – sitting impatiently in the back of her stylish but stationary car while her chauffeur lies beneath the vehicle trying to remove a large branch. Cheekily, Max has included himself and Romney in *The Jolly Roger* sailing down the Tyne towards Newcastle, a scene recalling a boating expedition to the Isle of Wight.

Another job for Nicholson & Corlette took Max to Martley in Worcestershire for a week to paint the organ case for the village church and a painted panel inscription commemorating its vicar the Reverend Hastings. This was followed by the design of a memorial to Dean Charles John Vaughan, headmaster of Harrow School, for St Martin's, the church Vaughan had built in Kensal Green.

Once again Max spent Easter on retreat at Cowley, and in May he and his good friend Ben Boulter took their bicycles on a train to Switzerland and headed for Oberammergau. Years later Ben recalled their 'memorable … journey to the Passion Play, travelling out with the Ramsay MacDonald[9] family'.[10] The all-day performance of this remarkable play, performed by local villagers with the acclaimed Anton Lang as Christ and Hans Meyer as Herod, touched Max deeply. He wrote simply: 'Too wonderful and moving to be here described.'[11] Captivated by the Swiss landscapes and the people, he crammed in as much detail as he could in his tiny diary: 'O. is 3000ft top of Alpine valley, snowfields around & over bright blue sky, fields full of flowers, rushing waterfalls, whitewashed houses …' with 'Divine little children – peasants wonderful clothes – Tyrolean – black hair onto shoulders.'[12] Their 'subsequent ride along the Rhine was one long gurgle of Pleasantry',[13] Ben later told Evan Gill, while on their arrival in Speyer they witnessed the 'great crowds & flags'[14] to celebrate Prince Henry of Prussia's arrival from England.

Max's next major job was the painting of Chandos Hall in Maiden Lane, assisted by Frederick Etchells. There were also numerous smaller commissions for lettering and decoration: sixty jobs were logged in 1910 – but, despite all his training and experience in the profession, he had no commissions for architectural work. As an artist–craftsman, he was considered as little more than a house painter, as his pay for the Mission Hall had shown. Architecture, on the other hand, was a highly respected profession commanding significantly higher fees. He was determined to succeed in the field as the considerable time he spent on creating designs for architectural competitions makes clear. That summer he spent 318 hours on an entry for a competition to design the Usher Hall in

JOHN·PARSONS·HASTINGS·CHARITY

1907

A sum of £300. the interest whereof is to
be distributed annually at the discretion
of the Rector and Churchwardens in fuel
or other articles of household consumption
among the deserving poor of the parish
of Martley. was given by the
REVⅮ. JAMES FRANCIS HASTINGS.
CHARLES PAGET HASTINGS Esᵠ &
Mʀꜱ ELEANOR ELIZABETH LLOYD.
in memory of their Father, the
REVⅮ. JOHN PARSONS HASTINGS.
Rector of this Parish 1875, to 1907

Hastings Charity Memorial
Board, St Peter's Church,
Martley, Worcestershire,
oil on wood, 1910

Edinburgh,[15] a collaboration with his architect friend John Greaves. Their design – one of over a hundred – was unsuccessful, but they immediately entered a competition initiated by glazed-brick manufacturers for which the duo designed a 'Grill' restaurant, a venture that won them the first prize of 50 guineas.

There must have been celebrations too, when Max's proposed town house design was accepted for that year's Royal Academy Summer Exhibition. One reviewer wrote that it was 'a really fine and dignified town house – and we hope it may rise from the state of being "proposed".'[16] The design with its polychrome glazed bricks must surely have been inspired by the department store owner Ernest Debenham's new home in Addison Road, Holland Park – known as Peacock House because of its exterior cladding of cream terracotta bricks with inlays of blue-and-green glazed tiles. The architect was Halsey Ricardo, who advocated the use of such bricks on the facades of buildings, not simply for aesthetic

PROPOSED LONDON HOUSE

Proposed Town House design shown at the 1910 Royal Academy Summer Exhibition, watercolour on paper, 1909

reasons, but to protect against London's acidic pollution, caused by smoke from coal fires from over a million chimneys across the capital.

One of the more interesting jobs that summer was the design of fireplace tiles for Francis Cornford, a classical scholar, and his wife Frances, a poet. Eric had recently carved two inscriptions for Conduit Head, their newly built home in Cambridge, and had recommended Max for the fireplace work. The theme chosen for the (now-lost) sitting-room tiles was evolution – the theory propounded by Frances Cornford's grandfather Charles Darwin – with the simplest creatures on the lowest tiles rising to mammals at the top. The surviving dining-room scheme was simpler with exotic birds perching amongst leafy vines.

The summer had not been all work. Max had enjoyed what would be the first of many visits to Woodside, Ricardo's country home in Graffham, and, after delivering two sample tiles to the Cornfords in early September, he and his friend Greaves took a few days off to cycle around East Anglia. Their first stop was Ely where they ascended the cathedral tower to see the 'glorious view' and sketch the octagonal lantern before chatting with farmers at the bar of the Bell Hotel. In the next five days they cycled through a multitude of villages and towns such as West Walton with its 'exceedingly fine tho' ruined church',[17] Wisbech,

Top section of dining-room fireplace tiles designed for the Cornfords' house, Conduit Head, Cambridge, 1910

King's Lynn, the Terringtons, Wiggenhall St Mary where Max noted the 'beautiful coloured screen' in the church, St Germans – 'such a lovely village on R. Ouse' – Swaffham, Yaxham, eventually ending their journey at Wymondham where they sketched the church font and admired Sir Ninian Comper's 'fine carved evangelists' before catching the train back to London the following day.

Ely, lead lantern, watercolour on paper, 9 October 1910

For Lutyens this year, Max was also involved in the foundation stone inscription at St Jude's Church in Hampstead Garden Suburb which would be carved by his brother Eric. And there were small lettering and painting jobs for Rothenstein and a host of architects including Pite, Frederick Charles Eden, Charles Spooner and Albert Randall Wells.

Design for engraved silver napkin ring – a gift from Greta Johnston to her husband, pen and ink on paper, 15 December 1909

The Johnstons continued to be close friends – the previous December Max had designed an inscription for a silver serviette ring for Greta – a Christmas gift to her husband – and in October 1910 Max was honoured to become godfather to their third daughter Priscilla. Other friends had also married: that autumn Max was best man both to his friend John Greaves and Gordon Moore, Eric's brother-in-law and owner of a printing firm for which Max had done commercial work.

The Art Workers' Guild continued to play a central role in his life and on Friday 18 November 1909, Max had been elected into the Senior Section – 'his 1st appearance',[18] he wrote proudly. He attended the meetings most weeks and also read papers on a variety of subjects: between 1910 and 1912 he read at least three papers, including 'Tempera and Size Painting', 'Town Planning' (with Ricardo) and 'Wall Painting'. It was also where he met Cecil MacDowell, a young Dublin architect who spoke at the guild in late January 1911 on Irish architecture.

Max was particularly interested in the subject as he was about to paint a wind dial in Dublin for Lutyens at Howth Castle, home to the Gaisford St Lawrence family for over 800 years. His first two weeks in Ireland were spent in relative solitude but in his third week that May, he called on MacDowell, whose home was in nearby Sandymount. From then on he spent most of his spare time with the MacDowell family, enjoying musical evenings, going for long walks on the 'strand' and partnering Cecil's eighteen-year-old sister Alice on the lawns in family croquet matches.

Unusually, the Howth map was painted not on a wooden panel but on old plaster above an impressive stone fireplace. It depicts the castle, surrounded on three sides by the Irish Sea, and a fleet of gilded ships, each bearing the name of one of the Gaisford St Lawrence children. The castle had a centuries-old reputation for being haunted and, in later years, when the wind was gusty or strong, the movements of the indicator

Edward Johnston and his youngest daughter Priscilla c.1914

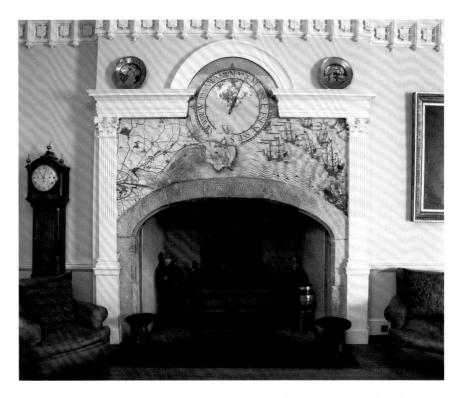

Howth Castle wind-dial map, paint on plaster, 1910

could cause alarming 'Ghostly noises' – so 'the rods down the chimney … were disconnected …' and the indicator has never turned again.[19]

A pivotal architectural work that year was the prize-winning design of a church in Teddington – the first in a series of close collaborations with the architect Arthur Grove. Max's senior by some fourteen years, Grove – like Nicholson – had been a pupil of Sedding. Due to a lack of funds, the Teddington church project was first delayed then abandoned until after the First World War when an alternative design was commissioned.

In the spring of 1911 London was busy preparing itself for the Coronation of George V, whose father Edward VII had died the previous June. Max's friend Graily Hewitt was commissioned to create a calligraphic address to be presented to the new king as a gift from the Royal Institute of British Architects (RIBA). Hewitt wrote out the text but asked Max to draw and paint the heraldry that decorated the opening pages. This relatively small job took at least twenty-eight hours but the result contributed to a magnificent piece of joint craftsmanship, just one of several undertaken by the pair.

Occasionally Max enjoyed a weekend of creative domesticity with Eric and family: 'I am down at Eric's this wk-end so write by the fireside from

Competition design in partnership with Arthur Grove for St Mark's Church, Teddington, watercolour on paper, 1911

Ditchling. Ethel is putting Joan to bed; Betty and Petra are snoring, Cribb [Eric's apprentice] is making a set of doll's furniture in the kitchen.'[20] There were also memorable weekends with close friends such as Wilfred Box, a former pupil of Sir Charles Nicholson, and Edmund Burton (possibly a fellow architect or craftsman working in Lincoln's Inn). In July Max rode pillion on Burton's motorbike to Brooklands[21] where they watched the start of the *Daily Mail* Circuit of Britain Air-race, reputed to be the inspiration for the comedy film *Those Magnificent Men in their Flying Machines* (1965). With aviation still in its infancy, the race attracted crowds of thousands, all coming to see the seventeen young pilots in their flimsy machines bump across the airfield, attempting to take to the skies in their efforts to win the £10,000 prize for the fastest time to Edinburgh and back.[22]

The end of the summer was marked with another communal mural project with a different set of artists, this time at the Borough Polytechnic, a college specialising in the teaching of skills for trades and industries such as plumbing, baking and shoemaking. The group had been asked to design and paint contemporary murals in the new dining-room by the artist and critic Roger Fry, who had organised the highly controversial 'Manet and the Post-Impressionists' exhibition which had opened at London's Grafton Gallery in November 1910, and was regarded by many as 'the

The humble & loyal Address of the Royal Institute of British Architects to His most excellent Majesty the King

May it please your Majesty.— We your dutiful subjects the President and Council, on behalf of the Royal Institute of British Architects and of the Architectural Societies both in the United Kingdom and in the British Dominions beyond the Seas in alliance therewith, of

Address presented by the Royal Institute of British Architects to King George V, heraldry by Max Gill, writing by Graily Hewitt, pen and ink, watercolour and gold leaf, 1911

apostle of modern art'.[23] He believed strongly that good modern art, as opposed to the 'crassly mediocre and inexpressive',[24] should be displayed in public spaces for the benefit of all, not simply the elite. A writer in the literary-magazine the *Athenaeum* agreed: 'Our walls are smothered with classical mythology figures painted in empty rhetorical style bequeathed by the Late Renaissance. A bad tradition is supreme.'[25] In her biography of Fry, Virginia Woolf wrote:

> [Fry] wanted to see … pictures of ordinary life that ordinary people could enjoy … he got the artists to design cartoons; he got the committee to accept their designs; and in the autumn of 1911 the students of the Borough Polytechnic were given pictures not of saints or Madonnas, but of the pleasures of London, to look at as they ate their meals.[26]

First sounded out about the project early in 1911, Max visited the college with Frederick Etchells in early February. A fortnight later he was discussing the scheme with Fry and other members of the team over lunch at a Chinese restaurant.[27] Max was a surprising addition to the group as he was inclined to favour representational art over Post-Impressionist Art espoused by Fry and his fellow artists on the project. In fact, on 13 January 1911, Max thought a lecture entitled 'Post-Impressionist Art' at

the Art Workers' Guild by T.B. Hyslop, superintendent physician at the Royal Hospitals of Bridewell and Bedlam, was 'splendid'; in this talk Hyslop proclaimed that such paintings were the degenerate products of diseased minds.[28] The group began the first murals at the beginning of August without Max, who joined a week later.

The original theme of the paintings was 'Getting the Food', but this was changed to a more light-hearted subject: 'The Pleasures of London' or 'London on Holiday',[29] 'a theme designed to reflect the everyday world experienced by the working class students', Fry thought. Duncan Grant painted two panels – *Bathing* and *Football*, Albert Rothenstein contributed *Paddlers*,[30] Frederick Etchells subject was *The Fair*, Roger Fry depicted *The Zoo*, Bernard Adeney's panel was *Sailing Boats* and Max painted *Punch and Judy*. All seven murals were painted on canvas with a limited palette, and to create a unifying effect each was surrounded by wide borders of the same colour tones providing 'a dark contour to increase the rhythm of the design, as in Byzantine mosaics'.[31]

Punch and Judy shows were a popular entertainment of the time, always featuring the same comic characters and events. In his mural Max depicts Punch turning the tables on the hangman, who dangles from his own gallows, watched by a delighted young audience. Meanwhile, the skeletal-looking showman – or 'Bottler', as he was called – and his fat whistle-playing assistant stand on either side of the red-and-white-striped booth geeing up the crowd, eager to collect their pennies. Max's picture seems to suggest that the entertainers have more in common with the characters on the stage than with the children.

When the paintings were unveiled in early September, they provoked extreme reactions. *The Times* reviewer was critical of several of the works, but positive overall: '… the main result is that the room is a very pleasant and interesting place'[32] while the *Evening Standard* claimed that it was 'the most important artistic event of 1911'.[33] The *Athenaeum* too was encouraging:

> … the decorators of the Borough Polytechnic must be prepared to be howled at as anarchists and charlatans because, instead of setting themselves to copy the works of dead masters, they have dared attempt what the masters achieved – the expression that is of the significance of contemporary life.[34]

The *National Review* on the other hand was outraged and declared that the paintings were a 'hideous, clumsy nightmare' and that 'the perpetrators

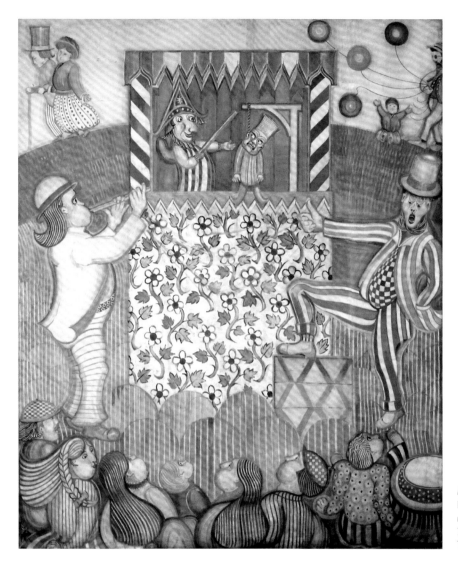

Punch & Judy, mural for the Borough Polytechnic dining room, oil on canvas, 244 x 183 cm, 1911
Tate Collections N04570

of these travesties are more to be pitied than to be blamed'.[35] Fry, however, was very pleased:

> My work at the Borough Polytechnic has been a great success, at least in arousing interest. They had a great debate on it the other night which I was asked to open. It was a very amusing occasion with much freedom of speech, but on the whole they seemed inclined to be converted to my view. The Press has been almost entirely on my side.[36]

Detail from *Punch & Judy* showing 'A' for Alice

In general, the critics liked the paintings of Duncan Grant best, although Frederick Packer, secretary of the governing body, thought that 'only Max Gill's Punch and Judy show really relieved the gloom'.[37] *The Times*, however, thought that 'Max Gill's "Punch & Judy" is too determinedly comic as if he had tried to paint down to his subject. One feels that with the best will in the world, he has not made it amusing because it has not amused him.'[38] Max himself reported to his younger brother Vernon, now living in Canada: 'The general result made a great stir when the critics had been let in. My subject was a "Punch & Judy show": but you wait till you see the remarks, I had some "cutting" ones all right.'[39] He took his older brother to see the murals, but if he expected Eric to be impressed, he was mistaken. In his diary Eric wrote: 'Very interesting & in many ways admirable but terribly stylistic and wilful. E.G. take warning!'[40] Years later he wrote the following to Jim Ede, assistant director of the Tate which had just acquired the Borough Polytechnic paintings: 'Yes, I know Max Gill quite well and intimately . . . He is a jolly nice man . . . I don't like his work much but I like him awfully.'[41]

Thanks to the controversy, the enormous publicity certainly brought the artists to the attention of the establishment as well as to the public in general, even though it may not have been in quite the way Max might have anticipated. There was little or no financial reward and one assumes therefore that he saw it as an interesting summer project among friends as well as a commission that might bring him wider recognition.

Hidden in the mural is the letter 'A' – a reference probably to Alice MacDowell, to whom Max had formed an attachment the previous year in Dublin. In mid-September, shortly after finishing the Borough Polytechnic work, Max was invited back to Ireland by the MacDowells to celebrate the wedding of Cecil's other sister, Ada. What began as a fortnight's holiday was prolonged to a five-week stay because he was – according to his letter to his brother Vernon – '"fed up" a bit with work'.[42] Another reason must surely have been his growing friendship with Alice – but he rarely shared such personal information even with his own family. On his birthday Alice presented Max with the sheet music for a song: 'Absent yet present', a poignant reminder that he would remain in her thoughts and heart when he left, and the evening before his departure on 16 October, Max met 'in the library w. A – dearest',[43] where perhaps promises were made. Just hours later she waved him farewell from the Dublin quayside as his boat set sail for England.

The couple expected to be reunited within months as Max had been offered a job by Lutyens at Lambay Castle, 'where I am to do some

painting-work some day (or rather, some month) next year'.[44] A few days before leaving Dublin, he had been ferried by Fargy, the boatman, in his skiff across the three-mile stretch of water that separated the mainland from Lambay Island. The castle – 'an ancient … pebble-dashed, semi-fortified little stronghold with crow-step gables'[45] – was purchased by the banker Cecil Baring in 1904, and had recently undergone major restoration and alterations by Lutyens, who had suggested that a wind-indicator map would be an excellent decoration over the study fireplace.

On his explorations of the island, Max was captivated by the rocky scenery, the whitewashed coastguard cottages, tiny chapel and Norse burial cairn, and thought it would be 'a wonderfully restful kind of place to go to for a month'.[46] He was astonished to discover that 'the little island is alive with weird animals that elsewhere are extinct'.[47] In actual fact the curious collection of creatures were merely exotic, and included snakes, lizards, rheas, tortoises and wallabies. Baring was a passionate amateur naturalist, who travelled all over the world collecting animals, which he would release on the island. They were allowed to roam freely, much to the surprise of unsuspecting visitors.

In the end, the wind-dial map idea was abandoned, probably because of the cold and damp conditions in the castle, which was only used in the summer months. Instead, Max designed the inscription for an impressive stone plaque bearing an inscription commemorating the restoration of the castle with the names of the architect and his builder J. Parnell & Son.

Tablet in Lambay Castle, Ireland, incised stone designed by Max Gill, 1914

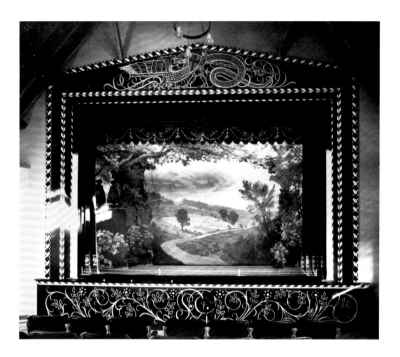

St George & the Dragon mural on stage front at St John the Divine Parish Hall, Richmond, 1911

With neither time nor a professional reason to return to Dublin any hopes of seeing Alice again were dashed. He did, however, carry out a number of other commissions for Baring, including the design of the company seal and cheque, and later an imposing First World War Roll of Honour for the bank, as well as a number of other inscriptions at Lambay, including a poem – composed by Baring – for the mausoleum of Baring's beloved wife Maude, who died tragically young, aged only forty-six.

Towards the end of the year Eric asked Max to paint and gild his newly carved lettering on the Pre-Raphaelite artist William Holman Hunt's tomb in St Paul's Cathedral. And Max was also engaged in decorative work for Arthur Grove, who was in charge of major alterations at St John the Divine in Richmond where additions included a chancel, a lady chapel and a new parish hall. Max described his first contribution:

> I was decorating, with 2 assistants, a Hall at Richmond. A kind of glorified 'Parochial Rooms' with 3 stories. And my little game was to superintend the general painting of the whole building, and in particular to paint up a 'St George & the Dragon' scene over the proscenium front. You see, there was a stage & 'wings', i.e. all in the type of a London theatre and really for a Hall quite an elaborate thing.[48]

CHAPTER EIGHT

Hare Court, North End and the North-East

1912 – 1913

IN APRIL 1912 ARTHUR GROVE invited Max to join him at his chambers at 1 Hare Court, a late seventeenth-century building in the Inner Temple just across the lane from the Temple Church. The premises were more spacious than his flat at Lincoln's Inn, an important consideration as he and Eric had given up the rooms at 21 Old Buildings at the end of the previous year. As he told a brother:

> it was more convenient to move to chambers there … where there was a clerk who could look after 'callers' and 'phone' for me. Also the rooms as 'office' are more so than at L.I. – however nice they were … I was sorry to leave the old rooms, where I had been for 9 years, but it's quite the best arrangement.[1]

There was also a bedroom so he could, he said, 'stop up as long and when I like, in town'.[2] It also made sense because Grove and Max were collaborating on various architectural and decorative schemes. The new chambers were sub-let from Edward S. Prior and shared with Grove as well as commercial artist Harold Nelson and silversmith Henry Wilson, who had his own room here. The main studio looked south over Pump Court and had two tall windows under which was a deep worktable spanning the entire width of the room and on the side wall was an impressive carved mantelpiece. The nearest lavatory and running water were on the ground floor; even in the 1930s these rooms retained a Dickensian quality, almost untouched by time.

The studio at
1 Hare Court, c. 1913

Ben's Boulter's wife Bertha at the gate of 'North End', North Moreton, Berkshire, c. 1913

The decision to join Grove at Hare Court coincided with an invitation from his friend Ben Boulter to share North End, a small farmhouse in North Moreton, near Wallingford, Berkshire (now Oxfordshire), which Ben and his brother Basil had inherited on the death of their father that February. Initially, Max's intention was to use North End, which he described as 'so pretty – in its way and wonderfully quiet in a hidden-away little village',[3] purely as a weekend retreat, but he liked it so much that he decided: 'to "live" here at North End – going up to town mid-week – i.e. for Tuesday's class at Clapham – which I still have – and staying on according to work that wants my personal attendance.'[4]

Max threw himself into helping Ben on major house improvements and within a fortnight he had cleared a shed at the bottom of the garden to create a studio, where his first job was the painting of four statues for the Lady Chapel at St John the Divine in Richmond. On Sundays he attended the services at All Saints, the twelfth-century village church, and became a popular member of the community, playing his violin at their musical evenings.

Ben and Max were kindred spirits with their shared love of lettering and drawing as well as their passion for cycling. Their tours around the local countryside were still vivid in Ben's memory forty years later. He recalled one escapade:

> we found ourselves in the Square at Banbury 'Is your cock-horse ready to make the circuit?' asked he [Max]. Whereupon we set to and were doing the maddest sort of roundabout, when Max came off, but in his Maxish way he turned it into a joke, remaining with one leg in the air, to the delight of the Banburians![5]

Ben Boulter

Among the various Boulter relations who came to stay at North End that first year was Ben's eighteen-year-old cousin Norah. It was high summer and Max would interrupt his painting work to take her rambling through the local meadows and cycling up 'the little winding hill'[6] to Cholsey. Norah's home in Richmond was conveniently close to St John the Divine where Max was working and for a few weeks the couple met frequently but as summer faded into autumn so did their romance.

Max played host to a variety of his own friends and family at North End, which he jokingly called his 'country residence'.[7] In July his parents came to stay for a fortnight. They were well-acquainted with the neighbourhood as years before Arthur Gill had twice acted as locum

Reredos, Lady Chapel, St John
the Divine Church, Richmond,
Surrey, 1912

vicar at the church in nearby Blewbury. Max's father was particularly keen to immerse himself in some painting: 'I cherish a special regard for that studio of yours at the bottom of the garden & fondly fancy myself & my easel happily occupying its floor', he wrote to Max shortly after the visit was mooted.[8] Rose Gill was missing her boys since they had all left home[9] and would have been thrilled to see Max in his new country home. After she returned to Bognor, Eric joined Max and their father, and the trio set out on a pre-planned three-day walk from Oxford to Stratford-upon-Avon which they reached wet but 'nothing daunted'.[10]

Despite their artistic differences, the brothers were on good terms with each other. They met frequently in London, Eric sometimes staying overnight at Hare Court. In February 1912 Max took him to Caxton Hall to hear a discussion between G.K. Chesterton and Bishop Gore on Christian social obligations. Eric, who had once disliked Chesterton, was now more inclined to 'revere and love him, as a writer and as a holy man, beyond all his contemporaries'.[11] For the most part the siblings shared socialist ideals, and with Eric now on the road to conversion to the Catholic faith, they also now shared religious beliefs.

In late 1909 Eric had started to experiment with sculpture, which soon became an all-consuming passion. The bread-and-butter work of letter-cutting in the workshop was then mostly delegated to his apprentices, the most proficient being Joseph Cribb, who had been taken on by Eric in 1906. From 1911 onwards it was Cribb who usually carved Max's inscriptional designs, for example the tablets in Lincoln Cathedral commemorating Dr William O'Neill and General Sir Henry Errington Longden.

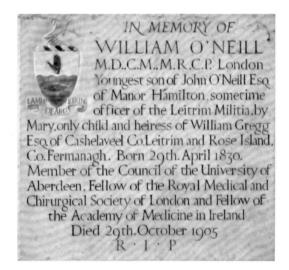

William O'Neill commemorative tablet from Lincoln Cathedral, incised Hopton-Wood stone (carved by Joseph Cribb), 63.5 × 53.3 cm, 1913

For Lutyens there was more inscription work at St Jude-on-the-Hill in Hampstead for which Eric did the carving, a clock dial on the gate at Great Maytham, the new country home of Harold 'Jack' Tennant, the Scottish Liberal politician and under-secretary of state in the War Office, and Max's most lucrative job of the year – a large wind-dial map for Lindisfarne Castle in Northumberland.

The owner of this iconic edifice was Edward Hudson, founder of the magazine *Country Life Illustrated*. A confirmed bachelor in his late fifties, the shy and socially awkward Hudson was not by all accounts a handsome man – his large head and bulging eyes prompted Lytton Strachey to describe him as 'a fish gliding underwater, and star-struck … A kind of bourgeois gentilhomme'.[12] Enchanted by Munstead Wood in Surrey, the house Lutyens had designed for his friend, the garden designer Gertrude Jekyll, Hudson had commissioned a country retreat at Sonning in Berkshire: Deanery Garden. Henceforth, Hudson became Lutyens' greatest admirer, patron and publicist, championing the architect's work regularly in *Country Life*. It was largely this exposure that resulted in Lutyens rapidly becoming the leading country house architect of the Edwardian era.

Edward Hudson, owner of *Country Life* magazine

Hudson had bought the romantic but dilapidated Tudor castle at Lindisfarne a decade earlier and over the following years Lutyens transformed the ruin into an Arts and Crafts jewel. Given a free hand not only with the design but also the fixtures and fittings, he created a remarkable medieval-style interior; its narrow stone passageways with rounded archways led into flagstone and brick-floored chambers

furnished in plain oak, tapestries and pewter tableware, reminiscent of the Dutch interiors that had captivated Lutyens in Holland over a decade before. Max's wind-dial painting was to take pride of place over the enormous stone fireplace in the entrance hall, where it would be the first thing to be seen by a visitor stepping over the threshold.

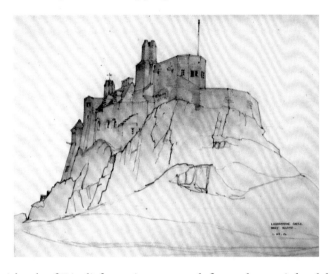

Lindisfarne Castle, pencil and watercolour on paper, December 1912

The island of Lindisfarne is separated from the mainland by a vast expanse of sand and mud flats and is usually approached by means of a causeway accessible only at low tide. When Max and his architect friend Francis Grissell, who was assisting on the project, arrived at Beale Station on the morning of Saturday 18 November and discovered that the pony and trap supposed to meet them had not arrived, they decided to set off across the sands to the castle perched on its rocky crag. The distance was, however, deceptive and the tide had turned, so by the time the intrepid pair were nearing the end of their four-mile walk, they found themselves wading through the ever-deepening waters of the North Sea. Despite their misadventure Max's enthusiasm for this 'most splendid site'.[13] was not in the least dampened. Over the next three weeks these two young men explored every corner of the island, often at dusk when the light had become too poor to work. Rose Gill marvelled at her 'little Mac'[14] being 'an inmate of this romantic & historic retreat', sleeping in a '17th century bed – impregnated as it must be with the spirit of dreams and mystery'.[15]

All was going well until, three weeks after they had begun, Hudson arrived. His reaction was both unexpected and disappointing. Although there must have been lengthy discussions about design, Hudson had clearly changed his mind and now he 'wants all to be "ancient"',[16] Max wrote.

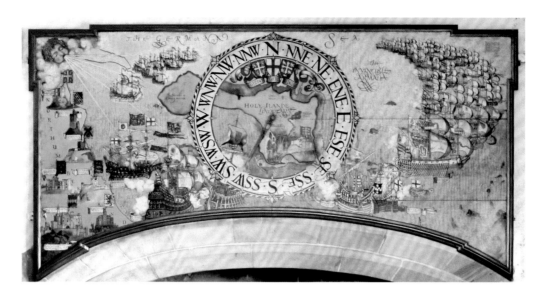

Wind dial from Lindisfarne Castle,
Northumberland, oil on wood,
137.2 × 294.7 cm, 1913

There were no arguments; Max, in his usual quiet way, simply accepted Hudson's wishes. He and Grissell packed up and headed south and the wood panel was sent down to North End to await a redesign in the New Year.

With the instruction to produce something more historical, Max decided to paint – with a little artistic licence – the routing of the Spanish Armada by Sir Francis Drake and the English fleet in 1588 off the coast of Northumberland; it should be said that, in reality, the Armada had been wrecked as a result of severe North Sea storms. The focal point of the map is the Holy Isle, with its castle and monastery founded by St Cuthbert, who can be seen collecting his 'beads', as the local fossil crinoids became known while the Northumberland coast is depicted with its string of castles including Dunstanburgh, Warkworth and Alnwick. The Tudor-style picture with its galleons, heraldry and sea monsters suited Hudson's castle admirably. The meticulously depicted warships were the result of hours of sketching at London's Royal Maritime Museum. Eventually completed at the end of July 1913, the panel missed being photographed for the *Country Life* article published that June but it eventually appeared in the magazine in an article about wind-dial maps in November 1925.

On arriving back in London on 11 December 1912, Max hurried round to the Kingsway Theatre to buy tickets for Galsworthy's new play *The Eldest Son: A Domestic Drama in Three Acts,* which had opened three weeks before. Barker had asked him to design the sets, which – in stark contrast to *Justice* – showed the interiors of a country mansion

Detail from Lindisfarne
Castle wind dial, 1913

including an oak-panelled hall with a broad staircase and a comfortably furnished morning room. The plot of the play focuses on the injustice and hypocrisy which result when a baronet and his son both cause local girls to fall pregnant. Galsworthy judged his new work to be 'a fairly good *succés d'estime* and the usual commercial failure'.[17] while Max's verdict was that his 'scenery came out all right' and the play was 'itself good but questionable'.[18]

Romney Gill, c. 1912

At the end of January 1913, there had been great family celebrations in Bognor to welcome Romney back from Papua, on furlough for several months. He managed to entice Max away from his studio to make several nostalgic excursions: to Lincolnshire to visit the missionary college at Burgh-le-Marsh; to Leigh where they were greeted with joy by Mary Brown; to Ditchling to stay with Eric and his family; and to Cowley where they once again spent Holy Week together on retreat. Max also took him to his North Moreton bolt-hole where the pair performed their old favourite, *Box & Cox*, for an audience of Boulters and local friends.

After five years away, Romney was realising how keenly he missed his family, especially his dearest brother Max. On the tiny mission station he had built up in Boiani, he often felt isolated; he was usually the only non-native person among his community, with no one to share or understand his concerns, and no one to confide in. He had the notion that Max could join him in his missionary work and wrote proposing he should join him in two years' time. Max tried to let Romney down gently:

> I have thought very sincerely over your proposal … I do not feel that I can do so. It is a big question, and a great step to take, I know; but I feel that the course I have been pursuing since I left Nicholson's and came on my own is, as far as I can see at present, the appointed path for me, made as I am. Naturally at the 'first glow', to go to Papua would seem indisputable. But one has to sort the 'novelty' of travel, aye, even the 'happy proximity' to you, were I to come; the 'restful' (in a sense) atmosphere of your village life – from the really spiritual side of one's life. I mean taken away the material outlook; one has to find the spiritual or immaterial force, and its direction and significance. I realize, too, all we could do together so well; and yet, – and yet …[19]

Romney's leave was over all too soon and on Friday 9 May 1913, Mother, Father, Max, Eric and Mary Brown escorted him to Tilbury where he

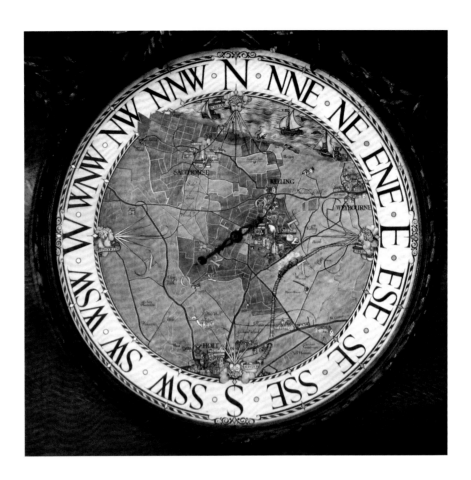

Wind dial from Kelling Hall, Norfolk, oil on wood, 83.2 cm diameter, 1913

was to begin his passage to Australia and from thence to Papua. Max went aboard with Romney while the others stood 'drinking in the scene'[20] on the wharf. They glimpsed Max and Romney on a deck high above them. 'We saw Romney urging Max to go as all the other visitors were doing & still he delayed', wrote their mother.[21] Max continues the story: 'I played the game up to the last moment: Romney urged me to go ashore – & still I delayed. I lied furiously about there being a lot more time, & then I discovered my tickets.'[22] The rest of the family, of course, had known all along but managed to keep it 'a profound secret – Romney did not suspect it in the least'.[23] Romney was thrilled:

> Max coming along with me to Toulon is – without doubt – the most happy surprise I have had my whole life! I could have bashed him in the eye or else kissed him when he brought out his ticket. It's made just all the difference to me.[24]

On Max's return from southern France, there was plenty to do: the Lindisfarne wind dial, a set of shields at Rushton Hall in Northamptonshire, a tablet and mural for King's College Hospital in Denmark Hill as well as work at Knebworth. A week after the Lindisfarne panel had been sent off, Max travelled up to Norfolk to visit Kelling Hall, the first major house commission for Edward Maufe, who had trained with William A. Pite, architect of King's College Hospital.

This thirteen-bedroom Arts and Crafts mansion had been commissioned by the oil magnate Sir Henri Deterding, managing director of Royal Dutch Shell, and was designed to be used for weekend shooting parties; the magnificent panelled trophy room on the ground floor housed a splendid array of antlers and other hunting memorabilia. Max was commissioned to paint a circular wind-indicator to be set into the carved mantel panelling, showing a bird's-eye perspective of the area bounded by Holt to the south and the North Sea to the north. Reminiscent of a sixteenth- or seventeenth-century estate map, it shows Kelling Hall itself at the heart of a patchwork of green fields embroidered with copses, cottages and wildfowl of the area.

According to Nicholas Deterding, a great-grandson of Sir Henri, 'its original purpose was so that they could work out where to go for partridge shooting'.[25] Unknown to the Deterdings the map hid various references to people in Max's life:[26] the child near the railway bridge is Max's god-daughter, three-year-old Priscilla Johnston, while the sailing vessel unloading at Weybourne bears the name of Halsey Ricardo's younger daughter Esther.

Detail from Kelling Hall wind dial showing boat named *Esther*, 1913

CHAPTER NINE

The Wonderground Map
of London Town

1913 – 1914

W HILE MAX WAS PUTTING the finishing touches to the Lindisfarne
panel, he was summoned back to town for a meeting with Gerard
Tuke Meynell, the owner of the Westminster Press, to discuss a 'Map of
London for Underground Railway'.[1]

Born and raised in a Quaker family near Newcastle, Meynell came to
work for his uncle, Wilfrid Meynell, at the Westminster Press in London
and by 1900 he owned a controlling interest in the company. Ever
ambitious, he set about expanding the output of the press from magazines
and jobbing work to book printing. In late 1912 in partnership with
Edward Johnston, and others, he created the *Imprint*, a short-lived but
renowned periodical that dealt with every aspect of printing and the
making of books. Meynell, a stocky bespectacled man with a hooked
nose, was impulsive and would act 'with such energy as to force other
people to fall in with his plans',[2] in his eagerness to see a brilliant idea
come to fruition.

Gerard Meynell as a young
man in the 1890s

Meynell had already had dealings with Frank Pick, the commercial
manager of the Underground Electric Railways of London (UERL),
having supplied him with a set of posters by artists of the Senefelder
Club (a group promoting the art of lithography). Pick was a quiet
but determined man dedicated to public service and was an 'unusual
combination of Underground executive and visual fanatic'.[3] When he
joined the Underground Group in 1906, the station platforms were poorly
lit with smoke-stained walls cluttered with all manner of advertising,
hardly pleasant places for the thousands of daily commuters or the casual
visitor to London. With a few relatively inexpensive strategies, he set
about transforming the look of the network, making station frontages,
ticket areas and platforms more appealing to the public. Meynell not
only introduced Max to Pick at this time but also engineered a meeting
between Pick, Johnston and Eric Gill to discuss the design of an alphabet

for the underground signage.[4] Typographic expert Beatrice Warde wrote that Meynell was 'one of the few master printers who could have held his own in conversation with two such mind-shakers as Johnston and Pick'.[5]

One of Pick's early measures was to replace the confusing mass of advertisements with a select few, displayed in specially made frames together with attractive and interesting underground publicity posters designed by leading artists of the day. Pick believed implicitly that 'moral and civic harmony could be achieved through integrating art and design with everyday life',[6] beliefs that can be traced to the Arts and Crafts movement. The poster campaign Pick launched was intended to change people's perceptions about the underground, not only encouraging the public to travel more, but also creating a system that Londoners could take pride in.

Frank Pick, commercial manager for the Underground Electric Railways of London, c. 1915

From the start Pick made it his business to educate himself about art, design and lithographic poster production by talking to the artists and printers he worked with and through contacts he made at the Central School of Arts and Crafts. He commissioned work not only from established artists such as Frank Brangwyn and Fred Taylor but also young upcoming artists including Edward Bawden and Rex Whistler and women artists including Mary Adshead and Nora Batty. His loyalty to favoured artists such as Max Gill was legendary, with many receiving numerous commissions over the decades. In those early days, however, when poster art was still in its infancy and Pick had little knowledge of art and design, the printer would be trusted with the whole job from start to finish, from choosing the artist right through to producing the finished poster. One such printer was Gerard Meynell.

The earliest surviving fragment of artwork for Max's poster is undated but shows a small, clearly recognisable section of what would become known as *The Wonderground Map of London Town*. It depicts four different designs for the underground station as well as experimentation with the black-and-white edging patterns. Meanwhile, a serpent already inhabits the Serpentine, a lake in Hyde Park, and Roman capitals spell out the beginning of the border message: 'By paying us your penniesss . . .' This preparatory sketch, executed in pencil, pen-and-ink and watercolour, may well have been used to demonstrate to Pick an idea of what Max intended.

Progress on the map was erratic due partly to prior commitments, notably a six-week job starting in early September at Lincoln Cathedral, where Sir Charles Nicholson was overseeing major repair work. Max was employed to restore the faded medieval decorations in the Bell Ringers' Chapel, including the painted names of seventeenth- and eighteenth-century bell-ringers – a historic record unique to Lincoln. He was helped

Section of the earliest known design for Max's first map for the London Underground, pen and ink and watercolour on paper, 77 × 83 cm, 1913

by Anna Ricardo and Francis Grissell for the first fortnight of September, before being joined by Anna's friend, former Slade student Mary Creighton. With such a competent group in position here, he was able to interrupt his own stay to travel back to London on several occasions for meetings with important clients such as Maufe, Hudson and Meynell and to take his classes at the Clapham School of Art and also now the Central School of Arts and Crafts.

Mary Creighton, a fair-haired confident young woman, was a daughter of Mandell Creighton, the late Bishop of London, and Louise Creighton, a champion of women's education. She was to become a lifelong friend of Max. She was a member of the Friday Club – a forum for discussion and exhibitions of innovative and challenging art, formed in 1905 by Vanessa Bell, who was also a friend until the two disagreed about modern art, with Creighton shying away from the avant-garde artists preferred by Bell. Max was firmly on Mary's side: after they visited an exhibition of work by the London Group at the Goupil Gallery in Regent Street, he declared that there were 'some lovely ptgs. [paintings] of scenery, but most not understood by me'.[7] Almost forgotten today, Mary had made a name for

Restored painted panel showing the names of the bell-ringers of Lincoln Cathedral, 1913

herself for a variety of work including murals and engravings and by 1912 her work was being exhibited at the Venice Biennale alongside artists such as Frank Brangwyn, William Strang and Walter Sickert.

It is remarkable that these daring young ladies were happy to scale considerable heights to work on the wooden scaffolding in their cumbersome and impractical Edwardian full-length skirts. In those pre-war days, it was still frowned on for middle-class women to work yet Max had no hesitation in employing female assistants. All the painters have their initials painted in the bottom right corner of the restored mural. Max also painted a delicate decorative frieze on either side of the ribs of the vaulted ceiling.

A few days after returning to London in mid-October, Max began courting Anna Ricardo's sister Esther, who had also helped on the decorative scheme at St Luke's Mission Hall in Chelsea. They had also met on his many visits to the family home in Bedford Square and Woodside, the Ricardos' country home in Graffham. His diary records their first outing together – a theatre performance in London: '"Androcles & Lion" E? Yes, calling at Bedford Sq. 6.30.'[8] Two days later she accompanied him and the Lincoln painting team to the Ideal Home Exhibition at Olympia, where the public and the art world were in a state of excitement over a controversial room designed by the directors of the Omega Workshops: Roger Fry, Duncan Grant and Vanessa Bell.

Max Gill with Esther Ricardo at
Woodside, Graffham, c. 1912

The following day they went on the first of many expeditions to London
Zoo – a place that featured prominently in the London map Max was
still in the process of drawing.

Max had also committed himself to a job for the architect Oswald
Partridge Milne, a former pupil of Lutyens. This was a map for Josiah
Smale, owner of the largest silk business in Macclesfield, for whom Milne
had just built Lyme Green House in Sutton, Macclesfield, Cheshire. After
visiting Smale and sketching the house and its surrounds, Max submitted
a small-scale pen-and-ink design for approval before beginning the full-
size panel which was to be a bird's eye perspective of Smale's house and
grounds with a curved horizon formed from the Macclesfield canal. But
tragedy struck on 27 December 1913 when Smale collapsed and died
of a heart attack aged just forty-nine years old, and the map, although
begun, was never completed.[9]

With deadlines in November and December past, Max turned his
attention back to the London map. As soon as the pen-and-ink artwork
had been completed, it was delivered to Meynell, who printed up proofs.
Max then took a copy down to Ditchling where he began the colouring
'in Eric's workshop – a fine place just built'.[10]

The Eric Gills were now living at Hopkins Crank, a farmhouse with
outbuildings on Ditchling Common, East Sussex, about four kilometres
north of Ditchling village. Eric, with his usual zeal, was bent on pursuing
his latest idea of living off the land in a more isolated working community,
away from the distractions of village life, where the food would be
home-grown, the clothes home-made from home-spun cloth and the

Map-panel design for Josiah Smale, pen and ink on paper, 1913

children home-educated. This semi-monastic lifestyle also appealed to Max, who was no longer staying at North End following Ben Boulter's marriage, and in August 1913, it was agreed that Max should also come and live at Hopkins Crank. An outbuilding was chosen to be converted into a house by the local builder, and Max moved all his possessions down from North End and put them into storage in Hassocks, and began sketching plans for his new home: 'Drawing my barn at Ditchling most of the day',[11] he wrote in a diary entry.

With the publication date of the underground poster less than a fortnight away, Max was back at Hare Court for a last late-night session at his drawing board. He wrote on 9 March 1914 with some relief: '… worked on last sect. of London map … doing colouring – till 3am Tues – when I completed it (Began August 1913).'[12] It had taken him just over seven months and hundreds of hours of work.

From the moment it was unveiled at underground stations across London on Monday 23 March 1914, it caused a sensation. Naturally, Pick had ensured a fanfare of publicity designed to entice the public into stations to see this 'burlesque topographical map of London'.[13] With headlines such as 'Fun on the Map of London',[14] articles unanimously praised this 'striking' poster, which 'is sure to arouse more than ordinary attention wherever it is exhibited'.[15] Even *The Times*, which declared that the humour was 'somewhat primitive', grudgingly admitted 'the total effect of the poster is quite striking'.[16]

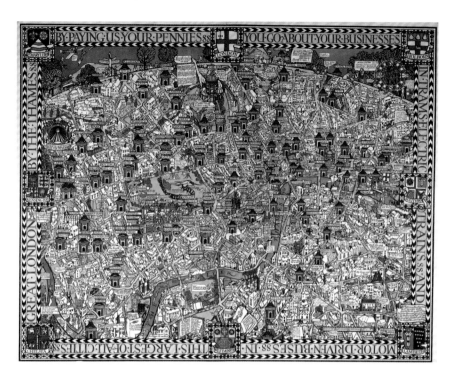

A quarter of a century later Max wrote modestly of his work for Frank Pick:

> The series of posters (quad-royal size 50" x 40") I designed for the Underground Railway showed the facilities offered for travel by their service. Naturally historical references were many, and full licence was allowed for humour and play upon etymology and topical illusions [*sic*]. Still they were accurate in their data and the Ordnance Surveys being adhered to supplied the necessary rigidity.[17]

Initially called simply *A Map of Central London,* Max's creation soon became known as *The Wonderground Map of London Town.* The passenger waiting for his train could hardly miss this quad-royal (101 cm by 128 cm) poster – with its bright primary colours, its medieval-style black-and-white chevron edging, and jewel-like heraldic emblems of the London boroughs. Then there was the eye-catching yellow border with its bold red Roman capitals spelling out the message: 'BY PAYING US YOUR PENNIESSS – YOU GO ABOUT YOUR BUSINESSES – IN TRAMS ELECTRIC TRAINSSS AND MOTOR DRIVEN BUSESSS – IN THIS LARGEST OF ALL CITIESSS GREAT LONDON BY THE

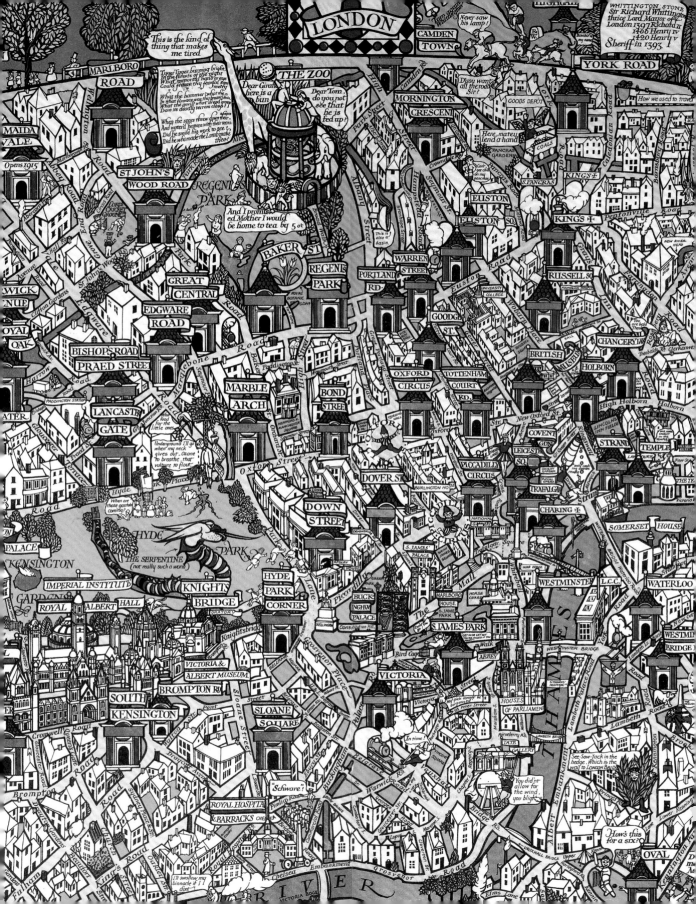

THAMESSS.' The curved horizon, a device Max had used in *Punch & Judy*, seems to emulate the *mappa mundi* of the Middle Ages, framing the upper part of what the *Standard* called:

> one of the most striking efforts in the way of pictorial burlesque ever attempted … Probably no other single sheet of the same size has ever before been so crowded with jokes, puns, and witticisms as this one is. The principal thoroughfares, the parks, the river, and the underground stations are shown, and the life of London in all its phases has been dealt with by the fun-creating pencil of the artist.[18]

It has been claimed that the 'humour and symbolism of Gill's map is virtually incomprehensible to the modern viewer today'.[19] To some degree this may be true, but much of the humour consists of simple pictorial slapstick, such as the pedestrian knocked down by a galloping highwayman, and visual puns like the serpent in the Serpentine or the coroneted gentlemen playing cricket at Lords.

The meaning of some jokes may be discovered in another section of the map: for example, in Hyde Park a group complains, 'When are those gas tubs coming?' while at Lots Road a Cockney workhand at the power station is asking, 'Are you sure them gas tubs are ready? "Ide Pork is waitin"'. Even a century after its creation, the map with its cartoon characters still engages and amuses people, no matter what their age or background. One scene that always raises a smile is the policeman near Earl's Court Station grabbing the robes of a coroneted aristocrat with a shout of 'the Earl's caught!'

An example of Max's black humour, as well as being a grim reminder of London's chequered past, can be seen at Tyburn where a raven awaiting the last gasp of the hanged man caws: 'What food for the little ones.' History is also represented in the legend of Dick Whittington, thrice Lord Mayor of London, and his cat, which also makes an appearance, and John Stow, the renowned seventeenth-century chronicler of London, is illustrated with a begging bowl imploring passers-by for 'their voluntary contributions & kind gratuities'.

The map may look dated to us now but a tube passenger in 1914 would have recognised the London of his own time. It depicts a time of enormous change, much brought about by technological invention and innovation. Gas lighting was by now commonplace as we can see from the Lots Road power station in Chelsea, and news headlines often

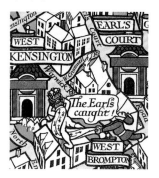

Earl's Court, detail from *By Paying Us Your Pennies*, 1914

featured the latest record-breaking achievements in the world of flight. In the top left-hand corner, a pilot is asking a flock of birds: 'Have I looped yet?' The feat immortalised was the first ever loop-the-loop to be seen in Britain, performed by Adolphe Peugod in a Blériot XI monoplane at Brooklands on 25 September 1913.[20]

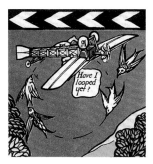

Looping-the-loop, detail from *By Paying Us Your Pennies*, 1914

Motor vehicles were now appearing on the streets. The first reliable mass-produced bus – the open-top Type-B omnibus first introduced in 1911 – had by now replaced horse-drawn public transport, although the one depicted here in Queen's Road needs a push to get up the hill while in Peckham Road, the driver of another has harnessed the pulling power of a top-hatted gent by holding onto his coat tails. Within a year the B-type would prove itself invaluable as a troop carrier in the coming war and the map leaves us in no doubt about the nationality of the enemy, for at Chelsea barracks a drill sergeant is barking in German '*Schwäre*' ('harder' in English) to a brigade of soldiers on the exercise square.

The map is brought to life with its cast of colourful London characters from the upper-class monocled gentleman in his top hat and tails asking 'What is work? Is it a HERB? to the comic depictions of road-menders, gas workers, bus conductors, eel sellers, town criers and coster-mongers with their cheeky Cockney humour and frequent comments about being thirsty or 'dry'. One pair 'Knockin' darn the Owd Kent Rowd', however, seems to have drunk rather too much!

Since one of Pick's objectives was also to boost passenger numbers at off-peak times by encouraging travel for pleasure, it was vital for the map to appeal to families. For the younger viewers, unable to see the top of the map, the bottom edge of the poster incorporated nursery rhymes like 'Oranges and Lemons'; an open page of Algernon Blackwood's popular new children's story, *A Prisoner in Fairyland*; cartoons of children, including a little girl pointing to a heraldic lion asking, 'Look Father, what a funny cat'; and a menacing 'Begarez Hog'[21] – a fearsome beast when famished but he is very fond of little children – when hungry'. Higher up the map, visible to older children, is London Zoo where a monstrous bird is about to gobble up a small boy; ignorant of his fate he wails: 'And I promised Mother I'd be home for tea by 5 o'c'.'

The clearly signposted underground stations were designed to look friendly and welcoming, with colourful roundels and conical red-tiled roofs rather like fairy-tale houses - and a white rabbit, reminiscent of *Alice in Wonderland*, appears as 'the oldest inhabitant of the underground'. Max also pays homage to his patrons: Frank Pick, in the words of a labourer wielding a pick-axe outside the UERL headquarters at St James saying, 'My pick

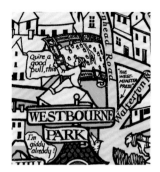

Gerard Meynell, detail from from *By Paying Us Your Pennies*, 1914

cannot be surpassed', and Gerard Meynell, who sits astride the roof of the Westminster Press in the Harrow Road casting a critical eye over a print of *The Wonderground Map* and commenting: 'Quite a good pull, this.'

There are also a number of references to family and friends including his older brother who is told to look at a mouse, his niece Joan ('You naughty boys, taking JOAN'S book'), his god-daughter Priscilla who is the child named to the right of the Begarez Hog and the Ricardo family whose mule, Modestine, is to be seen pulling a cart on the Jamaica Road. Max even parodies his studio address – 1 Hare Court – with a picture of himself holding a hare with the words: 'One hare caught in the Temple.'

The map achieved a success far beyond expectations and became a talking point among Londoners, continuing to provoke publicity long after its unveiling. In May 1914 the *Daily Sketch* wrote:

> … it makes the hoardings more popular than the underground trains. People spend, sometimes, twenty minutes examining it, so entertainingly does it parody the names and characteristics of the different districts of the metropolis … People watch so long, they lose their trains – and yet go on smiling.[22]

In later years a typical print run for an underground poster was 2,000, of which 750 copies would be allocated to stations, while the remainder would be sold at cost price to anyone who applied to the company. Demand for the Max's map was such that stocks soon ran out, and copies were soon changing hands for up to ten guineas. This demand prompted Meynell, who had retained the copyright, to produce a retail version in 1915 specifically for sale to the public at bookstalls and bookshops. Also quad-royal when opened out, this edition was divided into sixteen rectangles backed on linen, allowing it to be folded down to a more compact size. Its decorative covers bore the title – for the first time: *The Wonderground Map of London Town*, which replaced Max's original rhyme in the cartouche. Despite costing 6 shillings – a considerable sum in those days – the map was a bestseller.

Gerard Meynell undoubtedly profited enormously from *The Wonderground Map*. Max himself received £35 – equivalent to £3,700 today – for his artwork, a sum he probably thought quite sufficient for his labours, but like most commercial artists of the day he received no royalties. Meynell went on to exploit *The Wonderground Map* time and again in various guises. A smaller version was published in 1924 to coincide with the Empire Exhibition at Wembley with wording

Max in the Temple, detail from *By Paying Us Your Pennies*, 1914

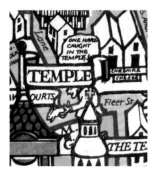

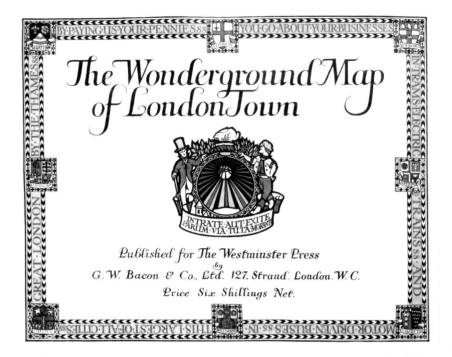

The Wonderground Map of London Town, first folded version, for retail sale, 1915

that began 'The Heart of Britain's Empire …' and a direction 'On to Wembley' plus the lion emblem positioned at the west end of the Harrow Road. It was also used to publicise the Field Distemper Fund, launched in 1923. The lion was replaced by a greyhound in a version brought out around 1927 when greyhound racing was first introduced at Wembley Stadium in London. Vignettes from the map also appeared on the endpapers of various books, including E.V. Lucas's '*More Wanderings in London*' published in 1916.

The map achieved an iconic status that no one could ever have imagined. Bought as a souvenir by foreign visitors to London and displayed at poster exhibitions in London and Paris, *The Wonderground Map* soon spawned a host of imitations. These included Wonder maps of Manhattan, Boston, Melbourne, Philadelphia, Mexico City and even one of Chicago's gangster land. Max's creation not only launched a genre of map-making that continues to this day, but it also pioneered the use of maps in advertising and publicity material.

PART THREE

Dorset

1914 – 1919

Tonerspuddle, Christmas card design, pen and ink on paper, 1914

CHAPTER TEN

The Bladen Estate and the End of a Romance

1914

MAX'S PREVIOUS ROMANCES HAD been with young ladies from rather staid, provincial backgrounds, often steeped in Anglican traditions. Esther Ricardo's upbringing had been very different. Halsey Ricardo and his wife Catherine welcomed friends and visitors from a wide range of society – artists, craftsmen, architects and engineers – ensuring that the children grew up into independent and liberal-minded adults, freethinkers who could determine their own futures. A student of biology at University College in London, Esther – often referred to in Max's diaries by the Greek symbol θ – was passionate about animals of every kind and used the old nursery on the top floor of her home in Bedford Square to house her menagerie, which included a parrot, a rabbit and a chipmunk. Max was full of admiration for her eagerness to learn, writing that she was: 'v. keen, beautifully so',[1] after watching her working hard for an embryology exam. She was a spirited young woman with a great sense of humour who could joke and banter almost as well as Max. They always had tremendous fun together as Max's animated diary entries show: 'went to Zoo (lovely day) & bought lime-juice & buns etc & had lunch under trees, having dared the lions in the "Mappen Terraces"! … took steamer to Greenwich … the Pools – looking at shipping, eating sweets & talking.'[2] There were also jolly lunches at college with her friends, as well as tours of the labs, often punctuated by comic incidents, jokes and quips, hinted at in his diary with such enigmatic quotes as: 'Will you have a fish cake?' or 'You've taken a year off my life!'[3]

Esther Ricardo, c. 1920

The Ricardos' London house, where he often dined with the family, became almost a second home for Max. Apart from Esther, around the table on any given evening might be Anna, her husband-to-be Charles Maresco Pearce, her brother Harry, fast becoming a respected and inventive engineer, as well as various cousins and aunts. The proceedings were often lively with animated conversation about the world of architecture and the

arts and crafts, music, books and politics. Sometimes the evening would descend into high jinks, as when Maresco had a 'bout of wrestling! W. Esther. – no vases broken'[4] or Esther might take Max on a furtive foray below stairs to eat 'brown bread and butter & sugar in pantry!'[5]

Max often accompanied Esther, sometimes with her parents or Anna and Maresco, to the theatre, the opera and the ballet. The cinema, still a novel form of entertainment, was another attraction; one film they saw went by the curious title of 'Tom fall out of the cupboard & that husband do "Tango" step around bed-post'![6] The tango – still considered rather risqué by many older folk – was the latest dance craze to storm the capital and was a popular number at the Arts & Crafts Fancy Dress Dance in January 1914, an evening of revelry at the Art & Drama Rooms in Mortimer Street. Max, dressed as the Renaissance sculptor Pietro Torrigiano, spent the evening 'dancing hard' with Esther who had gone as an exotic Persian princess. He wrote later: '(H)ad No. 7 dance … was "instructed" in other Tangos by (Esther). Enjoyed dance very much, tho' slightly marred by "clown-bladders & speech!"'[7] The evening ended back at Bedford Square eating oranges.

For all her love of London's attractions, nature-loving Esther, in contrast to her sister Anna, was a country girl at heart, preferring the calm of Woodside – their country house in Graffham – to the bustle of life in the capital. On one of his many visits to the Sussex house, Max, Esther, Anna, their brother's wife Beatrice, another former Slade student, and their cousin Betty Rendel embarked on a long-planned set of mural paintings depicting playing cards – kings, queens and knaves – in the nursery for Harry and Beatrice's young children. Max's diary hints at the fun he and Esther had together: 'went down to village – bought peppermints! Talk about behaviour afterwards',[8] and the following day records: 'Mr Ricardo, Anna, Esther & I went lovely walk … "Silent Pool" looking f. Cowslips – fighting "single sticks" meanwhile & doing sword-drill galore!'[9] He and Esther returned alone later to the 'Silent Pool to seek (alas in rain) for hibernating frogs under trees'.[10] And there was an early morning expedition with her to purchase more gold size for the card-room work:

> … off to Midhurst. Sun rose 8 … Had jolly ride (1st bike ride) across Heyshot way … bought G.S. … also cement & so back (after procuring bull's eyes). Rained, so dressed up under bridge – arr. back – very conscientious to rest of family.[11]

Playing card murals in the nursery at Woodside, Graffham, c. 1913

On the first evening of that January visit in 1914, as Max and the family were sitting in the drawing room about to retire for the night, Ricardo brought up the subject of his recent visit to Dorset. He was about to start work on a major architectural project for the department store owner Ernest Debenham and needed, as Max put it, a 'pseudo-clerk works chap'[12] to oversee the work on site. Coming at this moment in his career, which now consisted almost exclusively of lettering, calligraphy and map design, it would mark a change of direction. Since leaving Nicholson & Corlette, he had done little in the way of practical architecture and this project would involve not only designing buildings, but also the supervision of every aspect of construction from the sourcing of materials to the installation of plumbing. Nevertheless, architecture was clearly an area in which Max still aspired to work as shown by his occasional partnership with Grove and his persistence in entering architectural competitions. A long-term contract would also mean a steady income and a diary entry implies a hope that it might lead to a more permanent relationship with Esther. So, after a little hesitation, he decided that the offer was too good to turn down, and he was duly invited to a meeting with Debenham at his home in Holland Park. Max wrote: 'Discussed project of building & repairing cottages at estate in Dorsetshire – the "Puddle"- towns – when thro' Ricardo's very kind introduction † it was agreed that I superintend work down there – for at least 2 yrs! (A lot may happen in two yrs θ).'[13]

The terms agreed with Debenham specified that Max spend three days a week in Briantspuddle on estate business beginning in late March.

Sundial, oil on wood with gilded letters, Huntercombe Place (now Nuffield Place), 1914

This schedule would allow him the opportunity to continue his private work. Notable commissions in this year would be a sundial for Huntercombe Place (now called Nuffield Place) in Oxfordshire – a new house designed by Oswald Milne for Sir John Bowring Wimble, a painted altar for St Mary's Church in Somers Town near Kings Cross, a patterned screen at St Antholin's in Nunhead and interior decorations for the mortuary chapel at King's College Hospital.

He was also engaged in painting a perspective of Llanwern House, the home of the Welsh industrialist and politician David Alfred Thomas (later 1st Viscount Rhondda), which he visited in early March, describing it as 'a lovely old house (1696 date) with fine gardens all around hill, Severn R. & Newport in distance'.[14] He spent several days there making preparatory drawings of the mansion and estate, going to extraordinary lengths to achieve a bird's eye perspective – for this he perched for several hours up a tree, a sight that must have astonished his hosts. He also made copious notes on colour and detail and took a number of photographs. His commitments to Debenham meant that he did not begin the map until later in the year, by which time the war was well under way. No payment is entered against the commission in Max's ledger and his diaries throw no light on whether the map was ever completed.

As *The Wonderground Map* was hitting the headlines in London that March, Max was making his first visit to Dorset, where he would live and work for the best part of the next five years. A train journey from Waterloo to Wareham was followed by a short cycle ride to a village where he had tea at a riverside pub, after which, much to his amusement, he was accosted 'by a small boy who in dark mistook me for bailiff!' and speaking in dialect said: '"Mother wd. rather not see you today, wd. see you tomorrow".'[15] A seven-mile ride up hill and down dale along twisty narrow lanes in the dark brought him to Tonerspuddle,[16] a small hamlet consisting of little more than a cluster of farm buildings, a few cottages and, rather remarkably, its own place of worship, the tiny but ancient stone church of Holy Trinity. It was arranged that he would lodge at a sixteenth-century farmhouse with Hooper, the farm manager, and his family. The artist John Nash, who stayed with them in August 1915, described them as 'a rather grim couple'.[17]

The following morning Max awoke to find a landscape blanketed in snow. Undeterred, he set out across the Piddle valley for Briantspuddle,

Sketch perspective of proposed 'Building Works' – Briantspuddle, watercolour on paper, 33.8 × 64.9 cm, c. 1914

a mile distant, on the way negotiating the two fords, which heavy rains could often make impassable. His first encounter that morning was with the vicar of Tonerspuddle and Affpuddle, Mr Brown, who immediately invited Max to afternoon tea at the vicarage. Here he was bemused to find himself the centre of attention amid 'the Ladies Sewing Guild',[18] who would undoubtedly have been quick to spread the news of his arrival in the village.

His first task was to familiarise himself with the topography of the estate, to inspect the planned sites for the new model farm and cottages and locate local sources of raw materials such as lime, gravel and timber. Debenham's estate, bought from the profits from his successful drapery business, covered thousands of acres in the area around Briantspuddle, Affpuddle, Bere Regis and Milborne St Andrew. A practical idealist, Ernest Debenham was intending to create a modern experimental dairy farm together with well-designed new housing for his employees.

The village of Briantspuddle at the heart of the Bladen Estate was situated at a crossroads around which were a handful of old thatched cottages. It had neither a church nor pub. Although Debenham wanted to expand the hamlet, he also wished to preserve its character. In Halsey Ricardo he knew he had an architect he could trust and together they conceived of a set of buildings, modern in their construction materials and techniques, which would blend in almost seamlessly with the whitewashed and thatched traditional cottages of the area. At the east end of the village would be the Ring, a half-quadrangle of thatched buildings with curious little towers, also thatched, comprising the dairy as well as accommodation for the dairy manager. Behind these would be the stables, a machine-shed, the milking parlour and grain silos. Following

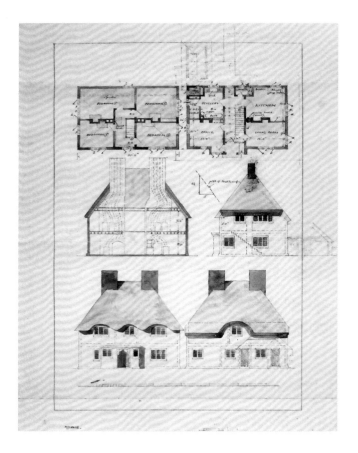

Plans for East Corner Cottage, Bladen Valley, Dorset, pen and ink and watercolour on paper, 75.0 × 38.5 cm, 1914

the original concept, Max went on to design many of these ancillary farm buildings as well as a number of the workers' cottages.

The design of these traditional-style dwellings was based not only on aesthetic considerations but also on function and comfort. They were equipped with modern conveniences, such as running water and baths, a fact that the more privileged section of the nation seems to have found rather amusing. Society magazine *Country Life* reported in 1919:

> Evidently the owner of the estate does not believe that all farm workers abjure bathing and use their baths as receptacles for coals or potatoes, for every cottage has a bath . . . Even if everyone in the countryside has not yet learnt the value of scrupulous personal cleanliness, it would be foolish to assume that the wage-earning classes are going to be slower than the wealthy in learning the value of a bath.[19]

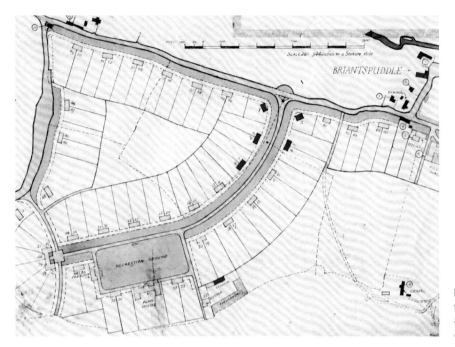

Part of estate plan showing the Bladen Valley, pen and ink and watercolour on paper, August 1917

However, Debenham was a practical man with vision and sound reasons as attested to in a 1929 estate leaflet: '… housing is an economic asset not only by means of the value of pleasant buildings in themselves, but also from the fact that those housed in them as a rule generally give better work.'[20]

The new cottages were to be built in 'hamlets or, as the modern phrase has it, on garden village lines',[21] and to keep costs down would use materials sourced locally, including the Portland cement, aggregate and water needed to manufacture the innovative 'Lean' system concrete blocks – 20 cm deep interlocking hollow blocks that were quick and easy to manufacture on site. This also necessitated the construction of a lime kiln and a power house for the oil-powered generators that provided the energy needed to pump water from the river. Each new cottage was to have 'a garden in front for flowers, a vegetable garden behind and an orchard strip on which are planted apple trees, and at the extreme end two pig styes and a fowl run'.[22] Debenham's forward thinking anticipated Lloyd George's idea of 'homes fit for heroes', and the Board of Agriculture's official post-war policy 'to develop the cottage holding for occupation by ex-Service men who are regularly employed on a farm, rather than to launch them on an uncertain future'[23] as independent and inexperienced smallholders.

Setting up the infrastructure required, hiring labour, settling on locations and all the other aspects of such an ambitious project, not to mention dealing with his other work, led Max to take on a pupil architect Bernard Evans for a six-month trial period. Two months later, a second pupil, Isobel Hobart-Hampden, a grand-daughter of the Earl of Buckingham, joined Max for a 'month's trial preparatory to 2 years articles as "painter"'[24] at the Temple studio. Little is known about her, but it is likely that she was a friend of either Rachel Russell or Anna Ricardo and may have studied art at the Slade.

By the end of May 1914 the 'pegging out' of the first Bladen Valley cottages and the proposed dairy buildings had been accomplished. And as the weather warmed and the days grew longer, Max used his evenings and Sundays to explore the county on his bicycle, on foot and on horseback, venturing as far afield as Corfe Castle and Lulworth Cove. His skill as a marksman was revived on outings with the estate gamekeeper, and he quickly became the scourge of the local rabbit warrens: 'I shot 7!',[25] Max declared proudly after his second time out. On hot summer Sundays, he would sit in the shade on the banks of the Piddle with a fishing rod and catch brown trout that would be taken back to the Hoopers for their supper or up to London the following morning for the Ricardo's breakfast table in Bedford Square.

The three-day-a-week contract allowed Max the freedom and flexibility to travel up to London almost as often as he wished, primarily for business but also to see Esther who would sometimes join him on London site visits. Her impishness made these into light-hearted affairs. One Saturday afternoon they took a steamer to Greenwich to see the Parish Hall fireplace 'painted some-while back … Esther & Peggy went to sleep on billiard table!'[26] Esther was also his supporter at the talks he gave, including one at the Friday Club on 'Wall Painting & Materials', a paper that apparently provoked much discussion, although Max wondered: 'how many walls will be painted as a result?'[27]

He, in his turn, supported her, not only in her biology investigations but also in her political campaigning. Like her mother, Esther was politically aware and an active supporter of women's rights. Max attended a suffrage meeting in May at the Art Workers' Guild, at which Esther was stewarding. At the end, after a little persuasion, and no doubt eager to please his sweetheart, the naturally conservative Max 'at length, after doubts'[28] took the plunge and signed the membership form. Despite loving a girl with an independent spirit, he still felt that a woman's destiny was looking after her home, her husband and their children, just as his mother had done.

Eight days later Max was back in town, first to take Esther to the Chelsea Flower Show, and the next day to join her family in the 'naturally beautiful'[29] celebration of Anna's wedding to Maresco Pearce at St Giles-in-the-Fields and the reception at Bedford Square afterwards. After finishing his work at the King's College Hospital Chapel the following day, he called round to the house and had a 'jolly time' with Esther and several of her girlfriends helping to '"finish up food" of yesterday's wedding feast!'[30]

Now that Max was based in Dorset, the pair inevitably saw less of one another and perhaps this accounts for the doubts and misunderstandings that began to dog their relationship. After a glorious summer excursion to Bradfield College's famous amphitheatre in Berkshire to see *Euripides* performed by the boys in ancient Greek, Max wrote: 'Very happy day – especially after my wonderings since I received her letter 25th last – mentioned it all – whilst walking to Bradfield – "What a duffer you are". – So it's all right.'[31] But in reality, it was not 'all right'. Esther's behaviour seemed to become ever more capricious. To his annoyance, she would cancel engagements at the last minute or change train times without telling him and then make up stories to excuse herself, causing him to remark: 'I almost insulted her! By suggesting her superior art in fabricating excuses – all a joke.'[32] Three days after this, he, Esther and her cousin Peggy were at the opera *Prince Igor* at Drury Lane. He wrote that they 'Stood – or craned necks – all time, but enjoyed it immensely – altho' Walter Hoath [*sic*] was "amiable" all eve'.[33] Max escorted Esther home afterwards as usual but, although Max could not have known then, Walter Goldie Howarth was to be a serious rival for Esther's affections.

Jealousy could also have played a role in Esther's growing estrangement. She may well have resented Max's close friendships with his female assistants, particularly her sister Anna's friend Mary Creighton. He was spending a great deal of time at Mary's home at Hampton Court Palace[34] where they were painting a design for a jungle scene complete with tigers and exotic birds, which they were hoping Lutyens would commission as a fresco for the Viceroy's Palace in Delhi. Max's diary also reveals: 'A proposition – first expressed by Mary – somewhile considered by me – that she should be articled to me from next Oct. – for a year for 3 days a week – very keen on it.'[35] Esther might also have been irritated that Mary, together with her friend Nora Belzani, had stayed with Max in Tonerspuddle for a week that July and now Mary was talking about renting a cottage nearby.

Immediately after Mary's Dorset visit, Max was invited down to Graffham for a few days. It had been almost three weeks since he and

Max Gill and Mary Creighton, artwork for proposed jungle mural for Viceroy's Palace, Delhi, watercolour on paper, four sheets, each approx. 76 × 80 cm, 1914

Esther had seen each other and he was unsure how things stood between them: 'I last saw her on the 2nd – what thoughts have been since then', he pondered.[36] He was right to be concerned. Her mood swings in the first two days unsettled him deeply. On the second afternoon she refused to join Max and her cousin for a walk, claiming that she was '… going to sleep … too tired to come out',[37] yet complained later, after their return, that she 'had intended coming'[38] after all. In spite of this inauspicious start, the rest of Max's stay passed happily. The pair painted together, enjoyed country walks and drove round the local lanes in Esther's trap drawn by her stubborn mule Modestine (depicted on *The Wonderground Map*), who often refused to be harnessed and would have to be chased round the field with Max and Esther in hot pursuit, to everyone's great hilarity. The following month during another visit his lingering doubts crept to the fore once again and he noted: 'Most lovely evening & a lovely drive – and yet? Yet I wd. like to know if "What's the good in anythink" is "nothink", whether it is worth fretting over?'[39]

Max's concerns about Esther were to be eclipsed by major world events. A political crisis in Europe had been brewing for some time and matters came to a head when Germany declared war on Russia on 1 August and then invaded Belgium two days later. Max was down in Dorset on Tuesday 4 August when he heard the news: 'War between Great Britain and Germany was declared 11.30pm … How strange to read this in years to come', he wrote.[40] Three weeks later he was summoned to dinner at Moreton House, where he learnt from Debenham that 'he had let all men 19–30 yrs of age volunteer for service in "Kitchener's Army"'.[41] Max was twenty-nine and had

undergone several years of military training with the volunteer forces, yet Debenham was clearly not prepared to let him go. Perhaps he felt that the farm once in operation would be of benefit to the war effort; he may also have thought, like many, that the war would be 'all over by Christmas'.

Later that day Max stepped off his train at Waterloo station to see hundreds of the 'wounded being detrained – back from battle of Mons', noting that they seemed 'all very cheery'.[42] Three of Max's six brothers enlisted almost immediately and seventeen-year-old Cecil volunteered for coastguard duty in Bognor. The twins Vernon and Evan – both of whom had emigrated to Canada – returned to British shores in November 1914 in the first wave of Canadian Expeditionary Forces. They spent some weeks at a training camp on Salisbury Plain, now transformed from green rolling hills to a sea of tents, draughty makeshift huts and boardwalks resting on a lake of mud. Max, who visited with Eric, was astounded at its vastness, writing: 'it extends miles & miles – (for the 33,000 men).'[43]

With the departure of all the young and fit estate labourers, together with his pupil Bernard Evans, Max was left with the daunting task of organising a new workforce made up of older and less able men recruited at the Weymouth Labour Exchange. Within weeks, however, the project was back on track and the first of the Bladen Valley cottages began to appear along with the foundations of the Briantspuddle dairy.

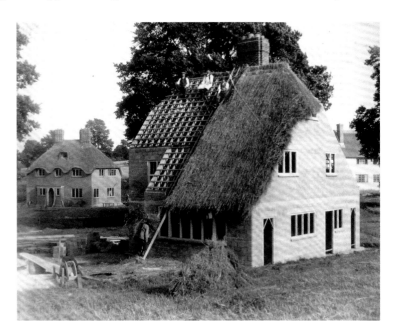

Thatching a cottage, Bladen Valley, c. 1916

In mid-August Max managed a rare visit to his parents at their new home at West Wittering, where they were celebrating Arthur Gill's first Sunday as vicar. A few days later he was in Birmingham discussing a lettering scheme for the Bournville Junior School with Mary Creighton, who was painting a set of murals there with another former Slade student Mary Sargent Florence. This was followed by a weekend at Mary's home at Hampton Court Palace. Mary was now engaged to Arthur MacDowell, but despite this Max and Esther were seeing even less of each other, whether by design or lack of opportunity is unclear.

At Esther's twenty-first birthday party in September – when he presented her with a hand-painted bowl – there was little chance of time alone and they did not meet again until 6 October – his own birthday – when he was invited to dinner at Bedford Square. Esther failed to appear until dinner had already begun and remained uncharacteristically quiet throughout the evening. Max was disappointed that his thirtieth birthday went unremarked: 'Birthdays are not well remembered by the Ricardo family – it seems a pity …',[44] nevertheless he could not believe ill of Esther: 'She had been (at the) dentist during day. Was that the reason of her quietness?'[45] he wrote before going to sleep that night.

Max's concerns were settled once and for all on the evening of 2 November. Sitting up in the nursery, where he and Esther had enjoyed so many cosy conversations, 'she told me of "a foolish" thing she had done – now engaged to Walter Howath [*sic*]. So, are my doubts dissolved – said "goodbye"…'[46]

Never one to bear a grudge, Max remained on good terms with Esther: 'she wrote me such a kind letter on Wed. – so that my friendship has not after all been in vain',[47] he wrote. Importantly, his relationship with her father Halsey Ricardo was unaffected.

Painted bowl, possibly the one given by Max to Esther for her twenty-first birthday, 1914

CHAPTER ELEVEN

An Old Flame

1915 – 1916

Now thirty, Max seemed to be tiring of the bachelor life. Several of his siblings: Eric, Enid and Gladys were now married, as were many in his circle of friends: Edward Johnston, Ben Boulter, Edmund Burton and Anna Ricardo, and most were producing families too. Esther's rejection acted as a catalyst for him to take action although later in life he would claim that his next move was also provoked by his 'loneliness in Dorset'.[1] Within days of his return to Tonerspuddle, Max had written to his former sweetheart Muriel Bennett and after exchanging several letters, she agreed to meet him one Sunday at the end of February 1915 at the convalescent home in Cranbrook where she was nursing wounded soldiers. Max described this momentous visit:

> She was in uniform & looked splendid: Introduced to Matron Burton & to staff sisters & had lunch w. them. Afterwards M. & I went lovely walk towards Sissington[2] & back through lovely scenery to pine woods … Our walk lasted 2.30 till 5.10 – we had so much to say – & I deferred till the evening purposely all I wanted to say. Tea at 5.15ish w. Matron in her sanctum & afterwards M & I left for Sissington Ch. … naturally we were happy – so after so many years – so many trials – with M. ever brave – we are to be married … God bless us both.[3]

After receiving Muriel's parents' blessing for the marriage, Max lost little time in spreading the good news to family and friends including the Ricardos. Debenham was swift to allay any fears Max might have had about work, guaranteeing his job 'for at least another year from next March',[4] much to Max's relief. The question of a home was also resolved by Debenham who, Max wrote, 'acquainted me with fact that Dairy Farm Tonerspuddle might conveniently be our house – Muriel and mine – so we inspected it & arranged for me to repair it as soon as I wished!'[5]

Construction work on the Bladen Valley was now well under way

and a new village hall was also planned. This was to be decorated inside with murals representing the seasons and village life painted by Max and four others – including Dora Carrington – organised by William Rothenstein, who had recently painted Debenham's portrait. In a letter to Rothenstein, Max wrote:

> Miss Carrington came down last Friday and is staying with me at the Hoopers – till next Thursday. She is very keen about it all and thoroughly entering into all our building schemes, its village problems, agricultural life: already she is making studies of the various implements and has sketched Fookes the thatcher at work upon a cottage roof. Certainly she for one should be excellent at her panel 'SUMMER', and I am glad we have her.[6]

Earlier there had been some confusion about who was holding the purse strings, with Carrington 'understanding that her expenses were to be met by Mr Debenham. I advanced her £3, but Debenham jocularly said to me afterwards – "Don't worry me about it, get the money's [*sic*] from Rothenstein – it's his job!"'[7] Dora Carrington was attracting the admiration of John Nash, another of Rothenstein's quintet of artists in Tonerspuddle that summer. Nash – a conscientious objector – was lodging with the Hoopers at Tonerspuddle Farm, where he was made to feel unwelcome. Years later he wrote to a friend saying that they '"sparsed" our food while the farmer made constant hints about my not being in the Army',[8] but he also recalled the kindness of Max and Muriel Gill. Debenham suggested that Duncan Grant should also paint a panel in 'the Boys' Room',[9] so Max wrote to Rothenstein:

> Anyhow I sounded Grant … and he was very keen to be doing something … I suppose you have no real objection to his working in the room adjoining if and when the Hall is built, so long as he – Duncan Grant – is sincere about it all & is not too 'special'?[10]

Rothenstein's response must have been lukewarm at best for Max replies:

> All I do know is that not for a moment would I suggest – however much we like him or his work – coming in amongst the panels – proper of the Hall, the co-operation of yourself with the 'four' and me. … So we will leave him out anyhow for the time being.[11]

As the war escalated and costs spiralled Debenham abandoned the idea of building a new village hall in favour of converting an old barn whose walls were later decorated with portraits of local characters by his daughter Alice.

Max and Muriel's wedding, 21st August 1915

Max and Muriel's wedding day was looming. As the months passed Max began to have doubts and confided in his old friend Ben Boulter, who advised him shortly before the big day that there was still time to back out – even at that late stage.[12] Ben's advice went unheeded and Max married Muriel as planned on Saturday 21 August in an early morning ceremony at St Peter and St Paul's Church in West Wittering performed by his father and was followed by a gathering at the vicarage. The celebrations were attended by both sets of parents as well as various siblings and Max's best man Wilfred Box. There were notable absences: Romney was in Papua New Guinea, the twins on active service near Ypres and Kenneth was lying in a London hospital having been seriously wounded in battle, also at Ypres. The local newspaper reported that the 'bridegroom … was for three years in the King's Colonials, and but for the fact that he is at present in the middle of an important architectural undertaking at Toners Puddle, Dorset, would probably by now have been at the front with his brothers'.[13] Debenham's wedding present to the couple was a handsome antique Chinese lacquered cabinet, which was to become one of Max's most treasured items.

Signing the hotel register,
honeymoon cartoon no. 3,
pen and ink on paper, 1915

Types & Colours, journal
published by the Westminster
Press, 1915

February
1915

Their short honeymoon in Devon was immortalised by Max in a series of charming cartoons depicting comic moments such as Max writing Muriel's maiden name in the hotel register watched over by a highly suspicious landlady. On their return the couple moved into their new home, the sixteenth-century Dairy House in Tonerspuddle.

In just over a year, Max's life had changed dramatically – both professionally and personally. From being a relatively unknown commercial artist, primarily doing inscriptions and decorative painting, he had become, as a result of *The Wonderground Map*, a household name. His connection with Meynell had also proved productive providing him with a steady stream of graphic art commissions for publications including Meynell's journal *Types & Colours*. The Bladen Estate work had now firmly established him as a professional architect, and he was also leaving his bachelor life behind. His union with Muriel is commemorated in the top right corner of *Theatreland*, Max's second pictorial poster for the Underground Electric Railways. The commission had been eagerly received by Max at the end of January 1915: 'Called on Pick (of Undergd. Co.) w. Meynell at 5.30: wanted to draw another map – this time of theatre-land! Jolly job.'[14]

With the onset of war, underground passenger numbers had begun to plummet, especially in the evenings. Pick hoped to entice the public back on to the network by publicising that the theatres of London's West End were still open for business. Max's *Theatreland* map, published in late 1915, spells out the theme: 'The Westminster Press have exploited me for the Underground Railway Company wh. bid you now come to Theatreland – to one of the theatres …'

Theatreland presents a picture of a stage in mid-performance so that the viewer – in other words, the underground passenger – becomes a member of the audience. The proscenium arch – the map's border – is made up of underground roundels, each publicising a West End theatre alongside its nearest tube station. Meanwhile the stage is a scene of mayhem, with actors tumbling into the orchestra pit to avoid the falling curtain which is decorated with a map of London's theatreland at night. In contrast to the brightness, colour and abundance of detail of *The Wonderground Map*, this presents a much simpler and starker picture of the capital, with darkened buildings and brightly lit windows and almost deserted streets. It is of course a city in wartime and allusions to the conflict are scattered across the map, including an army recruit being measured for his uniform and a

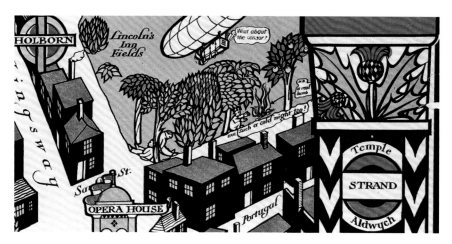

Eric and the fire-bomb, detail from *Theatreland*, poster for London Underground, 1915

Zeppelin dropping a fire bomb on Lincoln's Inn, where Eric can be seen warming his hands saying, 'Such a cold night too.' This incident recalls the so-called 'Theatreland raid', which occurred in October 1915, when seventeen theatregoers standing outside the Lyceum Theatre were killed.

Both *Theatreland* and *The Wonderground Map* were displayed at the eleventh Arts & Crafts Exhibition of 1916 at Burlington House, a sign that posters were beginning to be accepted as an art form. This was due in great measure to Frank Pick's determination that art and design should play major roles in commerce and industry. The previous year, he had been instrumental in founding the Design and Industries Association, whose aim was to improve the quality of industrial design.

Back in Dorset Max and Muriel were settling into married life in their new home. The Dairy House was a large thatched cottage with a rose-covered porch, a substantial garden and uninterrupted views southwards across the Puddle Valley. Living conditions were spartan. With no piped supplies, water needed to be drawn from a nearby well, the house was lit by oil lamps and candles, and the fireplaces and wood-burning range used for cooking needed plentiful supplies of logs from the estate.

Max delighted in coming home after a long day on the estate or from a trip to London to find 'dear Muriel awaiting me'.[15] Other aspects of married life, however, were failing to live up to expectations. Despite being over thirty years of age, Muriel was – as she confessed many years later – ignorant of the mechanics of sex until her wedding night. As a consequence, this side of their marriage was disappointing for both and probably traumatic for Muriel. These difficulties were compounded by their mutual inability to discuss emotional matters. Although they cared for each other, there was an underlying incompatibility that Max had

Max and Muriel, detail from *Theatreland*, poster for London Underground, 1915

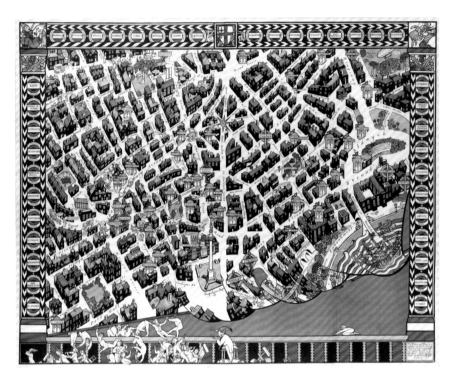

Theatreland, poster for London Underground, 102 × 127 cm, 1915

failed to recognise when he rekindled their relationship. Many years later he confessed that:

> my marriage was one of impulse, alas, based on an earlier romance – a romance which had thrice culminated in broken off engagements. Then the 'loneliness' in Dorset in 1914 bade me remember the Muriel of my youth & I married impulsively, without really knowing her further than earlier happy memories suggested. I realized my mistake from the start … this is not real marriage – not even mutual companionship.[16]

Their upbringing and religion had, nevertheless, instilled a reverence for the institution of marriage and an abhorrence of breaking sacred vows made before God. This resulted in a tacit acceptance of their situation and a determination to make the best of it. For decades Max confided in no one about his unhappiness, not even his brother, Romney. Max would have been surprised to learn that several siblings, as well as his mother, had always harboured doubts about Muriel's ability to make Max happy.

In the first few months of their marriage, Muriel sometimes accompanied Max on his business trips to London and also on a long

Opposite:
Section of *Theatreland*, poster for London Underground, 1915

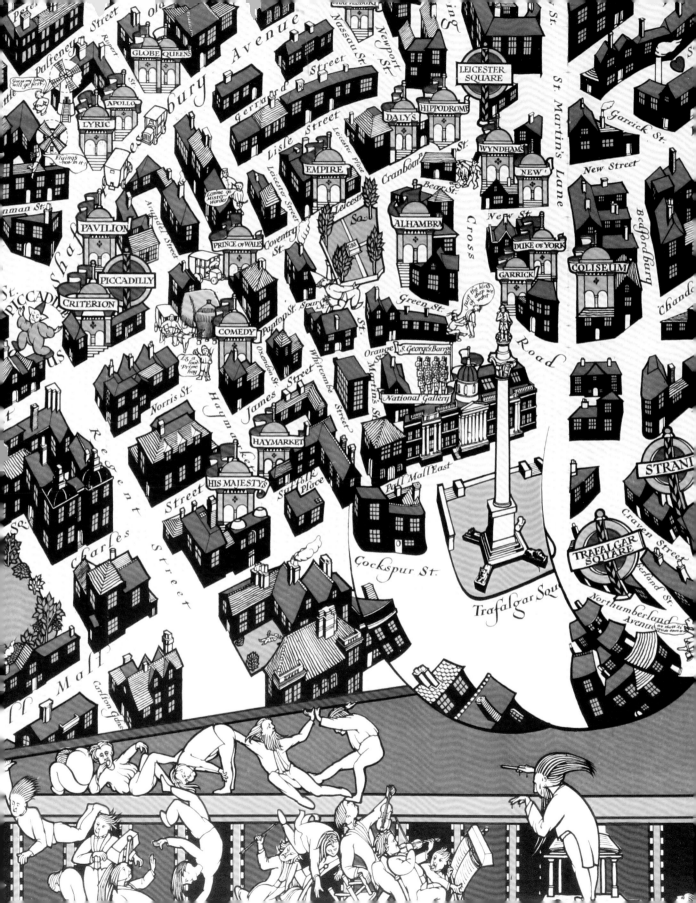

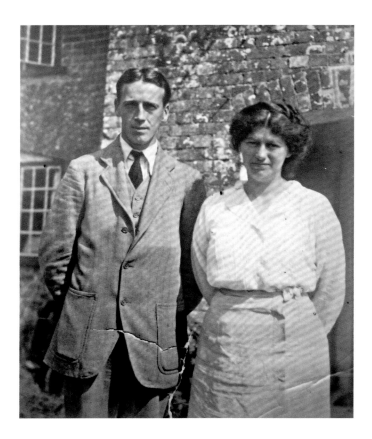

Max and Muriel outside
The Dairy House,
Tonerspuddle, 1915

painting job at the Cambridge Medical Schools. She was a caring wife
and homemaker, but thrust into the isolation of life in a rural backwater,
she had to endure extended periods on her own, a situation she was
totally unprepared for, especially after her recent life as a nurse in a
busy hospital. In Tonerspuddle she had no family nor friends; she felt
isolated and lonely. And though there were opportunities for socialising
with the ladies of Briantspuddle and Affpuddle, her reclusive nature
prevented her from taking the initiative. In early October 1915, she
gained a companion in the form of Bruce, a puppy given to Max as
a birthday present by his sister Gladys. And later that month the local
doctor confirmed that she was to have a baby.

John MacDonald Gill was born at The Dairy House on 6 June 1916.
His birth marked a new stage in the couple's relationship. Parenthood
provided an instant often delightful diversion from the problems arising
from their incompatibility and Muriel, a natural mother, settled quickly
into her new and absorbing role. After John's birth Muriel stayed in
Dorset while Max continued to have the luxury of regular stints in

London where he would meet old friends and enjoy stimulating debates, talks and exhibitions – just as he had done in his bachelor days. On his return to Dorset he would be greeted lovingly by Muriel, who would have warmed his slippers by the fire, just as Max's mother would have done for his father.

One of Max's jobs at this time was to design the cover and section headings for *Overseas*, the journal for the Overseas Club and Patriotic League. He had been recommended to Sir Evelyn Wrench – founder of the magazine – by Joseph Thorp, a champion of Max's work. The cover shows a galleon sailing into the setting sun, a striking image that is still used by the organisation today. Thorp was drama critic for *Punch* magazine and a prolific writer with a fascination for and love of the graphic arts, especially typography. Eric Gill had designed his bookplate while Max created the letterhead for Thorp's Decoy Press, an imprint of the Curwen Press. During the war, Max also designed covers for other journals and magazines, including *The Town Crier*, *Flying* and *Land & Water*.

Like Meynell, Thorp was an indefatigable enthusiast. In late 1916, after reading some anonymous rhymes in *Punch,* he made it his mission to find out who had written these charming poems. The editor refused to tell him, but he eventually discovered Eleanor Farjeon's name through their mutual friend Francis Meynell. Eleanor later wrote: 'No-one ever tried to resist "Thorplet's" commands. He was a charmer, a sort of Puck whose touch turned sober commerce into fantasy.'[17] Farjeon had hoped to offer her *Nursery Rhymes of London Town* to a publisher in time for Christmas but Stanley North, the chosen illustrator, had failed to produce more than one picture. On hearing this Thorp's instant response was to ask her: 'Will you leave it with me?'[18]

Before she knew what was happening, he had not only 'commanded' his friend Gerald Duckworth to publish the book but had also engaged Max Gill to do the illustrations. It was a brilliant match. Many of the drawings Max produced are reminiscent of scenes in *The Wonderground Map* and suit the subject and humour of Farjeon's witty verses perfectly, from the petulant monarch hurling his sceptre into the river in 'King's Cross' to the 'Old Lady' armed with her quiver of needles in 'Threadneedle Street'. Thorp himself later enthused about 'the beautiful quality of the line and balance' of the images.[19] Intended as a light-hearted read for adults – countering the depressing news from the Western Front – the book inevitably became a children's favourite too.

Cover of *Overseas*, journal for the Overseas Club and Patriotic League, May 1920

Nursery Rhymes of London Town, dust jacket, 1916

In the months before his first child was born, Max was also working at the church of St Osmund at Parkstone in Poole, which the poet John Betjeman later proclaimed to be 'the finest example of Byzantine architecture in England'.[20] The architects Prior and Grove were creating a magnificent Romanesque basilica with interiors fashioned by the same group of artist-craftsmen they had employed at St John the Divine in Richmond: Henry Wilson, Bainbridge Reynolds, Ernest Gimson and the two Gill brothers. The pulpit Max painted was replaced in 1922 but his other work survives, notably the gilding and painting of the carved grille-screen designed by Wilson that separates the nave from the Reservation Chapel. In October 1916, before its final installation in the church, the screen was displayed in one of the four apsidal chapels created at Burlington House for the 11th Exhibition of Arts & Crafts, masterminded by Wilson, president of the Arts & Crafts Exhibition Society at that time.

Gilded grille-screen at
St Osmund's Church,
Parkstone, Dorset, 1917

CHAPTER TWELVE

Eric comes to Dorset

1917 – 1918

Until early 1916, service in the armed forces was voluntary, though most young men had seen it as their duty to join up, but with such devastating losses of men on the battlefields of Ypres, Passchendaele and the Somme, it became necessary to introduce conscription, first for unmarried men and then, in May 1916, married men too were included. Having trained in the Sussex Yeomanry and King's Colonials as a cavalryman, it might have been expected that Max would join the services. However, it seems that Debenham had insisted that he continue the job of building the Bladen Estate farm. When conscription began in 1916, Max received an exemption, presumably because his job on the farm project was considered to be a vital agricultural venture, and his health may also have played a role since at this time he was in need of a mastoid operation. After his recovery from this surgery in June 1917, he was classified as level Ciii, which meant he was fit for 'Sedentary Service at Home Camps'.[1] Keen to play his part in the war, he obtained a letter of introduction from Lutyens, and wrote to General Braucker, who was in charge of personnel at the Air Board, offering his specialised skills as a map-maker. No reply survives but since Max continued working on the Bladen Estate project until the war ended, his offer must have been rejected.

Eric was also exempted from military service, in his case due to his work at the new Roman Catholic Westminster Cathedral carving *The Stations of the Cross*. After these were completed in the late summer of 1918, he was then called up and served the last months of the war as a lorry driver at the RAF Mechanical Transport Camp at Blandford in Dorset. A year before this he had designed a memorial cross for Briantspuddle. Debenham had conceived the idea of having a 'village cross' at the entrance to the avenue of new cottages known as the Bladen Valley in early 1915 and had asked Max's brother to submit designs. Mounting numbers of battlefield casualties amongst the Bladen Estate workers triggered a change of plan and Debenham decided that a memorial to these brave local men, many of whom he had exhorted to enlist, would be more appropriate.

The memorial work meant that Eric came to the area a number of times, always staying with Max and Muriel in Tonerspuddle. On his initial visit, Max and Debenham showed him the proposed site of the memorial at the entrance to the Bladen Valley, and on the second, the brothers visited the Langton Matravers quarries to select the Purbeck stones, which were later transported to the Ditchling workshop in Sussex. At the end of May 1917 the large base stones were transported back to Dorset on a horse-drawn lorry by Eric, his close friend Hilary Pepler and the driver Fred Mockford. When they finally reached the Bladen Valley after a three-day journey, they sat by the roadside hot, hungry and thirsty, eating their last supplies of bread and butter. After unloading the stones, the trio continued on to Tonerspuddle. Eric was deeply unimpressed by the village which he irreverently called Tonerspiddle, complaining: '… couldn't get nought else – no beer, no meat, no cheese, no shops, no pub, no church – a god forsaken hole.'[2] But Max and Muriel at the Dairy House gave the men a warm welcome treating them to a 'very good feed'[3] of fried rabbits, followed by a lively lantern-lit evening of talk and music.

The upper sections of the monument, including the figure of Christ, were not added until the following summer when Eric returned to complete the assembly and carving, a task which had permitted him an extension of his exemption from military service. On his arrival this time he found the Dairy House thronging with house guests: his sister Enid along with Ben and Bertha Boulter and their children. There was also a new arrival in Max's family – Mary, born on Good Friday.

The weather that May was warm and in the late afternoon the Gills and Boulters would have picnic teas up on the heather-clad hillside behind the house. When Eric joined them after his letter-cutting on the war memorial, he would sometimes be provocative, 'arguing with Max & B.C.B. about the Church',[4] but after supper at the Dairy House everyone would join in the lively sessions of music and singing and there was, no doubt, much talk of the war. Eric sometimes retreated to the solitude of his room to catch up with correspondence, and to jot the day's events down in his diary or to sketch himself – as this curious diary entry notes: 'Drew myself in mirror (not my face).'[5]

After the Boulters departed, Eric's assistant Desmond Chute came to stay at the Dairy House. This tall, languid, rather theatrical character – likened by Cecil Gill to Aubrey Beardsley – had come to assist his master with the final cutting of the memorial inscriptions.[6]

The memorial cross was dedicated a day after the signing of the Armistice in a ceremony led by the Bishop of Salisbury. It attracted a great

Eric Gill, Briantspuddle war memorial, Portland stone, 1917

OUR BRITISH DEAD

Here do we lie , dead , but not discontent ,
That which we found to do has had accomplishment.

No more for us uprise or set of sun ;
The vigilant night , the desperate day is done .

To other hands we leave the avenging sword ,
To other tongues to speak the arousing word .

Here do we lie , dead , but not discontent ,
That which was ours to do has had accomplishment.

Forget us not , O Land for which we fell —
May it go well with England — still go well.

Keep her bright banners without blot or stain ,
Lest we should dream that we have died in vain .

Brave be the days to come , when we
Are but a wistful memory

Here do we lie , dead , but not discontent ,
That which we came to do has had accomplishment.

'Our British Dead', poem by
Joseph Lee of the Black Watch,
manuscript by Max Gill for an
exhibition at Thomas Hardy's
home Max Gate, pen and ink
on paper, 25.3 x 15.6 cm, 1917

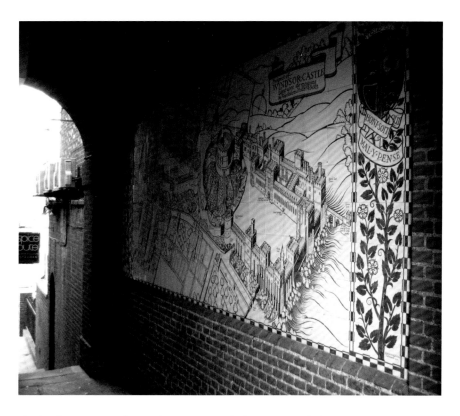

A Prospect of Windsor Castle,
Windsor, painted tiles,
183 × 427 cm, 1918

deal of attention from the great and the good of the county, including Dorset's most famous literary figure Thomas Hardy accompanied by his wife Florence. As members of the Dorset Natural History and Antiquarian Field Club, he and Max would have met occasionally at the monthly meetings in Dorchester. They shared a background in architecture and a strong interest in the preservation of local buildings so the Bladen Estate project, with its emphasis on vernacular styling and traditional materials, would have interested Hardy greatly. In 1917 Max contributed a piece of calligraphy for a small exhibition at Hardy's home, Max Gate and Mary Gill, who was born in Tonerspuddle, would delight in telling her own family that as a baby, she had been dandled on Hardy's knee.

Aside from his estate work Max had also been designing a 5.2-metre-long blue-and-white tile map entitled *A Prospect of Windsor Castle*, based on a 1663 engraving by the Bohemian artist Wencelaus Hollar. Commissioned by Sir Henry Boot, founder of the high street chain of chemists, the map was installed in a narrow covered alley – on land donated by Boot – running from Thames Street towards the river. Max was also at work on illustrations for Farjeon's sequel to the *Nursery Rhymes of London Town* as

Left:
Sun Engraving emblem, 1918

Right:
Illustration, the Sun Engraving house magazine, *c.* 1918

well as three maps for Frank Pick and a painted organ screen for St John's Church in the village of Broadstone, near Poole.

Thanks to Gerard Meynell, there was a plentiful supply of graphic commissions during the war, particularly from the Sun Engraving Company, a Watford-based printing firm. Its founder, the 'tall, handsome, reserved and steady'[7] Edward Hunter, was not only a printer by trade but also an astute businessman.[8] Within a few years of establishing the Anglo Engraving Company, he had bought up several other printing firms and brought them together in 1918 under the banner of Sun Engraving. One of Max's first design jobs for the Sun, as the firm became known, was their logo – a sundial backed by a sunburst against a bright blue sky and emblazoned with the company motto, 'I keep the time'. According to Hunter's daughter Eileen, these words once led an impatient client to return a piece of the notepaper with the additional words, 'It's a bloody lie'[9] neatly written beneath it.

Other items Max designed for Sun Engraving included an ornate ceremonial key for the opening of its new Watford works, the company war memorial and signage over the company's Milford House offices. With a reputation for high-quality photo engraving and colour printing, the Sun would become the largest printing firm in the country producing such well-known periodicals as *Picture Post* and *Vogue*. In those early years of the firm's existence Max designed covers and mastheads for *Homes and Gardens*, *Country Life* and *Home and Country* – the magazine of the

Women's Institute. Max also designed covers and illustrated articles for the Sun's house magazine *Illustration*. This was a high-quality promotional production demonstrating the company's technical skills, particularly in colour printing, and had a masthead designed by Edward Johnston. Hunter's daughter Janie spoke of how her father had admired Max Gill's work and put commissions his way. In later years Hunter would be Max's financial saviour.

By the end of 1918 many of the Bladen Estate cottages had been completed, as had the innovative dairy complex, stables and a pair of brick grain silos. Almost certainly inspired by buildings Max had seen in Normandy, the silos with their distinctive octagonal slatted roofs were singled out for mention in an exhibition review:

> In a place with such a name as Briantspuddle, Mr Gill could, admittedly, not be too austere. He had to put little pointed roofs on his forms and give the spectator a clue to tack them on to – oast-houses, peel-towers or something recognised as picturesque . . . this slight, remote piece of architecture is, to our mind, the finest piece of architecture in the Exhibition.[10]

Silos, Bladen Estate Dairy Farm, Briantspuddle, c. 1917

CHAPTER THIRTEEN

An Alphabet to Remember

1918 – 1919

IN 1918 MAX WAS finally able to make a more direct contribution to the war effort, not on the battlefield but as a member of the Headstone Committee of the Imperial War Graves Commission. The IWGC was founded as a result of the vision of Sir Fabian Ware. As commander of a Red Cross unit, he had witnessed first-hand the horrific slaughter taking place on the battlefields of the Western Front and the haphazard nature of the burials. By 1915 he had set up a registration system to record every burial but he also determined that each serviceman should have a dignified and permanent resting place. This led in May 1917 to the foundation of the IWGC. The cornerstone of Ware's vision was equality: 'What was done for one should be done for all.'[1] In other words, there should be no distinction between officers and the lower ranks.

Sir Frederic Kenyon, director of the British Museum, was appointed head of the commission, which now became responsible for the registration of deaths as well as the design and building of the cemeteries

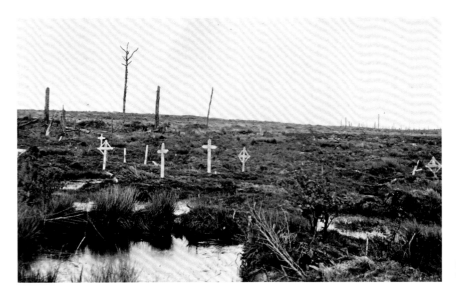

Battlefield graves, Maple Copse,
Ypres Salient, 1920

and memorials. The three most eminent architects of the day – Sir Edwin Lutyens, Sir Herbert Baker and Sir Reginald Blomfield – were charged with the overall design of the cemeteries and by early January 1918 the Headstone Committee had also been formed with Max as lettering adviser.

It was the single most important lettering commission of Max's career. Over the years some have wondered why his brother Eric was not asked to join the committee with some even conjecturing that Max's invitation must have been due to an error on the part of a clerk at the IWGC. By this time, however, Max enjoyed a considerable reputation as an inscriptional designer having done such work for numerous clients including both Kenyon and Lutyens. He had been a teacher of lettering at both the Clapham School of Art and Central School of Arts and Crafts and had also presented papers on the subject at the Art Workers' Guild and at the Society of Calligraphers. Just two years before, Lawrence Weaver – one of the most eminent and knowledgeable writers on the arts and crafts – had commented: 'Among modern exponents of Roman lettering, Mr Eric Gill and Mr MacDonald Gill take a high place.'[2] This sentiment was echoed by another contemporary, Joseph Thorp: 'Max Gill is one of the admirable band of craftsmen who are restoring the beauty of the incised, painted, written and printed letter.'[3] Unlike his older brother, however, Max was no self-publicist and would even make self-deprecating jokes about sitting on the Headstone Committee alongside two such eminent men as the director of the National Gallery and the keeper of the Wallace Collection, telling his younger brother that he was the 'one little bug' alongside 'two big bugs'.[4]

Kenyon himself selected the key members of the IWGC committees. In his preliminary report he wrote of the Headstone Commitee:

> I have been fortunate enough to obtain promises of assistance from Mr D.S. MacColl, Keeper of the Wallace Collection, and Mr C.J. Holmes, Director of the National Gallery, whose names will command the confidence of the whole artistic world … With regard to the lettering of the inscriptions (a very important factor in the general effect) no better authority could be desired than Mr Macdonald Gill, who has been good enough to promise his services. I am inclined to think that an informal body of consultants such as this, varying according to the nature of the questions to be decided, is preferable to a formal advisory committee.[5]

It is interesting that on 10 February 1919 Eric Gill met Kenyon at the British Museum and presented him with two unsolicited reports he had written on the making of headstones and offered his services to train men in letter-cutting. The subject was discussed at the next Headstone Committee meeting a week later when it was decided 'to take no further action on these two reports for the present, but to take note of Mr. Gill's willingness to co-operate in the work'.[6]

Various designs for the headstone were suggested including a number submitted by the public and members of the forces. Each was discussed and most swiftly dismissed. Comments on a stone cross on a hump-backed pedestal came in for much criticism from all including Max:

> I have been trying to find a good word for it; it is impossible. In my opinion, apart from the extra cost such a cruciform design would entail and apart from its impractibility for 'wearing' properties, the design is most ugly and ungainly and would be a terrible eyesore if erected.[7]

Lutyens too thought it 'extraordinarily ugly'.[8] The eventual decision was that the headstones should be plain – more like those of an 'English churchyard than a cross'.[9] It was also decided that the graves would be laid out in 'rows in their ordered ranks' so as to 'carry on the military idea'[10] with every stone alike in shape and dimension to reflect equality in death. Arranged in rows, side-by-side, the stones would give the impression of soldiers standing to attention on parade. Each stone was to be carved from white Portland Stone, 1 metre tall, 7.6 cm thick and 38 cm wide with a curved top to protect it from the weather. Each grave was also intended to have its own identity with the name, honours, service number, rank, regiment or corps, date of death and age of each soldier together with a brief family message, if desired. Max's lettering was designed to be cut with a 60-degree angle, steeper than normal not only to withstand weathering but also to allow more shadow to give greater legibility when seen from a distance along a row.

There was a great deal of controversy about the commission's work, especially the decision not to repatriate the dead. Debate also raged about the proposed form of the cemeteries, memorials and headstones. It was ironic that Max had become a member of the IWGC in the light of Eric's attitude to their proposals. It appears that the brothers had argued – 'not very amicably'[11] – early in January 1919. In a polemic published in the *Burlington Magazine* just weeks after his offer of help to the IWGC had

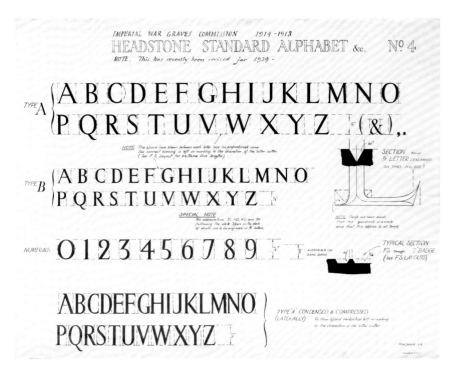

Headstone Standard Alphabet
No. 4, 1918, photostat with
hand-written note added by
Max c. 1940

Opposite:
Regimental badge design
templates designed to ensure
uniformity of carving, photostat
proofs, 25.4 × 25.4 cm, c. 1920

been rejected, Eric railed against the standardisation of gravestones and cemeteries claiming that uniformity would 'enslave, intellectually, morally, aesthetically, or physically'[12] the men producing the headstones. He also condemned the designing of monuments by architects, who he accused of being 'the artistic counterparts of business managers'.[13] And finally he made scathing remarks about his brother's alphabet, saying it was 'rather feebly artistic lettering (we have seen specimens)'.[14]

How to reproduce the regimental badges on the headstone was problematic. The committee initially believed that carving such an intricate design into the stone was totally impracticable. Max therefore drew a number of scaled-up badge designs to be used in experiments by members of the National Association of Master Monumental Masons and Sculptors using metal and pottery badges inset into the stone. In early 1919, however, the committee decided that carving directly in the stone could be done easily if the badge could be reproduced 'in a simpler form of carving, in the silhouette style, without so much modelling'.[15] Thus Max Gill began the time-consuming task of scaling up and drawing 150 badge 'cartoons' in 18 cm roundels to be used as templates by stonemasons to ensure uniformity. He was offered assistance: Kenyon and Ware suggested that draughtsmen in the London office could help[16] but this offer does

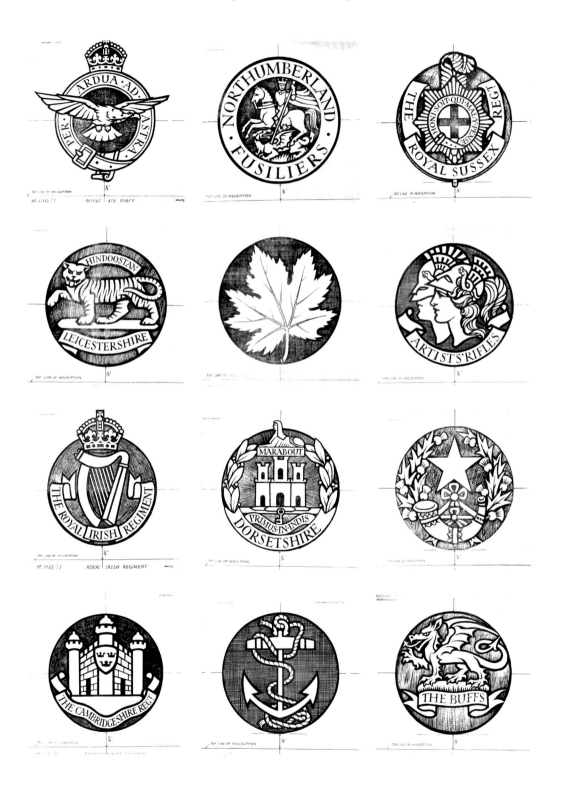

Memorial to the Missing of the Somme (designed by Sir Edwin Lutyens) at Thiepval, France

not appear to have been taken up. All the final designs for the badges for both the First World War and Second World War (until late 1946) were drawn and signed by MacDonald Gill.

From late 1919 the first cemeteries began to take shape across Belgium and Northern France. Each had a commemorative cross or Stone of Remembrance that presided over regiments of white gravestones, each with its neatly tended flower bed. Max designed the alphabet in several sizes so that it could also be used on the larger stones including the Stone of Remembrance as well as Sir Reginald Blomfield's Menin Gate at Ypres and Sir Edwin Lutyens' Memorial to the Missing of the Somme at Thiepval, on which are inscribed the thousands of names of those whose bodies were never found.

Without a local grave to visit, bereaved relatives often wished to remember their son, brother or father with a physical monument or memorial. They would come to Max wanting a brass plaque, stone tablet or wooden panel on which a commemorative message could be inscribed to their loved one. These would usually be for the local church but in one or two instances the memorial would be placed in the home. Behind every memorial lay a poignant story of love and loss and Max would have heard many in his discussions with grieving families.

Max himself could empathise. The Battle of the Somme had claimed the lives of several close friends including his brother-in-law Ernest Laughton – who had married his sister Gladys – and Francis Grissell, who is commemorated on Lutyens' Thiepval Memorial to the Missing. Despite injuries, his four serving brothers all survived until October 1918 when tragedy struck. Just three weeks before the Armistice was signed, Max's brother Kenneth, a pilot in the fledgling Royal Air Force, was mortally wounded in a plane crash shortly after taking off from Le Touquet aerodrome. Awarded the Military Cross the previous year, Kenneth had flown over from his base to visit his wounded brother Evan at the military hospital in Le Treport where he had also seen his parents and sister Angela. Their father broke the news to Max:

Kenneth Gill, *c.* 1915

> But this sad – terrible – tragic news is about dear dear Kenneth. He had been flying over three or four times before we arrived to see & cheer up Evan & flew over on Tuesday last – alas! it was for the last time. He met with a crash on returning to his Drome & lost consciousness from the first. The mist & fog had forced him to make for a strange Aero – with this result. Our hearts are broken.[17]

Kenneth Gill's grave, Fillièvres Cemetery, France

PART FOUR

Sussex

1919–1932

Max, John, Muriel
and Mary Gill, 1920

CHAPTER FOURTEEN

The Post-War Years
1919 – 1924

In the early summer of 1919 the Bladen Estate contract with Debenham came to an end. Although Max was given the opportunity to extend it, he decided to return to Sussex. With the farm and many cottages now built, he had accomplished enough and – after five years of being an employee – he wanted to be his own man again. Still, his work for Debenham had been a godsend in many ways. One unintended consequence was that it had saved him from the horrors of the Western Front. It had also provided him with a steady income during a period of great austerity when many artists and architects lacked work, allowing him to save enough to buy his own home.

Max was drawn back to Chichester, a place he knew well and where he had spent two happy years of his boyhood. As a temporary measure – while searching for a house to buy – Max and family moved in with his parents at the vicarage in West Wittering. In June Arthur Gill reported excitedly to Evan:

> they have seen a suitable house – & where do you think? – why here in Chichester! Won't it be fine, if they get it? It is a house in West St not far from our old house in North Walls. It would be so jolly if they really settle down so near to us here – so that we can see something of each other very often.[1]

For Muriel, who had been unhappy in the remote hamlet of Tonerspuddle, the move to Chichester with all its amenities must have been an enormous relief. Max too was glad to be back, confessing to his brother that '… after our Dorset semi-isolation find Sussex a great improvement'.[2]

The house they had settled on was West Lodge, a substantial white-walled Georgian house on the corner of West Street and Chapel Street and within a stone's throw of the cathedral. Separated from the street by a high brick wall, it was fronted by a large garden – perfect for the children

to play in, safe from the dangers of the motor vehicles that now rumbled along the cobbled street beyond. Max swiftly set about making changes as he explained to his brother Vernon who was now back in Canada: '… "effecting improvements" – which is an abiding pleasure to an over-worked architect–builder–painter sort o' chap, as you can imagine.'[3]

One of these 'improvements' was the creation of a studio. Since moving, Max had been using what he called 'that spiral workshop against the kitchen',[4] which had been far from convenient. The entrance was outside and it was too close for comfort to the kitchen with all its associated noises as well as interruptions from noisy and inquisitive young children; it was also very small and awkward to work in. In 1923 he converted the attic rooms into a large and airy L-shaped study with a tall workroom, as he described in a letter to Romney in Papua:

> I have raised the ceiling from 6'6" to some 11'0" and put in a double-light and top-light dormer on the 'west' view, attaining also a glimpse of the cathedral through the south 'cheek'. Come over and inspect it, and see it isn't 'half a bad jot by half … very satisfactory for work – right away as it is from the Nursery![5]

On the first floor one of the smaller rooms was turned into 'The Oratory',[6] a place reserved for family and private worship, where the children were encouraged to pray before breakfast and bedtime. He described this room as 'a joy to us all and tho' only formed within the last few months, already breathes out restfulness and offers its meditative powers to our little household'.[7]

West Lodge, Chichester, c. 1920

Anne, the third and last of the Gill children, was born at West Lodge in May 1921. Max thought his children 'all a blessing'.[8] Mary described her father as kind and understanding and rarely angry: 'if one of us did something naughty or stupid … he would take the time to sit us down and talk about it with us, he would listen and explain why something was wrong'.[9] Max also took every opportunity to introduce his children to such favourite haunts as the chalk pits, north of Chichester, where he and Romney had played as boys.

Such outings with their workaholic father were sadly few and far between, but because he was the parent who brought the most fun into their lives, he was adored, especially by his daughters. Muriel, however, provided the solid stable home at the centre of family life, just as Max's mother had done, and she had the help of a local girl Florrie who worked as a maid with the Gills for many years.

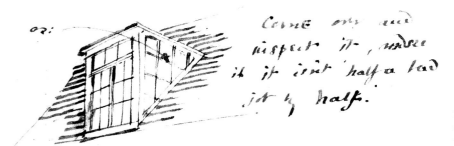

Studio window at West Lodge, drawing in letter to Romney Gill, 29 August 1923

Although surrounded by churches large and small within the city walls, the family worshipped at St Bartholomew's, a run-down grey brick and stone church situated in Mount Lane just beyond the West Gate. The religious fervour that Max had displayed as a young man – with his occasional leanings towards the monastic life – seems to have dissipated but his Anglo-Catholic faith remained an integral element in his day-to-day existence, as his creation of the Oratory shows. He was bemused at the diverse views he encountered at St Bartholomew's; in a letter to Romney he spoke of 'our throes and doubts – not so much as to whether we are Christians or not but assuming each thinks he is, the fact that he also thinks his interpretation is the one and only right one: typically non-Catholic controversies'.[10] He also complained of the 'petty parochial jealousies' at the church and asked Romney 'to imagine it all – and pray too for us'.[11]

Having an architect in the congregation was a major asset for the church and Max's talents were soon put to good use. First he was invited to be a 'people's' churchwarden and a member of the Parochial Church Council and Finance Committee. Then in 1921 he was asked to advise on the state of the building and draw up plans for major structural works that included the removal of the tower, which 'perched rather awkwardly',[12] the remodelling and extension of the chancel as well as the refurbishment of the interior. The works were eventually completed in 1929.[13]

A visitor who saw the church in its pre-decorated state recalled 'the rather dreary building' and talked to Max about his scheme 'to make it a blaze of colour'.[14] His arts-and-crafts-inspired mural designs for the church, however, were only partially executed and his work in the nave was painted over in the fifties - 'an extremely irresponsible act …', according to the principal of Chichester Theological College, 'to spite the existing congregation'[15] perpetrated without permission by the last serving vicar. The beautiful chancel ceiling with its star-studded ultramarine ground bordered with flowers and foliage survives along

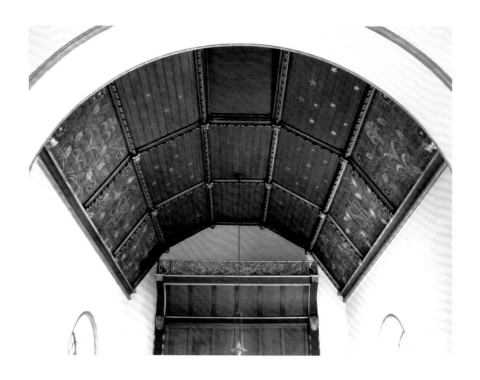

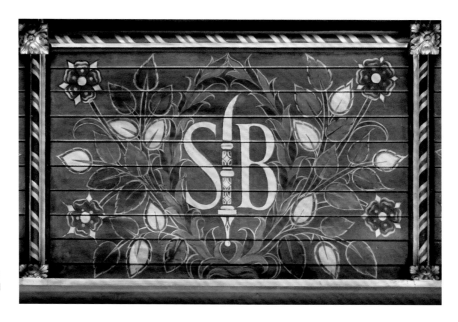

Chancel ceiling, St Bartholomew's
Church, Chichester, painted wood
boards, 1929

with furnishings also designed by Max: the altar, reredos, candlesticks and chip-carved prayer desks.

Max was soon an active member of the Sussex Archaeological Society, the South East Architectural Group and the Rotary Club, attending meetings of these as well as those of London-based organisations such as the Society for the Protection of Ancient Buildings and the Society of Poster Designers. He did, of course, have a genuine interest in the work of these societies, but he also benefited from the network of contacts they offered – vital in the building of a successful local practice. The 1920s would be his busiest and most lucrative years. Despite significant gaps in Max's payment ledger between 1920 and 1924 entries show that he was engaged in a wide range of architectural work including designs for houses, surveys and alterations of local buildings including churches.

His largest job in the spring and summer of 1921 was for the 8th Duke of Richmond who hired him to design an extensive set of structures at Goodwood racecourse, just outside Chichester. These included a new public stand to seat 2,000 race-goers, a luncheon room, enclosures, turnstiles, guard rails and a weighing room, works that grossed him £1,000, the most he would ever earn from a single architectural project.

The new public stand at Goodwood racecourse, near Chichester, West Sussex, newspaper cutting, 1921

There were also numerous commissions for individual commemorative works as well as memorials for villages, parishes, university colleges and even companies, all wanting to acknowledge their debt to their men who had courageously marched off to war to save their country never to return. Each memorial was different. At St Andrew's in Roker, Max painted an impressive chevron-bordered panel that stretches across the rear wall of the church, while for St Osmund's

 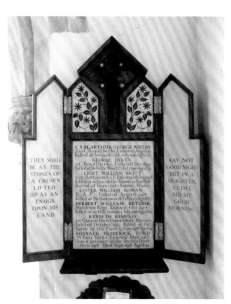

Left: First World War Roll of Honour at St Osmund's Church, Parkstone, Dorset, painted wood, 1921

Right: First World War memorial triptych (open) at All Saints' Church, North Moreton, Oxfordshire, painted wood, 102 × 52 cm (closed), 1921

William 'Billy' Kingswell, c. 1937

in Poole he produced a substantial three-part shrine presided over by a life-size carved figure of Christ on the Cross.

For Barings Bank Max designed an imposing stone slab for the entrance hall of its headquarters, and for the *Country Life* office, he painted the names of the fallen on a wooden board. The hundreds of former Balliol College students killed in the war were commemorated on five bronze plaques he designed for the passageway outside the college chapel, while for those of Christ Church, Oxford, he created two magnificent carved stone memorials with heraldic headings set in gothic niches in the cathedral porch. For the churchyards at Horne in Surrey and Bere Regis, near his old home in Tonerspuddle, Max designed plain Portland stone churchyard crosses and for the church in the village of North Moreton he produced a blue painted triptych. He also contributed to the refurbishment of St George's Chapel in Chichester Cathedral dedicated to the fallen of the Royal Sussex Regiment, a job stretching over some years involving the writing of names on the later panels, as well as the design of altar rails and other furnishings.

With the deluge of commissions now coming in, Max was in need of assistance and in 1923 he recruited William Kingswell, an experienced young sign-writer born and bred on the Isle of Wight. The two men immediately fell into an easy working relationship; Max was always referred to as Mr Gill while Billy, as his family and friends called him, was always plain Kingswell. He was a meticulous craftsman who could be

trusted to get on with a job without needing constant supervision and always seemed to know just what Max required. Technically, he came to know almost as much about the work, including map-painting, as Max, and their talk in the studio was filled with references to 'scumbling'[16] and letting the undercoat 'grin through'.[17] Priscilla, Edward Johnston's daughter, later worked alongside them both and found Kingswell 'kind and thoughtful', a man who was 'quick-witted and could play up to Max's quips like lightning, responding almost instinctively'.[18]

Max's lettering was distinctive, a hallmark of his work, so he alone lettered his maps, important graphic work and manuscripts. Joseph Thorp's description of Max working in his studio goes some way to explaining this:

> That sense of mastery is eminently exemplified in his astonishing command of the brush, his favourite implement. Watch him drawing a letter or number with a brush, whether in Indian ink on paper or in oil colour on wood or canvas. The tool sweeps round with an unhesitating certainty which gives those admirable curves and delicate scrip [*sic*] and finals [*sic*]. No precise measurements and careful outlines worked to with a niggling hesitancy, however painstaking, would give that spontaneous 'freedom'. The letters are alive. The brush is made to do its work in its own way, the forms being dictated by the tool – a fundamental working rule of fine craftsmanship. It all looks so confoundedly easy, and that, I think, gives an added pleasure to the critic … Of its kind, the work is as near perfect as craftsmanship can attain.[19]

The Hare Court studio remained Max's London base and he would often stay here for two or three days a week. Grove was now semi-retired and two other commercial artists Whitby Cox and Jack Orr now used the studio alongside Max and Nelson. In the early 1920s he was designing an extraordinarily wide variety of items, ranging from a cottage for Francis Meynell and a manuscript for the architect Sydney Tatchell, to a sundial for Charles St John Hornby, director of the high street stationer W.H. Smith & Son, and maps of all kinds for both company and private clients.

Another W.H. Smith director, Arnold Danvers Power, commissioned a large map of Westminster.[20] The Houses of Parliament and Westminster Abbey are the key buildings but also depicted are Power's residence in Dean Trench Street, the homes of various friends and local institutions,

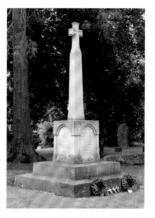

First World War memorial at St Mary the Virgin Church, Horne, Surrey, 1920

Sundial for Charles St John Hornby, Chantmarle, Dorset, incised slate with gold infill, 1921

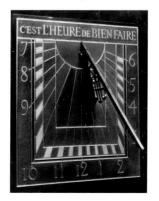

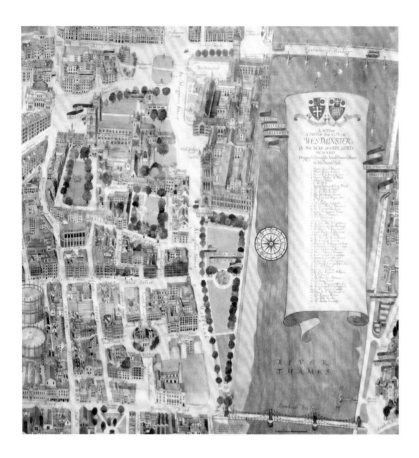

such as the gasworks and the public baths. Homage is paid to W.H. Smith & Son in the form of an advertisement on the red bus crossing Westminster Bridge where a small boy seems to have his head stuck in the decorative ironwork. Next to Lambeth Bridge stands a sign declaring: 'Officers in command of troops passing over this bridge are requested to give orders to BREAK STEP.' The warning was absolutely genuine. By 1910 the suspension bridge was considered so dangerous that it had been closed to vehicles and the authorities were concerned that a regiment marching in step might trigger a catastrophic collapse. In 1924 a parliamentary act was finally passed allowing a new bridge to be built.

Pick, who became joint assistant managing director of the UERL in 1921, had commissioned two system maps and a pictorial map in 1917 although these were only published in 1920. Max refers to the latter as the *North Downs Map* but, confusingly, it has also come to be known as the *Surrey Downs Map* or *You've only got to choose your bus* – the first line of its border message. Produced to publicise the underused Country

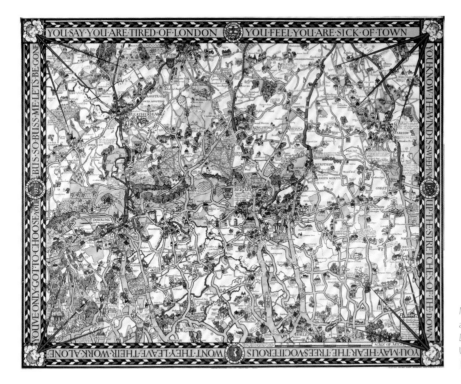

North Downs Map (also known as *You say you are tired of London*), poster for London Underground, 102 × 127 cm, 1920

Bus service, the poster claims to 'induce adventurous souls to mount the Dorking or the Reigate or the Caterham bus for a voyage of quaint discovery'.[21] The *Daily News* wrote that it is 'in the charmingly naïve traditions of the old cartographers, and it makes all these pleasant green places and winding roads of Middlesex, Kent and Surrey very alluring … what Londoner could resist … for it is full of fantastic wonders'.[22]

As one might expect, puns and jokes abound. A phoenix rises from the flames engulfing Phoenice Farm while a frustrated archer aiming at a stag jumping over a grove of trees at Deer Leap Wood complains, 'Why won't he keep still!' There is something to please everyone: historic castles, picturesque windmills, sites linked to eminent figures including Wotton House near Dorking, the home and burial place of diarist John Evelyn, and viewpoints such as that at Ashcombe Wood where an observer remarks, 'You can see S. Paul's from here'. Day trippers in need of refreshment are also catered for with picnic places and local hostelries like the Running Horse at Leatherhead, Surrey, which still quenches the thirst of visitors today.

Surrey was a county Max knew well and, as in his *Wonderground Map*, he personalised certain locations with initials. These include St John's

Detail showing John and Priscilla, *North Downs Map*, poster for London Underground, 1920

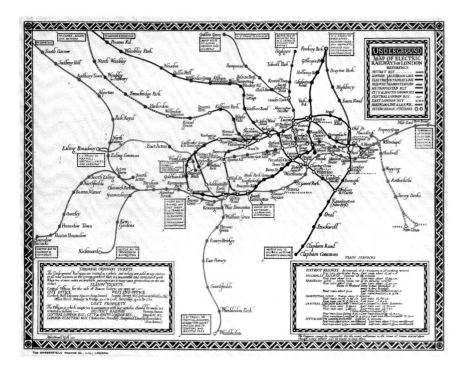

London Underground
system map, 1920

School at Leatherhead, where Cecil and Kenneth, his youngest brothers
were educated, the home of the Cullens – Kenneth's parents-in-law[23] –
at Headley, and Norbury Park, the birthplace and former home of his
old friend Grissell, who had been killed on the Somme. The youngest
of Max's siblings is depicted in a hot-air balloon with a worried
companion shouting: 'Throw out more sand, Cecil', and on the bottom
edge Max's son John and god-daughter Priscilla can be found sitting
among the daffodils.

The diagrammatic maps Max designed for the underground are
less well known. The first of these was published in 1920. At least
three versions were published in the following years as well as a map
of Greater London transport and others to show bus and tramways
routes. The maps were displayed in stations but were also available to
passengers in a handy folding pocket-size format. Max's italic lettering
contrasts sharply with Edward Johnston's *sans-serif* alphabet which was
now appearing on the underground system signage. The map was,
nevertheless, a landmark in the evolution of the system map prior
to Harry Beck's iconic tube map created in 1931. Max's version was
one of the first to eliminate background detail, thus simplifying the
look and making it easier for passengers to find their stations and

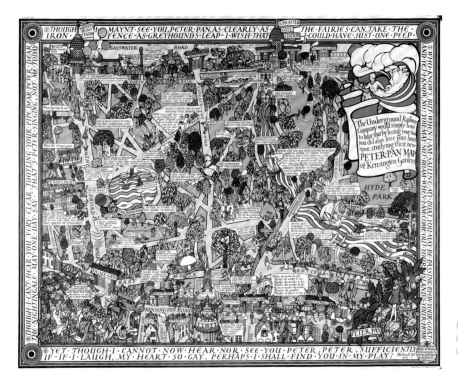

Peter Pan Map of Kensington Gardens, poster for London Underground, 102 × 127 cm, 1923

routes. The omission of the Thames was not a popular move and it was reinstated by the next designer − Fred Stingemore − in 1925.

Rather than commissioning posters through printers such as Meynell, Pick was now dealing with artists directly and agreed to give Max a one-off payment of £50 plus 1 *s* for each poster sold. A year later *In the Heat of Summer* − another map of Central London − appeared at stations, rapidly followed by the last of the post-war trio, *The Peter Pan Map of Kensington Gardens*. This enchanting poster illustrates J.M. Barrie's 1906 story of the same name, which predates his better-known classic *Peter Pan or The Boy Who Wouldn't Grow Up*. The map depicts Peter's adventures as an infant who, in horror at the thought of becoming an adult, flies out of his nursery window and into nearby Kensington Gardens where he encounters characters such as Solomon Caw the crow, Queen Mab and her fairies as well as a host of other lost children. The *Daily Telegraph* declared:

> … the younger generation will delight to follow their friend in a wonderful itinerary through the children's pleasure ground. The artist has contrived to introduce so many incidents and familiar objects into his picture that there is some ground for

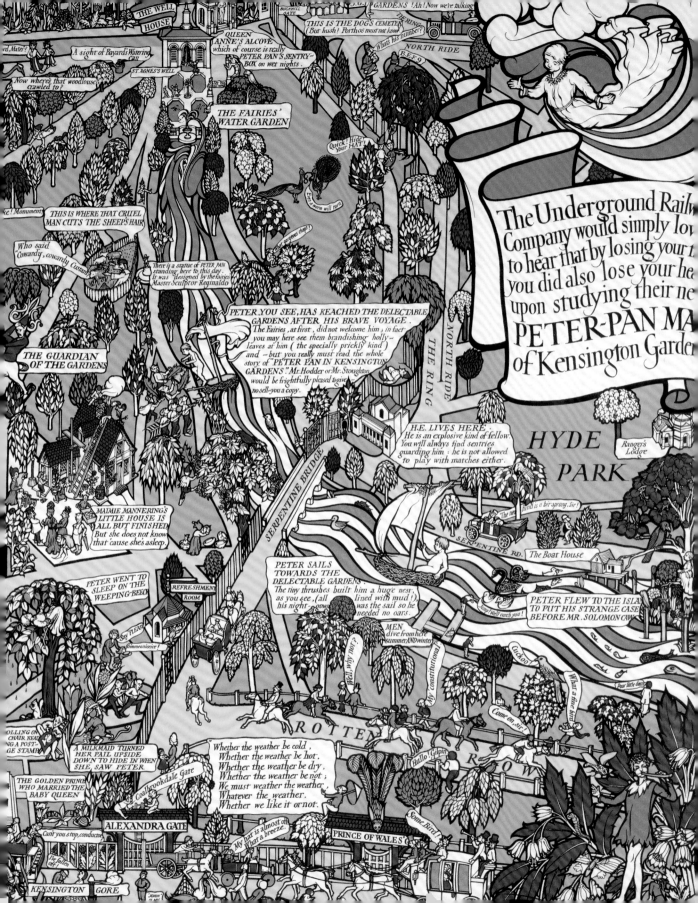

the company's assurance that 'by losing your brain you did also lose your heart upon studying their new Peter Pan Map of Kensington Gardens.[24]

Shell-Mex and Pratt's Oil were beginning to follow London Underground's lead in exploiting the potential of poster art – including pictorial maps – in their advertising. These companies were making massive profits on the back of the boom in popularity of the motor car; however, it was the awe-inspiring flights of the early aviators that were now making the biggest headlines. Many of the air races and record-breaking attempts were being sponsored by these oil companies that naturally wanted as much publicity as possible. Max was asked by both firms to come up with pictorial maps showing the air routes of these remarkable events.

One of these posters was *Half-way round the World on "Shell"*, which depicts the prize-winning flight of Captain Ross Smith and his brother in 1919. Together with two young aviation engineers, they completed the journey from Britain to Australia in twenty-nine days in a modified Vickers Vimy bomber in a total flying time of under 136 hours. The race, which was sponsored by the Australian government and Shell-Mex, was only open to Australians flying in British-made planes and the £10,000 prize money was shared equally by the brothers and the two mechanics who flew with them. The map shows Ross Smith's flight path complete with scheduled refuelling and rest stops such as Cairo, shown with its Great Pyramid and Sphinx, and Delhi with Lutyens' magnificent Viceroy's Palace. The map is also peppered with whimsical quips: a giraffe in Africa remarks: 'Personally, I prefer neck to neck races', while an Indian tiger lurking by a human skull tries to tempt the airmen down with: 'Why not land here? Good accommodation.' Flight was still a highly dangerous pursuit: only one other plane completed the race; the rest crashed, resulting in the tragic deaths of four of these pioneers. Captain Ross Smith would lose his life in a flying accident at Brooklands less than three years later.

The King's Cup Aero Course in 1923 – also sponsored by Shell-Mex – was treated in similar style with depictions of local landmarks. The inclusion of a young woman bathing in the Wash in East Anglia, proclaiming 'I always use Lux in the Wash', must have delighted the soap company and is an indicator of the potential for joint ventures in product marketing.

Max's poster maps for the underground were now appearing in exhibitions at such eminent locations as the Victoria and Albert

Opposite:
Section from the *Peter Pan Map of Kensington Gardens*, 1923

Detail from *Half-way Round the World on "Shell"*, poster for Shell-Mex, 76.2 x 50.6 cm, 1921

Detail from *The King's Cup Aero Course* map, 1923

Museum, whose director Sir Cecil Harcourt-Smith was one of the first establishment figures to recognise that such works were worth exhibiting. Before the war, posters and other graphic art had been snubbed by the art establishment because it was thought impossible that such commercial, modern and ephemeral work could have artistic value despite its popularity with the masses. The explosion of art for publicity led to a shift in attitude. This was in no small part due to the quality of the London Underground posters for which Pick insisted on employing talented up-and-coming artists who could design innovative eye-catching images. Between 1922 and 1929 the North Court of the Victoria and Albert Museum was the venue for several exhibitions of contemporary industrial or commercial art. Graphic art was also being promoted by new organisations such as the British Institute of Industrial Art founded with the support of Harcourt-Smith as well as groups such as The Society of Graphic Arts and the British Society of Poster Designers, of which Max was a committee member.

Commercial art was nevertheless destined to remain the poor relation. With hundreds of commercial artists working in London at this time, competition was strong so fees tended to be small, but this bread-and-butter work was useful because it built up trust between a company and the artist often leading to a steady stream of commissions. Apart from magazine covers for Sun Engraving, Max was now working with

'UNICORN—RAMPANT
SANS REGARDANT'

book publishers such as the Nonesuch Press, for whom he designed the dust jacket for Francis and Vera Meynell's *The Weekend Book*, and G.P. Putnam and Sons, for whom he designed a distinctive stork logo as well as the calligraphic covers for a string of war memoirs, including the first English translation of Erich Maria Remarque's classic *All Quiet on the Western Front*.

In this post-war period Max was also profiting from the rocketing demand for advertising material. London with its many art colleges was, unsurprisingly, at the heart of this commercial art trade. The Central School had led the way in training skilled technicians in drawing, lettering and printing, but now other technical colleges and art schools were training large numbers of illustrators, designers, printers and engravers. There were plenty of jobs for these young artists in the capital with the burgeoning number of magazines and newspapers filled with advertisements, and companies producing ever-increasing quantities of trade papers, newsletters, leaflets, catalogues and posters. Advertising agencies came into their own in the 1920s. Max took on commissions for both Charles Barker – a well-established British firm – and also the pioneering American firm of J. Walter Thompson, the first to set up a dedicated Creative Department, earning its founder the title of 'father of modern magazine advertising'.

Heal's, the famous furniture store in Tottenham Court Road, London, was one of a number of firms that preferred to manage their

Left: Frontispiece of *Apropos the Unicorn*, 1920

Centre: Dust jacket for *All Quiet on the Western Front*, 1929

Right: Dust jacket for *The Weekend Book*, 1924

Stork emblem for G.P. Putnam's Sons, pen and ink on card, 1929

Catalogue of Coloured Furniture & Pottery, 1920

own publicity, hiring the services of the bright stars of the art world. The managing director Ambrose Heal was not only a businessman but also a designer and advocate – together with his like-minded friend Pick – of good design in industry. In the early 1920s a framed copy of *The Wonderground Map* was displayed in the kitchen furniture department of Heal's and the store owner himself had one on a wall at his family home. Max produced advertisements for the full range of the store's goods as well as a poster for an exhibition at the Mansard Gallery, a dedicated exhibition space set up by Heal in 1917 on the top floor of the Tottenham Court Road store where both established and up-and-coming artists and craftspeople could show their work. During its existence it hosted some innovative and influential exhibitions by the Camden Group, Group X (Roger Wyndham and his British Vorticists) and modern French artists including Claude Monet, Pablo Picasso and Amadeo Modigliani. The first exhibition at the gallery was a display of London Underground posters provided by Pick, and a later ceramics show included a group of Max's hand-painted tiles and bowls.

At Baylin's Farm, Heal's country home near Beaconsfield, Max and assistants – Isobel Hobart-Hampden and Rachel Russell – transformed the sitting room into a brighter living space by scalloping and painting the oak-beams, a scheme that later featured in *Country Life* magazine.

Max and his painting assistants at Baylin's Farm, left to right: Rachel Russell, Max Gill and Isobel Hobart-Hampden, 1920

CHAPTER FIFTEEN

Promoting the Empire
1924

MAX HAD GROWN UP in the reign of Queen Victoria when few questioned the greatness of the British Empire or its right to govern its many far-flung colonies. The First World War, however, brought about irrevocable shifts in attitudes, politics and the economy. Colonies such as Canada and India, which had supported the war effort by supplying men, equipment and other resources, were now becoming more assertive in their demands for independence. At the same time Britain was suffering from massive unemployment and economic hardship.

In an attempt to create public awareness of the benefits of empire and to strengthen colonial cohesion, the government staged the British Empire Exhibition at Wembley, a massive event displaying culture and products from every corner of the empire, including Great Britain itself. The official brochure declared: 'It is a stock-taking of the whole of the resources of the Empire' where you could 'learn more geography than a year of hard study … and be able to see in each case the conditions of life of the country he is visiting'.[1] It also contained an exhortation from the Prince of Wales, president of the Organising Committee: 'We must unite to make the British Empire Exhibition a success worthy of our race.'

Hundreds of British companies grasped the opportunity to promote their products and services at this memorable event, giving work to a multitude of commercial artists. 'I have been very busy on sundry works for the Wembley Exhibition',[2] wrote Max to his brother at Easter 1924. For a large illustrated book *The Pageant of Empire*, he designed the cover and a beautiful map of *The World in the Time of Cabot*. There was a large canvas map of Great Britain for Spillers showing their milling centres and trading partners, which Max found particularly challenging: 'Quite a big thing to paint vertically, when my room at West Lodge … is just 10'6" high.'[3] And for the Shell-Max stand he produced an 'oval modelled and painted map of the world, around which, by electricity, run 28 carved & painted models of "things in which petrol spirit is used"'.[4]

Cover of *Pageant of Empire*, souvenir book 1924

Overleaf:
The World in the Time of Cabot, printed map in *Pageant of Empire*, 30.5 × 52.1 cm, 1924

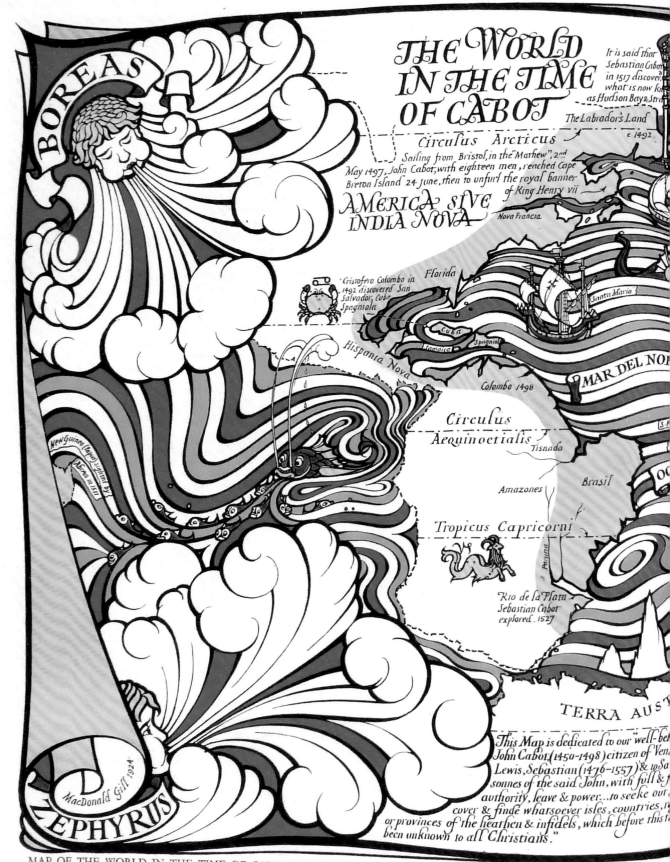

MAP OF THE WORLD IN THE TIME OF CABOT

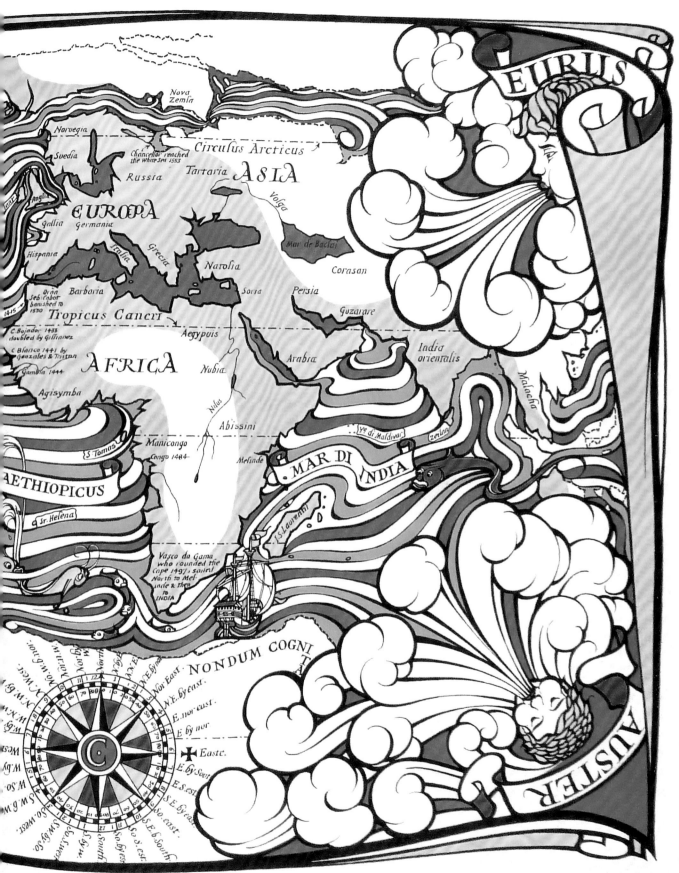

MacDonald Gill

He also worked on Queen Mary's Doll's House, a 'wonderful creation by Sir E.L. Lutyens Archt of, which I, with some 2000 others, have been invited to elaborate (my own work actually being decoration & coats-of-arms in 5 of the room-lets, drawing for the portfolio (one of 200) – and the general "Entrance Ticket to view same", at Wembley.'[5] The drawing mentioned was a tiny watercolour measuring just 3.8 cm by 2.5 cm entitled *The Fairy Doll's House*, destined to be kept in the library drawers. Max remarked that Lutyens' building contained 'everything in it necessary for and typical of the 1924 house. "Everything" is not too big a word for there's hardly anything you could name that has been omitted.'[6] He took his youngest brother to see it at Lutyens' office in 1923: 'I wish you could see it,' Cecil wrote to Romney, 'for its really great fun – from the electric lights in each room, with switches the size of a pin's head – to the bottles of Bass in the cellars ¾" long and full of beer! Max has a few jobs to do in it – such as painting up the titles under oil paintings 4" long & painting royal crowns over the doorways!'[7]

The most imposing of Max's works was not to be seen at the exhibition but on the outside of the nearby Staples Mattress factory, which occupied a prominent corner site near Wembley. In a letter to a brother, he described a series of 'permanent advt. [advertising] vitreous enameled panels – 17' x 10'6" – (eight such areas + other lettering 100' x 5') all in colour, chiefly white lettering & coats of arms on red'.[8] The panels were so visible that the exhibition's handbook directed motorists to turn off the Edgware Road at 'a large illuminated sign at Staples Mattress Corner'.[9] The location has been a landmark for drivers to this day though the original signage and building are long gone.

When the exhibition closed in October 1925, it was acclaimed by most as a great success. Nevertheless, there was still much ignorance about the colonies. Sir Leopold Amery, Secretary of State for the Colonies, had been dismayed to hear a woman at Wembley talking of Japan as a British colony. And the government was still concerned about the long-term health of the economy. Some countries were beginning to protect their markets with trade tariffs, which were affecting agricultural exports from the colonies in particular, yet Britain continued to advocate free trade. Instead of imposing curbs on imports, it was agreed that there would be a push to promote trade amongst the colonies and the mother country. At this time the empire covered almost a quarter of the world, and it was thought that 'judiciously developed, it could become much more economically self-sufficient, less vulnerable to foreign competition.'[10] This concept was the basis for the establishment in 1926 of the Empire Marketing Board (EMB).

The chairman of the EMB, Sir Leopold Amery, appointed a prominent civil servant Stephen Tallents as secretary. During the First World War, Tallents had overseen food rationing, a tricky task that had shown him the importance of the role of publicity in creating understanding and reshaping opinion. Part of his job with the EMB was to oversee the operations of its Publicity Committee, which included the organisation of lectures and media activities, the most important of which was to be a poster campaign. An inspired move was to bring in a man who knew all about commissioning posters, Frank Pick. His knowledge of printers and artists was formidable and although the poster sub-committee as a whole discussed the choice of artist and subject, it was nearly always Pick who dominated the meetings and made the final selection. Even decisions made in his absence were marked 'subject to Mr Pick's approval'.[11] Although open to the work of new artists, Pick was naturally drawn to the group of tried and tested artists who had produced posters for the London Underground. Max Gill, referred to as 'the famous poster artist' in the press,[12] was chosen to design an EMB logo, and an eye-catching map poster for the campaign launch.

Highways of Empire was previewed at an exhibition held at the Royal Academy in November 1926, when the quarter-size pen-and-ink artwork was displayed, but it was only unveiled in its full glory on New Year's Day 1927 when it appeared on hoardings in major cities across the country. It created a sensation, with the *Spectator* going as far as calling it 'a masterpiece'.[13] The forty-eight-sheet poster measured 7 metres by 3.5 metres, making it one of the largest ever displayed in Britain; in

Overleaf:
Highways of Empire, poster for the Empire Marketing Board, small display version, 101.6 × 152.4 cm, 1927

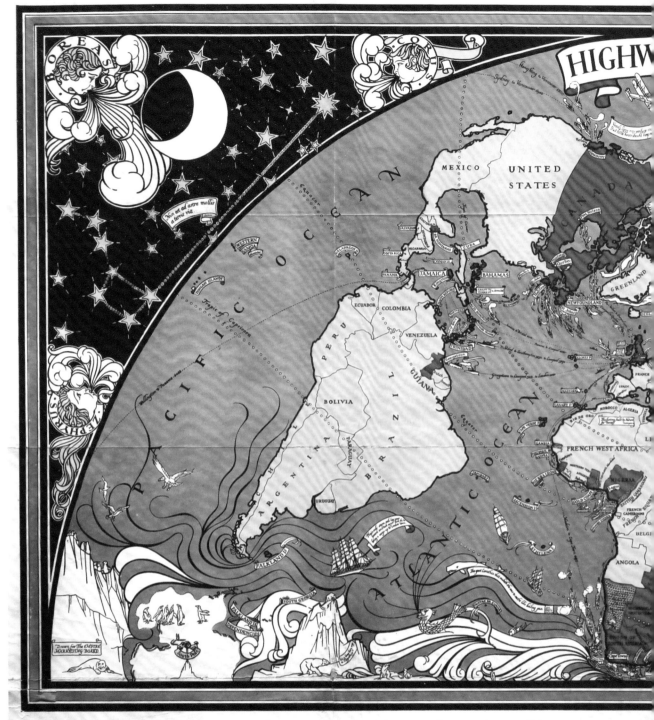

BUY EMPIRE
HOME AND

swbo *ISSUED BY THE EMPIRE MARKETING BOARD*

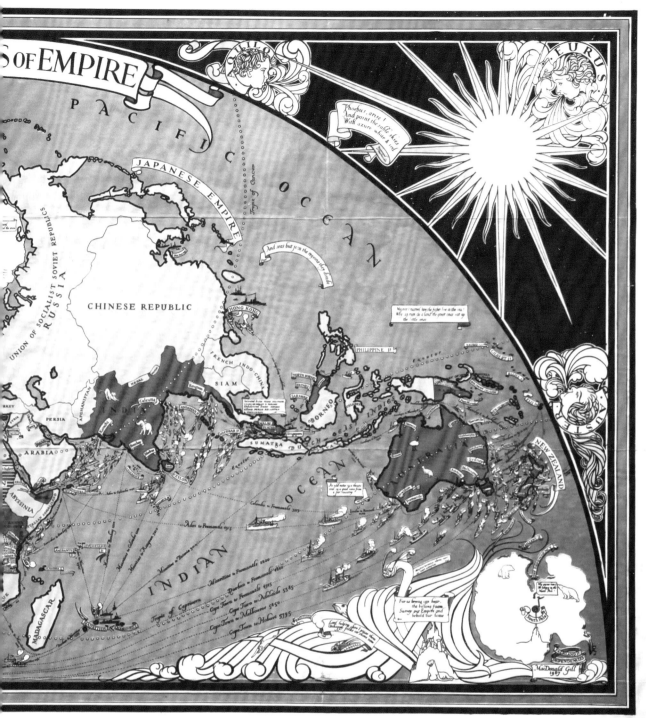

...S OF EMPIRE

PACIFIC OCEAN

Phoebus, arise!
And paint the sable skies
With azure, white & red

And seas but join the regions they divide

JAPANESE EMPIRE

Tropic of Cancer

UNION OF SOCIALIST SOVIET REPUBLICS RUSSIA

CHINESE REPUBLIC

HONG KONG

FRENCH INDO-CHINA

SIAM

PHILIPPINE IS.

BORNEO

CELEBES

SUMATRA

INDIAN OCEAN

NEW ZEALAND

ARABIA

PERSIA

AFGHANISTAN

INDIA

Calcutta

CEYLON

MADAGASCAR

ABYSSINIA

Tropic of Capricorn

For us berow age bear
the billows foam,
Survey our Empire and
behold our home

MacDonald Gill 1927

GOODS FROM OVERSEAS

PRINTED FOR HIS MAJESTY'S STATIONERY OFFICE BY JORDISON & Cᵒ LTᴰ LONDON & MIDDLESBROUGH.

Manchester, hoardings had to be specially made to accommodate this mammoth poster. The message was clear: in large capitals at the bottom of the poster it read 'BUY EMPIRE GOODS FROM HOME AND OVERSEAS', and the amount of red on the map left the viewer in no doubt about the vastness and importance of the British Empire. The *Manchester Guardian* reported:

> … a jolly thing, packed with entertaining detail … Imperialism without tears … England blushing a patriotic scarlet and ridiculously small at the heart of the world, which is exactly what is wanted … Across the bright blue seas – the highways of Empire – the British ships swarm and cluster round the great ports like bees on the threshold of the hive.

The *Eastern Daily Press* described the scene after the poster was unveiled on the Charing Cross Road in London:

> … an elderly gentleman equipped with a bulging umbrella and a wealth of erudite, spontaneous eloquence, was vigorously lecturing a large crowd in the vicinity of a newly hung poster, in yellow, red and blue, with black and gold decoration, which was labelled 'Highways of Empire'.
>
> It had attracted attention on account of the queer view of the world it gave by reason of its unusual projection. London was somewhere in the centre – about where you would expect to see the Sahara. The North Pole appeared to have slipped down to Birmingham. The elderly gentleman was enlightening the ignorant regarding the poster when the police found it necessary to intervene in the interests of vehicular traffic, for buses, vans and cars stretched in a solid stationary column down to Cambridge Circus.[14]

Polar bears at the South Pole, detail from *Highways of Empire*, 1927

Max's original pencil sketch had in fact used a Mercator projection, but Pick's committee thought this unsuitable for the scale of the poster and, after much discussion, they settled on the hemispherical lunette,[15] which results in two South Poles. Max placed several polar bears here, a mistake apparently picked up at the proof stage and turned into a joke – apparently at the suggestion of Tallents – with one of the creatures enquiring, 'Why are we here? We belong to the North Pole.'[16] Apart from this and other entertaining quips, there are quotations from

Canada & Newfoundland portraying their Products and Fisheries, poster for the Empire Marketing Board, 101.6 × 152.4 cm, 1930

Seneca, Virgil, Francis Bacon, Byron, Benjamin Franklin and Shakespeare while the bulk of the imagery harks back to early cartography: a heavenly canopy studded with stars, moon and sun, and oceans filled with curious sea creatures.

The EMB aimed to educate the public, and many of the posters and propaganda were designed to appeal to the young.[17] A smaller version measuring 1.52 metres by 1.02 metres was reprinted with an informative text replacing the EMB slogan; this sold at 3 *s* 6 *d* but was free of charge to schools. Hundreds of letters were received from grateful teachers: it was 'a wonderful help both in Geography and History lessons', wrote one.[18] In 1929 at the 'Schoolboy's Own Exhibition', 26,000 visitors printed their own scaled-down copy of the map on a hand press, and later the map was reproduced both as a postcard and as one of a set of cigarette cards.[19] *Highways of Empire* was almost certainly the most popular map of its time.

Max was one of the highest paid artists working for the EMB. He received 150 guineas each for *Highways of Empire* and the seven subsequent poster maps he designed for the board, presumably in recognition of the intricacy of these productions. Just one poster was the equivalent of the average man's annual salary.[20] By comparison, Paul Nash received less than half that amount for one of his works while Reginald Percy Gossop was offered only 200 guineas for a set of five frame posters. The other posters in the series Max designed for the EMB focused on individual

Empire Marketing Board
emblem, proof print, 1927

countries: Scotland, Ireland, England and Wales, Australia, New Zealand, Canada and South Africa, and showed the resources and exports, such as fish, agricultural produce, timber and minerals, not only in pictorial form but also in panels of up-to-date statistics, making them invaluable for use in the classroom. The last of these was published in 1932, the year before the EMB was closed down.

CHAPTER SIXTEEN

A House and a Home
1924 – 1926

SINCE MOVING TO CHICHESTER, Max's architectural practice had been steadily growing. This business was now generating significant amounts in professional fees, far exceeding those he had earned for most of his commercial art. Max would never attain – and perhaps never aspired to – the standing of architects like Lutyens, but he had proved himself highly competent and could be relied on to design a modest, well-appointed and comfortable house of the type a middle-class businessman could afford and enjoy living in.

In line with the architectural principles of Morris's Arts and Crafts movement, Max designed houses built in traditional styles and with local materials, believing that buildings should harmonise with the landscape to preserve the heritage and unity of an area and its community. Most of his Sussex houses were roofed in thatch and partially clad in timber clapperboards.

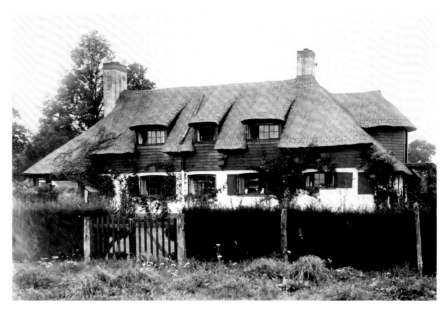

House at Itchenor, 1920s

Left: wooden door latch at Darwell Hill, designed by Max

Right: Design for wooden door latch, pencil, pen and ink and watercolour on paper, 1939

Interiors were simple, practical and well-lit with specially designed fixtures and fittings including door latches and curtain rails. Although a traditionalist, he was, nevertheless, prepared to compromise to please his client and was always happy to install modern comforts such as hot-water systems and central heating.

In 1924 he wrote that he was 'about to commence an interesting one [house] at Battle'.[1] This was Darwell Hill, a country house for Ambrose Heal's brother Harold, who was the chief shareholder and managing director of Staples Mattresses. He was, according to a cousin, the 'black sheep of the family … very superstitious and difficult'.[2] In his memoir *Clinging to the Wreckage*, his nephew John Mortimer recalled:

> My uncle Harold designed all his own clothes as he designed his furniture, with a slide-rule, and to his own specifications. He wore wide-brimmed sombreros and had invented a sort of padded flap which hung down at the back of his waistcoat to keep his bottom warm. He was a meticulous man and appreciated conformity. At one breakfast he measured his rasher of bacon with a slide-rule and sent it back to the kitchen when he found it too long.[3]

Completed in 1926, Darwell Hill was of 'half-timbered oak – & brick nogging, & stone construction'[4] and built on a commanding hill-top site, giving the impression of a substantial and imposing house although in reality it is little more than one room deep. A vaulted ceiling in the downstairs corridor is reminiscent of Max's old lodgings at Lincoln's Inn, while the overall appearance of the house is similar to one that Max

had drawn on a recent holiday in France. Incorporated into the house were a number of novel features including a concealed set of pull-out steps at the base of the loft staircase – a cunning space-saving measure in the narrow upstairs corridor. Heal's idiosyncratic tastes in colour could be seen in the grand two-storey high entrance hall, which was originally decorated in 'a marvellous shade of pink with a grand chandelier',[5] recalled cousin David Heal, while the bathroom suite and wood floors, like Heal's Rolls Royce, were sky blue. Mortimer's father would always refer to the house as the 'North Pole'[6] as it was generally underheated – Heal's poor suffering wife Marjorie 'had a sort of tweed overcoat made to match her dress for indoor wear'.[7]

The water supply came from harnessing a nearby stream but proved remarkably inefficient when trying to fill a bath, as John Mortimer discovered:

Marjorie and Harold Heal, 1920s

> I remember … turning on the tap. Nothing whatever happened for the first quarter of an hour. Then, on a clear day with the wind in the right direction, from a distant hillside, you could hear mechanical movements as of sluice gates opening. During the next thirty minutes water could be heard approaching and then a dense cloud of steam gushed from the pipe like a triumphant herald announcing the arrival of a thin brownish trickle which disconsolately dripped into a bathtub which might have been personally designed for Tallulah Bankhead in the heyday of the Savoy Hotel.[8]

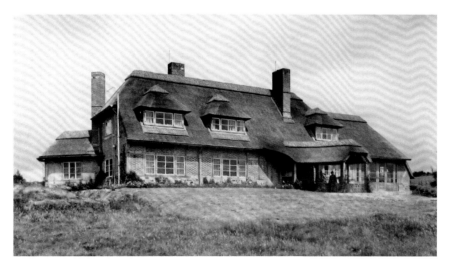

Darwell Hill, Netherfield, Sussex, 1926

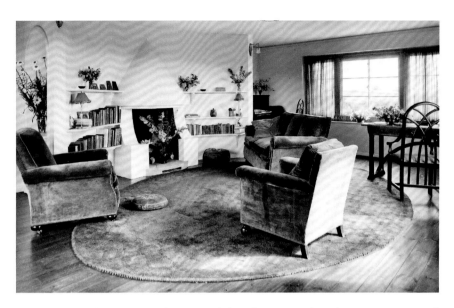

Sitting room at Darwell Hill,
1926

This drawback was not discovered by the journalist from *Country Life*
magazine who visited in 1928. He declared that the house with all its
'ingenious arrangements' was admirable[9] merely disapproving of the Crittall
windows: 'The large window panes and the horizontal arrangement of
these is a departure from accepted methods, and not, in my opinion, an
improvement.'[10] Heal must have sorely tested Max's patience – by the time
the house was finished, the two men were barely on speaking terms.

In 1925 Max began hatching plans to build a family home in West
Wittering. Although still nurturing a deep affection for Chichester, he
found it much changed from the city he had known as a boy. Motor vehicles
pumping out exhaust fumes had replaced the quieter horse-drawn traffic
leading Max to describe West Lodge as 'too noisy and petrol fumey to stay
in'.[11] Shortly after selling the house, he joked: 'In fact the purchaser is now
advertising the sale of the property as a "desirable garage and petrol dump
with motor accessories thrown in." What a come down!'[12]

Now earning substantial amounts of money, Max was able to purchase
a prime plot of land, a stone's throw from a small sheltered inlet with
pamoramic views over East Head and Chichester Harbour, and then set
about designing and building his new house. Completed in the autumn of
1926, it was initially named Snow Hill – after the grassy common in front
of the house – but a year later it was renamed South Nore. It was a large
square house with white-painted walls and a red-tiled roof surrounded
by a sizeable garden enclosed by a low brick and flint wall. Much of
the ground floor was taken up by the large, long sitting room which

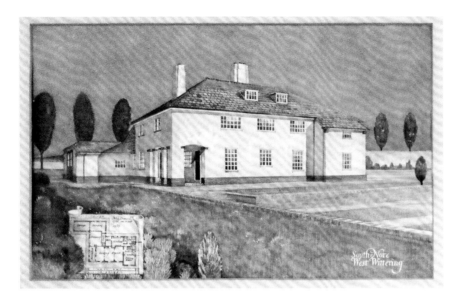

South Nore,
watercolour on paper, 1929

was furnished with plain Arts and Crafts style pieces including Ernest Gimson chairs and a dresser housing Max's collection of pewter. The varnished wood floors were covered with oriental carpets and rugs and the fireplace was decorated with hand-painted tiles. Adjoining the north side of the house were two purpose-built studios: one 'dry', for designing and drawing, and the other 'wet' for the messier paint jobs. The first major work to be created here was the wind-dial panel commissioned by the sugar magnate Oliver Lyle for Shorehill, his country home at Kemsing in Kent, still known to locals today as Treacle Towers. Started in 1926, the panel would be delivered to Lyle the following year.

A key factor in choosing West Wittering as a home would almost certainly have been Max's desire to support his aging parents. Arthur Gill, now seventy-seven years old, was still performing his duties as vicar here at St Peter and St Paul and still active enough to enjoy riding his tricycle around the parish, although as Evan told his brother Romney: 'Max says he has undoubtedly aged during the past year … and is a little more forgetful of incidents.'[13] Though five years younger, Rose was too becoming increasingly frail. Max's sister Gladys and her daughter Rosemary also lived nearby in one of the pretty Coastguard Cottages.

A few months after the move, Max told Romney that they were 'settling down in our new home very happily'.[14] His daughter Mary recalled an idyllic childhood at South Nore with seemingly endless summers of hide-and-seek, cricket, picnics on the beach, swimming and messing about in boats. West Wittering at this time was becoming popular with artists,

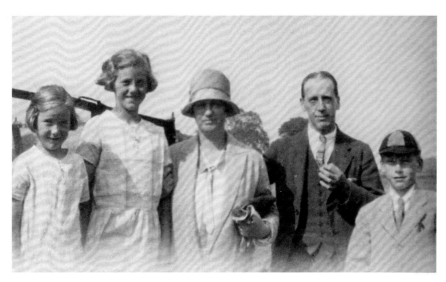

The Gill family, left to right:
Anne, Mary, Muriel, Max, John,
c. 1927

many of whom had second homes here, including Max's friends Stephen
Spurrier and Bernard Adeney, whose family had a beach hut adjacent to
the Gills'. Bernard's son, Richard, remembered playing with the Gill girls
when he was a boy. He recalled Anne as rather 'prim and proper with a
clipped voice'[15] and Mary as a 'fun and spirited' young girl who charmed
him with magical stories about the 'fairies who live in the woods' where
they played. The boy's greatest adoration in those far-off days was reserved
for Muriel who, unlike his own 'irritable and bossy' mother, was 'warm
and cuddly' and would 'grab and kiss him' as soon as she saw him; he
always wished she were his mother.[16] Muriel always welcomed children
but was ill at ease with adults, especially those outside her direct sphere,
such as Max's friends with whom she had little in common. Unless she was
obliged, she tended to shy away from such social occasions.

Max, on the other hand, loved visitors coming to the house, although
he did find it rather trying when his work was continually interrupted, as
often happened in the summer. This was because his studio faced on to
Snowhill Common and the public footpath skirting Chichester Harbour
and it was all too tempting for friends and acquaintances to put their heads
in at the open window and exchange cheery greetings. An occasional
visitor was the eccentric architect Oliver Hill who would motor down
from his Haslemere home in his splendid blue Rolls Royce coupé and
turn up on the Gills' doorstep unannounced, sometimes with a parrot on
his shoulder – a source of immense delight for the children.

Although proud of his offspring, Max was concerned not to spoil
them, as this extract from a letter shows: 'you should see Mary and Anne

playing their piano-duets together – it's a sight, especially for fond parents (who realise that too much fondness must be suppressed – for their benefit).'[17]

Both happy, strong and lively characters, the girls were home-schooled until their teenage years. At least one governess was deemed unsuitable but eventually Lucy Funnell, an ex-head girl of the local grammar school, was recruited to take the free-spirited pair in hand. 'Fun' – as she became known – lived up to her name. Only a few years older than her charges she became one of the family and was dearly loved by the girls who kept in touch with her and her family until she died. Mary recalled the daily handwriting sessions, supervised by Fun, when they had to copy lines of italic letters in their Graily Hewitt exercise books as beautifully as possible to please their father. When she was about nine, Mary said, the three children were told that they should no longer call their parents Mother and Father but call them by their proper names Max and Muriel.

The Stately Gavotte, Muriel and Mary Gill, pen and ink, 1924

John was a sensitive boy, doted on from birth by his mother in her loneliness in Dorset. Max also loved his son dearly but his high expectations and tendency to criticise John for his occasional failures resulted in a barrier between them in adulthood. John's early schooling was in Chichester, but by 1927 he was boarding at a school in Eastbourne, East Sussex – presumably in the hope that he would go on to university, an opportunity denied to Max due to lack of money. In a letter to Romney, Max admitted that his ten-year-old son was 'not a scholarship – natural-standard-born scholar – nor were we …: the present phase is "aeroplane-flying" equivalent to the "engine" period of our "Duncannon"[18] youth'.[19] But John redeemed himself with his skill at football and his father always endeavoured to support him in school matches.

Having a purpose-built ground-floor studio as part of the house was a boon. Here he could handle large panels easily with no steep staircase to negotiate – as at West Lodge and Hare Court. Much of his time was spent closeted here with Kingswell, both men drawing or painting in a concentrated silence occasionally broken by a question, comment or even a burst of quick-witted banter. A self-confessed workaholic, Max admitted to Romney that he 'must get out of doors more',[20] but at least at South Nore, it was easy to snatch a few minutes for a brisk walk or a game of cricket with the children. Once they collapsed in gales of laughter at the sight of him striding down to the beach with sofa cushions tied round his legs in place of shin pads. Anne Gill remarked in

later years, that their childhood had been 'such a riot that it was difficult for grown-up life to compete'.[21] His daughter Mary also recalled the risky word game he played with complete strangers where he would make an off-the-cuff risqué remark such as 'Tickle your arse with a feather',[22] which would prompt an incredulous 'What?' The trick was then to think up something – without hesitation – that sounded similar but plausible such as in this instance: 'Particularly nasty weather.' It did not always go as planned – 'once he said something like "You've got a nasty face I think" to a shop assistant and then tried to pretend he'd been asking about ink. The man serving him understood exactly what had been said and was definitely not amused.'[23]

Rarely a week went by without a trip up to London, where he would usually stay for one or two days, sometimes more, leaving Kingswell to hold the fort at the South Nore studio. Instead of the train Max would now sometimes travel up in his new Morris motor car, which was, for some unknown reason, nicknamed Baird. In town, he would often meet up with one or more of his siblings for supper or a play, and Eric could always find a bed at 1 Hare Court. Evan's wife Mailie who came down from Liverpool every year to stay with an old friend in London, adored her brother-in-law and described him as 'great fun' and with 'a wicked sense of humour'.[24] Her daughter remembered being regaled with stories of Max – clad in his bohemian black cloak and wide-brimmed black hat – sweeping her mother down the Strand to the theatre.

There was always the possibility with Max that he might do something unpredictable. Once he and a pal were walking past a theatre queue when 'To the friend's dismay he at once took off his jacket, rolled up his sleeves, spat on his hands and gave every sign of being about to entertain them in some spectacular manner. At the last moment he saw an imaginary policeman and, hurrying away, overtook his friend who was making off at a smart pace pretending not to know him.'[25]

CHAPTER SEVENTEEN

Maps and Murals
1926 – 1929

During the 1920s there would invariably be a map panel being painted in the studio at South Nore. These were usually destined to be set in wood panelling, often above a fireplace, rather than hung on the wall as would a framed-canvas painting. The production of a panel map was a far longer process than for a poster map. First there would be lengthy discussions with the client, followed by research as well as a 'tour' to sketch buildings and local features. Geographical accuracy was of paramount importance and to ensure this Max used Ordnance Survey maps ordered from Stanford's in London that would be scaled up or down to the correct size. A small-scale sketch might be presented to the client for approval before a full-size version was drawn onto tracing paper and then transferred onto the pre-prepared mahogany or oak panel. Only then did painting begin. With so many other jobs in hand, a large map could take years to complete. The massive Tillingbourne Valley map, measuring 1.98 metres by 1.45 metres, created for the Hon. Margaret Wyndham, a Lady of the Bedchamber to Queen Mary, was begun in the autumn of 1926 and eventually delivered to Hazelhatch – her Lutyens-designed house near Gomshall in Surrey – just before Christmas 1928.

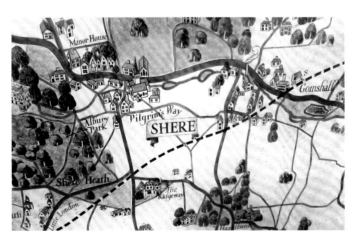

Detail from map panel for the Hon. Margaret Wyndham, oil on wood, 198 x 119 cm, 1926–8, Shere Museum, Surrey

In the mid-1920s there were two other map panels in progress. One of these was a circular bird's-eye perspective wind dial for Trinity College, Cambridge. Commissioned by the architect Edward Maufe, this commemorates a former student, the millionaire Conservative MP and High Sheriff for Buckinghamshire Augustus Henry Eden Allhusen, who had died in 1925. In 1927 a large panel map was commissioned for Kelmarsh Hall by its tenant, the Anglo-American MP Ronald Tree, master of the Kelmarsh Hunt who may have seen a similar map that Max had done for Sir Raymond Greene's hunting lodge at Burrough-on-the-Hill in Quorn Hunt country.[1]

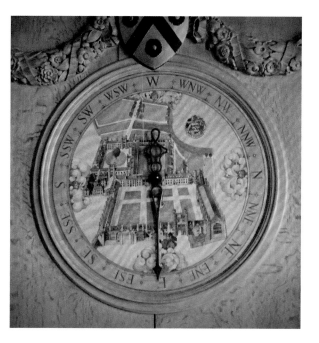

Wind-dial map,
Trinity College, Cambridge,
oil on wood, approx. 83 cm
diameter, 1926–27

Early that year Max had the first in a series of meetings with the architect Edward Prior about painting the chancel of St Andrews, in Roker near Newcastle, a church sometimes described as 'the Arts and Crafts Cathedral of the North' because of its architectural design and the many fixtures and fittings designed by master craftsmen. These include stained glass by Albert Henry Payne and Edward Burne-Jones, a magnificent tapestry to a design also by Burne-Jones, woodwork by Ernest Gimson, metalwork by Alfred Bucknall, a stone font by Albert Randall Wells and inscriptions by Eric Gill. Prior had apparently envisaged such a mural depicting the creation myth when he built the church twenty years before. Local shipping magnate Sir John Priestman had paid for the building

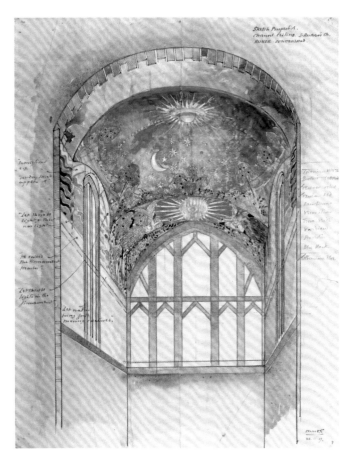

The Creation mural design for St Andrew's Church, Roker, Sunderland, pencil and watercolour on paper, 23 February 1927

in memory of his mother but at that time funds were not available to paint the chancel. The work was now to be paid for by his sister Polly to commemorate her husband – founder of a successful grocery chain and former Gateshead mayor – Walter de Lancey Willson, who died in 1907.

Max made at least two preliminary visits to Roker – the first, in early February 1927, was presumably to meet Prior at the church to discuss the design. Max's first drawing, entitled an *Outline Sketch of Proposed Decoration to Chancel Ceiling, St Andrew's Church, Roker, Sunderland*,[2] indicates the basic concept, but a detailed coloured design dated 23 February 1927 has recently come to light in his former home in Sussex. The work was due to commence in June, but this was postponed until late August due to other work commitments. The group of painters he assembled included Rachel Russell, his assistant of previous years, Margaret Rope (nicknamed Tor), a young woman who would make her name as a stained-glass artist, and John Farleigh, a young art teacher, who would become well known

The chancel with scaffolding
during the painting of
The Creation mural,
St Andrew's Church, Roker,
Sunderland, 1927

as an illustrator and wood-engraver. Farleigh's memoir describes his experience in Roker:

> In the middle of the vacation . . . I was asked by Macdonald Gill to help in the painting of a church decoration in Sunderland. I blessed the two years [this should be 'months'] I had spent on the mural, even if I felt I had only learned to separate the white of an egg from the yellow, and in three days' time I found myself in the train with no idea of what I would be expected to do. There is little to fear, however, for those who work with Macdonald Gill, for he is most able in making every-body happy and getting his men to work. In the evening our party went to inspect the church and the scaffolding. We all climbed up, except one man who failed to conquer his fear . . . he returned after a few days' unsuccessful effort. When I reached the top I lay down on the planks and wondered if I should ever get down again. In a few days we were sliding down the poles instead of using the ladders and the 'Seven Days of the Creation' appeared on the walls in a few weeks. When I had finished I felt I should like to do a church single-handed, but another church, like another book, did not seem available. I had the pleasure, however, of making a lasting friend of Gill, and I returned to London with enough money to carry me through. I will not enlarge on our adventures so near to heaven in Sunderland: our weekly visit to the melodrama; high teas on Sunday in caves along the coast, where there are 'such quantities of sand' (the original walrus is in the local museum), or watching a wedding from the top of the scaffolding.[3]

The vibrant fresco, painted in the traditional medium of egg-tempera, represents the biblical story of the creation alongside the relevant quotations from Genesis. On the ceiling are depicted the hand of God the Creator, the heavens with a moon, stars and sun (in the form of an electric light) with facing walls depicting Adam and Eve surrounded by an array of terrestrial plants, birds and exotic creatures above waters teeming with aquatic life-forms and land.[4]

The mural at Roker took many weeks of work and was the reason for only one of several periods that Max had spent away from home in 1927, albeit the longest. And at the end of that year he was approached about a major painting project in Hayes Town, near London. When he was in

Opposite:
The Creation, tempera on
plaster, St Andrew's Church,
Roker, 1927
(Angel heralds above window
have been destroyed by damp.)

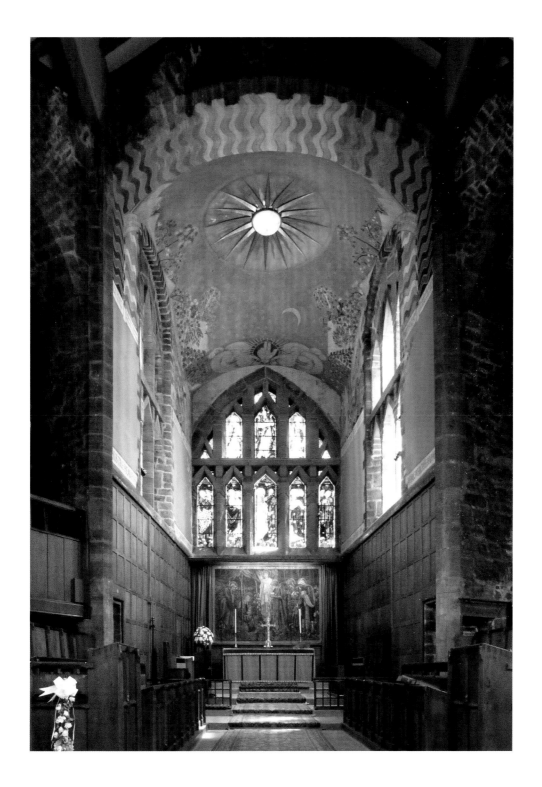

Detail from The Creation, tempera on plaster, St Andrew's Church, Roker, 1927

town, Max could slip back into the bachelor-style life he had always enjoyed there – the theatre with friends and relations, lunches at the Cock, suppers at the Café Royal, talks at the Art Workers' Guild as well as numerous exhibitions and society meetings. In 1928 he was involved in the setting up of the British Society of Poster Designers'[5] exhibition at the Royal Institute Galleries and he also had a series of meetings with Lutyens for whom he was designing items to decorate the Government buildings in New Delhi, including the Royal Cipher which was to be emblazoned on the leather upholstery in the Viceroy's House.

Such projects may not have been the only factor keeping him away from home. A name that crops up a number of times amongst the client appointments and his son's cricket matches in Max's diaries between 1926 and 1929 is Alice Brettells. Little is known about her except that she was the slim, red-haired wife of Leonard Brettells, who Max may have met in London. Their friendship was far more than just a casual fling. A decade later Max admitted that he had been in love with Alice, saying that he 'had even considered leaving M [Muriel] then'.[6] His preoccupation with Alice led to her depiction as a wind in at least one map including the W.H. Smith panel completed in 1931.

Head, believed to be Alice Brettells shown as a wind in the painted map for W.H.Smith, oil on wood, 1929–31

Alice lived outside London and – with a husband and young daughter – it must have been difficult to justify frequent or prolonged visits to the capital. Her meetings with Max seem to have been fairly infrequent.

One of their favourite trysting places was the Prompt Corner, a café or restaurant where they would dine together presumably without attracting undue attention, although Max did take her at least once to the Café Royal, where they would almost certainly have been spotted by someone Max knew. Their brief encounters would usually be over by 9 pm when she had to catch her train home from Paddington.

Muriel was not blind to her husband's extra-marital interests. Years later she described Alice as 'one who did make trouble and come between them, one of his many girls!'[7] Mary Corell particularly remembered her mother's unhappiness when the Brettells came on holiday with them to the Belgian seaside resort of Blankenberge in August 1931. The affair eventually ended sometime after this – perhaps the holiday galvanised Muriel to issue an ultimatum or perhaps Alice's husband Leonard realised that something was afoot and put a stop to the relationship. No diaries or letters from this time exist to provide an answer.

The job in Hayes Town was for Max's old employer Hubert Corlette, who wanted him to paint the nave and chancel ceilings of St Anselm's Church, which was in the final stages of completion. The elaborate scheme was in three sections. The chancel section consisted of forty-two panels of symbols – in gold on a white ground – referred to in the Book of Revelations, while the eighteen central nave panels show a sunburst on

Royal Cipher for upholstery at Viceroy's House, New Delhi, gold embossed leather, 1928

Section of ceiling decoration at St Anselm's Church, Hayes Town, Middlesex, 1928–29

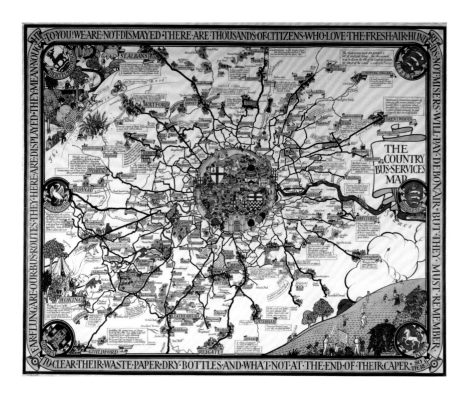

Country Bus Services, poster map for London Underground, 102 × 127 cm, 1928

a deep blue background next to panels depicting the twelve signs of the zodiac. The borders along the cornices contain an inscription that provides the key to understanding the decorations, beginning 'The Heavens declare the Glory of God …'. There was a further set of symbolic panels over the baptistry area and finally there were the constructional timbers in between the panelling that were to be chequered in black, white and red. It was the longest church painting job Max ever undertook. Starting on 27 November 1928 immediately after finishing the map panel for Margaret Wyndham, it was completed in late February the following year after nearly three months of work with experienced assistants such as Rachel Russell – and possibly Mary Creighton and Kingswell.

Despite the complications in his private life, Max nevertheless portrayed an idyllic family cricket match in his *Country Bus Services Map* produced for London Transport in 1928. Most of the figures are identifiable by an initial. Max is the bowler, Eric is shouting 'Hit it, Mother!' while other siblings and children are fielding or watching the game from the sidelines. At the heart of the map lies London, depicted as a compact walled city surrounded by a great swathe of countryside dotted with fascinating towns, villages and ancient sites all with notes or quips designed to entice Londoners to hop

onto a country bus to venture out of the city to sample the fresh air, the sights and the local hostelries on a Sunday. To allay the fears of country dwellers about day trippers leaving behind their rubbish the border message instructs: '. . . but they must remember to clear their waste, dry bottles and what-not at the end of their caper. So there!'

Many affluent Londoners were also seeking a rural retreat where they could get away from the noise and pollution of the city. The Chichester Harbour area, with its sandy beaches and safe sailing, was particularly popular with many business people and artists and Max's architectural services were in high demand. In the 1920s he designed many houses and cottages in West Wittering and the nearby villages of Birdham, Itchenor and Selsey, including one for his artist friend Stephen Spurrier. These tended to be fairly modest affairs, some plain, some picturesque, some tiled, some with thatched roofs, but all built to blend in with the local style. Rather grander was the six-bedroomed house he designed for Commander Kenneth Poland on the West Strand foreshore at West Wittering which featured in a 1933 *Country Life* article about Max and his work. Its walls were of brick with flint and on the seaward side the first-floor bedrooms opened out on to a deep balcony fronted by a decorative wooden balustrade and supported by pairs of patterned brick columns which enclose a shady loggia or 'verandah'.

West Wittering had attracted some well-known names. The car designer Sir Henry Royce lived here for many years until his death in 1933. Eric had designed a font for Rolls-Royce in 1906 and Max was now hired to design publicity material for the company including

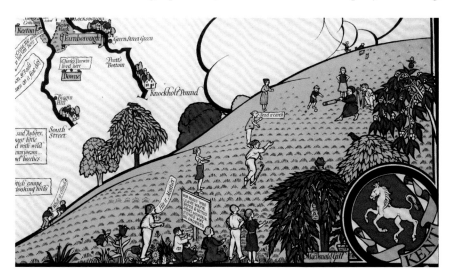

The Gill family playing cricket, detail from *Country Bus Services* map, 1928

Rolls Royce bookmark, 1927

a pair of colourful bookmarks. Apparently Royce once took the time to repair Arthur Gill's lawnmower reassuring the grateful vicar that no job, however small, was without meaning. This message resonated with Eric, who shortly afterwards carved an appropriate Latin inscription for Royce's mantelpiece.

In June 1929 Romney arrived back in England on furlough and Max spent as much time as he could with his brother. Not only did they enjoy family gatherings in West Wittering with their parents and siblings, but Max also took him to visit some of the clients he had mentioned to Romney in his letters, including Darwell Hill. A few months after returning to his mission in Papua, Romney wrote: 'I simply loved going round with you on your tours of inspection. Please remember me to the jolly lady who was always making out that you were too particular; also to the oldish couple – them with the patent trapdoor leading up into the attic.'[8] Romney had also joined the Max Gills at the beginning of August for the first days of their holiday at Wimereux, a picturesque French coastal resort boasting a splendid array of Belle Epoque buildings – perfect subjects for Max to draw. Then Muriel and Max accompanied him to Paris to see him off at the Gare de Lyon on his long journey back to Papua.

The couple returned to Wimereux that afternoon to continue their family holiday. But early the following morning – on Tuesday 6 August – Max's world was shattered when he received the news that his mother, who had been suffering from breast cancer, had died early that morning. He was distraught: his older daughter Mary was shocked at seeing her father break down and weep. By 11.30 that morning he was on a boat back to England to join his siblings, most of whom had been at her bedside in her final moments. The funeral took place two days later in West Wittering but she was buried in the Brighton Extra-Mural Cemetery near her young daughters Cicely and Irene. The *Sussex Daily News* noted that she 'had won the respect and esteem of a very wide circle of friends, and Mrs Gill's passing will leave a big gap in the life of the district she knew so well'.[9] His role model throughout his boyhood, she had remained an important figure in Max's adulthood and was the standard against which he judged all women.

Rose's death posed a dilemma for the Gill family. Arthur Tidman Gill was now eighty-one and becoming increasingly frail and forgetful and unable to live on his own. The time had come for him to retire and on the 2 November he left the vicarage and came to live at South Nore. Romney wrote: 'All I can say, or rather will say, is that "it is just like you and Muriel". God bless you both.'[10]

CHAPTER EIGHTEEN

A Financial Crisis
1929 – 1932

LIKE SO MANY MILLIONS of others around the world, Max was unable to avoid the consequences of the Wall Street Crash, when the New York stock market collapsed overnight on 24 October 1929, and the subsequent and longer-lasting effects of the downward economic spiral of the early 1930s known as the Great Depression. Few wanted to spend, or be seen to spend, their reduced incomes on luxury goods and this inevitably affected makers of such products. Artists and craftsmen found themselves with half-empty order books having to compete on price so profit margins were sometimes much reduced.

Max's income had always been erratic – it was in the nature of his work. His income peaked in 1930, a year that saw him receive payments totalling nearly £3,000, the equivalent in today's money of around £170,000. Max must have been one of the highest earning commercial artist/craftsmen of his time, although it should be remembered that most working in this field were not also architects. His ledger details payments of around sixty jobs in 1930. By far the biggest earner was the lettering of the Rolls of Honour at Norwich Castle, a Lutyens commission, for which he was paid £350 while just one of several payments made by Ronald Tree for the Kelmarsh map of the Pytchley Hunt amounted to over £150. His architectural commissions also paid handsomely: the house for Commander Poland at West Wittering earned Max around £170 while a modest cottage at Itchenor brought in £70. A drawing room extension incorporating an octagonal tower with gothic casement windows for The Strange Hall in Bosham earned him around £150 and a new wing for Warennes Wood in Mortimer, near Reading, the home of Sir George Mowbray, grossed him £800 between 1927 and 1929.

At the other extreme there were numerous small fees for the mass of bread-and-butter jobs: two guineas for a medallion, eight guineas for a Putnam book jacket, £18 for a Balliol chapel plaque and £62 for a tombstone. These figures are the amounts

Drawing room extension with octagonal tower at The Strange Hall, Bosham, West Sussex, 1931

Uncle Sam dust jacket for
Putnam's, pen and ink on paper,
1930

St Richard medallion, 1931

he received; costs go unrecorded. His main professional outgoings would have comprised the rent on the Hare Court studio, travel costs, as well as wages to his full-time employee Kingswell. His profits were substantial until this watershed year of 1930.

The first indication of a looming crisis in Max's finances can be seen in his payment ledger in 1931 when his total income, although still substantial, dropped by one quarter. He may also have suffered losses as a result of the collapse in share prices. And by October Romney was writing: 'Dear Max, you who have so many other worries and financial anxieties. Dear Muriel, you who have to suppress so much of your plans and desires for home and husband and children.'[1] The following year was a financial disaster: Max's income plummeted to just £802.

One major drain on the family income was the children's schooling; by their teenage years, all three were at boarding school. Neither Max nor Muriel were particularly extravagant, however they lived a comfortable middle-class life, rarely entertaining on anything more than a modest scale, and Muriel, who could never be described as fashionable, spent little on clothes. Despite the drop in income, Max still took the family to Belgium for their summer holiday, almost certainly funded by renting South Nore to Miss Katharine Cox, the principal of Anne's boarding school, Hayes Court in Kent, where Max had carried out various improvements.

Against this backdrop of financial worries, there were tensions at home. Max's relationship with Muriel had deteriorated as a result of his close friendship with Alice Brettells, and there was also the constant presence of Max's father whose needs were becoming harder to meet. With Max often in London, Muriel bore the brunt of caring for him. The children, when home in the holidays, also found their grandfather tiresome. At mealtimes he would admonish them about the way they ate, advising them to chew every mouthful forty-nine times – and they would laugh at his tedious recitations of Tennyson's 'Idylls of the King'. Max confided his concerns to Romney who responded: 'Thank you especially for letting me into the atmosphere of your feelings with regard to Father. Your patience and generosity amaze me. You will say: "What else could we do?" I know; all the same I am amazed and thank God for the example you show us all.'[2] Eventually, however, the situation became untenable, and after much soul-searching, Arthur Tidman Gill moved into a home for retired priests at Dormansland in Surrey.

The stresses and strains were also taking a toll on Max's health. His goddaughter Priscilla Johnston – who visited the Gills in the summer of 1931 – noticed his state of near exhaustion. Apart from an exchange

At the Gills' beach hut, West Wittering. Back row: Jeremy Pigott, Muriel and Max Gill; front row: Mary Pigott, Anne Gill and a family friend, 1931

of Christmas cards every year, there had been virtually no contact with the Johnston family since Max's brother Eric had quit Ditchling for the wilds of Wales. But that July twenty-year-old Priscilla and her close friend Mary Pigott, daughter of artist Louis Ginnett, together with Mary's two-year-old son Jeremy, arrived in West Wittering for a fortnight's holiday. In fact one of the attractions of the place for Priscilla had been the chance of meeting her godfather – her father's 'fabled'[3] friend of whom she had but vague childhood memories.

A few days after their arrival the two young women dressed themselves up – and 'highed it'[4] as Priscilla put it – in the evening sunshine down the lane past the Coastguard Cottages and knocked on the door of South Nore. She was unsure if Max would even recognise her but to her amazement, he did so instantly and promptly gave her a kiss. The girls were invited in and introduced to Muriel and ten-year-old Anne, the youngest of the three children. Priscilla thought her 'rather a sweet child and obviously adores her father'[5] but pronounced his wife to be 'uninspiring'.[6] Muriel appeared to be in low spirits – hardly surprising given that she must have been dreading the forthcoming family holiday to which Max had audaciously invited the Brettells. Of Max, Priscilla wrote: 'He was very charming. Mary said he was the sort of man she wd. like to marry and I liked him very much too & felt completely at ease with him. He has a very interesting face but looked terribly tired, poor dear.'[7]

Priscilla was keen to see some of Max's work and the girls were duly invited to supper the evening before the family left for Blankenberge. Mary was tired so Priscilla went on her own. Max greeted her warmly, but Muriel sent down a message to be excused because she was packing. After they had eaten, Priscilla was taken into the studio. 'Talk was easy & delightful as ever while we had supper. It was only afterwards, when he showed me his work, that he was different, quieter … It was serious … To me it was an honour to be shown his work. Even so it was not altogether easy, being shown someone's work. It never is unless it is someone one knows extremely well.'[8]

At that time Max was extending the painted map he had painted the previous year for Ronald Tree at Kelmarsh Hall. Priscilla – who knew of his London Underground posters – was surprised:

> The Pytchley Hunt panel was quite different from anything of his that I had seen before. I had thought of his work as bold, brightly coloured and fantastic. I was even a little disappointed in the panel at first because it was so quiet. It was in fact much more beautiful than anything of his that I had seen but it was different & it took me a little time to make the adjustment.[9]

Then Max escorted her back to the footpath. Afterwards Priscilla wrote of their encounter: 'But we left off exactly where we began. After all that time alone, I didn't know him one scrap better.'[10]

Detail of the hunt from *Map of the Pytchley Hunt*, oil on wood, 264.8 × 246.4 cm, Kelmarsh Hall, Northamptonshire, 1930

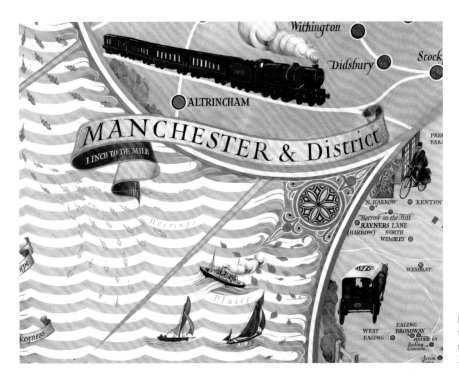

Detail showing modes of transport, W.H. Smith & Sons map, oil on wood, 221 x 221 cm, 1929–31

In the studio at that time may also have been the map Max was completing for Britain's leading stationer W.H. Smith & Son.[11] This large panel, which was two years in the making, had been commissioned to mark the change in company structure from a partnership to a limited liability company. It showed the locations of all the firm's retail outlets and its distribution network that employed modes of transport of almost every type including horse-drawn vans and aeroplanes.

The first of two large trapezoid-shaped panels for St Stephen's Porch at the Palace of Westminster may also have been in the South Nore studio. Measuring 3.2 metres wide and 3.3 metres at their deepest points, each of these maps was made of two mahogany panels 3.8 cm thick, so heavy that steel slats were fixed to the backs to keep the panels tightly together. *A Plan of the Houses of Parliament* is bordered with the royal coats-of-arms and shows such locations as the 'Site of the trial of Sir Thomas Wentworth, the Earl of Strafford'. The other is a map of *The Cities of London and Westminster*, bordered with the heraldic devices of the London boroughs and depicting the public buildings, historic sites and the underground stations that serve the area. In homage to the second map's benefactor – the London Underground – Max inserted the letters U.D. instead of A.D. before the completion date of 1932. Patricia Lovett,

Max adding the final touches to *A Plan of the Houses of Parliament*, St Stephen's Porch, Palace of Westminsteroil on wood, 320 × 330 cm, 1932

one of Britain's leading calligraphers, has written of Max's 'strong and lively letter forms from the Houses of Parliament map … the lettering varies from flourished capitals, compressed capitals and a formal miniscule style, with a delightful addendum in italic where perhaps the text didn't quite fit!'[12]

These 'charming new panels'[13] were finally unveiled on the 19 October 1932 with a fanfare of publicity and described as being 'a welcome addition to the amenities'.[14] Max was paid a total of £300 in three instalments – much-needed funds to relieve his increasingly straitened circumstances.

At the beginning of 1932 Frank Pick had commissioned another of Max's humorous poster maps for the London Underground: *A Clash of Arms*. With borders densely packed with the heraldry of London boroughs, the map appears to be a poster version of *The Cities of London and Westminster* panel for St Stephen's Porch. It was the last published

A Clash of Arms, poster
for London Underground,
102 × 127 cm, 1932

poster map that Max would design for the London Underground.

Max was struggling not only with his finances but also with poor health. Romney was concerned:

> I heard from dear faithful Evan and Mailie by the last mail, and they both tell me of your recent (then) visit and also, alas, how unwell you have been … And I am so sorry to hear that funds do not exactly roll in. (Evan sent me your letter.) It must be frightfully worrying for you and dear Muriel. How I wish I was in a position to help a bit![15]

Despite this gloomy picture, Max's income had recovered a little by the end of the year and there was work in the pipeline. Prospects were looking up for 1933.

PART FIVE

Priscilla

1933 – 1947

Priscilla Johnston, 1945

CHAPTER NINETEEN

A Chance Encounter
1933

The year began promisingly with two important commissions. The first was a painted map panel for the Mayor's Parlour in Worthing Town Hall and the second was a large tapestry map for South Africa House, a substantial building in Trafalgar Square being refurbished by Sir Herbert Baker for use as a consulate. Before embarking on these projects he spent time with his family, taking his son rowing, the girls to a puppet show and his sister Angela to the theatre – to 'buck her up after strained visit to Father'.[1] Arthur Gill was rapidly declining and Max wrote two weeks later that he was 'v. weak + doubtful if recognized me'.[2] There were also lunches and teas with friends including his brother Kenneth's widow Lulu (who was now remarried), a BBC concert with fellow artist Harold Nelson, dinners at the Savage Club of which he was a member and the usual weekly evening meetings of the Art Workers' Guild in Queen's Square, Bloomsbury.

On 18 January 1933 Max was at the guild to hear his brother Eric read a paper entitled 'Lettering and Commerce' to the Society of Scribes and Illuminators. The place was full of friends and acquaintances including Ambrose Heal, Harold Curwen and Frank Pick, who took the chair that evening. Amongst the crowd afterwards Max spotted – to his surprise – his goddaughter Priscilla Johnston. In a letter to her father the next day she mentioned the encounter:

> … afterwards I was standing about when I was suddenly hailed by someone so nice and unexpected – no other than my charming godfather. He talked about coming to see you in his desultory and vague manner. I urged him to and said you'd love to see him … I gave Uncle Max my address and both telephone numbers and he said he'd ring me up sometime and we would foregather when he was in town.[3]

Eric also recognised her and 'we talked a little. He said he hoped he hadn't said anything to offend me … He was charming … He and Uncle Max and HLC[4] & I all stood about discussing my books!'[5]

Now twenty-two years old, Priscilla was the published author of two moderately successful romantic novels – *The Narrow World* and *Green Girl* – and had just completed a third. She had grown up with her two older sisters in Ditchling, home to many of the craftsmen known to Max, in a household surrounded by the artistic chaos of her father Edward Johnston but with a supportive structure supplied by her understanding and loving mother Greta. Now she was seeking independence, freedom and adventure in London and was sharing a flat in St Peter's Square, Hammersmith, with her close friend Mary Pigott and her son Jeremy. She had found a job with the Rural Industries Bureau, although with no shorthand and erratic spelling, she was, by her own admission, an incompetent secretary, far happier mapping out new plotlines and characters for her next novel. She also kept a daily journal documenting almost every detail of her life: events, people, conversations and thoughts. These journals record the development of her relationship with Max and give unique insights into his character and his work.

Three weeks later Max bumped into Priscilla again at a First Editions Club private view where Eric was presenting another lecture, this time on the subject of 'Illustration and Printing'. Max chatted with her for some time and as guests started drifting away, it was clear Priscilla was in no hurry to get home – it later emerged Mary was at their flat entertaining a male friend. Priscilla recounted what happened next:

> He said he'd like to ask me to have dinner with him but did not know if he had enough money. He turned out his pockets & found something over eight shillings – I – with my background of ninepenny lunches at Woolworths – exclaimed that that was plenty, how could he doubt it? He said he thought I might have grand ideas about where I should be taken, which made me laugh.[6]

Max took Priscilla to Roche's, a French restaurant in Soho, which her father had described thirty years before as 'a rather cheap & reasonable "bohemian" sort of place'.[7] Here they talked almost non-stop over 'an excellent three-course dinner with chicken and green salad for half-a-crown',[8] washed down with a bottle of wine. They then headed towards Charing Cross station where Priscilla could catch the tube back to

Hammersmith. 'As we walked I took his arm – I thought he would like that. I was right',[9] she wrote. Although her novels were all about relationships and romance, she often exhibited an extraordinary lack of inhibition and awareness of her own sexuality and allure. To her it was the most natural thing in the world to take a man's arm – it was simply a spontaneous gesture of warmth, interest and friendship.

Instead of taking the turning to the station Max led her towards the Temple saying: 'If we go on you can come back with me and see what I'm working on.' There was no hesitation on Priscilla's part: 'This was what I'd been hoping for. I was eager to see his work.'[10] The moment she stepped into the studio Priscilla was enthralled – the walls were covered with drawings of colourful exotic flowers, all sketches for the border decoration of the tapestry map he was designing for South Africa House. Max boiled the kettle on a little gas stove in the fireplace and they sat drinking tea on the floor and talked on. Unfortunately, the two glasses of sherry and half a bottle of wine she had drunk earlier in the evening began to take their toll. She began to feel 'intensely ill'[11] and in need of fresh air, so they wandered down to the river and leant on the parapet for a while watching the lights reflected in the dark waters before parting at the Temple tube.

There was nothing accidental about their next meeting. Max sent a note asking her for supper and they met at Roche's. Since the South Africa map designs were needed urgently, they went back to the Temple

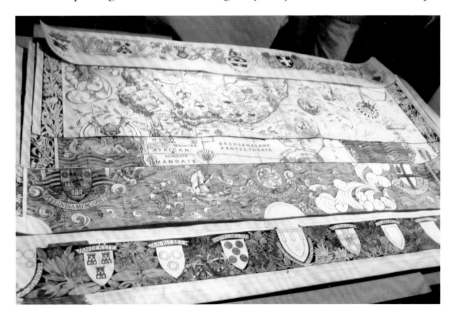

Sections of artwork for the South Africa tapestry map, pen and ink and watercolour on paper, 1933

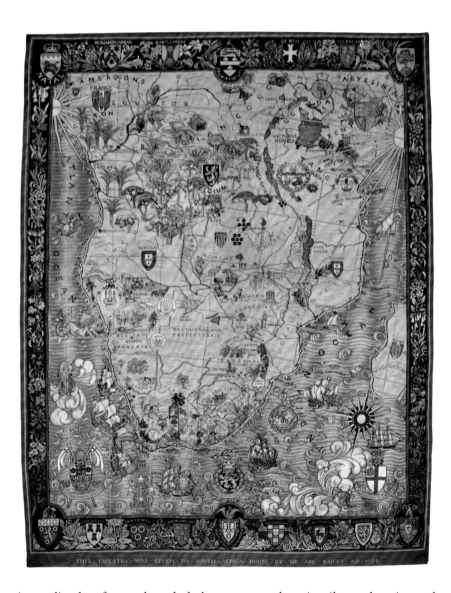

South Africa tapestry map at
South Africa House, London,
290 × 381 cm, 1933–34

immediately after and settled down to work – in silence but in each
other's company – he on the tapestry map and she correcting proofs for
her latest novel. Before parting at the tube station to catch the last train,
he took her in his arms and they had their 'first "real" kiss'.[12]

Max was soon besotted with Priscilla. How could he not have been
tempted by such an attractive, free-spirited and vivacious young woman?
He must also have been flattered by her genuine eagerness to know more
about his work, the most important element in his life. She not only
listened intently when he talked about it but also responded with intelligent

questions and comments, unsurprising perhaps for someone brought up in the Johnston household. The age gap of twenty-six years mattered to her not one bit. In fact, her teenage diaries and novels reveal a fascination for older men; she often felt they were more worldly, more sophisticated and more interesting than young men of her own age, who always seemed gauche and immature. She also had – as a result of her upbringing amongst the artists and craftspeople of Ditchling – a reverential view of artists, believing them to be special, set apart from others. All through her youth she had heard stories about this mythical Uncle Max and now here she was in his company. The fact that Max was her godfather was also immaterial. He intrigued Priscilla just as much as he had on her visit to South Nore two years before – he could talk so easily and amusingly but rarely revealed much about his private thoughts or feelings.

One of the things that delighted her was his extraordinary ability to talk to anyone no matter their class or job. On leaving Roche's that second time, she 'found him talking to the porter about his [the porter's] wife's illness'[13] and further on in Covent Garden they stopped at a flower seller who talked to Max 'about his twin sons of 8 who were clean and straight & he didn't want them to go near a market ever, but to learn the accordion'. Priscilla wrote: 'I loved him & I loved Max while he talked to him. M. was taken by the accordion idea & told the man he wanted the beauty of music for his son because he had always had the beauty of flowers.'[14] She was also taken aback at his habit of crossing the road without looking, somehow always managing to avoid an accident: 'Max never waited, he walked straight into it. One had the feeling of bearing a charmed life, crossing the Strand with him, for – what was so remarkable – it was perfectly safe. It was as though he had his own private dimension into which he could slip, and I with him.'[15] But it was fascination that drew Priscilla to Max, rather than passion or love – that followed later. For her their relationship seems to have started as an amorous adventure without serious thought for the future, but for Max it was serious almost from the first.

With each meeting their feelings strengthened – and on 14 March Priscilla became Max's lover. For her it was a life-changing act, signalling the beginning of a deep commitment. She declared in her journal:

> We take off our hats to March the 14th for the final taking of a decision so momentous – possibly – as any is like to be … From Char + [Charing Cross] I walked, thinking to myself 'This is the last time I shall walk beside the river alone with my virginity'. I was happy & excited & horribly frightened, really.

Frightened, more than anything, that I should go back on my decision. This, however, I did not do.[16]

And so their love affair began. In his diary Max was discreet, careful never to write Priscilla's name, just the letter P, and at first there was some reticence about being seen in public together. When they met at gatherings, they would enjoy the frisson of excitement generated by their clandestine relationship. In a note before the launch party for Priscilla's book at the end of March, Max wrote: 'Should I see you across the strangers heads on Friday, a flick across your forehead with your hand will signify "I will be there". What conspiracy!'[17] At such events, they would pass one another tiny notes scribbled on scraps of paper with messages such as Max's: 'Don't smile like that across the room my love. You make me want to come to you Darling.' Priscilla awakened in him feelings that perhaps he had never experienced with any other woman. She came to dominate his thoughts, even creeping into the images he was creating. The head representing the wind in the Worthing Town Hall map is unmistakably Priscilla's.[18]

Despite his feelings for Priscilla, Max was unable to abandon his family. At weekends he had no excuse to stay in London and in recent years the bulk of his work was carried out at South Nore where Kingswell was employed. So when they were separated, he and Priscilla stayed in touch by writing almost every day. Max wrote his letters in the studio 'when the family were all abed'.[19] 'What a blessing I have a studio separate from the house!' he wrote. 'There I can disappear into and fortunately immerse

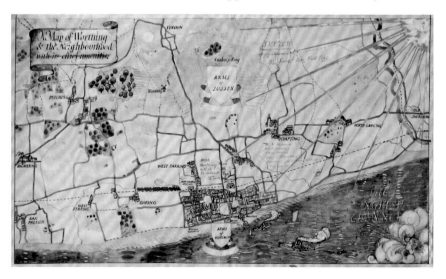

Worthing Town Hall map design, pencil, pen and ink and watercolour on paper, 1933

myself in work and most fortunately forget the friends outside and think … of her …'[20] Priscilla fretted that someone might come upon her letters and suggested that he burn them, but he never heeded this advice.

Priscilla found it frustrating that Max could not see her more. Moments were snatched between client meetings; evenings were often short and weekends were almost impossible. After some months he gave her the spare key to his car – so that she could wait in more comfort rather than hanging around on the street. Baird, as the car was nicknamed, often played a central role in their times together, motoring them to clients as well as favourite haunts such as the Savernake Forest, where they would lay out Max's black cloak in a secluded glade and be undisturbed by nothing more than an inquisitive deer. 'Mr and Mrs Baird' became their pseudonyms. Their letters were full of longing for such times as these: 'Oh, the lovely morning … I would we were in the country, you & I & Baird. All green it must be getting – the leaves are almost more exciting than the flowers. So much, so much there is for us to do …',[21] Priscilla wrote in early April.

The irregularity and uncertainty of their meetings led to tensions. She became intensely irritated, for example, when Max took his son John on a work trip to Cornwall. And when a letter from him did not arrive, she complained: '… it is she who writes the letters, in this alliance, even as it is she who makes love "parce que l'homme est trop busy or lazy or je ne sais quoi".'[22] She failed to understand that Max was being pulled in two directions. When he was in London, he could not altogether forget the responsibilities of his home, family and studio at South Nore, yet when he was there he was aching to return to the city and his darling Priscilla.

Her new novel was selling well, and she had begun another so at the end of April she left her secretarial job at the Rural Industries Bureau. This allowed Priscilla to dedicate more time to writing but it also gave her the freedom to accompany Max on his business trips. In late April she was thrilled to be at his side on a visit to the Morris looms at Merton Abbey, where the South Africa tapestry map was being woven, and a few weeks later there was a week away in the West Country, where Max was meeting the vicar of St Michael & All Angels in Bude Haven in Cornwall to talk about a refurbishment scheme. The discussions and measurements took only two and a half days, leaving the rest of the week for him and Priscilla to have a lazy drive back through Clovelly, Glastonbury and the Savernake Forest, ending with an hour's boating on the river at Pangbourne.

With encouragement from Priscilla, Max renewed his friendship with her father Edward Johnston. On 30 March, after visiting his own father

at Dormans, Max made a detour to Ditchling and paid a surprise call on his old friend, rather unsure how he would be received. He need not have worried. First Greta and then the two older daughters Bridget and Barbara greeted him most warmly. Priscilla had already told her sisters about their relationship and Max later told her that Barbara 'was wonderful … nothing was said … but … I was conscious of a sympathetic understanding'.[23] He was also delighted when their father came down to tea a little later and 'immediately fell to as though I had met him but yesterday'.[24] After this happy reunion, Max would often find an excuse to visit Cleves, the Johnston home – both with and without Priscilla.

Max's own father died at the end of May that year. As co-executor with Eric of Arthur Gill's will, Max had to devote much time to dealing with the funeral, legal meetings and correspondence. There was little money and most of their parents' possessions, including a collection of South Sea native spears and arrows, had been auctioned when Arthur Gill had left the vicarage.

Money was something Max needed – not only to reduce his overdraft but also because he wanted to take Priscilla on holiday to France. His solution was to ask Edward Hunter for a loan that would be guaranteed by a second mortgage on South Nore. Hunter – perhaps in an attempt to help Max out of his financial fix – also commissioned a map of Hertfordshire for the Sun Engraving board room at the Watford printing works in place of the portrait that had been suggested by members of his board. Priscilla wrote: 'That man is a complete, full grown guardian angel to you, isn't he? If I were your wife I could thank him … but as it is all I can do is to feel glad.'[25]

The holiday to France now assured, Max put aside family considerations, and in late July he and Priscilla caught the boat-train from Victoria to Paris, the first stop on their ten-day holiday. A few days later they travelled to the Normandy coast, staying a few days in Granville, an historic fishing town, followed by a week in Carolles, another charming resort, where they shared some idyllic moments as Priscilla reminded Max writing from Ditchling soon after: 'it is exactly a week … since you and I swam out to the raft upon a morning as fair as this present … What a morning that was … Actually I think this one is as beautiful … but I shall forget this morning in a little while, and I shall remember the other one all my life …'[26] There were tensions, however, and not for the first time. Priscilla, who had always found talking about her feelings a natural thing, was continually frustrated by Max's inability to talk about his. Months later she wondered if this would ever change:

It may be that you simply can't and won't talk to anyone. There are people like that, I know. I expect such people are in the majority, specially among men – I've made a fuss about our not talking before. I mustn't get into the habit of it! If we can't we can't & there's no more to be said. Too many barriers there are, too many barriers.[27]

Although Priscilla's books were producing a small income, she needed a job to afford the rent for the St Peter's Square flat. There had been a suggestion that Priscilla should come and work for Max at Hare Court and she had been eager to settle the matter before going to France:

Darling, what shall I do about a job? … Do you really want me, & if you do, what would you like to give me? If only you could give me very little (by which I mean less than £2) I might come & work for you, while I was looking for something else … Also … I should be able to come on expeditions with you … to balance this advantage, however, there is the question of discretion … people would, presumably have to know about it, owing to the proximity of Whitby Cox & so on. Or do you think I should buy some blue glasses & bleach my hair [to deceive Harold Nelson] and work at your office under a pseudonym.[28]

The idea made sense. Although she had no professional experience, Priscilla was a competent artist. Throughout her girlhood, she and her sisters had spent much time sketching and painting watercolours, often to illustrate their games and stories, and shortly before coming to London she had trained in art and needlework at Brighton School of Art.

A few days after returning from France, Max broached the subject with Muriel. Resigned to the fact that she would be able to do little or nothing to change any decision Max had made, she put up little resistance. Max, rather pleased with himself, recounted their conversation to Priscilla:

I told Muriel on Friday … 'I find Priscilla is out of a job – has been secretary to the Rural Industries – does typing and shorthand – has done nearly 3 years at Brighton Art School – I have suggested that she helps me in September – she is considering it'. To which Muriel said, 'it sounds quite a good idea – but isn't she writing?' Max then replied 'Oh yes, halfway

through another book … but she's only to be at the Temple the 2 or 3 days I am up, in fact, if I get Greaves to share the office it will be for those days I'm not up and there will be room all right etc.'[29]

So it was that Priscilla began helping Max at the Hare Court studio. In her memoir Priscilla recalled those early days:

It was a part-time job & not well-paid but it was unfailingly interesting & in fact, led to much more exciting work later, though of that I had little idea at the time. Max bought a second-hand typewriter & for the first time experienced the luxury of having his letters done for him. He also taught me to colour plans of houses so that I could help him with his architectural work. The job I did most of all was squaring up maps to produce a copy in a different size. Whatever map he was asked to do this was always the first stage because one could never buy a map of exactly the right size.[30]

She was impressed with the tidiness of the studio: '… everything was put away – so much so, indeed that I couldn't find half the things I wanted.'[31] She found Jack Orr and two of the other artists at the studio, Harold Nelson and his art student nephew Edmund, friendly and helpful. Whitby Cox, who was married to Max's niece Evelyn, was another matter. On her first day he blatantly ignored her, walking in and out of the room without acknowledging her presence, giving, as Priscilla said: 'an impersonation of an Englishman not having been introduced.'[32]

Nevertheless, she loved being in the studio which she spoke of as a place of intense calm. Here, Max was in his element, especially when he was painting a map. She wrote:

The real thrill was to watch him doing it – in an old green painting smock, with a pipe gripped between his teeth, horn-rimmed glasses, and one small vertical line between his eyebrows revealing a complete & serene concentration. He did not object in the least to being watched, his concentration was sufficiently secure to remain undisturbed.[33]

Every time a letter arrived or the telephone rang, a thrill would go through her, as it signalled the electrifying possibility of something new and

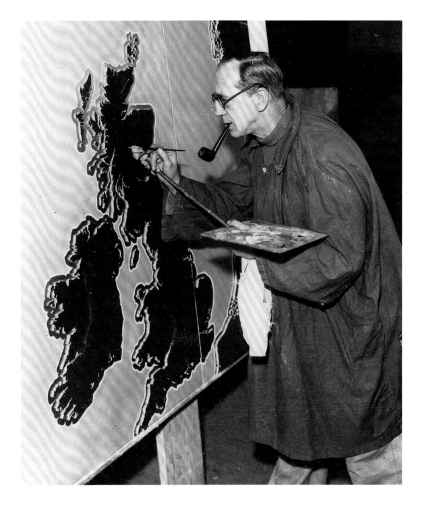

Max at work 'in an old green smock, with a pipe gripped between his teeth', 1935

exciting. And as soon as a job came in, Max's creative mind went into action. She used to wonder where his ideas and originality came from:

> People used to say he was 'clever', as indeed he was, but to me the word always seemed inappropriate. Obviously he must have planned things in advance, but watching him at work, one had the sense of something bubbling up spontaneously, an outpouring of that vitality that constantly expressed itself in some unexpected way … His mind was uncharted. The question of how it worked was not a subject that interested him … he was complicated and simple at the same time & child-like in his irresistible desire to topple the solemn conventions of life and make them absurd.[34]

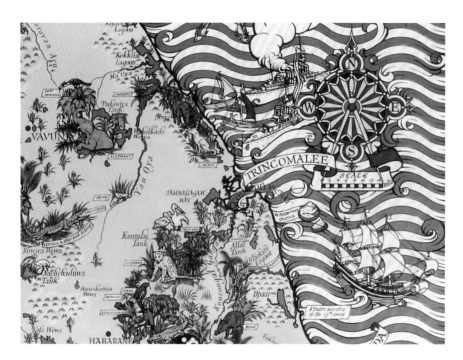

Detail from *Map of Ceylon showing her tea and related industries,* poster for Ceylon Tea Propaganda Board, 76.2 × 50.8 cm, 1933

The first map Priscilla helped him create was commissioned by the Ceylon Tea Propaganda Board (CTPB), a quasi-Government body funded by the large tea companies, such as Lipton's, to promote tea buying and drinking across the British Empire. This was at a time when increasingly efficient growing methods had boosted production while sales were in decline due to the rising popularity of coffee and soft drinks. The CTPB was headed by Gervas Huxley, who had previously worked on the poster committee of the Empire Marketing Board and had seen Frank Pick's methods at first hand.

To learn more about the island, its historic sites, fauna and flora, Max and Priscilla sought the help of expert John Still, who had spent much of his life in Ceylon, first as a tea planter and then as an archaeologist. He showed them photographs and described where elephants and other creatures could be found, how the local people lived, and where ancient sites such as Sigiriya were located, and at the end of the afternoon they took away a pile of books about the country, including Still's own, *The Jungle Tide.* The map was finished at West Wittering just after Christmas and Max wrote to Priscilla: 'You can't think how happy I felt, this morning too, checking your colouring and adding-in portions of colour we hadn't time to discuss. I'm glad "P" got in to strengthen the bottom right corner.'[35]

Of all the year's festivities, Max loved Christmas and always created a magical day for family and friends, observing the usual family rituals and adding in the unexpected to delight the assembly. He explained:

> … always I shall hear the rustle of the Christmas stocking paper – to me it is one of the abiding joys of having been a child – of being perhaps one still? A mystery that cannot be explained, a hiatus between the two worlds of actuality and fantasy, an intimate proof that among hundreds of semi-slumbering children the Santa Claus of another mysterious world has not forgotten you …[36]

Max in the smock hand-embroidered by Priscilla, c. 1934

Parted from Priscilla that Christmas, he nevertheless enjoyed the day, hosting a party of fourteen for the festive meal with his sister Gladys and other relations joining them afterwards. Priscilla's gift to him – finished some weeks later – was a lovingly hand-embroidered painting smock.

Max's compulsion to be with Priscilla was an encouragement to take time off work. Judging from Priscilla's friend Mary's comment that he was looking fifteen years younger, this was having a rejuvenating effect on Max. Appointments were organised to justify longer periods in London and short business trips were extended to create opportunities to meander in the countryside with Baird. That autumn Max also took the bold step of taking Priscilla to visit his daughter Anne at her boarding school in Abingdon. After meeting her, Priscilla declared that 'she was as charming a child as ever I met' and that evening when she and Max were in bed she said: 'if this is the sort of thing you can do I'd like to have one myself.'[37]

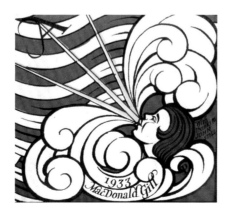

Detail showing the head of Priscilla Johnston from *Map of Ceylon showing her tea and related industries*, poster, 1933

219

CHAPTER TWENTY

Cambridge: Painting the Poles
1934

I<small>N 1934 M</small>AX AND P<small>RISCILLA</small>'<small>S</small> lives were dominated by a major commission to paint maps for the Scott Polar Research Institute in Cambridge. This had been founded primarily by the efforts of its director Professor Frank Debenham, a geologist on the ill-fated Terra Nova expedition to the South Pole on which Captain Scott and his heroic team had lost their lives so tragically in 1912. Designed by Herbert Baker, the new building was funded by public subscription in their memory. Max was to create two 4-metre-diameter maps of the Arctic and the Antarctic inside the domes in its entrance hall, each recording all the major expeditions to the Polar regions up to the present day. After much work on the designs in the studio, the actual painting began in May.

Priscilla's memoir and diaries give insights both into Max's working practices as well as the couple's relationship. She wrote: 'We drove down

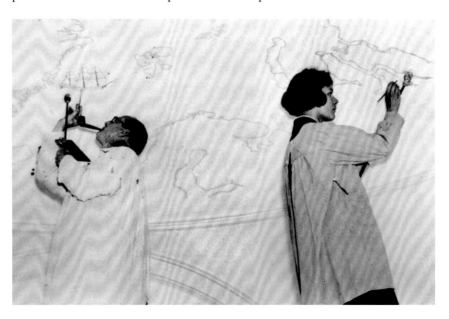

Max and Priscilla painting
The Arctic map at the Scott
Polar Research Institute, 1934

to Cambridge with Max's old leather Gladston [*sic*] bag full of paints, pallets, brushes, maulsticks & all the rest, also our overalls & for me, the trousers I had bought for working on scaffolds.'[1] These consisted of solid boards resting on a framework of wood poles so

> when working near the centre one felt completely secure but to reach the outer parts of our dome meant leaning over the gulf beyond the boarding. At first this made me shudder, the floor seemed such a very long way away ... Time did wonders in enabling one to adjust to an existance [*sic*] up in the air.[2]

Although Max was an old hand at working up at such heights, even he had the occasional accident: here at Cambridge his foot slipped through the boards in the final weeks of the job leaving him with painful – and debilitating – bruising.

The first map to be done was the Arctic. The lines of latitude and longitude were marked out with a pencil attached to a long string fixed to a drawing pin in the centre. Then land masses and pack ice edges were outlined with the help of experts of which there was no shortage – in fact almost everyone in the building seemed to be an expert eager to give advice. Each expedition ship was painted at the furthest point it was thought to have reached and the name of each expedition leader was inscribed around the edge of the map in gold. The earliest shown is Pytheas, the Greek who made a remarkable voyage in a small vessel in 325 BC, sailing up between Greenland and Spitzbergen to reach what he thought was the end of the world. In contrast to this is the depiction of Amundsen's 1926 crossing of the Arctic in the airship *Norge*.

The map of the Antarctic illustrates Scott's ship the *Terra Nova*, and also Shackleton's vessel *Endurance*, shown trapped in the pack ice in 1915, and the tiny *James Caird* carrying the explorer a small crew towards South Georgia in search of help and rescue for the remaining party marooned on Elephant Island.

Priscilla's first job was to paint the white background, but later she was also allowed to colour the waves, the pack ice and the mountains, leaving Max free to concentrate on elements requiring greater skill such as the ships and lettering. She was a novice at map-painting so in the early weeks her brushwork did not always come up to Max's high standards.

Ernest Shackleton's ship *Endurance*, detail from *The Antarctic* map, Scott Polar Research Institute (The Polar Museum), Cambridge, 396 cm diameter, 1934

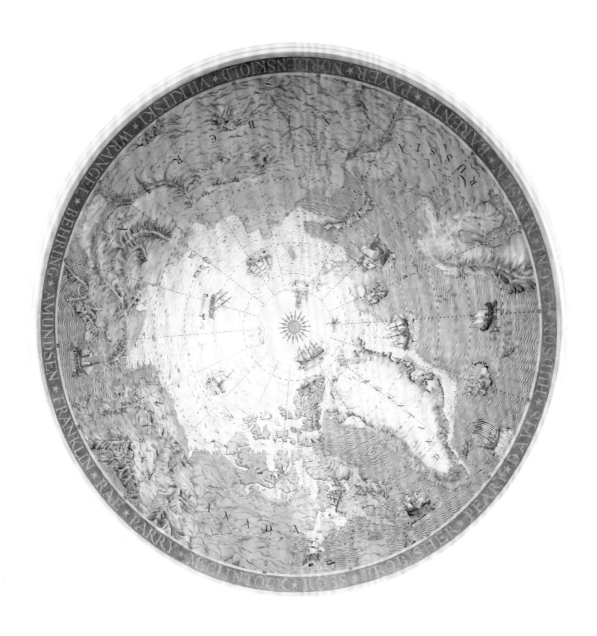

The Arctic, Scott Polar Research
Institute (The Polar Museum),
Cambridge, paint on plaster;
396 cm diameter; 1934

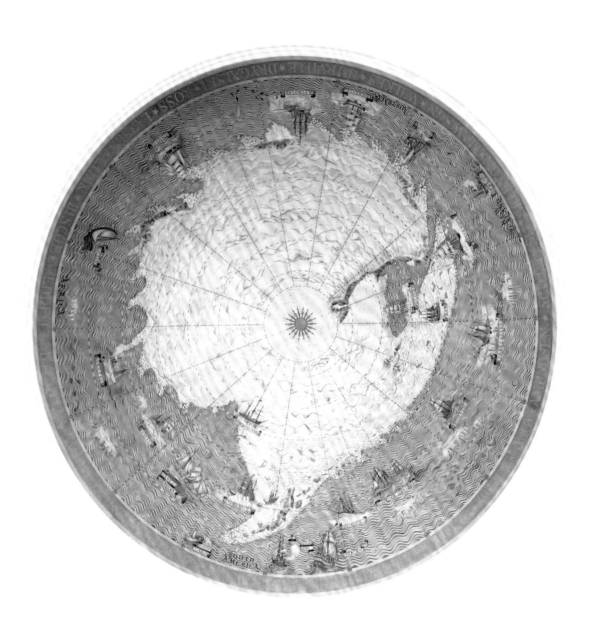

The Antarctic, Scott Polar Research
Institute (The Polar Museum),
Cambridge, paint on plaster,
396 cm diameter, 1934

He would criticise in ways she found both irritating and even hurtful:

> He brooded over me & gave me advice, ('I shouldn't do that, dear. Really dear, I shouldn't do it like that') until I thought I should scream. So I said, 'How nice it was here yesterday afternoon!' and he took offence & went to the Museum to draw.[3]

And when she painted an area of sea that was not to his liking he painted it out so 'destructively' that she felt the impulse to 'fling down her brush and rush from the skaffold [*sic*]'.[4] When she tried to talk to him about his attitude, he accused her of not being genuinely interested in his work 'but merely shamming', a criticism which he knew to be untrue; deeply hurt, she burst into tears and left the scaffold.[5] They usually made up quickly and such incidents were forgotten by the evening.

He did often pay her tribute and sometimes he recognised his failings. His work, however, tended to take precedence over almost everything else, as he acknowledged in a letter to her:

> Thank you so very much for so many things – even whilst I may at times be work-selfish. G.B.S. in his 'Cpt. Brassbound Conversion' makes the Capt. understand that even in his zealousness to work lies gross selfishness … meantime we are happy – save for these constant separations – more happy than I could have dreamed it possible a year and a few months ago – before I re-met you – before I knew you. My darling, my darling.[6]

As the weeks passed Priscilla became more proficient and there was thankfully no further cause for complaint. Working together on the scaffold settled into a rhythm, as she explained:

> We worked in an almost cloistral silence most of the time, in a mutual but separate concentration which, as the long hours crept by, seemed to insulate us from the outside world. When we stopped to look & rub an aching arm or neck it was almost like waking from sleep. Time was measured by the church clock down the road which played a few notes at every quarter building up to the whole phrase before striking the hour. This unfailing musical accompaniment contributed its own poignantly evocative flavour to the atmosphere of the time.[7]

Overall, their time in Cambridge was happy: Max and Priscilla revelled in the freedom to go about together as they pleased. Most people assumed they were a couple; on one formal occasion they were amused to be announced as 'Mr and Mrs Gill'. They also enjoyed working at the institute where Debenham's secretary Betty Creswick ran a 'hospitable office', where everyone in the building was welcomed. The place was also enlivened by a party of young explorers who were preparing a three-year Antarctic expedition to Graham Land in the ship *Penola* under the leadership of John Rymill. Max and Priscilla would go down to the River Cam to watch them learning how to roll kayaks. There was never a dull moment. Away from their work, they wandered the Backs, laughed at the hilarious antics of the students at May Balls, saw a number of productions at the Festival Theatre and were supper guests with a host of Cambridge acquaintances including Professor Debenham and Sydney Cockerell, director of the Fitzwilliam Museum and an old friend of Priscilla's father.

Priscilla was much amused by Max's response to overheard conversations in a café where they regularly had tea. The same two schoolboys would often sit at an adjoining table and gossip about 'how Bardswell was a sneak & … Grey, who was "hopeless" had brought a ferret to school'.[8] After many such sessions, Max enquired where they went to school. Priscilla recalled Max's conversation with the pair:

> 'Do you happen to know a boy called Bardswell? You do? Oh, he's in your form – fancy that! … I hear he's a bit of a sneak but I don't suppose it's true, what do you think?'
>
> The boys exchanged startled glances and asked if he knew their schoolmate, but Max continued: 'There's a boy called Grey. Isn't he at your school too? Hopeless sort of chap – all those stories about him & his animals.'
> 'What stories? they asked, 'What animals?'
> 'Wasn't there a story about his taking something to school – what was it? A hamster? No, wait a minute – wasn't it a ferret … & let it loose in Mr Palmer's class?'
> 'Look, do you know him, Sir?' they burst out.
> 'I've heard something about him', said Max absolutely truthfully.[9]

Priscilla was not Max's only assistant on the Polar maps. While she was in London, Kingswell came for a few days, and later Priscilla's sisters Bridget and Barbara also lent a hand for a short time. John Gill – now eighteen years old – also helped for a while but quickly realised that working with

Upper section of the Atkins panel at St Michael & All Angels Church, Bude Haven, Cornwall, oil on wood, 1944

his father was not for him.[10] Even with this extra help the maps were not completed until 6 November, two weeks after the public opening of the library by King George VI.

Funded by an anonymous benefactor, the two maps eventually earned Max £350, some of which went to his various assistants. In July Max had still been worrying about 'those horrible debts'[11] while Priscilla noted that 'orders for maps keep pouring in but "still there is no money in what is called the till". They all seem to want & expect to get maps for about £50.'[12]

Meanwhile, Max's job at St Michael & All Angels in Bude Haven was underway. The extensive refurbishment here had been commissioned by the Reverend Cuthbert Atkins, who had been the vicar at St James Church in Edgbaston a decade before, where Max had been responsible for many improvements. One of Priscilla's first tasks at the Temple in the autumn of 1933 had been to paint the plans of the Bude Haven church. There was to be carved wood panelling over the lower walls, a set of new pews, carved prayer desks, painted panels for the Children's Corner, a painted altarpiece, candlesticks and aloft there was to be a rood cross. A commemorative window was also commissioned from Veronica Whall, daughter of the great stained-glass craftsman Christopher Whall.

The work entailed many visits over the years providing the perfect excuse for Max to take Priscilla away. In September 1934 the couple drove down for the dedication service. Although the vicar was welcoming, she felt extremely ill-at-ease staying at the vicarage: 'I was

afraid … I hated arriving there. I felt I was losing him & that a vicarage was no place for me & it was all so dark & gloomy. Because they were all church people I felt he would be with them against me.'[13] Priscilla was not religious in the slightest and was always bemused at his behaviour when in a church. Some years later, after a tour of the church in Buxton where Max was to paint a panel, she wrote: 'He [Father Lancelot] & Max kept bowing this way & that & doing things with Holy Water … I was simply consumed with embarrassment … and yet I felt so rude & boorish, disregarding their ritual.'[14]

The Bude Haven scheme, which took over ten years to complete, involved several visits a year. Priscilla recalled one occasion when Max was asked to prolong his stay by a day but was reluctant as he had an important appointment in London the following afternoon. He was persuaded, however, when told that he could catch the Padstow to London express from a station near Bude in the morning. On discovering the next day that the train would not be stopping there, he told the stationmaster that the train must be stopped on account of the importance of his appointment in London:

> He spoke of Lord This and Field Marshal That & the Viceroy of India & the Home Secretary, but they were all people for whom he actually was doing work. The only thing that was not strictly accurate was the impression he managed to convey that all these dignitaries were waiting in London for the chance of work with him.[15]

The train was duly ordered to halt and Max climbed on. A guard soon searched him out in an empty compartment and wanted to take down his name whereupon 'Max looked up from his papers with an air of faint surprise "I'm Gill, Gill of London",' and the guard, duly apologetic, crept away.[16]

In the summer of 1934 Max was contacted by Manchester Collieries, a large Lancashire coal-mining firm, which wanted an impressive map for their head-office. They negotiated hard and, despite Priscilla's misgivings, Max finally agreed to do it for £150. The map showed the firm's pitheads, wharves and coal-distributing centres around Lancashire together with the cities of Manchester, Liverpool and all the important towns of the region. It is full of quips in local dialect, as well as pictures and vignettes highlighting local customs, historic figures and events. Next to Chorley, for example, where a series of reservoirs had recently been built, a local

Detail from *A Map showing the Pitheads, Wharves and Distribution Centres of Manchester Collieries Limited*, location unknown, oil on canvas, 74 × 107 cm, 1935

GPO emblem, printer's proof, 1935

man says: 'Vast reservoirs here, but owing to t'drought I drink beer.' After the nationalisation of the coal industry and the subsequent closure of the firm's offices, the map disappeared and its whereabouts are unknown.

On the day the collieries map was due to be finished, Muriel made a rare visit to the studio and the two women came face-to-face for the first time since 1931. She arrived clutching three bunches of violets bought, she said, from a 'miserable-looking little man instead of taking a taxi, so that he might have some lunch'.[17] They chatted about cats and kittens and Priscilla thought her 'very sweet and very like Mary [Max's daughter]'[18] and was troubled 'not because I felt that we were wrong – not even a little – but that she would think so & would be so much hurt. I liked her. She is a simple person & would become very boring I am sure, but a nice person, I thought, as far as it goes.'[19] Priscilla went home shortly after Muriel, leaving Max to work on the Manchester map till 5 o'clock the following morning. He then arrived at Priscilla's flat, let himself in quietly, crept into bed and slept until woken by Priscilla with the news that there was 'a deputation of four stately gentlemen from the GPO'[20] wanting to see him about the poster map he had been commissioned to design. He greeted them unshaven, but 'he made them laugh so much it did not matter'.[21]

The General Post Office were impatient for Max to deliver a map poster illustrating the Radio-Telephones network. In charge of public relations for the GPO was Sir Stephen Tallents, who had been secretary

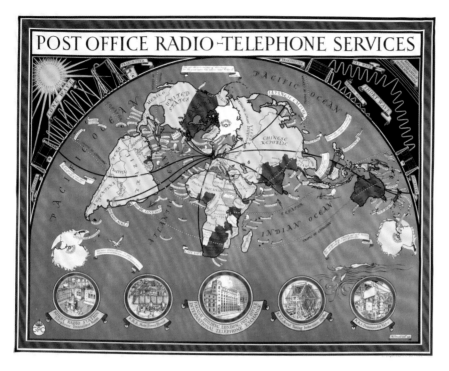

Post Office Radio-Telephone Services, poster for the General Post Office, 102 × 127 cm, 1935

of the Empire Marketing Board until its demise in 1933. He brought the skills and expertise he had acquired at his time with the EMB to set about rebranding the organisation. Max's first job was to design a new emblem. The initial idea was to produce a decorative design along the lines of the EMB logo but after some months it was felt that a more modern, cleaner look was needed. The final version, using Eric's Gill Sans letters, came into usage in the summer of 1934 and continued to be used until 1953.

Tallents was making full use of the media in an effort to bring the GPO up to date and to change public perceptions, commissioning events, films such as *The Night Mail*, and a poster campaign. The pictorial map Max was designing was to showcase the public radio-telephone system of which the GPO was justly proud. The service was based at Rugby Radio Station from where the first radio-telephone call had been transmitted across the Atlantic in 1927 using low frequency long-wave radio signals. Seven years later *The Times* wrote, 'Rugby was the centre of an extensive system of radio-telephone services, radiating from this country like the spokes of a wheel to the most distant countries of the world.'[22]

Just as *Highways of Empire* had celebrated the maritime trade routes linking the empire, now this map was highlighting

Aerial Tuning Inductance, detail from *Post Office Radio-Telephone Services*, 1935

the global telephone pathways that were revolutionising international communications. Max explained the technology in simple pictures of pylons, cables and radio waves while five roundels depict equipment and locations including the Faraday Building in Central London, the Rugby Radio Station Transmitter Room and the Main Power House.

Max's refusal to discuss emotional matters continued to frustrate Priscilla and was a common complaint in their conversations and her letters to him: 'I could not get near you', she wrote in an undated letter of this time. Priscilla sometimes made life hard for Max to bear. More than once he felt threatened by her occasional romantic attachments. Her youthful enthusiasm coupled with her beauty and intelligence made her attractive to the opposite sex. And she was often drawn to good-looking and interesting men. At Christmas 1934 at a friend's party she had been charmed by Georg von Harten – a handsome young pianist – who declared: 'when she smiles it is "like the sunrise"'[23] and allowed herself to be invited for a drive in his 'marvellous Terraplane car'.[24]

On their return she invited him up to her flat. When he took her in his arms and kissed her, von Harten clearly thought – unsurprisingly perhaps – that Priscilla would be a willing partner. In fact, she was taken aback: 'I was a fool,' she wrote, 'I must have given him a wrong impression … and then Von H did not attract me physically.'[25] Despite this admission, she found him fascinating and saw him again on a number of occasions. She finally came to her senses when she met his wife at the post-recital party at von Harten's home. After Mrs von Harten's warm and gracious welcome Priscilla thought: '… he was merely greedy wanting more. I shan't see him again … I felt a pang at his passing … once again I have been mistaken in a person.'[26]

A relation observed that 'her awareness of sexuality and its power was highly developed. She knew she could make men (and sometimes women) happy so easily and whether she used that power was very much up to her. Scruples didn't really come into it – jealousy wasn't a problem – she was sometimes startled to discover that it was a problem for other people.'[27] She found it impossible to comprehend why Max should feel this way and attempted to reassure him that he should not see von Harten as a threat. She told him:

> I am so different with him & should give him different things & in a different way – not our things … You know that his body means nothing to me, his kisses woke no faintest desire to respond, unless it were a mental desire to make the man happy

because he seemed in need of something. He left me quite cold, which you never did … I do not feel that these outsiders should need to cause so much heart-searching.[28]

Understandably, Max found it difficult to conceal his hurt, especially when she insisted on recounting her exploits. However, only too aware that Priscilla was twenty-six years younger than him, and afraid that if he did not go along with her wishes, he might lose her, Max reluctantly agreed that '"he would be prepared to lend me to another man, relying on my discrimination". That made me very happy & made life seem much simpler.'[29] His decision resolved the matter, at least for the time being.

In almost every other way Priscilla was the perfect partner, especially where his work was concerned. She was the most devoted assistant, dependable, enthusiastic, hardworking and becoming more skilled every day. Her understanding of the creative process had been nurtured since childhood and she soon acquired a formidable knowledge of the materials and techniques he used. She also understood implicitly that his work was more important to him than anything else in his life.

Apart from the joy of seeing Max skilfully draw or letter a map, Priscilla also loved the unpredictable situations that seemed to happen around him. In February of 1935 they finished the large cartoon for the flag for the new headquarters of the Royal Institute of British Architects. Barbara Johnston had come on deadline day to help. As soon as the paint was dry, the three of them plus the design piled into a taxi to the Portland Place building where the artwork was rushed into the committee room. Max and Priscilla took the opportunity to show Barbara around the splendid new building,[30] which had been opened the previous year by the King and Queen. Their tour took them out on the roof with Max saying, 'Just for a minute' and Barbara commenting 'How easily you get out here'.[31] There was a moment of horror when it was realised that the door had locked behind them. Priscilla recalled: 'It was very cold. We wondered about spending the night there & did not like the idea.'[32] Max sprang into action and without hesitation he climbed over the parapet, shinned down a drainpipe to another roof six metres below and disappeared. Then briefly in true theatrical style he 'appeared, bowed, kissed his hand, bowed again on the fire-escape and vanished',[33] minutes later reappearing at the door to rescue them.

There was also an adventure at Knebworth House in Hertfordshire. They came here in May after a session at the Scott Polar Research Institute to repair the paintwork and the gilding because 'the varnishing men had

washed out all we had done'.[34] Lord Lytton – Lutyens' brother-in-law – wanted the Rectors' Board in the estate church altered. After working on it for some hours in the magnificent library, Max and Priscilla were invited to take tea with Lady Lytton and the Earl, who had been showing some day trippers round. Most of them, he said, had been nearly blind. Priscilla commented:

> so blind that they left the field gate open & we saw a whole battalion of horses trotting down the garden … The Lyttons rose with a shout & a cry & dashed into the garden, we also. We ran to & fro horse chasing or horse hunting. They vanished in a wild bit among trees & presently came charging back on top of us, full gallop. They dashed away across the lawn throwing up huge clods of earth with Lady Lytton after them wringing her hands & saying 'That'll be the last flower gone – the last flower gone!' … I went away into the kitchen garden to escape her lamentations.[35]

After the hue and cry had died down and the horses presumably captured, Max and Priscilla continued their journey back to London.

Royal Institute of British Architects flag for its new headquarters in Portland Place, 1935

232

CHAPTER TWENTY-ONE

A Mural for a Queen
1935 – 1936

THE MOST IMPORTANT COMMISSION of 1935 had its origins three years
before. In early 1932 Max had been approached by Cunard to design
a painted map for a new ocean liner which was under construction
in the Glasgow shipyards. The liner was to be luxurious, furnished and
decorated with specially commissioned artwork and furnishings by
some of the top British artists and craftsmen of the day, including Dame
Laura Knight and Vanessa Bell. It would eventually rival the magnificent
French liner *Normandie*, holder of the Blue Riband, awarded to the
fastest passenger vessel on the Atlantic crossing.

There was some wrangling over the price to be paid for Max's map
panel. The Minutes of a Cunard meeting state:

1 Large Map looking forward 19' x 10', Gill proposed the fee of
£950 for this piece whilst Cunard stated that they would be happy to
pay £500.

2 x maps on large uptakes, 11' x 5', Gill proposed the fee of £700,
whilst Cunard suggested £400.[1]

Construction of the RMS *Queen Mary* had begun in December 1930
but twelve months later all work ceased due to the national economic
crisis and for over three years it rusted in the Glasgow shipyards until a
government loan was granted in early 1934 and work began again. After
the liner was finally launched on 24 September 1934, she was fitted out
and furnished.

On 27 February 1935 Cunard contacted Max again. Priscilla wrote
that it was 'celebrated as Cunarder Day. We had a Cunarder cake for
tea. We were excited – but only £500 – that isn't enough.'[2] After some
wrangling Max's *Map of the North Atlantic* was officially sanctioned
by the Cunard shipbuilding committee in May when authority was
requested for a payment to Max of £850 for the 'map on for'd wall'.[3]
The news was received with great relief by Max and Priscilla who both
felt it would solve his money problems once and for all, allowing them
to set off on a five-week holiday in Portugal feeling optimistic.

CUNARD WHITE STAR LINER "QUEEN MARY" THE WORLD'S LARGEST LINER.
Length, 1,018 ft.; height from masthead to water-line, 250 ft.; from top of funnels to water-line, 130 ft. Tonnage 75,000. Speed exceeding 30 knots. The largest and fastest ship in the world. Accommodation for 5,000 passengers. Launched at Clydebank by Her Majesty The Queen, 26th September, 1934.

Postcard of the RMS *Queen Mary* sent by Max to his godson Peter Gill, 1936

This was the third consecutive year they had holidayed together, and Muriel was furious. A week after his return from Portugal, she and Max climbed up to Chanctonbury Ring, a mysterious prehistoric fort on the South Downs, where they had traditionally celebrated their wedding anniversaries. On this, their twenty-first pilgrimage to this romantic spot, Muriel confronted Max telling him bluntly how deeply unfair it was that she and the children had not had a holiday for three years. She also expressed her anxiety that her place in his life was being taken over by Priscilla. Unused to such plain speaking from his wife, Max was embarrassed and – unusually for him – at a loss for words, and he blustered about their no longer being young twenty year olds needing holidays.

He was convinced that Muriel had been encouraged to speak out by his older sister Enid who had already accused Max of having a mistress, which he had vehemently denied. He was certainly not prepared to give Priscilla up but neither could he admit to his affair and risk divorce and its repercussions. His response to the situation is a rather damning illustration of his apparent lack of empathy for Muriel and his inability to understand her plight. They walked away from their old trysting place with nothing resolved.

Max had already begun a preliminary watercolour sketch for the *Queen Mary* map and now had a meeting with the firm responsible for the liner's interior to discuss his design. The basic content was approved but the company had decided the colour scheme needed changing. Priscilla despaired:

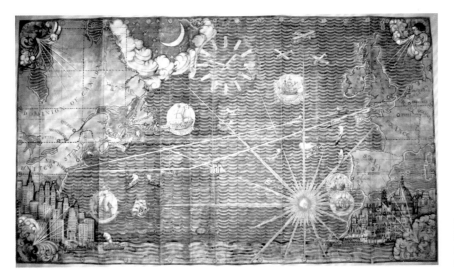

First design for *Map of the North Atlantic* for RMS *Queen Mary*, watercolour on paper, 80.5 × 160.0 cm, 1935

We went round to see Mr Whipp of Mewes[4] & Davis [*sic*] about the Cunard panel. They now want the land black with vague brown clouds in between. To me it sounds quite hopeless. I feel it's a mistake … However, Max is quite happy about it, & that is what matters, after all. I suppose he can visualise it, which I certainly cannot.[5]

As a commercial artist, Max was used to bowing to his clients' needs – it bothered him little. In fact the colour change proved to be an improvement as it integrated the map perfectly with the art deco furnishings of the wood-panelled First Class Dining Room.

At the end of October 1935, after the final designs had been approved and the panels cut to size and prepared, Max, Kingswell and Priscilla started work. At 7 metres by 4 metres, the map was far too large for Max's Temple studio, so space was made at the enormous timber store at Hammersmith belonging to Waring and Gillow's, who were supplying the ship's furnishings. Lines of longitude and latitude were first marked out by Max and Kingswell 'with a piece of string, rubbing the string with chalk, holding it at each end, pulling it away in the middle and letting it fly smartly back'.[6] Next, outlines of land and cloud were drawn from tracings, and then the first paint was applied. Kingswell endeared himself to Priscilla when, rather than telling her directly that she was doing something badly, he would say 'That's a bit tricky, isn't it? I sometimes find it helps to do it like this.'[7] The trio settled into a 'pleasant strange routine,[8] each focused on their own particular piece of map, only interrupted by the

Overleaf:
Map of the North Atlantic, RMS *Queen Mary*, oil on wood, 396 × 732 cm, 1936, RMS *Queen Mary*, Long Beach, California

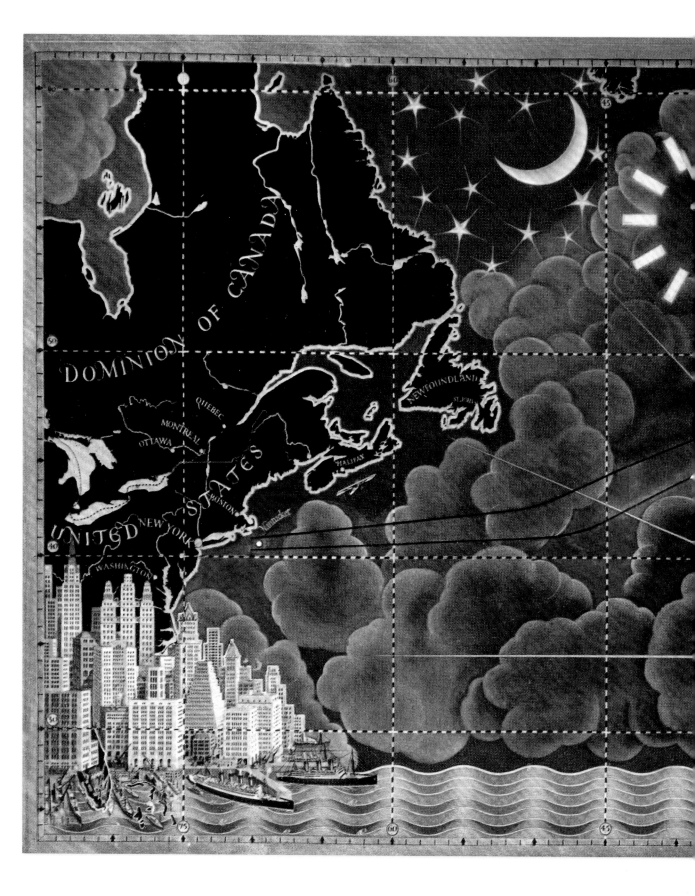

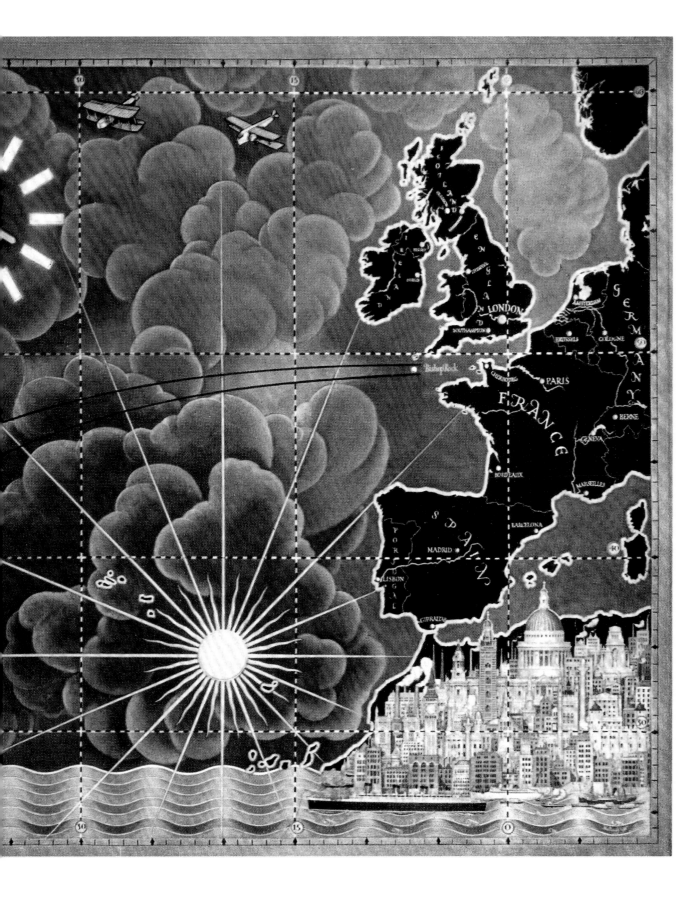

Painting the *Map of the North Atlantic* at Waring & Gillows timber store in Hammersmith. Left to right: Priscilla Johnston, William Kingswell and Max Gill, December 1935

porter bringing cakes from his wife and forays to the nearby Glenthorn Dining Rooms. At this 'Pull up for Carmen'[9] as Priscilla described the transport café, they would play games of 'Corinthian Bagatell on the pin tables',[10] after eating hearty lunches washed down with mugs of tea.

Max concentrated on the two city scenes, which contrast the Old World and the New – London with St Paul's Cathedral as the centrepiece on the right and New York with its cluster of skyscrapers on the left. The panel would be electrically lit from behind to produce a dazzling sun, glowing moon and twinkling stars and an illuminated clock. Two tracks were cut across the panel to mark the summer and winter routes of the ship, and on these a crystal model was to be electrically propelled between the Bishop's Rock lighthouse and the Nantucket lightship. When the RMS *Queen Elizabeth* came into service in 1946, a second model was added so that passengers could see the relative positions of the sister ships.

At the beginning of January – before the map was taken up to Glasgow – there was a party at the warehouse to celebrate its completion with guests ranging from Max's affluent professional associates down to the humblest of friends and relations. The friendly porter was most impressed: 'a very nice class of person you had last night, some

very nice cars here!', though as Priscilla said: 'our own friends had probably come by tube and done us no credit at all.'[11]

A few days later Max, Priscilla and Kingswell travelled up to Glasgow to finish the mural. When they saw the liner in John Brown's dockyard for the first time, they were astounded: she was gigantic, towering above even the tallest buildings. On the dockside they were met by a manager who, after checking his watch, stopped them setting foot on the gangway. Just at that moment a whistle blew, the signal for swarms of men to come streaming down all the gangways for their dinner break. After finally boarding the ship, they were escorted into what Priscilla described as 'a strange enclosed world, windowless, a labyrinth of narrow gangways, where the opening of what seemed like quite ordinary doors could reveal dark, cave-like spaces: theatres, swimming baths, a chaple [*sic*]'.[12] Through a porthole they saw the curious sight of a herd of cows grazing in meadows right next to the Clyde and it seemed as if 'the ship had put to sea without our knowledge'.[13] By this time the painted panels had been fixed onto the for'ard wall of the First Class Dining Room and 'looked already as much at home as though it had been there always'.[14] Apart from minor repairs, the map still needed much work. Priscilla spent days painting in hundreds of tiny windows in the skyscrapers of New York while Max concentrated on 'emphasising the detail of his delicate painting of the principal buildings of London'.[15]

Priscilla recalled that she was the only woman working on board a ship with 7,000 men, indeed the manager had at first been 'chary of letting in a "lady"' on board'.[16] She was amused to find herself regularly under the scrutiny of 7,000 pairs of eyes when the workers crowded into the Dining Saloon to wait for the dinner whistle. The ship was also home to a population of mice which would make little rattling noises. Kingswell – thinking that Priscilla might be frightened by them – would throw matchboxes to scare them off.[17] In a moment when Max was absent, Kingswell confided to Priscilla that he was thinking of leaving West Wittering and finding a 'permanent' job – an indication that he was now being paid on a temporary basis. With Max now working more at Hare Court – assisted by Priscilla – Kingswell was becoming redundant.

The ship was unheated and the intense cold penetrated their exposed fingertips making it difficult to hold the paintbrushes. To add to their difficulties they would often turn up in the morning to find that their scaffolding had disappeared, taken away by electricians, carpenters or decorators all intent on getting their own work done. The map was far too high to be reached by any other means and sometimes whole days

went by waiting for its return or in the search for replacements. Priscilla could not fathom why Max was rarely ruffled: 'To see Max's precious time being continually wasted while he remained so calm about it & always saw the foreman's point of view & sympathized with his difficulties really maddened me.'[18] Someone once said to Priscilla, 'Max is awfully nice but don't you sometimes feel like knocking his head off?'[19] The scaffolding trouble once sparked a furious row between them and she was quite taken aback when for once 'instead of being cold & retiring into himself, [he] answered … in the same way'.[20]

Priscilla detested their time here. Glasgow in the winter was the opposite of Cambridge in the summer. She hated how dark it was in the morning and '… how dead it was at night. If we went to a cinema everything was closed when we came out and there was nowhere even to get a cup of coffee.'[21] The final straw was the theft of her handbag from their lodgings.

The hardships and hard work were worth it for the acclaim that followed. Pictures of the map appeared everywhere: on the ship's menu cover, in numerous brochures and news articles, and even on a 'cigarette-type' card which came in every packet of Mars Chocolate Ices. As a commercial artist Max was unconcerned at his work being used to sell a product but he understood that Priscilla found such usage 'rather sacrilegious – like showing your child in whom you are justly proud of and love to the public to find they exploit the beautiful dress she is wearing … Something that is personal and precious to oneself is suddenly become public property.'[22]

Max also painted an altarpiece for the ship's Anglican chapel. Although the original is now lost, photographs survive showing a simple crucifixion scene with three figures.

In late March 1936 Priscilla went down to Ditchling to see her mother, who had been ill for some time. A diary entry makes the observation about how such separations made reunions so hard: 'The trouble about our seeing each other is that it takes so long to get started. We have to get to know each other all over again every time.'[23] Their separation was to be longer than expected as Max fell ill in West Wittering and had to delay not only his return to London but also another trip to Glasgow. They were reunited on 4 April but the following morning, Priscilla's sister telephoned with the sad news that their mother had died the evening before, just hours after Priscilla had returned to London. The funeral was five days later. Max of course came to support her. She described him as looking 'young & pale,

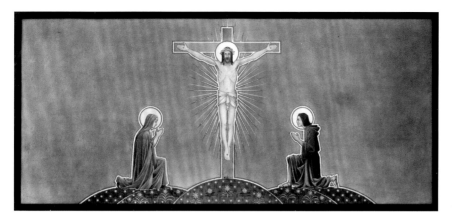

Altar painting for Anglican chapel on RMS *Queen Mary*, location unknown, oil on wood, 1936

beautiful & unobtrusive' and during the service 'his face was transfigured by prayer … lost to the world'.[24]

Max had been eager to see Priscilla as he had just received the proofs of the cover he had designed for her latest novel *Burnt Mallow*. He was also keen to show her his new car – a grey Standard 12 upholstered in blue and fitted out with all sorts of new gadgets. A few days later the new Baird was taking them down to Cornwall, to check some refurbishments Max was supervising at the parish church at Week St Mary. Journeys back from the West Country were often broken to show Priscilla work he had done long before such as the model village and farm in Briantspuddle. On another trip they visited Hampton Court to see the First World War Roll of Honour which had been commissioned by Mary Creighton's mother and at Richmond he showed her the reredos statues and parish hall decorations at St John the Divine. She was also taken to Darwell Hill, the Sussex house Max had built for the eccentric Harold Heal, where they were welcomed most hospitably.

In May 1936 on their way to visit Eric, Max took a surprise diversion to Nashdom, now a Benedictine monastery, to show Priscilla his very first painted map. She thought: 'It was funny – the colour laid on very thick, darkened with age & not stippled – patchy green parks showing all the brush marks, but a nice map and much in the same stile [*sic*] as the later ones.'[25] On reaching Pigotts, the Gills' home in Buckinghamshire, they found the whole family assembled, including 'squads of brats' and Max's sister Madeline, who was in England on leave from her missionary work in Poona in India, and whom Max had particularly come to see. Priscilla's attention became diverted by the conversation between Eric and a young woman: 'E. talked to the girl most of the time, she complaining of her job & he trying to solve the problem of industrialism. It

Heraldic tapestry frieze, Old
Council Chamber, Coventry,
unveiled 1936

was funny to listen to them as his remarks were all general & theoretical
& hers entirely personal.'[26] When alone with Priscilla, he asked: 'What
are we to do with the discontented lady?' and she thought he was 'really
worried about her, he is such a sweet person'.[27]

Three days later they were on the road again, this time to Coventry
where Max had been asked to give a speech at the reopening of the Old
Council Chamber at St Mary's Hall after its restoration. The centrepiece
was Max's tapestry frieze, woven at the William Morris looms at Merton
Abbey, which included the coats of arms and emblems of the English
monarchs. Max disliked making speeches and had insisted that Priscilla
come and 'hold his hand'.[28] Despite his nervousness, however, he put on
a good show in front of all the dignitaries, who included the Mayor, Mr
Pridmore, the instigator of the scheme, as well as the managing director
of Morris & Co., Henry Marrillier. Max opened by proclaiming that 'it
was a propitious day. "For has not the *Queen Mary* sailed today? Has not
Mahomed won the Derby?"'[29] Priscilla noticed that 'people pricked up
their ears at this as news of the Derby had only just arrived & they had
not all heard of it' and Max continued, 'she's a very fine ship & he is, no
doubt, a very fine horse, but where will they be in 500 years? But the
work you are doing, will be here in 500 years.'[30] His words went down
well, much to his and Priscilla's relief – she too had been 'ridiculously
nervous but enjoyed it & thought it good'.[31]

It was Priscilla's turn to be in the limelight the following month when
her novel *Burnt Mallow* was launched to considerable acclaim. It was chosen
by the *Daily Mail* to be its Book of the Month and in one edition of the
paper, an entire page was devoted to a review under the heading 'Young
Woman's Story of a Wife's Sacrifice'. Described as 'a novel of extraordinary
balance & understanding', the narrative focuses on a woman who sacrifices

her own happiness by allowing a divorce so that her husband can marry another woman. Divorce was a subject that was very much in the minds of both Priscilla and Max. In the hope, perhaps, that she might identify with the main character, Max presented his own wife with a copy of the novel for her birthday. It was a cruel gift. She could not have avoided noticing that the book was dedicated: 'To MacDonald Gill.' Priscilla, for her birthday later that year, received from him the framed artwork of *Burnt Mallow*.

As a present for designing the cover she bought Max a new suit from Savile Row as she disliked the ones he usually wore. By all accounts, he often sported clothes with a Bohemian touch, such as a purple waistcoat or his trademark black cloak; a niece commented: 'Max seemed to me so picturesque, with his broad-brimmed black hat – his pastel colored shirts – pale blue – pink, I believe acquired in Brittany. Ahead of his time in the late Twenties at least for a professional man who operated out of Hare Court in The Temple.'[32] She also said: 'Uncle Max was the Gill uncle with the most charm – he was so whimsical' and like many, she thought Max must have baffled 'poor Aunt Muriel, who always seemed a little breathless – and left a few paces behind'.[33]

Max's London friends and acquaintances were by now accustomed to seeing Priscilla at his side but for propriety's sake their true relationship could not be openly acknowledged. Although attitudes towards her varied enormously, all were unfailingly polite, and most were friendly. Max's older sister Enid, however, was in regular contact with Muriel and was indignant at his treatment of her. She rarely missed an opportunity to goad her brother into admitting the affair – without success it must be said. After an evening at the theatre with Max, Priscilla and his brother Vernon, who was visiting from Canada, the subject turned to holidays and Enid pointedly asked Max where he was going, and Priscilla was astonished at hearing him say 'straight out "I'm going to Ireland with Priscilla". The others were too polite to comment & after a moment's silence the conversation turned to other topics.'[34]

On the first leg of their journey to Northern Ireland on 21 August, they dropped Max's younger daughter off in Stratford where she was to stay with a schoolfriend. Fourteen-year-old Anne – who adored Priscilla – gave her father a shock when she nonchalantly said that 'she thought it quite natural that if a man found someone else with interests in common … for instance, people working together like your Priscilla',[35] they should be together in a relationship. When he related this to Priscilla, he said: 'She doesn't know.' But Priscilla replied knowingly: 'She soon will.'[36]

Burnt Mallow dust jacket, 1936

After overnighting in Chester, they reached Liverpool the next morning in plenty of time to do a little sightseeing before boarding the overnight car ferry to Belfast. First they went to admire the half-built Anglican cathedral but were far more excited by Lutyens's new Roman Catholic cathedral. Priscilla wrote:

> … is most impressive. Only the crypt so far being built. Its domes heaving out & the earth at your feet like half unearthed Egyptian ruins. It is to be 4 times as big as St Paul's, the man said. We went down into the crypt and wandered round & it was fascinating. I never saw domes being built before, bricks layed in a wooden curved frame: under construction.[37]

Over the next two weeks Max and Priscilla enjoyed the wilds of the Antrim countryside taking long, often strenuous, walks across stony hillsides and boggy moorlands, climbing up waterfalls, exploring caves on the rocky coastline, sketching landmarks such as the Round Tower on Devenish Island, getting soaked in rainstorms and making love in the heather. As always there were occasional misunderstandings and misbehaviour. Once Max took umbrage when Priscilla told him he was behaving 'like an obstreperous small boy who didn't know where to draw the line'[38] and he drove off leaving her by the side of the road, before returning a few minutes later, to her great relief. Their voyage home was also memorable. Shortly after leaving port, the ferry began to pitch and roll as a gale – 'the worst since February'[39] – swept across the Irish Sea. Max and Priscilla 'tipped from side to side of the bunk, quite unable to sleep', and 'every now and then came a CRASH from somewhere outside or the sound of piles of dishes or baskets of cutlery upsetting'.[40]

Despite their sleepless night, they took the opportunity in Liverpool to visit the Cunard offices and on the drive south they called in at the Minton Hollins factory in Stoke-on-Trent to discuss the tile map Max was doing for the Employers' Liability Assurance Corporation based at Hamilton House on the Embankment in London.

Shortly after their return, Max took Priscilla down to West Wittering at the request of Muriel, who had just read *Burnt Mallow*. It was five years since Priscilla had been there with her friend Mary Pigott and then in very different circumstances. They arrived just as the architect Oliver Hill was leaving with an astonishing entourage comprising 'a professor, a schoolmistress, 2 children, two dogs and a monkey'.[41] After supper various young friends dropped by to see Anne and there was

Hamilton House tile map, London, plastic-made enamelled white tiles – painted and fired by Minton Hollins from designs of Max Gill 203.2 × 264.2 cm, 1936

naturally much interested discussion about Priscilla's novel. Muriel made the ironic comment that 'it seemed completely real to her while she wasn't reading it, as well as when she was'.[42] The remark seemed to have little effect on Priscilla, who was marvelling at seeing Max at the centre of home life. Having assumed that he would somehow be different at South Nore, she was surprised to find that 'he was exactly the same'.[43]

The following day Max showed her the harbour and they visited clients in the village of Slindon, and later while he worked in the studio, she typed his letters. In Max's absence one evening, while she and Muriel sat together by the fireside chatting about him and his mother, Muriel confessed her dislike of visitors. To her great credit, she neither levelled any accusations nor attempted any confrontations. Instead, throughout the entire visit Muriel behaved extremely graciously towards Priscilla and made her welcome in her home.

On their way back to London, Max and Priscilla drove Anne back to Hayes Court, the boarding school where she was now head girl, before making a quick stop at Hare Court to throw some painting items into Max's Gladstone bag in preparation for next morning's journey down to Bude Haven. The next day they were on the scaffolding painting the new Rood Beam and its statues.

Another major commission was a set of three large maps for Imperial Chemical Industries (ICI). These were begun in November at the Temple with Priscilla and Edmund Nelson squaring up the first big

canvas joined by Kingswell in December. Max needed all the help he could get as he had so much work, some already in progress including the large tile map for the Employers' Liability Assurance Corporation head office, and other jobs to be started, such as a Christmas card for the BBC, two more tapestries for Coventry and a 'nice job – Coronation routes',[44] commissioned by the publisher Odhams for the Official Programme planned for the crowning of Edward VIII.

The death of King George V had been announced in January 1936, while Max and Priscilla were working on the *Queen Mary* in Glasgow. His eldest son, the debonair and popular Prince of Wales, succeeded to the throne as King Edward VIII and preparations were set in motion for his Coronation at Westminster Abbey on 12 May the following year. The new king, however, was in love with American divorcée Mrs Wallis Simpson and on 1 December 1936 he announced that he wanted to marry her. The public, who until now had only heard rumours of this relationship, was enthralled by the revelations of this clandestine royal love affair. The country was split – everyone had an opinion. Priscilla – ever the romantic – wrote: 'I was all for the king…',[45] as was Muriel, who happened to be up in town. Max, on the other hand, believed that 'self-sacrifice wd. be a finer thing & that he should give her up'.[46] The nation was shocked when the constitutional crisis that followed forced the King to abdicate on 10 December. Max had already begun the Coronation routes map but now it seemed unlikely that it would be needed.

BBC Christmas card, 1936

CHAPTER TWENTY-TWO

Paris and the Glass Maps
1937

A COLLECTIVE SIGH OF RELIEF swept the country when George – the next son in line to the throne – reluctantly agreed to take his brother's place and it was then decided to continue with preparations for his Coronation on the date already planned.

Although Max's map for showing the tours of Edward VIII was now redundant, Odhams still wanted Max to design a centerfold map of the procession route for an amended Official Coronation Programme. In early January 1937, the publisher also asked him to produce a title page for the programme that would feature the coats of arms of the United Kingdom and Dominions as well as the badges of the Crown Colonies and dependencies. It was short notice at a time when Max had a great deal of other work, and the design of this – as well as a coronation telegram for the GPO – led to what Priscilla called 'The Coronation Rush'.[1] The intricate artwork for the title page was completed in just four days, a feat only achieved with the help of an artist commandeered

Coronation procession route map, Official Programme for the Coronation of George VI, 19 x 39 cm, 1937

Mail Steamship Routes, poster for the General Post Office, 102 × 127 cm, 1937

from the publisher. The programme was published in a standard version retailing at 1 *s*, and the de-luxe embellished with gold and bound with gold cord which cost 2 *s* 6 *d*. Nearly two million copies were distributed worldwide to book-sellers, newsagents, schools, hospitals, municipal authorities and businesses, who presented thousands to their loyal employees and clients. Over one hundred thousand were ordered by the United States alone.[2]

To add to the workload, the GPO were also requesting two more posters: one to highlight the modernity of its postal service and the other to show the country's network of wireless stations. *Mail Steamship Routes* depicts the journey of a letter from the post-box across the Atlantic with a street scene that includes a postman in his smart new uniform with its restyled cap and the very latest Morris Minor Eight mail van. Never able to resist an opportunity to include a ship, Max managed to cram in a set of eleven roundels illustrating vessels through the ages, from an Anglo-Saxon longship to Isambard Brunel's gigantic iron steamship SS *Great Eastern* and the RMS *Queen Mary*.

The second map poster – *Post Office Wireless Stations* – is a good example of Max's whimsical way of problem solving. The multitude

Post Office Wireless Stations,
poster for General Post Office,
102 × 127 cm, 1939

of radio masts he had to illustrate needed to be placed in their proper locations up and down the country, but on the usual map orientation of the British Isles the masts would obscure each other. The solution was simple – Max simply turned Britain on her side, instantly allowing plenty of space to display each mast separately without overlap. The poster was published in 1939.

Other work in the pipeline included a panel map of Hertfordshire for the new County Hall at Hertford, a commission from the architects James and Pierce that would eventually earn Max the much-needed sum of 300 guineas, two more tapestries for St Mary's Hall in Coventry and house plans for his son John and his wife-to-be Pam, for which her father Dagmar Ells was paying.

Most exciting of all, however, was a request from the architect Grey Wornum, who was in charge of the design of the interiors of RMS *Queen Mary*'s sister ship RMS *Queen Elizabeth*. At a dinner party in February 1937, Wornum had turned to Max and casually asked: 'Have you got any ideas for the new Cunarder?'[3] When Max replied that he had not been asked, Wornum responded: 'Well, there's no one else but you', and went on to praise the *Queen Mary* Map as 'magnificent – the most magnificent

thing on the ship'.[4] When Priscilla heard, she was equally thrilled although neither could have known that this job would not actually happen for another nine years.

A full workbook, however, seemed to do little to allay the 'frightful money famin [*sic*]'[5] that still afflicted Max. In January his bank manager had refused to extend his overdraft and was advising him to sell South Nore. Although Max agreed with this drastic measure in principle and had begun talking of building a smaller house – even discussing it with Muriel – he did nothing. In May he attempted to see Edward Hunter in the hope of a small loan to pay for another holiday to the South of France but twice Hunter refused to see him. Disappointed, he returned to the Temple and told Priscilla the bad news. To his surprise, she said that she would lend him the money: 'so that was all right, but I felt so angry with Hunter,' she wrote, 'that it took a long time to get over it.'[6]

When the last of the three ICI maps was finished, a celebratory Private View was held at Hare Court, which involved much 'clearing & tidying the room & pinning up posters & book jackets & things'.[7] Max and Priscilla hosted a crowd of over two dozen including Stephen Tallents, now with the BBC, fellow architects Oswald Milne and Charles Cowles-Voysey, artist friends such as Mary Creighton, Maresco Pearse and Louis Ginnett, Max's bank manager, Mr Anderson, and an array of other friends and relations. Two days later the canvases were taken to Olympia where Max and Priscilla installed them at the ICI stand ready for the opening of the British Industries Fair on 15 February.

At the opening of the British Industries Fair, they were particularly keen to see Oliver Hill's model of the British Pavilion for the 'Exposition International des Arts et Techniques dans la Vie Moderne' to be held in Paris later that year. Max 'thought it "amusing" that he had not been asked to contribute, & was not pleased with O.H.'[8] so when Hill rang up three days later asking him to design two maps for Imperial Airways for the Paris show, Max was pleased.

Hill wanted 3-metre diameter glass disc maps to illustrate the airline's network of routes across the eastern and western hemispheres. Glass was a new medium for Max and although he was to have 'a free hand'[9] with their design, he would have little control over their making, which would be done by a specialist firm.

With the Paris show due to open on 25 May there was little time, yet Imperial Airways seemed unable to decide on basic details. A succession of entries in Priscilla's diary reveals the frustrations. On 16 March she complained: 'yesterday came the very tiresome news that Imperial

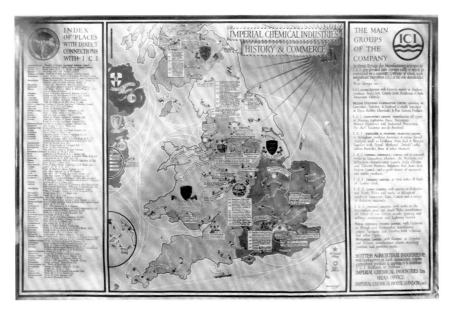

ICI History & Commerce map, oil on canvas, 251.5 × 167.6 cm, 1937, location unknown

Airways don't know how their American routes are to go + can't have America on the map. So all our week-end's work was wasted & we had to start again',[10] and in mid-April when Imperial Airways wanted more alterations, she wrote: 'they aren't nice to work for',[11] and a day later she bemoans the fact that they 'still don't know the size'.[12]

With deadlines rapidly coming closer, Max decided to spend a weekend at South Nore working on the drawings for these and the first of the two GPO maps assisted by Priscilla and her sister Bridget. Once again Muriel was most gracious towards Priscilla, who learnt some odd facts about Max. She was 'electrified', for example, at hearing that 'Max makes up poetry in bed in the mornings',[13] but Priscilla was also 'maddened by her complaints of the house – the kitchen wrong, water heating, windows, cupboards, & everything – & – always the cry of "I'm not going to have it in the new house" & always the party manners & party smile for the visitors but not so for Max. I got so angry'.[14]

Another house guest was Hugh Hunt, a school friend of John Gill's, whose parents lived abroad. He had spent nearly every school holiday at South Nore and considered Muriel as a second mother. Priscilla had been told that he was 'something of a menace' but at the start of her stay she 'found him a sweet creature'.[15] When she returned the following weekend, however, she found him alarmingly transformed. Someone, probably John, had clearly enlightened him about Priscilla's role in Max's life and he was now in a state of rage. Priscilla – in her naïveté –

was completely unable to fathom his hostile attitude as her diary shows: 'Hugh, alas was in an awful state of anger & defiant bluntness, for no known reason, which lasted … throughout my visit & rather spoilt the feeling of it.'[16] She was discomfited too by his stares and his 'mischievous grin with a touch of malice'.[17] His malevolence reached its zenith after lunch one day when she asked him: 'Is there anything I can do? to help wash up, & he said "Yeah – fall downstairs & break your neck".'[18] It is remarkable that she continued to be mystified about the reason for his vicious comments, noting in her diary: 'something made me think that wasn't only badinage.'[19] Max too seemed to be in a state of denial, reassuring her that Hugh's bad mood was simply because the girl he was attracted to was now going out with another young man. Priscilla was eventually enlightened by her more worldly-wise, older sister Barbara.

Tensions in the house had been compounded by John's forthcoming wedding to local girl Pamela Ells. Daughter of a wealthy businessman, she was quite a catch. His wedding gift to the pair was two acres of prime land to set up John's plant nursery, an allowance until the business got on its feet, a car and a new house designed by Max. Unfortunately, John was having serious doubts about the marriage but with wedding gifts already arriving at the house, the arrangements all made and expectations running high, he could not bring himself to call a halt to the proceedings. Muriel was deeply worried about her son but Max seemed to be less concerned and, unwilling to be involved with such emotional drama, would have been relieved to return to London.

The designs for the glass maps were now finished and shown to Imperial Airways who then demanded a multitude of amendments. Then followed a bizarre impasse. The London Sand Blast Decorative Glass Works could not find out the exact size of the discs from the glass company, which had received the order for the panes but also did not seem to know the size; meanwhile the frame-makers knew the size but would not divulge it. Eventually, however, the measurements were given so the designs could finally be finished and sent to the glass works. Here the glass discs were first to be sculpted by the sandblasting process to show the topography of the continents and the waters of the oceans, and then coloured with transparent dyes. Max and Priscilla spent an enjoyable visit at the works to see the process:

> … masking material covered the surface of the glass & was cut away on the parts to be sandblasted. The circular sheets of glass were laid flat on a kind of a giant table & girls climbed onto it

& sat on the glass to do the work. The management modestly provided screens to go round them in case too much leg was displayed as they climbed on & off their place of work … this arrangement caused much entertainment in the factory.[20]

Due to the delays, the first map was only completed in early June, some weeks after the deadline. But Max and Priscilla were both pleased with the results: she declared that the maps looked 'perfectly lovely … splendid … the blue is so beautiful and so is the red'.[21] When both discs were ready, they were to be transported directly to Paris where Max and Priscilla would see them on their way to the South of France.

Max and Priscilla had been in Paris in mid-May with Ralph Ellis, a painter now best remembered for his hotel and inn signs. They were there at the request of the Department of Trade to organise the repair and painting of Mary Adshead's broken 'gastronomic' glass map of the British Isles which was in the Buttery, the British Pavilion restaurant.[22] When they arrived at the vast exposition site in the area around the Eiffel Tower, they were astonished to find the place, with just four days to the opening, 'in an incredible state of frenzy and the British Pavilion inside consisting simply of steel girders, & heaps & heaps of boards & wires & bits of this & that strewn about and a multitude of men'.[23]

The three painters worked during the day but then were free to wander round the exposition site to marvel at the remarkable structures and objects produced by other nations. They also tasted some Parisian nightlife, first with a visit to the Folies Bergère, where 'Josephine Baker was the chief attraction – & a very attractive attraction she was too … a lovely body, & very clever & versatile too'.[24] Priscilla's opinion of the Mayol – known for its nude revues – was critical: 'second rate and rather crude … They kept saying "You will be near the stage, you will see everything – everything!" and so indeed we did – too much in some instances.'[25]

Only a handful of the exposition buildings were finished. The most memorable were the German and Russian Pavilions both of which seemed to symbolise the tensions gripping Europe at that time. Priscilla observed:

> Across the river from us … Germany and Russia confronted each other in what one could not but feel to be uncomfortably defiant attitudes. Germany had its eagle on the top of an immensely tall tower, as if determined to be uber alles. Russia, opposite, was a low building further dwarfed by a couple of

young giants on the roof striding aggressively towards – as it happened – Germany. In 1937, with all Europe on tenterhooks, this did not seem a happy augury.[26]

Despite its underlying philosophy of Peace and Progress, the exposition was pervaded by feelings of mistrust and suspicion: little technical information about inventions was forthcoming, and visitors were stopped from sketching or taking photographs of exhibits. This may explain why there are no photographs of the glass maps. Long after the event, Max wrote to Imperial Airways asking about the fate of the maps and if photographs had been taken – but no response exists amongst Max's surviving papers. There is no trace of the maps today – perhaps they shattered on their journey back to Britain – their fragility was evident at the time. Just one tiny, tantalising scrap of artwork survives to convey a hint of their beauty.

Fragment of proposed design showing Papua (where Romney Gill was a missionary) for one of the Imperial Airways glass maps, watercolour on tracing paper, 1937

A few days before Max and Priscilla set off for France in mid-August, Muriel made a desperate appeal to her husband. This anguished conversation – held in front of their daughter Mary and her boyfriend Lewis – was recorded in a letter from Max to Priscilla. Every argument Muriel put forward was rebutted with lame excuses:

'I wish I was coming too', she said, 'perhaps you'll take me to where you are going – to the S. of France?' to which I replied: 'yes, it's possible, but when will my ship come home,' but, said M 'you ought to be able to afford to take me away: you have plenty of work on haven't you?' 'Yes, but I'm not

sure if one doesn't get really more of a holiday by going off on one's own!' M. 'But P. is going with you!' 'Oh yes, but I mean – away from the household chores and references to domestic problems.' M. 'Well it's not as tho' you lived at home always! You are just as much away as at home. Most husbands take their wives away with them!' 'Yes, of course,' said I, 'but it doesn't say it's the best holiday – the necessary complete rest' and so it went on until she finally left the room.[27]

As usual, Muriel's arguments made not a bit of difference, but Max felt some embarrassment at the scene being witnessed by Mary and Lewis and felt the need to justify himself: 'To them I was obliged to add – "This much at any rate – that to go away with someone who is interested in painting and drawing and reading and poetry – which are my life – insures a real holiday in advance. I'm not going to make comparisons" They seemed sympathetic.'[28] That evening Muriel sat at the piano and asked Max to accompany her on his violin, to play the air 'Lulli', which they had first heard on a family trip to Rouen. He wrote: 'I felt all the time it was deeply pathetic as it was all too too late: too late by four or is it five years?'[29]

A week later he and Priscilla were on the boat train to Paris where they hoped to see the glass maps in situ. On arriving at the Imperial Airways stand, they were appalled to see only one of the glass discs and after making enquiries, they discovered that the other had been broken at the glass works, had been remade and this too had broken in transit. A third had just arrived and was about to be installed that evening.[30] Once in place the pair lit up the Imperial Airways stand with a 'natural brilliance'[31] and were declared a 'great addition'.[32] Max had found the experience of the new medium 'enthralling',[33] although Priscilla felt that once again Max had undersold himself, only receiving 105 guineas for a job that not only had been immensely frustrating but had also taken an inordinate amount of time and energy.

After Paris they journeyed on southwards to Porquerolles, an unspoilt forested island sanctuary where they enjoyed three weeks of sunshine, sea and secluded beaches. Max came back refreshed and relaxed. In the months ahead he would need all the energy he could muster for the pile of work awaiting him back in England as well as the emotional battles that were playing out at home. He and Priscilla settled back into the usual work routine at the Temple, back to the GPO wireless stations map and a tea map depicting the three main tea-producing countries in the empire: India, Ceylon and Java.

Outwardly, little seemed to have changed but in Max's private life everything was heading in one direction. Both he and Priscilla were mentally preparing themselves for the big moment when they would be able to live together permanently. That June Priscilla had written that she was 'more resolved to marry him if ever it shall be possible'[34] and even imagined having his child. Now, with Max's daughter Mary about to leave home to study music in London and with talk of the house being sold, the couple dared to talk of the time when they could be together. Priscilla wrote: 'things are tending one way … one period – & it has been a happy one, heaven knows – is drawing to an end … Well, I am ready – I am more than willing & it seems … that "everything's coming my way"'.[35]

Most of the family friends in West Wittering now seemed to be aware that Max was having an affair with Priscilla. Many were scandalised and with sympathies tending towards Muriel's side, Max would sometimes be treated with coldness or barbed comments. Muriel had been right in her accusations – Priscilla was now, in effect, his London wife: darning his socks, caring for him when he was ill with flu and giving him homely advice when she had to leave him to go down to Ditchling to look after her father:

> But please Lambie, take care of yourself … I know how difficult it is to take one's health seriously but you know when men work the way you work they generally keep right on till they're almost sixty or sixty-five & then just drop down dead … BUT NOT FOR YOU – because I want you, darling, please & you mustn't leave me – not for a long, long time.[36]

With Priscilla, Max also experienced, perhaps for the first time in his life, true sexual fulfillment. She was an emancipated and uninhibited young woman and it was often she who initiated their love-making; indeed she wrote that 'it is an enchantment & delight & it is a most profound thrill to feel that I am able to stir him & to carry him into a forgetfulness of all but me'.[37] He was deeply in love with her and they were, for the most part, blissfully happy together.

Priscilla also became Max's financial saviour. Money – or lack of it – was still a constant worry for Max. But in the autumn of 1937, Priscilla's aunt died, leaving her the sum of £3,000, and she offered him a loan of £1,000 to pay off his debts. Despite his protestations she insisted, and this led to an excited conversation about how it might enable him to separate from Muriel sooner than they had expected. He began speaking of divorce and said with resolve that 'it was this year that rabbits were to become

Opposite:
A Great Industry: Where Our Tea Comes From, poster for the International Tea Marketing Expansion Board, 127.0 × 63.5 cm, 1937

256

A · GREAT · INDUSTRY
WHERE·OUR·TEA·COMES·FROM

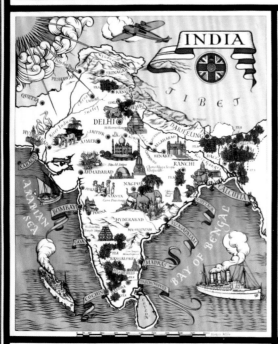

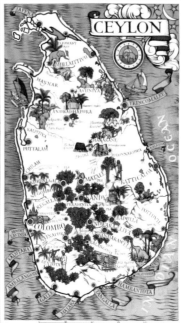

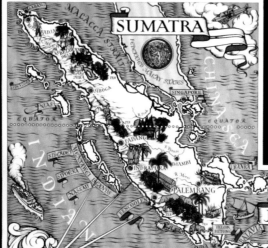

He-men', to which she responded: 'I rather want you to marry me.'[38] Max was 'knocked out' at this declaration, so taken aback that he could not even light his cigarette. He told her he would speak to Muriel soon, but already he foresaw that religion for her might be 'one possible serious snag'.[39] Religion was surprisingly not the sticking point for Max that Priscilla had anticipated: '[he] said he did not consider that original marriage … valid because it had never come to perfection – to real fulfillment… "she has never been in my heart as you are, darling".'[40] Priscilla wrote in her diary that this was 'possibly about the most momentous discussion of my life'.[41] When he wrote to her three days later from South Nore, Max was still ecstatic:

> Darling – your exciting piece of news of last Thursday night fills my thoughts while I work even among the waves of the 'Home & Country' map I sail along so happily – thinking – thinking – and saying 'Dear Priscilla' … now all things seem possible and very soon now – sweetheart – I shall have a proposition to make – I had to weigh up so many things … My heart is too full of love for you to seek expression by words – in this letter – all I say now is 'Good Night Beloved' and 'May God Bless You always'.[42]

The following Saturday evening, after arriving back from a week away, she let herself into the Temple studio and finding Max not there decided to surprise him. She undressed, climbed into bed and waited in the dark. She heard him come in and watched him through the half-closed door pottering around the studio for a few minutes before he came into the bedroom. She wrote:

> He stopped dead … and neither of us spoke … he knelt by the bed & took me in his arms so thrilled to have me back … he warmed a rug and put it round me & took me to the other room … we sat before the fire and talked. He made quite a long speech about how long we had been together & how happy we had been, ending with the words 'I wonder if you think you could ever marry me' so I said 'Yes', and then we got very thrilled … & he said 'now we are engaged'.[43]

He presented her with a gift – a little silver jug. The conversation then turned to the future – perhaps the first time they had dared to discuss plans for a permanent life together – and 'after that we made love …

& he said "Do you love me? Say it" & I said "I love you, my darling" & he gave a sort of groan & clutched me to him … & we went to sleep in each other's arms'.[44]

Max's decision was now made and, of course, Muriel would have to be told. But he wanted to wait until he felt the circumstances were more favourable – when Mary and Anne were more settled and the house could be sold freeing up money for the inevitable costs of a divorce. Priscilla's journal reveals that Max did begin telling those close to the family that changes might be afoot. She recorded Max's conversation with Mary's boyfriend Lewis, to whom Max said that 'after Christmas he might have things to discuss with all the family … he wanted L to understand a little how the land lay. L said they were all very fond of me [Priscilla] & thought it most natural that she [Priscilla] shd go about with me [Max] when in London.'[45]

Max celebrated Christmas with his family at South Nore. Priscilla, meanwhile, had gone home to Ditchling to be with her father and sisters. A celebration of sorts was also held when Max and Priscilla reunited on 30 December at the Temple. Here they began by 'going through all the files and throwing masses of them away – the same thing as Max has been doing at WW, & a fitting way of ending the old year – into the waste-paper baskets they all went'.[46] Max called it 'severing my connections'.[47] That New Year's Eve they partied hard at the London Casino, where they feasted on oysters, watched a cabaret featuring naked girls, a monkey and a camel made of two men and ended the night with 'riotous' dancing on the stage. At midnight, as the chimes heralded the beginning of 1938, Priscilla and Max both agreed: 'this is Our Year.'[48]

Aloes, Langoustier, Porquerolles,
watercolour on paper,
5 October 1937

CHAPTER TWENTY-THREE

This is Our Year
1938

JANUARY BEGAN WITH A ten-day separation as Max needed to be at home in West Wittering. With no reason to linger in London, Priscilla decided to spend a few days in Ditchling where she was able to confide her hopes and feelings to Barbara. She feared she was pregnant and was fretting that Max would react badly so sought her sister's sympathy and reassurance. In her own mind Priscilla had weighed up the options and rejected the idea of abortion, deciding that she would 'see it through,'[1] although she had reservations about sharing this new life with Max with a baby. In fact, she was worrying needlessly about Max: '… he feels it would be best … to have it … "it has come because we love each other so much," he said. He was adorable to me & I was very thankful I had told him & no longer had it on my mind.'[2] It turned out to be a false alarm but it did play a role in crystallising their thoughts on the possibility of having a family. Now they talked openly of having a child who might carry on Max's artistic work: '… perhaps a son may be ours: perhaps after all someone of my blood – our blood may carry on the art of map-making – into another generation …'[3] None of his three children had any such ambition.

Max would not be hurried into telling Muriel. In November the previous year he had talked of February, but when it came the date was postponed again. Priscilla wrote wistfully: 'I wonder when, if ever, we shall be able to declare ourselves. It seems to get further & further away, doesn't it?'[4] And she sometimes wondered about their compatibility:

> Max always said that Muriel did not give him 'intellectual companionship' & he said I gave him 'intellectual companionship' & that is exactly what I feel that he does not give me. He is so sweet, so interested & admiring (when not thinking of something else) & yet so incapable of reciprocation … to be married to him would be like being married to a charming child, much as I might love it I should sometimes want a grown up husband.[5]

But despite Max's shortcomings Priscilla still loved him deeply telling him: 'I am happy – very very happy, not only superficially … I believe in our relationship – in your capacity to give me something necessary to me – in a way that I never did before. I believe that we are on the same track, though our ways of following it may be different.'[6] For Max there was never any doubt that Priscilla was the love of his life and would ultimately be his companion for life: '… my work and you, my dearest, & you without my work somehow now are all one … this proposed act of "breaking away" is a step demanded of me. Of course, I shall miss much in local acquaintances…but this is nothing…or very little in comparison with the 'home' we are going to build.'[7]

Priscilla's inheritance had not yet come through and Max's debts were mounting. His ledger shows no payments received for the first three months of 1938, and he was struggling to pay the bills, both domestic and professional. Towards the end of January, Priscilla met Max's bank manager to discuss her possible loan to Max. Mr Anderson was frank and told her that Max's financial situation was not good and that 'it was a bad investment for a young woman'[8] and – until she revealed her true relationship with Max – he was extremely suspicious of her motivations. He was eventually won round, but the money would not be available for another few weeks leaving Max to charm Mr Anderson into extending his overdraft.

When Priscilla's money finally came, she proudly presented Max with a cheque for £825, thinking that would solve all his problems at a stroke. But her happiness turned to depression when she looked into his accounts and found that not only was there £400 in interest outstanding but also 'the bills – alas – come to more than was first thought – to about £600 … even [Veronica] Whall[9] can't wholly be paid. I had thought this would be an occasion for rejoicing … and I found I couldn't rejoice'.[10]

It was fortunate for Max that his children were no longer dependent. His younger daughter Anne – now sixteen – was studying at the Royal Academy of Dramatic Art (RADA) and currently performing in a production of *Children in Uniform* in London. Her older sister Mary had been working for family friends as a nanny but was about to embark on a singing course at the Royal College of Music with her fiancée Lewis Leslie. Luckily for Max, her godmother Lulu, Kenneth's widow, was paying the fees.

The two girls had grown up into independent-minded and attractive young women who both loved looking smart and fashionable in expensive-looking outfits. Unknown to most, Mary was an excellent seamstress who designed and made most of their clothes. This fooled

AVXILIIS·OLIM·STETIT·ALMA·COVENTRIA·REGVM·
DVM·FORTVNA·FVIT·MAGNOS·COLIT·HINC·EDOVARDOS·
HENRICOSQ·SVOS·VRBS·NON·INGRATA·PATRONOS·
IAMQ·ADEO·AFFLICTIS·CRESCIT·SPES·ALTERA·REBVS·
ELISABETHA·TVIS·PRINCEPS·MITISSIMA·SCEPTRIS·
LÆTIOR·ILLVXIT·NVLLO·PAX·REGE·BRITANNIS·
ERGO·AGE·DIVA·TVIS·SIS·FOELIX·CIVIBVS·VSQVE·
EXVPERANS·PATRIAS·ET·AVITAS·ÆMVLA·LAVDES·

Design for heraldic tapestry for St Mary's Hall, Coventry, watercolour on board, 9 × 27 cm, 1938

many people, even their uncle. After a talk Eric had given at the Bank of England, he, Eric, Denis Tegetmeier, Max, Priscilla and the girls all had supper at Roche's – 'it was great fun, a very gay party,' wrote Priscilla,

> Eric with Anne & Mary; both looking very charming, on either side of him … Afterward we stood at the corner of the street deciding to part and I heard a murmur from D.T. to E. '– financing these young ladies. It must take some doing.' E said it was awful to think of. Certainly M & A were looking more expensive than they are. The lightness with which Max gets off is astonishing.[11]

The last work on hand – the second Coventry tapestry designs – were finished in mid-March 1938 and celebrated in style with two evening cocktail parties. The first turned into a very lively affair when Anne arrived with a noisy gang of her fellow students from RADA, who 'kept together throughout', wrote Priscilla, 'stayed till the end, ate all the biscuits & were very RADAish'.[12] There was also a smattering of artist friends such as the sculptor Bainbridge Copnall, who had also been asked to contribute to the RMS *Queen Elizabeth*, as well as past clients including Frank Pick of the London Underground. Priscilla took an instant dislike to the businessman because, she said: 'His immediate reaction to anything is "That must be doing pretty well" or "There's no money in it".'[13] The following evening she would doubtless have been charmed to meet fellow writer Eleanor Farjeon, creator of *Nursery Rhymes of London Town*, which had been illustrated by Max more than twenty years before.

These occasions were always an opportunity to present Max's range of work to a potential commissioning audience and at this time his work prospects were looking distinctly bleak. His hopes rose after a meeting with

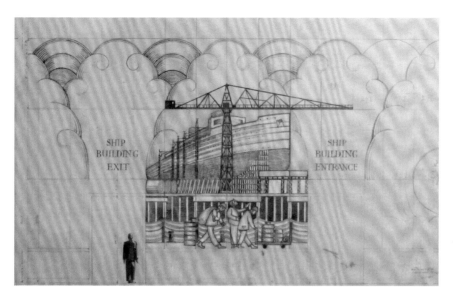

Shipbuilding, mural design for the entrance hall of the UK Government Pavilion, Glasgow Empire Exhibition, watercolour on paper, 69.5 × 55.5 cm, 1938

Herbert Rowse, who was designing the United Kingdom Government Pavilion for the Glasgow Empire Exhibition, the last of the great empire exhibitions. The architect was at his wits' end to find an artist to do the mural for the entrance hall having already rejected a number of designs. The meeting took place in Liverpool and Priscilla was so anxious to hear the outcome she dashed down to Euston to meet Max off the train:

> I was tremendously excited about the job & eager to know if he had got it … & then, round the sweep of the long curve of platform, in it came … then all the doors burst open & in a moment the whole long platform was lost in a seething crowd so that I thought I should never find him & then – there he was! That was typical. What he was looking for he found at once, unfailingly, whether it was one person in a crowd, or, as on one occasion, an earring in the heather … I was dying to hear Max's news. We went & lunched nearby & he told me all about it. The subjects of the four exhibition halls were to be Shipbuilding, Steel, Coal and Fitter Britain. In 1938 these subjects were far from having acquired the melancholy overtones that most of them have today … During lunch [he] outlined the plans which were already taking shape in his mind.[14]

Rowse had been 'charmed' by Max's sketch, which he thought showed an overall unity of design which the others had lacked.[15]

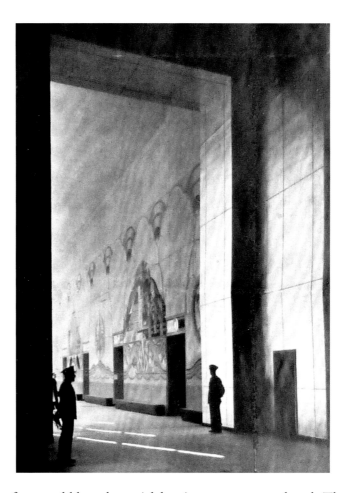

Entrance hall, UK Government
Pavilion, Glasgow Empire
Exhibition, 1938

The fees would be substantial, but it was a mammoth task. The mural panels would cover the entire wall of the entrance hall – 61 metres long by 9 metres high. In Max's design, each section had a large painted image and smaller roundel which corresponded to one of the four themes. With only a month before the exhibition opening, time was of the essence. The panels were far too big to be painted at the Hare Court studio so Max rented space at Lyndhurst's Scenic Studio in Lambeth and a team of a dozen painters was assembled: Kingswell, Priscilla, Max's daughter Mary, their sign-writer friend Ralph Ellis, Harold Nelson's nephew Edmund and an assortment of art students[16] from Goldsmiths College, the Central School and the Royal College, including a pair of lovers who seemed more interested in each other than in the painting.[17]

In the rush the youthful team lacked finesse, but they certainly made up for it with their enthusiasm. 'With so many students about', recalled

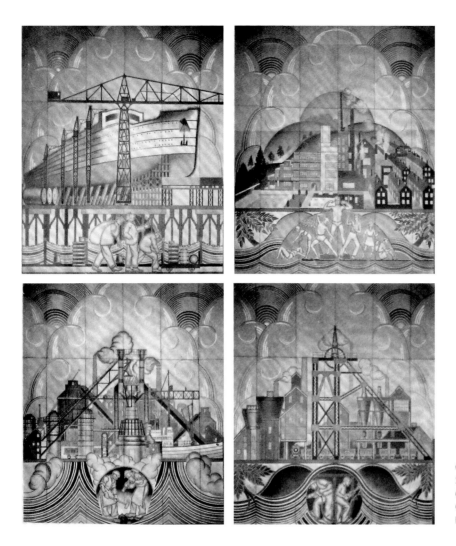

*Clockwise from top left:
Shipbuilding, Fitter Britain,
Coalmining, Iron and Steel,* UK
Government Pavilion, Glasgow
Empire Exhibition, 1938

Priscilla thirty years later, 'it was a very gay collaboration with much
by-play in the intervals. The boys used to charge about playing horses
with Adrene [*sic*] and Mary riding on their shoulders'.[18] As the urgency
increased, the team worked into the early hours, finally completing the
panels in a last desperate all-night session. The job had taken just three
weeks. Exhausted, dishevelled and looking like a 'gang of hooligans',[19] –
the entire team headed for a well-deserved breakfast at the Lyons Corner
House on the Charing Cross Road 'where they attracted a large audience,
mostly children – watching fascinated by the open door… "Gor blimey,
there are ten of 'em".'[20] Next day Mary lunched with the students who
unanimously declared 'how nice Max was to work for … the ideal

employer, friendly & yet just separate & willing to give other people's ideas a fair trial before turning them down'.[21]

The panels were sent on ahead to Glasgow to be installed, while Max and a handful of others were to follow a few days later. Max set out early on the morning of 27 April with Priscilla and Mary as passengers but had only reached the outskirts of north London before they suffered a near calamitous accident when they were hit head-on by a car whose driver, a young naval officer on his way home from an all-night party, had fallen asleep at the wheel. Miraculously, no one was hurt, just a little shaken, but they had to hire another car as the Morris was a write-off, delaying the journey by a precious half-day.[22]

The following morning they had their first glimpse of the exhibition site at Bellahouston Park. Priscilla described the UK Government Pavilion as 'very clean & light & gay-looking, white building & paintings … lovely, very dignified & imposing with big gold lions outside the door … Our paintings were up & looked very good – red along the bottom & around the doors & the gold grilles above help it … but … a good deal … is sadly rough'.[23] Kingswell agreed, lamenting the students' work on the clouds: '… they look all right from below – it's only when you get up a ladder that it makes you want to cry.'[24] But the offending parts were soon made good in time for the pre-opening evening. Reviews were universally positive. The *Manchester Guardian*'s report was typical:

> The frescoes are the jam, and jolly good jam too, when as in the long one by MacDonald Gill on a great corridor wall of the British Pavilion one sees them through the rectangular mechanical forms of a fifty yard modern range of windows, softening their lines and adding interest and intrigue in a most delightful way. These decorative adjuncts are the best thing about Rowse's great British Government Pavilion.[25]

One guest, however, seemed less pleased. The *Sunday Graphic* reported that a friend of Lady Elgin was complaining about the 'Fitter Britain' panel: 'That's no good to me! There's nothing about ping-pong!', but when Max standing nearby overheard this he swiftly painted in a table-tennis bat and ball and all was well.[26]

The exhibition, which ran from May to October 1938, was an enormous success, despite the looming threat of war. When it closed, most of the buildings, including the UK Government Pavilion, were torn down and only a set of black-and-white photographs, a handful of sketches and

a sheaf of newspaper articles survive to prove the mural's existence.

After this mammoth painting task had been completed, the team went their separate ways. Max and Priscilla grabbed the chance to spend a few days exploring Glencoe, Loch Lomond and the Scottish borders before heading for home. On their way south, they stopped at places where Max had worked years before, including Whalton Manor in Northumberland and St Andrew's at Roker. Priscilla admired the chancel ceiling here as 'a gorgeous subject … a very decorative & interesting thing'.[27] Two days later they reached Lincoln Cathedral where Max had worked in 1913. The Bellringers' Chapel was locked so they approached a verger who '… suddenly recognized Max with amazement & joy. He said "You were a very young man then Sir! Oh yes, you were a very young man!"' recounted Priscilla, who also noted '… how strongly marked Max's style was then – as it is also in the Whalton map'.[28]

At the start of June the post brought the final Glasgow payment. The total for the job was £900 before expenses that allowed a number of Max's creditors to be paid including Lawrence Turner who had carved the rood beam statues for the Bude Haven church. It was, unfortunately, only a temporary respite and the debts were soon rising again, sparking a row between Priscilla and Max which prompted her to storm off home. On arriving at her flat she found, miraculously, a letter on the doormat from her publisher enclosing a cheque for £400. Once again, she was able to bail Max out.

Another piece of good fortune came the following morning at a meeting with the architect Charles Holden, famed for his underground station designs. Holden wanted Max to paint a 2.4-metre by 3.4-metre map for his latest architectural triumph, Senate House, the iconic art deco headquarters of London University. The map was to show the location of the university's colleges and was to hang on the end wall of the Chancellor's Hall. On this first visit, Holden was eager to show off his pride and joy and took Max and Priscilla on a tour. Although they both thought it a splendid building, Priscilla became most frustrated when he 'took us all over the building … except the big room where the map is to go which rather seemed to take the sense out of the visit. We talked of anything & everything but business'.[29]

By June Max was seriously laying plans to separate from Muriel. He sought advice from his solicitor and asked Priscilla to look for a London flat with space for a studio. On 4 July Mary came to see him to say she and Lewis had decided to marry at a London registry office on the 16 July; it was a union much disapproved of by Muriel. Max wrote to

Priscilla: 'Now my dear, I either tell M. [Muriel] of our plans – so much more important and clearly devastating than theirs – between the 18th & 22nd or, no I don't think I'll introduce 'or'…'.[30] So, just three days after Mary's marriage, he told Muriel that he was leaving her.

Naïvely, he had thought that 'with the family around her in my absence she should see a certain reasonableness in our scheme even if the news is somewhat staggering … Perhaps she is more prepared than I think, perhaps the thought of a small contained house will appeal.'[31] He could not have been more wrong. Muriel was distraught. After working herself up into a state of uncontrollable weeping, she clung to him and begged him not to leave and threatened to kill herself, saying 'My life is over.'[32] The dramatic scenes continued into the early hours of that night and the next, with their frank but futile discussions being joined by Hugh and John, who was enraged and told his father never to come to his home again. Both Mary and Anne, however, adored Priscilla and treated her like a friend or older sister; they would go clothes shopping, do each other's hair, have dressmaking sessions together and exchange confidences – even about Max. They were in London when Max told them about the separation on 22 July. Their initial shock was quickly replaced by distress for their mother but also an understanding that the marriage was over. They could see that their father's decision was inevitable and irrevocable. Anne, ever the romantic, told Priscilla: '… the point is simply that he loves you.'[33] It is curious that, despite knowing their mother was deeply upset, neither girl rushed back to South Nore to be with her – they only returned some days later, leaving John to comfort their mother in her time of need.

A few days after Max had returned to London, Mary rang Priscilla saying that Muriel wanted to see her. After much soul-searching – and discussion with Francis Leslie, Muriel's doctor – she decided to go to West Wittering. Over the following twenty-four hours, she sat and listened to Muriel's emotional outpourings:

> She told me, then, about the story of her marriage, how she had started insufficiently equipped, not knowing much about marriage, and of how she had been ill, later, and how she had thought that M. did not want her – she had waited for him and he had not come. Each had misunderstood the other, each had felt unwanted, and each had waited for a sign … so she had spent her life in 'slaving' for him & now had nothing … It was all profoundly sad.[34]

She also talked of 'Max's "girl's" – he always had girlfriends, she said, if it was not one, it was another, so it had seemed quite natural that there shd be me. She seemed to feel I was just like another, like the rest'.[35] Priscilla made it clear to Muriel that the decision had been Max's alone and that she would not stand in his way if he wanted to change his mind. In a conversation the next day Muriel also told Priscilla that 'for her their marriage vows had been sacred & were so still & she cd. never divorce him',[36] but also added: '… if I were to die I would rather you should have him to look after than anyone, because I think you do understand him.'[37] Of Max's daughters Priscilla wrote: 'I was very deeply affected by their sweetness & their attitude to me.'[38]

Weeks passed before Max wrote to his siblings about the separation, citing the chief reason as the irretrievable breakdown of the marriage. He deliberately omitted all mention of Priscilla. The replies were unanimous in their condemnation of their brother's action, although some were more sympathetic than others. His favourite sister Madeline, the nun in Poona, although unable to condone his breaking of wedding vows, at least showed compassion and understanding with her words: 'Separation was bound to come at last, as things seemed to be … I guessed the incompatibility – the lack of response on M's part to you, creative and otherwise.'[39] The most damning responses came from his brothers. Cecil, the youngest, wrote: 'This idea of separation seems to me an insult to God and a betrayal of manhood and your own ideals.'[40]

His older brother Eric, who was conducting affairs with two women in the community at Pigotts at the time, wrote to a friend saying that 'brother Max is so virtuous by nature and so stupid and muddle-headed . . . that he prefers to cast M. adrift and break up the home … rather than have a love affair to go to confession about'.[41] To Max he wrote: 'your action is both astonishing & inexplicable. In fact, on the face of it, it seems both mad & bad … quite abominably cruel to Muriel … very bad for the children … completely unchristian.'[42] Hurt and hating to be at odds with his brother, Max met Eric at the Savage Club to explain his reasons more precisely. Eric's attitude apparently changed dramatically as he listened to Max: '… what struck him (& how Eric-ish)', wrote Priscilla, 'was the physical failure of the marriage. It seemed as though, to him that accounted for & justified everything. Only he thought Max should have continued the compromise – permanently, apparently.'[43] At their parting, Eric kissed Max's hand, a gesture that prompted Priscilla to comment: 'Still, it leaves one with a rather odd feeling about Eric. He is brilliant & charming, but is he sound?'[44]

Romney, once Max's dearest brother, never wrote nor spoke to Max again. His brothers could have learned a lesson from Edward Johnston, who responded to the news with a kind and touching message to his daughter:

> Broken marriages have (partly because of my very happy one) always seemed to me to be tragedies, but I have never presumed to judge anyone concerned … You may be assured that my love for yourself & my friendship for Max continue undisturbed, & that you will be welcome here or anywhere that I call home.[45]

The vitriol doled out by Max's family saddened him and infuriated Priscilla, but nothing they said would shake Max's determination to part from Muriel. In any case, his siblings had been told some time after the deed had already been done. There would be no going back.

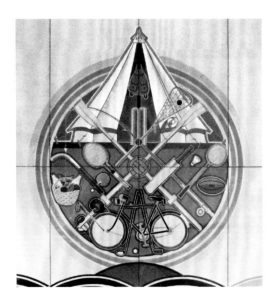

Sports equipment roundel for UK Government Pavilion mural, Glasgow Empire Exhibition, 1938

CHAPTER TWENTY-FOUR

New Beginnings
1938 – 1939

MAX WAS KEEN TO draw a line between his life with Muriel and his new life with Priscilla and two weeks after breaking the news to his wife, he ventured down to South Nore to discuss with her the division of the house contents. He was relieved to discover that she now seemed more reconciled to the situation and they managed to have an amicable meeting. There were also changes afoot at Hare Court, where the studio was being emptied prior to the decorators coming in to give the place a coat of paint. Then – as had become their habit – Max and Priscilla went on holiday to the South of France.

What had promised to be an idyllic three weeks turned out to be only a partial success. The first three days in Porquerolles were difficult, marred by Max's criticism of Priscilla's unsociability. His moodiness was exacerbated by a sad and pathetic letter from Muriel imploring him to change his mind; it would be years before Priscilla came to realise how much Max had been affected by the separation and its consequences. After that low point they began to enjoy the simple pleasures that the island had to offer: bathing on its deserted beaches, climbing up narrow rocky paths, crawling under wire fences and trespassing in private pine forests. Disaster struck in their third week when, shortly after arriving in St Tropez, Priscilla fell ill with a debilitating and painful bout of shingles. They returned home early and Priscilla was admitted into a nursing home to recover.

On 29 September the couple moved into 21 Joubert Mansions in Jubilee Place, Chelsea, their first home together. For Priscilla these early days of their life here were a novelty: 'like playing houses.'[1] For Max the feeling was more profound: 'I am so happy with a happiness and contentment – being with you – that I never knew before … And when we sleep, beloved, how peaceful it is – in one another's arms – away, far away from the worries of that day we have conquered …'[2] He even claimed that because of their new closeness 'my reticence is breaking down',[3] although his habit of a lifetime would be harder to break than this as Priscilla would soon realise.

Les Pins, La Grande Plage, Porquerolles, pencil on paper, 21 August 1938

The flat occupied the top floor of a rather dreary-looking Edwardian building but, as Priscilla's nephew remembered: '[it] had commanding views over the rooftops of Chelsea to distant landmarks like Battersea Power Station. I always remember the contrast between the dark and windowless corridor and suddenly stepping into a room flooded with light.'[4] With the addition of various oddments of furniture from South Nore and Priscilla's old flat, the place was transformed into a cosy and comfortable home. Priscilla recalled:

> In the studio Max had a large table with his drawing board on top, a big cupboard for storing paper, a Chinese cabinet and his piano. The sitting room was made homely with an Indian hand-woven bedspread in natural colours, rugs and cushions with covers woven at Ethel Mairet's workshop in Ditchling. And pinned on the wall was Max's latest Underground poster map of London. 'What riches it seemed to me.'[5]

Their relationship was now public knowledge and they lived openly as a couple; Priscilla even called him her 'husband'. Kingswell, who came to help on a map for the Cambridge Guildhall, was 'the same nice self … apparently taking everything for granted',[6] while Harold Nelson at the Temple studio simply told Max: 'Well, old chap, it's not altogether a surprise to me.'[7]

Old friends such as Ben Boulter, the Ricardos and Mary Creighton were – without exception – sympathetic and understanding. Mary admitted that 'it had surprised her when he married M & surprised that he kept it going – two sides, two lives, not in harmony'.[8] Priscilla's friends – who had known about her relationship with Max for years – all accepted Max without question. There were also new friends such as the Swiss–Argentinian adventurer and writer Aimé Félix Tschiffely and his wife, neighbours in Joubert Mansions, the actress Catherine Lacey, as well as Max's cousin Colin Gill, a well-known mural artist, and his wife Una.

Although Max's daughters were upset at the separation and the effect it was having on their mother, they were devoted to their father and were taking a mature and practical approach to the situation. Mary and her husband Lewis were renting a flat in nearby Earl's Court, where Anne also had a room, and the three would often drop in at Joubert Mansions. Anne became particularly close to Priscilla, who would lend a sympathetic ear when the teenage girl was having problems with one of her 'pale warriors',[9] as her 'endless' succession of boyfriends came to be known. By

December Muriel seemed more reconciled to her new situation. She was apparently 'so thrilled with her new house, furniture etc. that she has no time to be unhappy any more'.[10]

Max and Priscilla's evenings seemed to be one long round of private views, the latest films, West End plays, supper and drinks parties with their large circle of friends and acquaintances. Max still loved surprising people with his off-beam practical jokes. Priscilla recalled an evening when Max arrived at a dinner party with a noticeable limp. No question was asked until the end of the evening when he hobbled towards the front door, their hostess said: "You must come again" to which he replied: "I swear it on my sword!" at which point Max reached into his waistband and dramatically pulled out a full-length sword which had been concealed down his trouser leg for the entire evening.

The only dark cloud hanging over them was, as always, Max's lack of money. South Nore had been put up for sale for £4,000 in the autumn of 1938 but the property market, affected by the imminent international crisis, was in the doldrums. In some desperation, Max finally agreed to settle for the disappointing sum of £2,500. As soon as the sale was completed in February, a small mountain of debts was paid off, initially easing Max's overall money situation. Muriel had agreed to accept £200 a year – not much perhaps, but 'Max cld not dare to promise more'.[11] At a meeting at Goslings Bank the manager, 'kind & helpful' Mr Anderson, was forthright and urged Priscilla to take charge of the money and only 'allow Max … so much a week'.[12] But when she and Max sat down to work out a realistic budget, they were depressed to discover that by the time he had supported Muriel and Anne, and paid the rent for the flat and the Temple studio, 'there would be nothing left'.[13] On a brighter note, there was still a little work in hand including the continuing refurbishments at Bude Haven church as well as two large painted maps and a tea poster.

Their first Christmas together should have been 'a Gala Christmas' as Priscilla put it.[14] Although her father had told her that Max would be welcome at Cleves, her sister Bridget's grudging invitation had been 'coldly expressed'[15] and at one point shortly after the couple's arrival, she shut Max out of the drawing room leaving him alone in the hall while the others were upstairs. Unsurprisingly, Max felt like the 'not-too-welcome outsider'.[16] Christmas Day was a joyless occasion and he decided to return to London that same evening. Priscilla accompanied him part of the way along the snow-covered road in the dark to Hassocks station and 'parted from him in great distress'.[17] She was leaving herself the following afternoon but before she left, her father sat his daughters

Map of Cambridge, Mayor's Parlour, Guildhall, Cambridge, oil on wood, 193 × 152 cm, 1939

down in the sitting room and made a quiet announcement that lifted her spirits: he was to be made a Companion of the British Empire in the New Year's Honours' List.

Four days later Christmas was celebrated a second time – this time at Chelsea with Mary, Lewis and two friends – and suddenly Priscilla understood what Christmas meant for Max and what he had missed at Ditchling. After the ritual of distributing the presents, which had been piled under the tree, Max produced a basket containing a hat and proceeded to give a great speech, with gestures, before producing a roll of toilet paper and everyone was given lengths of this to fold and cut into paper patterns for a hat. Their guests told Priscilla later that 'it had been a real Christmas', 'so entertaining'.[18] She commented: '"That was Max" He is a lovely person to give a party with. He certainly shines as a host.'[19]

In the new year Kingswell, who had now set up his own practice, came again to lend a hand on a map panel commissioned by the architect Charles Cowles-Voysey. In June, after the usual celebrations, it was taken to Cambridge and installed above the fireplace in the Mayor's Parlour at the Guildhall. Max and Priscilla came to finish the panel in situ but as they tried to concentrate on the painting, they became increasingly annoyed by a stream of people wandering in and criticising their work. A

solution was soon found, as Priscilla recounts: 'we lock ourselves in, now, by the advice of the nice white-bearded clerk of the works (Howard) & the police (!) to escape the comments and suggestions of the Mayor & Corporation. This works very well.'[20] One of the worst critics was the mayor, who wanted a number of alterations including the 'arms of Cheshunt' but Voysey was completely on Max's side, saying in his 'quiet gentlemanly voice: "Of course, the real point is that it looks nice there".'[21]

Work on the University of London map for Holden was continuing and there was also the small county map panel of Hertfordshire to be painted for the newly built Hertford County Hall. However, the increasing likelihood of war with Germany was causing a widespread reluctance to spend funds on costly decorative works so other commissions were being cancelled. At the start of the year Max had been tremendously excited at the prospect of doing a 2-metre by 12.8-metre painted map for the new Bristol Town Hall – apparently 'the sum of £1200 was mentioned in passing!'[22] wrote Priscilla, but by the summer all hopes of this happening had faded. A map of Ruislip and Edgware for London Transport had even been begun and partly paid for, but it seems that this was never completed.

Map of Hertfordshire, roundel showing County Hall, Hertford County Hall, oil on wood, 106.7 × 91.4 cm, 1939

Early stage artwork for a map of the Temple area – probably for the London Underground, pencil and pen and ink on paper, c. 1940

Pick had also discussed two more pictorial maps, but after his departure from London Transport in 1940 there were no further firm commissions from the organisation, although an unfinished full-scale draft of a map of the Temple area discovered recently indicates that another was intended.

Although Max and Priscilla loved their Chelsea flat, they had often talked of finding a place in the country. Their search began in the early

summer of 1939 and within weeks they received details of a cottage near Midhurst in Sussex at the astonishingly low price of £200. A few days later, on their way back to London from Halnaker Park where Max had been finishing a large-scale Ordnance Survey Map for a Lutyens' client, the politician Reginald McKenna, they decided to make a diversion to see it.

Their expectations were low, and they had enormous difficulty finding the place, eventually being directed down a heather-fringed forest track. As they walked down the sloping path through dappled sunlight, they passed a small group of prosperous-looking men and women coming back up but thought little of it. At last the trees on the right cleared to reveal a derelict red-tiled cottage partially covered in ivy and surrounded by what had once been a garden but was now a jungle of evening primroses and nettles. The gutters were hanging off at precarious angles and on the front door someone had scrawled: 'RATS HOME FOR SALE 5/.'[23] Nevertheless, Priscilla was enchanted and even Max was charmed. The architect in him could see that the building was basically sound, and though it needed a great deal of work, it would make a perfect place for the two of them to live.

In high spirits they drove into Midhurst to ask the agent for the key, but he had bad news. One of the people they had seen on the track had put in an offer. For over a week Priscilla was in a dark depression, unable to get the magical cottage out of her mind. And then one morning a letter arrived at the flat. It was from the agents advising them that negotiations for the cottage had broken down and asking if they were still interested. They rushed down to Midhurst but were devastated to hear that the original buyer was looking over the place with a surveyor at that very moment and clearly intended to buy. Realising that they might lose the cottage all over again, they made a decision on the spot and announced: 'All right, we'll buy it.'[24] After a brief consultation with a colleague, the agent confirmed that this would be quite in order and asked if they would also like to purchase the adjoining meadow for £10. Naturally the answer was 'yes' and Priscilla hurriedly wrote out a cheque for £21 to cover the deposit for both. Moments later – just as the receipt was being typed – the other buyer arrived back and was outraged to find that the house had been sold and began to bully the agent, who fortunately resisted the attack. The man turned out to be a property developer, and hearing that Max was an architect, tried to persuade him to do a deal but Max was having none of it and 'murmured something polite but notably vague'.[25] After all this, the precious key was handed over and the jubilant couple set off for their first glimpse of the inside of what was now their house.

To be accurate, the cottage belonged to Priscilla – paid for by her aunt's generous legacy – but from the first it was intended as a home for them both. Over the following months – before the place was made habitable – they would drive down and spend weekends camping in the meadow, where they were thrilled to hear the whirring of nightjars and see the mysterious light of glow-worms punctuating the darkness. In the mornings they lit fires with wood collected from the nearby common and fried up hearty breakfasts of sausages washed down with tea made from water fetched from the neighbour's well.[26] Max took photographs and measurements so that he could draw plans for the renovations they wanted to make – though from the start they were determined to preserve the charm of the place. The main floor was lowered so heads would not be broken on the beams and a large fireplace was uncovered with its original bread oven intact. Cooking and heating of hot water was done over the fire with various iron bars and contraptions, and a well behind the cottage provided a supply of pure sweet water. There was no bathroom, just an ancient privy in the garden, and baths were taken in a tin tub in front of the fire.[27]

Priscilla and Max outside their Sussex cottage

CHAPTER TWENTY-FIVE

Wartime Worries
1939 – 1945

Tʜᴇ ɴᴀᴛɪᴏɴ's ꜰᴇᴀʀꜱ ᴡᴇʀᴇ realised when war against Germany was declared on 3 September. Works at the cottage were still in progress so Max and Priscilla decided to base themselves at Cleves, the Johnstons' home in Ditchling. Now in poor health, her father was being looked after by Bridget, who shouldered the responsibility of his care with little help from her sisters. Priscilla, even when she was at home, was often oblivious to the day-to-day chores needing attention and this led inevitably to difficulties between the two women. Max too – more used to the homely ministrations of his wife – sometimes remarked on Priscilla's lack of domestic skills. Once he pointedly told her that Muriel used to warm his shoes, and on another occasion he got into 'a state' and told her that 'she was a bad hostess',[1] simply because she had forgotten to serve coffee to their supper guests. Priscilla naturally found such criticisms hurtful but as a rule these dark moments were thankfully short-lived.

Priscilla understood that Max was also finding it hard to adjust to living at Cleves: 'Max then said … a lot about being here on sufferance. Poor Max he's used to being Master of the house … & feels a bit out of it here, specially when we spend our meal times talking about books he hasn't read & so on.'[2] Another difficulty here was their 'dynamic resting'[3] as Priscilla once called their daytime love-making. This was so often their way of making up after an argument and was almost impossible at Cleves where they had separate bedrooms and little opportunity.

Amongst the mass of belongings brought down from Chelsea was a large box containing the model of the Dublin War Memorial, which Lutyens had asked Max to paint prior to its display at the official opening of the Irish War Memorial Gardens. This imposing piece was set up in the hall at Cleves where there was just enough space for Max to work around the structure. The final touches – before it was sent off to Dublin in late October – included the addition of gold stars in the roof.[4]

With the onset of war life became harder for everyone including Max and Priscilla. Her diary entries in late 1939 record many of the changes:

their telephone was commandeered by the military, windows had to be blacked out, petrol was rationed and everyday items such as butter and eggs became scarce and expensive. Driving along dark country lanes became a hazardous experience too, as headlamps had to be especially dimmed or not used at all. With no streetlights, London's streets were also blanketed in darkness, and shortly before Christmas on his way home to the flat Max walked into a wall that left his face bruised and swollen and his nose 'a bloody mess'[5] needing specialist treatment.

This mishap added physical injury to Max's already fragile state of mind. That December they had returned to London for Max to sketch college buildings for the University of London map. They were getting ready to go out one morning when Priscilla's friend Mary appeared at the door, tearful and upset about her break-up with Charles, a handsome young Frenchman. After a hurried exchange, she thrust a letter into Priscilla's hand asking her to deliver it to him, then promptly left. Moments later Charles himself arrived on the doorstep, also in great distress. Priscilla was taken aback when he took her hand, stood for some moments in silence, then broke down claiming: 'Priscilla, I have no one.'[6] She handed him Mary's letter and after reading it, he abruptly turned and strode out of the flat but was dragged back by Priscilla. He then flung himself 'face down on the bed & cried … hard & uncontrollably, in great sobs'.[7] She felt desperately sorry for him and tried to comfort him: 'We sat on the bed & I held him in my arms I stroked his hair.'[8] Even she found it strange how she had come to this point 'in one step' but it was in her nature to be attracted by male suffering and she felt drawn to this creature who she described as having 'a curious & utterly foreign face, so unlike an Englishman'.[9]

Over the following days and weeks, to Max's extreme annoyance, Charles – which it eventually emerged was not his real name – became a semi-permanent fixture in the flat. Once Priscilla even allowed him to stay the night, causing Max to retreat to the Temple studio. The young Frenchman's misery – in all likelihood just an act to gain her sympathy – was such that Priscilla invited him into her bed although she claimed it was 'not as a lover but as a child'.[10]

Needless to say, all this intensified the disharmony between Max and Priscilla. Although he tried hard to tolerate Charles' presence, Max felt threatened by this good-looking young man who seemed to have wheedled himself very swiftly into Priscilla's affections. Despite this, she would insist that Max had nothing to fear. To his great relief the relationship ended after a few weeks, partly because Mary still seemed

to be involved with him. There also seemed to be a third woman in his life, one who would later accuse him of theft – an incident that led to his arrest and deportation back to France as a potential enemy alien.

In 1940 London began to suffer relentless night-time bombing raids with the East London docks a prime target. Max and Priscilla were at the Chelsea flat on 7 September when they saw one such attack:

> We watched it from the top floor … clouds of aeroplanes, tiny & very high, and great masses of smoke rising from somewhere in the East. When it was over … as it began to grow dark, there came a red glare on the clouds of smoke & when it was fully dark all the sky was red as though it was a lurid sort of sunrise & very bright, almost flaring, behind the silhouette of chimneys & spires.[11]

The same night there was another raid, this one much closer: 'there was a series of bad bangs, right near … the door shook as if someone was desperately struggling to get in'[12] and they fled down to the basement to join the other residents of Joubert Mansions.

After another raid in which the windows of the flat were blasted in, Max and Priscilla abandoned the flat almost entirely. If he needed to stay in town, he would use his room at the Temple. In late April the builders finished their work on the cottage and Max and Priscilla moved their things from Ditchling into their new Sussex home. Little by little, the tangle of nettles and thistles that surrounded the cottage was cleared, and a little stream was uncovered, and they began to explore the heathlands and forests of the common and the forest beyond the meadow. These were idyllic times, as Priscilla's journal records:

> I stood and watched him walking back to the house & beyond him the woods blurred by a blue evening mist & there we were on our own land working together & it seemed so much the sort of dream that one would have played with & cherished & taken out in one's mind last thing at night to look at & send oneself to sleep with … I wondered how it could be true … it seems a quite perfect instance of a dream come true.[13]

The little wash house – with the addition of a skylight and a coat of whitewash – made an acceptable, if cramped, summer studio. In the winter, however, it was far from ideal. There was no electricity, so lighting came

from lanterns and candles and the only heat came from the warmth of the wall that backed onto the living room fireplace. Nevertheless, several key wartime commissions were produced here including the large map for the University of London. Max had been worried about getting such a large wood panel up the stairs to the Chelsea studio, but in the end Holden agreed to it being painted on canvas. This was fortunate because it could now be rolled up and taken down to the Sussex cottage where he could work on small unrolled portions quite easily. Each college building – all sketched by Max in London – was set into a circle in its correct location, and their coats-of-arms decorate the borders.

Max also managed to produce the artwork that would become a sixteen-sheet tea poster, *Tea Revives the World*, which, when printed, would measure 6.4 metres by 3 metres, an enormous map to rival his *Highways of Empire*. It was pasted up on street hoardings around the country while a scaled-down version was printed to display on the walls of tea companies and their retail emporia. The poster had been commissioned in 1937 by Gervas Huxley, now joint head of advertising at the International Tea Marketing Expansion Board, a new organisation representing all the regional tea boards. He believed that having rival tea boards with separate advertising campaigns simply 'diverted trade from one producer to another'[14] and was therefore a waste of their natural resources.

The map was finished on 3 October 1940, just one month after London and other British cities had begun suffering the horrors and devastation of the Blitz. Although the map's original aim had been to encourage tea-drinking by all ages, genders and nationalities, thereby increasing profits for tea companies such as Liptons, it can also be seen as a piece of imperial propaganda. It shows tea as a unifying drink enjoyed by people in every corner of the globe and for those suffering the hardships of the Blitz it extolled the virtues of a nice cup of tea by means of quotations, such as Longfellow's 'Tea urges the tranquillity of the soul', which echoes the Ministry of Information slogan 'Keep calm and carry on.' The map is also packed with facts and figures, including such oddities as 'Samuel Johnson drank 16 or more cups of tea at a sitting.'

Since his separation from Muriel, Max had had little contact with his siblings although Evan's wife Mailie made a point of visiting when she came on her annual trip to London. The only one he saw with any regularity

Overleaf: Tea Revives the World, poster (small version) for International Tea Marketing Expansion Board, 76 x 152 cm, 1940

The British Isles, detail from Tea Revives the World, poster for the International Tea Marketing Expansion Board, 1940

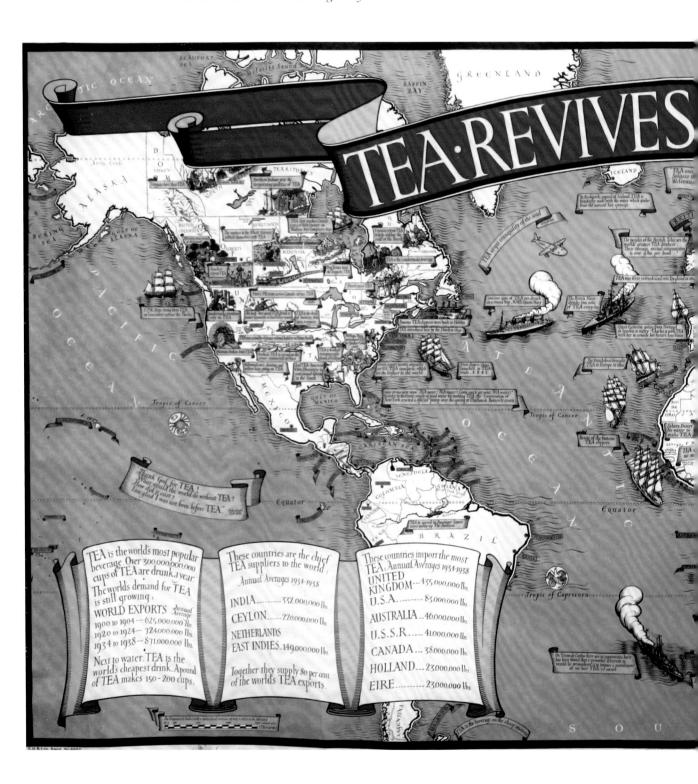

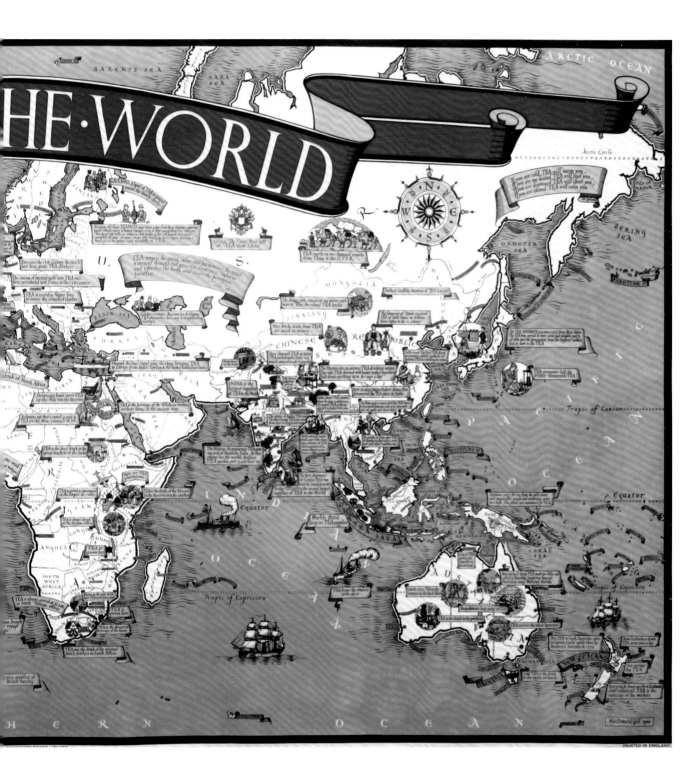

was Eric but the war and his brother's poor health meant they had not met of late. At a meeting on 19 November 1940 with Leonard Beaumont, head of design at the advertising agency Crowther and Mather, Max was shocked to learn of Eric's death, news of which had been broadcast on the BBC two days before. Mary Gill – not knowing Max's new address – had sent a telegram to Ditchling. Eric had died at Harefield Hospital after undergoing an operation to remove part of his lung, ravaged by cancer – the result of a lifetime of smoking and breathing in stone dust.

The funeral took place on 23 November at the chapel at Pigott's. Max arrived shortly after the requiem mass for his brother had begun and stood beside Evan and Angela next to the open coffin. Afterwards this was closed and laid on a horse-drawn cart cushioned with a bed of straw, and the family and a great entourage of friends and acquaintances 'from all walks of life'[15] trailed behind it through the lanes to Eric's burial place in Speen. Max and Evan then 'travelled posh at Mr Charles Holden's invitation in his car'[16] back to Pigott's where Mary Gill had organised a substantial lunch. Evan reported that it was 'the one big opportunity for 'fambly chat … a cheerful, happy gathering with plenty of banter going about between (or over) mouthfuls'.[17] Max's journey back to Sussex that evening took six hours, but he was pleased to report to Priscilla that 'all the family had welcomed him – yes, even Cecil',[18] who had criticised him so cruelly two years before. Shortly after this Max also read of the death of his cousin Colin who had collapsed and died of a heart attack while working in South Africa on a set of large murals for the Magistrates Court in Johannesburg.

Meanwhile Max's income for the year plummeted to its lowest ever – just £350. He could not even pay Muriel her allowance. Desperate for work, he turned to Frank Pick with 'a scheme for doing posters for the Ministry of Information'[19] and was disappointed when his offer was turned down. Pick had resigned his position as chief executive of the London Passenger Transport Board after a disagreement with fellow board members in April 1940, finally leaving in May, ostensibly for health reasons. It was a sad end to a remarkable career with the organisation. In August he accepted the position of director general of the Ministry of Information. But he was deeply unhappy here, finding the organisation 'dysfunctional and unmanageable',[20] and by the end of the year he had been effectively fired by Duff Cooper, the Minister for Transport. A few months later his successor at the MOI commissioned Max to design three small poster maps of Australia, New Zealand, and Canada and Newfoundland showing their natural resources.

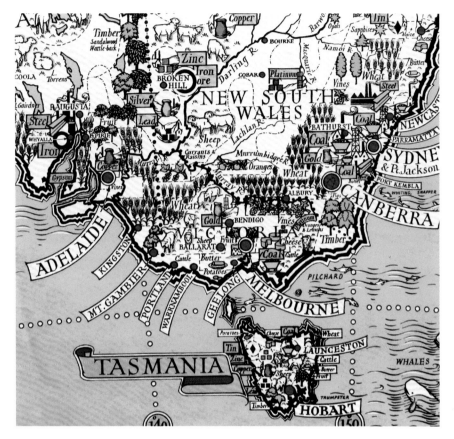

Detail from *Australia and her Natural Resources*, poster for the Ministry of Information, 50.8 × 76.6 cm, 1942

While Pick was still at the MOI, however, Max was hired to work on a film for the Admiralty.[21] *Eye Shooting* – a training film directed by Ray Harrison – was the first of three films for which Max would create maps, graphics and titles. It was to be made in Technicolor – a novelty in Britain where black-and-white was still the norm – and Max would work for the next two months at their processing laboratory in West Drayton, coming back to Sussex at weekends.

Painting for film was a new challenge and he set out from the cottage on Monday 10 December 1940 feeling rather like 'a little boy off to a new school'.[22] The process involved drawing and colouring artwork which would then be filmed using a rostrum camera. Towards the end of the war, he also worked on *La France Combattants* and *Target Germany* (1945), whose commentator was a young Richard Attenborough.

While working at Technicolor, Max generally stayed at the Temple, much to Priscilla's disappointment. Its proximity to the Thames, which provided a glittering pathway especially on moonlit nights – the perfect

Film frames for *Eye Shooting*, a series of training films for the Admiralty made by Technicolor, 1940–42

navigational aid for German bombers – made it an area of high risk. When the sirens sounded, Max would descend into the nearest air-raid shelter; he also did occasional fire-watch duty. The Temple had been badly damaged in September and October 1940, but this was nothing compared to the destruction wrought by the massive incendiary attacks of New Year's Day and the night of 10 May 1941. Shortly after this Max and Priscilla climbed the stairs of 1 Hare Court and looked through the shattered studio windows over the still-smouldering ruins. She described the extraordinary sight that greeted them: 'the view from Max's window had become unrecognizable. The river had mysteriously come much closer because everything between it & him had been obliterated … it was now all open, a view of the river across a stretch of rubble,'[23] she wrote. The heart of this medieval enclave had been ripped apart: the Temple Church, the Inner Temple Hall, the Cloisters, the Library, Fig Court, Pump Court and many other buildings had been destroyed. It was a miracle that Hare Court had been spared, but the powerful explosions had blasted many of Max's precious maps, materials and documents to oblivion.

Throughout the war years and beyond, Max worked again for the Imperial War Graves Commission. At the start of the new war, there was much debate within the IWGC whether to change the shape of the headstone but it was eventually agreed that it should remain the same but the lettering needed to be bolder and the numerals redesigned. In December 1939 Sir Eric Maclagan, director of the Victoria and Albert Museum, had suggested to Sir Frederic Kenyon – still head of the IWGC – that Eric Gill should be approached to adapt one of the two tablet alphabets that the museum already possessed, despite admitting that Gill 'could

The Temple area after the Blitz, 1941. Hare Court is the building immediately to the left of the Temple Church in the centre of the photo.

be very tiresome'.[24] The proposal was not met with enthusiasm and the director of works for the IWGC, Sir Frank Higginson, was then asked to prepare a revised sheet of numerals. His attempts were heavily criticised by committee members who urged Kenyon to bring Max Gill back to make the necessary changes.[25] Three weeks later a note in Sir Fabian Ware's hand duly records: 'Mr MacDonald Gill should be employed for this work.'[26]

The first meeting Max attended was on 2 April 1940, when discussions centred on the alterations required. It was concluded that firstly the alphabet needed to have 'heavier and more deeply cut thin strokes, strengthening the weaker letters and improving the numerals'.[27] Secondly it was suggested that the badge designs required greater contrast between the full-depth cut to the background and the lighter incisions of the fine line detail, and also that additional sections and details should be produced to guide the stonemasons. Of the 170 badges looked at by the committee, it was estimated that eleven needed minor alterations and thirty-six required major changes. There were also many new badges to be designed as a result of disbanded units reforming and new regiments being created. A fee of 3 guineas per badge was agreed.[28] This work would continue bringing in a small income for the rest of Max's life.

The Sussex cottage was located miles from the nearest town but was nevertheless touched by wartime events. Max wrote of hearing the thud of distant bombs, and nearby heathland was sometimes invaded by soldiers rehearsing military manoeuvres while overhead, fighter planes often practised their dive bombing, terrifying the animals. At dead of night Max and Priscilla would sometimes be woken by the eerie drone of bomber squadrons – the British on sorties to Germany

or the Germans en route to drop their deadly cargo on London. On one occasion, they joined the search for a German pilot who was supposed to have parachuted down nearby.

In comparison to London, though, life here was quiet – a 'gumboots-&-mud existence'[29] as Priscilla called it – with their activities almost entirely focused on producing food. The meadow was turned over exclusively to growing food crops – to which was gradually added a menagerie of livestock including hens, ducks, goats, rabbits and later bees. Priscilla, a novice in animal husbandry, soon acquired the basic know-how with the help of advice from neighbours. Even so, the animals were a constant headache: the hens sometimes refused to lay, a goat might fall ill, baby rabbits had a tendency to die or foxes would massacre the ducks. Despite the introduction of rationing, they never went hungry. There was usually a steady supply of eggs, vegetables and bottled preserves and the wild rabbits desecrating their crops would be shot and made into a tasty stew.

Priscilla was afraid that she would be called up for war work in some factory, but she managed to stave this off by claiming that she ran a smallholding. Fortunately for her, the lady official who came to inspect the place was sympathetic and agreed that Priscilla 'was engaged on work of national importance' and that the smallholding was a 'coming concern' rather than a 'going concern'.[30] As the months passed, however, the novelty of this existence faded and Priscilla complained:

> I envy you your life spent between here & London & your work. It leaves you free to appreciate this place, which to me can sometimes become a prison. I long to get rid of these unrewarding animals & to be free to do my own work & to go where I like when I like, but I suppose I must stick to it as long as the war lasts.[31]

In her need for company and diversion, she turned briefly to Patrick Brown, one of Anne's ex-boyfriends. She and Max both liked Patrick immensely, and had been sorry when Anne had thrown him over for someone else. When Max told Priscilla that Patrick was coming down for the weekend, she wrote: '… perhaps the two men I love best in the world.'[32] Max felt less threatened than he had with Charles, telling her that 'he didn't feel left out', even when she and Patrick sat on the sofa with their arms round each other. She appreciated Max's understanding – she never wanted to leave him and her love for him seemed to grow with time. Patrick's visit was short – just a weekend – so Max's tolerance was in

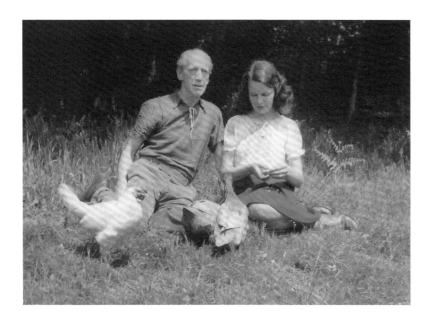

Max and Priscilla in the
meadow during the war, Sussex

any case not pushed too far. Mary Pigott later asked Priscilla if she wanted to sleep with Patrick but the answer was: 'No, that wasn't my idea of our relationship. I should probably love it, but it wasn't my role in his life.'[33]

In such an isolated location, the car was a lifeline to the outside world. Petrol supplies, however, were soon strictly rationed and eventually restricted to official use only. During the four weeks Max worked at Technicolor, he received a generous fuel allowance, but when that ended, Baird was laid up in the barn until the end of the war, their only means of transport now the local bus or train, the nearest station being only a couple of miles away. The cottage lay by the railway line and when Max's train steamed past, Priscilla would wave to him from the meadow and in the evenings coming home she would watch for his white handkerchief signalling to her from the carriage window. His quickest route home was along the tracks and sometimes she would walk along the lines in the dark to meet him, listening for the distant crunch of his footsteps on the chippings.

With no major work on hand, Max was relieved to hear from Lutyens in the first week of March 1942 about a job to draw the images of the saints on the plans of Liverpool's Roman Catholic cathedral. Originally designed in 1930 and begun in 1933, the building was intended to rival the city's Anglican cathedral in scale and grandeur. Sadly, only the foundations and the crypt of his grand vision would ever be completed; Priscilla and Max had been impressed by these on their visit there on their way to Ireland five years before. In December 1941 the Catholic

authorities had agreed to pay Lutyens the £5,000 he was owed plus £2,500 a year to finish the cathedral drawings. Max came up to London for a meeting with Lutyens at the Mansfield Street office on 10 March 1942. He must have been shocked at his old friend's appearance. Coughing blood, and suffering from persistent tiredness and fever, Lutyens had been diagnosed with lung cancer just months before and was a shadow of the man Max had once known. Emily, his wife wrote: 'He is so pathetic, it wrings my heart. He has grown so thin – his clothes look much too big for him.'[34] Max was paid £26 5s on 9 April for his small contribution, the last commission he did for Lutyens. The Archbishop Downey finally admitted to Lutyens that there were no funds for the project, so Lutyens paid Max out of his own pocket, a small sum but one Lutyens could ill afford. The drawings were displayed at the Royal Academy Summer Exhibition where they were much admired, but it was clear that interest in actually building this masterpiece had disappeared.

With only a handful of small commissions like this, money was in such short supply that Max was often unable to pay Muriel her full allowance. Nevertheless her attitude towards the separation had softened to the point where she began to contemplate a divorce. When Max caught wind of this, he went to see her in Chichester. Priscilla reported that he was surprised to find Muriel 'perfectly reasonable … & nice about the divorce question & also about me. The only difficulty now is money. An absurd one, but there it is & looming very large.'[35] Muriel wanted a lump sum of £500 which for Max was an impossibility. Their conversation would also have touched on their deep concerns for Mary and Lewis. At the beginning of the war the newly weds had travelled to Rome to study singing, but after the German invasion they had fled south with their Jewish friend and fellow singer Sigbert Steinfeld, who had escaped German clutches once and was now being pursued. No word had been heard from them for over a year.

Three days after this Max and Priscilla went up to Altrincham to see his daughter Anne, who was now touring England in a repertory company, playing the lead in Ivor Novello's *I Lived with You*. At a late-night party to celebrate Anne's twenty-first birthday, Priscilla fell into conversation with another of the theatre company's lead actresses, Catherine Lacey, and was delighted to learn later that the star wanted to meet Priscilla again in London. As the night wore on a drunken director, Max Colburn, cornered a sober Priscilla, draped his arm round her and effused about how much he liked her and Max and wished they would stay longer. To her astonishment he even began making advances to her own Max in the dining room:

'I … was present at a scene of affection between the two that I found profoundly embarrassing, I felt I shouldn't have been there.'[36] Her diary gives no explanation and there is no further mention of the incident. In any case, Priscilla, by nature, was a liberal freethinking woman who had at various moments in her life been attracted by women, so would have given little importance to such an incident.

The summer passed with little professional work for Max but plenty to occupy him at the cottage with sowing, weeding, harvesting, tending animals, building fences, cupboards as well as a wooden house for the goats. In early September Catherine Lacey arrived for her promised visit and delighted Priscilla and Max by throwing herself into their rural life and spent the best part of two days on backbreaking work digging up potatoes. Two days after her departure, Max left for the first of two five-day trips to wood carver Alfred Southwick's workshop in Crediton in Devon where he was to paint the twelve wooden panels he had designed for the Children's Corner at the church in Bude Haven.

Animal panels for the Children's Corner at St Michael & All Angels Church, Bude Haven, Cornwall, painted carved wood, designed and painted by Max Gill, carved by Alfred Southwick, 1942

Just before his trip to Devon, Max had been approached by an old Ditchling schoolfriend of Priscilla's, Joanna Bourne, to produce a map for the magazine where she worked, *Time & Tide*.[37] The commission was to produce, in collaboration with map publishers George Philip & Son, a map to commemorate a pivotal moment in twentieth-century history – the joint US and British declaration of future peacetime aims known as the Atlantic Charter.

Although the Americans were supporting the war morally and materially, they were determined to remain neutral. However, British

The "TIME & TIDE" Map of THE ATLANTIC CHARTER

The "Time & Tide" Map of the Atlantic Charter, poster, 89.0 × 113.5 cm, 1942

Prime Minister Churchill, aware that the war in Europe could not be won without American military might, had secret talks with US President Roosevelt in mid-August 1941. No commitment was made but instead the two men agreed eight 'common principles in the national policies of their respective countries on which they base their hopes for a better future for the world'. These aims are set out on the banner at the top of the map. In December 1941 – just four months after this meeting the Japanese bombed Pearl Harbor and America joined the war. Despite this, the principles of the Atlantic Charter, which had been ratified by the Allies, endured and became the blueprint for the Charter of the United Nations a few years later.

The "Time & Tide" Map of the Atlantic Charter, sanctioned by the British Ministry of Information as well as the American government, turned out to be a propaganda coup, with both sides eager to make a public show of these idealistic peacetime principles as well as the 'special relationship' that had now been forged between these two superpowers. Even at the design stage Max predicted that 'there will be a great demand for this map on both sides of the Atlantic, apart from the Empire at large because few people can memorise the eight points of the Charter so if I can interpret it pictorially our combined efforts will not be wasted'.[38] His map illustrates

Opposite:
The destruction of armaments, detail from *The "Time & Tide" Map of the Atlantic Charter*, poster, 1942

the anti-war message from Isaiah, 'They shall beat their swords into plowshares …', with a man stripped to the waist breaking up a jumbled pile of weaponry with a sledgehammer against a peaceful pastoral backdrop.

Max was keen to gain the approval of the authors of the Atlantic Charter: 'Its prestige (assumed) will certainly be enhanced if Mr Churchill and President Roosevelt can give it their imprimatur and signatures. I have suggested they be approached.'[39] Signatures were indeed obtained and duly inserted below the eight tenets of the charter on the map.

Designing the poster, as so often, was a race against time. Naomi, the daughter of Anna and Maresco Pearce, was recruited to help with tracing and colouring and the final version was sent off to George Philip & Son on 13 November. The first copies rolled off the presses at the beginning of December. Priced in bookshops at 5 *s*, it was promoted heavily as being 'a memento of one of the greatest occasions in the history of civilisation, as well as a source of information, which should have a place in every library, office, clubroom, school and home'.[40] Sir Francis Meynell sent a note saying: 'Congratulations on the lovely map',[41] and it was widely praised in numerous publications including *Headway*, the League of Nations Union journal where it was written: 'No better illustration of the Atlantic Charter could be imagined.'[42]

The first edition of 5,000 sold out within days and a second edition was immediately ordered. It was also marketed in North America, where it was immensely popular, and in early 1943 French and Spanish versions were produced for the MOI. For once Max received royalties on all copies after the first edition, bringing him well over £600. Even today *The Time & Tide Map of the Atlantic Charter* is considered by some to be one of the most important pictorial maps of the twentieth century and copies can be found in public collections around the world. In 1946 when the United Nations came into existence, the text on the map was amended and the title was reworded to become *The Time & Tide Map of the United Nations*.

The Atlantic Charter map did more than earn royalties, it was a catalyst for new commissions. In 1943 Philip's asked Max to design three more maps – Canada and Newfoundland, Australia, and New Zealand – to show their resources. And in 1943 he began map illustrations for a book by Phyllis Bentley on the history of the wool industry entitled *Colne Valley Cloth*. These were commissioned by Yorkshire mill owner and ex-First World War flying ace William Haigh – a colourful character who was also known as 'Buffalo Bill' because of his penchant for flamboyant wide-brimmed hats. During several visits to Yorkshire, Max filled a sketchbook with meticulous pencil drawings of mills, mansions and local landmarks,

Detail from the *Map of the Colne Valley Cloth District* published in *Colne Valley Cloth* written by Phyllis Bentley, 48.2 × 31.8 cm, 1946

most of which were reproduced in roundels on his colour map of the area. The book was eventually published in 1946.

Max also designed the dust jackets for several books. The most eye-catching of these was for *Coricancha, Garden of Gold*, written by his Joubert Mansions neighbour Aimé Félix Tschiffely, which also has a pictorial map of Peru folded inside the front cover. Others included Dilys Powell's *The Traveller's Journey Is Done*, Richard Dimbleby's *The Frontiers Are Green* and *The Waiting Year*, and *Letters to Malaya* by Martyn Skinner.

One evening at the Savage Club, where he was staying after the bombing of the Temple, Max got into conversation with Henry Williamson, best known for his novel *Tarka the Otter* but also notorious for his strong support for Oswald Mosley, leader of the British Union of Fascists. Convinced that Priscilla would enjoy talking to him as a fellow writer, Max invited him down to the cottage for the weekend. He was right. When Priscilla opened his telegram alerting her to the writer's visit, she was disbelieving but thrilled.

Unfortunately for Max, Williamson turned out to be 'a man rather ill & very unhappy',[43] characteristics that were guaranteed to endear him to Priscilla. After an emotional weekend with many intense conversations about his heartaches and vulnerability, Williamson departed but he continued to dominate her thoughts. The infatuation continued until the following May when she went to stay with him at his Devon home. She had decided that she would sleep with him, but the night turned out to be a disaster. His anger and surliness frightened her and

she realised that only now was he revealing his true nature and that to him she 'was "just" "a girl"'[44] – he did not care for her at all.

As soon as she could, Priscilla fled back to Max who, she reported, was 'tremendously glad to have me back … He was grave, interested, sympathetic. I could not see a trace of jealousy or of relief at the failure of the affair. A remarkable man …'[45] Priscilla's fling seems to have acted – perhaps bizarrely – as a tonic for their relationship. Max's love had been tested but he adored her more than ever and was angry that Henry Williamson had not appreciated his darling Priscilla, saying: 'I wonder if he knows that he is throwing away pearls.'[46] It also strengthened Priscilla's feelings: '… loving Max more than ever', she wrote two weeks later.[47]

The Allies were advancing across Europe and in June 1944 the Americans liberated Rome. A message from the Red Cross a few weeks later confirmed that Max's daughter Mary, Lewis and their friend Sigbert were all safe. Their extraordinary story of flight and survival is told in a long letter Mary wrote to 'My darling Max and Priscilla' later that year.[48]

The end of the war also marked the close of an era for Max. All those remarkable men who had influenced his life so significantly were gone. Halsey Ricardo, his architect tutor and mentor, had died in 1928. Almost exactly a year after Eric's death, Frank Pick had collapsed and died of a cerebral haemorrhage and in October 1943, the news had filtered through to Max and Priscilla that Gerard Meynell had killed himself, 'as he had so often said he would'.[49] On the few occasions they had seen Meynell in recent years they had been shocked to see his decline into alcoholism. His marriage had broken down and his behaviour had become increasingly erratic and he would rant about all manner of subjects. Furthermore, as a result of being duped by a rogue solicitor, he had lost all his money and was reduced to asking friends for handouts. It was a tragic end for a man who had inspired so many and achieved so much in the world of printing and publishing. Max was just one of many who owed him a huge debt – without Meynell there would have been no *Wonderground Map*. Then on New Year's Day 1944 the death of Lutyens was announced. Although not unexpected, the loss of this immensely influential figure must have saddened Max deeply: he had worked on so many commissions for the great architect over a period spanning thirty-five years. It is a sobering thought that had it not been for Lutyens, Max might never have designed a map.

Yet another blow came in the autumn of 1944. Late one Sunday afternoon Priscilla answered a knock at the cottage door and found their neighbour Richard Coomber, who would sometimes take telephone

messages for them, standing on the doorstep looking very grave. 'Your father passed away this afternoon', he said. Her initial distress was tempered by relief – although only seventy-two, Edward Johnston had been very ill for several years. His funeral took place in Ditchling two days later. One villager there was overheard expressing disbelief at the length of his obituary: 'All that in The Times, The Times of London … why the King wouldn't get more than that.'[50] Most locals had no idea that this quiet, unassuming and eccentric man had any claim to fame, that his inspirational teaching had changed the lives of an enormous number of people, including the Gill brothers, and that his alphabet designs and roundel for the London Transport signage had become an essential part of the look of London.

As Priscilla watched her father's coffin being laid on the trestles in the church, she was aware, but also appalled, that she might one day see Max's coffin: 'some very distant day, please God … but however distant, almost bound to come in the end – unless I could die fairly young.'[51] She had written shortly before this of watching him 'coming towards me along a path, or pottering about in the garden trimming the hedge or doing odd jobs of carpentry & think there may well come a time when I would give all I had in the world just to be able to see that again'.[52] The realisation that their life together might be cut short by his death made her determined to treasure their time together.

Coricancha dust jacket artwork, watercolour on paper, 1943

CHAPTER TWENTY-SIX

Endings
1945 – 1947

B Y THE END OF 1944 the fire-bombing raids were over and with the danger now receding Priscilla was impatient to return to London. The goats were sold and the other animals left in charge of her old friend Mary, who had bought the cottage next door. Unable to move back yet to the Chelsea flat, they based themselves at Hare Court where Max had to work in Whitby Cox's old room, his own still in a state of disrepair from the Blitz damage. The Germans were now deploying their latest deadly weapon, the pilotless V2 rocket, nicknamed the Buzz Bomb or Doodle Bug. This featured in a light-hearted map Max was painting for the retiring commander of the Bromley Home Guard.

Almost seven years had passed since Max had separated from Muriel. Comfortably settled in a small but cosy cottage near South Nore, she was now completely resigned to life without Max and was prepared to give him a divorce. By March 1945 a financial settlement had been agreed and divorce papers were duly served, citing Max's adultery with Priscilla. His siblings were not informed but Muriel did write to her old friend Molly, who was horrified to hear the news and promptly wrote to Max's brother Evan: 'I am wondering if she has gone crazy or done something queer. Otherwise he could not obtain a divorce … it is very bad & sad.'[1] Marital breakdown seemed to be running in the family. John Gill, so angry with Max for leaving his mother, had now left his own wife Pamela for another woman. And in her letter from Italy, Max's daughter Mary confessed to her parents that she had fallen in love with Sigbert and left her husband Lewis. Max's wry response to all this was: 'I've set a bad example, haven't I?'[2]

In 1945 Max was commissioned to create the *Cable & Wireless Great Circle Map*. The circular projection presents a flattened world that allows the measurement of the shortest distances travelled by radio beams, essential information for radio operators, while the colourful images illustrate the links vital for global telegraph networks – radio masts, cable-laying ships such as Brunel's SS *Great Eastern* as well as the transmission equipment and its operators. Sitting in the cinema audience waiting to see the Marx

Doodle bug, detail from *A Map of 'P' Sector Home Guard*, oil on wood, 91.4 x 91.4 cm, 1944, Bromley Museum and Archives

*Cable & Wireless Great Circle
Map*, poster, 108 × 132 cm, 1945

Brothers film *A Night in Casablanca*.[3] Priscilla and Max were startled to see
the map appear in a short documentary for which Max had also done the
titles. *The Great Circle Map* would be his last poster commission.

The long periods of isolation at the cottage during the war had inspired
Priscilla to begin a new novel. Its narrative focuses on a teenage schoolgirl
– clearly based on a young Priscilla – who develops a crush on her father's
architect friend – a man unmistakably modelled on Max.[4] A number of
scenes in the book are based on real-life incidents – in one the pair stumble
upon a tumbledown cottage that closely resembles Max and Priscilla's own
Sussex retreat. Once again Max took on the job of designing a dust jacket.

In May the war in Europe was over and in August the Japanese
surrendered. There were celebrations across the country including
Sussex, and life for Max and Priscilla took on an altogether different
rhythm. Although there was always much to be done in the garden,
the pressures had disappeared. Everything became calmer and more
peaceful. That summer of 1945 was glorious. The long days were hot
and sunny, occasionally punctuated by dramatic evening thunderstorms
when the meadow would be lit by flashes of lightning and the dried-up
streambed would be transformed into a gushing torrent. Priscilla wrote

of standing with Max in the garden at dusk gazing 'at the dark misty woods silhouetted against a pale apricot sky and the blue, blue wood smoke from the chimney hanging in the air'.[5]

This blissful period came to an abrupt end in mid-August when Max had an accident in the garden. He was at the top of a ladder trimming the overgrown hedge one evening when he lost his balance and the stepladder toppled over and, in an effort to save himself, he jumped and injured his ankle. When he came in 'limping and hopping', Priscilla just thought: 'it must be a joke or he is sticking it on'[6] but later that evening she saw how swollen it had become. What was first thought to be a bad sprain turned out to be a broken ankle bone that took many months to heal. Their Sussex summer was over.

After having X-rays in London, he and Priscilla decided to stay in Chelsea so that he could attend several weeks of physiotherapy. Unable to walk without crutches, he was still able to work in his studio. Immobility frustrated him and he became 'depressed and aloof'[7] and demanding to the point of nagging. This had the inevitable effect of alienating Priscilla, who found solace in the arms of their friend Patrick Brown, who had just returned from Rome. Although Max liked him immensely, he found it difficult to bear Priscilla's open affection for him and he became increasingly morose. This provoked a major row which resulted in a two-day silence. Although aware of his unhappiness she was unable to restrain herself, admitting: 'Poor darling, it does seem unfair to make him unhappy, but I couldn't not love Patrick after more than five years.'[8] Max's sulks propelled her into further recklessness a fortnight later, not only with her own sister's boyfriend who 'seized me in his arms & kissed me a good deal',[9] but also the following week when she was in a car with Tony, the husband of Anne's friend Honor, with 'Tony's arm round me and my head on his shoulder'.[10]

As Max's ankle improved, so too did his mood as well as relations with Priscilla and at Christmas they joined her sisters in Ditchling. On Christmas Eve they ventured forth to buy presents in the village where they kept 'meeting Meynels [*sic*] and Peplers as usual'.[11] At dusk the four of them went on the traditional raiding party to find holly and ivy for Max to decorate the house. In the morning Max dressed the two large spruce branches they had collected as a substitute for a tree while the girls cooked a festive dinner with all the trimmings. But first came the ritual of present opening. Priscilla's gift to Max was a pair of warm slipper-boots she had fashioned out of a piece of sheepskin while she received from him a hand-decorated manuscript-holder. It was a quiet but homely and

Dust jacket design for Priscilla's novel *The Sound of the Flutes*, watercolour on paper, 1946

happy day – a very different Christmas from the last Max had spent here.

Max and Priscilla then returned to London, exchanging the clear air of Sussex for the 'murky fog'[12] of London. At the flat they threw themselves into domestic chores with Priscilla spring cleaning and Max laying linoleum in the kitchen. Most unusually, the couple were at home to celebrate the first New Year since the end of war. At midnight London resounded not only to the ringing of church bells but also the ominous wail of air-raid sirens: 'Grimmish,' Priscilla thought, 'but I suppose people felt happy & exultant to welcome in a year that was free from war.'[13]

At the end of January 1946 Max received the decree absolute for the divorce. After their meeting with the lawyer, Max took Muriel and Anne out for lunch. Muriel asked Max when he was going to marry Priscilla and, mischievously, he proclaimed that he did not know if they would get married. But Anne was quick to interject: 'Don't be silly, of course you are – in the spring.'[14] Priscilla was thankful when she was told about this later but she was cross with Max: 'Lucky she [Anne] was there, but unfortunate & stupid & unnecessary anyway – ungracious too, I thought, when she [Muriel] has made this sacrifice so that we may marry.'[15] Max, of course, had every intention of marrying Priscilla and within weeks booked a date in May at Chelsea Registry Office.

Nevertheless, he and Priscilla still considered 14 March – the day they had cemented their new relationship in 1933 – as their real 'wedding day'. Priscilla wrote: '13 years. Good heavens, what a long time! Out to dinner to celebrate. We also celebrated in the appropriate way.'[16] Their contentment with each other was encapsulated in a funny but touching exchange a few days earlier: 'When I got into bed with him', she wrote, 'I sighed & relaxed & curled up against him contentedly & I said "Being in bed with you is my favourite thing". He said "My favourite thing is custard".'[17]

At Hare Court Max had decided to renovate the disused 'queer little attic floor'[18] above the studio and in early February had moved his things upstairs. On the 15th of the month he and Priscilla were at the private view of the Arts & Crafts Exhibition at Burlington House where the map panel and grandmother clock he had designed and painted for Edward Hunter were on show. It was a good opportunity to catch up with old friends such as Stephen Spurrier, whose disapproving wife acknowledged Priscilla and Max with a short bow before turning away. Hunter himself was there as well as the engraver George Friend, who had made the metal clock face. Another familiar face was Ambrose Heal, who had recently taken delivery of Max's bird's-eye perspective of his country home Baylin's Farm. In fact, that very morning Max

Clockface design for grandmother clock made for Edward Hunter, 1930

Detail from *A Prospect of Baylin's Farm*, Ambrose Heal's country home, oil on wood, 1945

had received a cheque in the post from Heal for £120 in payment. Unfortunately, this was less than half the sum agreed and Max could ill-afford to let it go but he was too embarrassed to mention the error. Now that war was over enquiries were flooding in; Max had not been so busy for many years. Shortly before the private view Max had been in Rye to discuss the lettering of additional names on Blomfield's war memorial and the following day, he was up early to catch a train to Shropshire, where he was to discuss a memorial for Wrekin College at Wellington School. ICI wanted a roll of honour for its works at Witton in Birmingham; Westhampnett church needed an extension of their First World War memorial to add the names of the Second World War victims; and All Saints' Church in Brightlingsea wanted Max to paint two statues and a set of tiles[19] commemorating parishioners killed at sea during the war. There was also a painting job at the ancient chapel at Lypiatt Park, Gloucestershire, and Priscilla's friend Mary Pigott had asked him to draw up plans for the renovation of her cottage. Meanwhile, there was ongoing work for the magazine *Today & Tomorrow*, the *Colne Valley Cloth* book, the General Medical Council and Harwich town council.

Commemorative tile, All Saints' Church, Brightlingsea, Essex, 1946

Max and Priscilla were also catching up with the London life they had missed during the war, squeezing in a multitude of concerts, films, plays and parties. They heard the tenor Peter Pears sing a programme of Britten music at Chelsea Town Hall and saw several films including George Cukor's 'very enjoyable'[20] *Caesar and Cleopatra* starring Vivien Leigh, the classic romance *Brief Encounter* for a second time and an off-beat Danish film called *The Toad*. They enjoyed seeing their friend Catherine Lacey playing the lead in *Duet for Two Hands* at the Lyric Theatre; they saw Donald Wolfit's production of *Cymbeline* at the Winter Garden Theatre which they proclaimed 'bad', and they were joined by Anne at the Arts Theatre for a performance of *Hamlet* played by Alec Clunes,[21] who was 'good & looked right too'.[22]

Dust jacket of *The Traveller's Journey Is Done*, written by Dilys Powell, 1943

There were also various exhibitions. At the Victoria and Albert Museum they braved the crowds to see the hugely controversial exhibition showing, as Priscilla put it, the 'violent and shocking' art by Picasso and 'merely dull'[23] work by Matisse. They also went to the major 'Greek Art' exhibition at the Royal Academy. It was the last day and there was 'a mob', commented Priscilla, 'Awful'. Determined to see the display, they 'struggled round peering over people's shoulders',[24] and in the last room were pleased to encounter the journalist Dilys Powell, who had lent a number of the exhibits. Three years earlier Max had designed the dust jacket and drawn maps of Greece and Perachora

for *The Traveller's Journey Is Done*, her biography of her archaeologist husband Humfry Payne.

There was also no shortage of party invitations from their wide circle of friends and acquaintances – from Catherine Lacey to Sir George Langley-Taylor, chairman of the council for the Protection of Rural England. Max also attended events on his own – a public meeting on housing addressed by the newly elected left-wing Labour MP Jennie Lee, and the annual dinner at the Savage on 2 March when he helped to entertain Field-Marshall Montgomery of Alamein, who was being made an honorary member. The war hero presented the club with a book of his memoirs and one of his famous berets and, according to Max, he made 'a very good speech on condition that nothing should appear in the press'.[25]

In the last week of February Max painted a plaque for Harwich council displaying their coat of arms including the message '… presented by the borough to the town of Esbjerg in Denmark as a token of friendship'. On Friday 8 March Max was summoned to Southampton by Grey Wornum, who 'definitely'[26] wanted him to do a map for the RMS *Queen Elizabeth*. The liner had been used as a troop ship during the war and was about to be fitted out for her proper role as a luxury passenger liner. After a busy morning of meetings in London Max travelled down to Southampton to find he had just missed Wornum but made good use of his time looking over the liner before retiring for the night in a cabin on 'C' Deck. He was witness the following morning to the pandemonium on board after a serious fire broke out in a medical storage area containing a supply of highly inflammable items. As smoke poured through the ship's ventilation shafts, firemen had to be hoisted up in the lifeboats to aim their hoses at the blaze on the Promenade Deck. Max surmised that it might have been sabotage,[27] but investigators eventually concluded that the cause was a carelessly discarded cigarette.[28] The emergency failed to stop his lunch with Wornum. With high hopes Max returned home, but months passed by without any word about the job.

Max had plenty to occupy his time; his workbook for May lists over twenty separate jobs. But the month brought the event he had hoped and longed for: his marriage to Priscilla. The brief ceremony took place with the least possible fuss at Chelsea Town Hall on Saturday 4 May. His daughter Anne and their friend Catherine Lacey acted as witnesses and afterwards the four of them celebrated with glasses of sherry at a nearby pub followed by lunch at the Chantilly restaurant. Marriage had never meant much to Priscilla although she recorded having what she called 'a stab of nerves'[29] before the rites began. Afterwards she stated

Borough of Harwich coat of arms with painted inscription, oil on wood, 1946

that 'the service had no significance for me, nothing that we said meant anything, it was just something that had to be done'.[30] For Max it was a different matter altogether. Although he had defied the conventions of the day to live with his mistress, he was at heart a traditionalist when it came to marriage.

They spent their ten-day honeymoon on Guernsey. During the ferry crossing Priscilla woke in the middle of the night to a strange sensation: 'I had a different name. I felt shocked when I saw my identity card, not that there should be Gill on it, that was natural, but that there should be no reference to the name of Johnston anywhere – I felt almost panic-stricken – I'd lost my name, it had gone!'[31] Once there, they were surprised and disappointed with the island, concluding it was rather 'suburban … with beastly little bungalows' while the hotel was criticised as 'oppressive'.[32] The holiday was saved by the weather and the scenery; Priscilla wrote that they thrilled at the 'marvellously exciting'[33] wild seas they saw on their clifftop walks and Max's overall verdict was 'A LOVELY HOLIDAY'.[34]

As soon as they returned to England, Priscilla headed down to the cottage where they were hoping to spend the summer, having let the Chelsea flat to an old friend for a few weeks. Max was to remain for a while in London at the Temple – in the new attic flat – to get on with his backlog of work as well as deal with 'letters galore'[35] and to organise appointments with a host of clients for the weeks ahead. At the cottage Priscilla woke one morning a week later to strange noises coming from downstairs and to her astonishment, she discovered Max 'dusting the ceiling with a feather duster and whistling to himself'.[36] Slipping into the house unannounced was how he used to surprise his mother. It had been a long while since Max had been to the cottage and there was much to do. The next day he set about extending the goat-shed into a garage for their car Baird, which had been laid up for several years.

On 1 June a family tea party was planned at John Gill's home at Birdham to celebrate his thirtieth birthday. Max and Priscilla were unsure how they would be received by both John and Muriel who was also to be there. It had been eight years since Priscilla had last seen Muriel and at first, Priscilla noted, she was 'nervous, talking v. fast',[37] but as the afternoon progressed Muriel became more at ease. Priscilla had no such nerves: 'It seemed quite natural to see her again … there was no drama left in the situation, for me.'[38] Even John. who had been so angry with both his father and Priscilla, was 'pleasant and surprisingly easy in his manner, even quite witty sometimes',[39] showing them around his vegetable garden and commercial tomato greenhouse before giving them

a tour of the house that Max had built. It also helped that John and his new wife Barbara now had a baby son, Max and Muriel's first grandchild, and there was much fussing and cooing and discussion about who the fair-haired child looked like, which amused Priscilla immensely: 'I just thought he looked like a baby, but you can't say that.'[40] Max described this long-overdue reconciliation as a 'happy meeting'.[41]

At the end of June the large University of London map, which Max had been working on intermittently during the war, was brought up from Sussex and hung in the Chancellor's Hall at Senate House. The detailed paintings of university and landmark London buildings were time-consuming to do and the painting was still some way from being finished. Now there was a rush because Princess Elizabeth was to receive an honorary degree at a ceremony in the hall. Max came up to London again in the week of 3 July to paint the border coats of arms but time ran out and some areas of the map remain blank including the central title cartouche. Although Max must surely have intended to finish the map, events intervened and the opportunity never arose.

In the second week of July Max at last received the go-ahead from Grey Wornum to begin the RMS *Queen Elizabeth* map. The disconcerting news was that it had to be completed by the end of August: '… he could

Detail from *A Map Showing the University of London Colleges*, Senate House, London, oil on canvas, 2.4 × 3.4 m, 1939–46

Draft design for the *Map of the North Atlantic*, RMS *Queen Elizabeth*, watercolour on paper, 1946

have said weeks ago that it was wanted at once but never a word till now, Priscilla complained, "Quite incredible the whole thing".[42] Immediately Max shut himself into the studio down at the cottage and began sketching.

The design for the map was approved at a meeting with Wornum on board the liner on 19 July. The map was too big for the Chelsea studio but Ambrose Heal heard of Max's dilemma and immediately offered space on the top floor of his Tottenham Court Road store. The canvas went up on the wall here in early August and the outlines of the sun, land and sea were quickly pencilled in with the help of Sanie Walker, daughter of a friend, and when Kingswell joined them, Max declared triumphantly: 'So now we can make a show.'[43]

The map, a smaller more elongated version of the *Queen Mary* map, was to have a lower border depicting a variety of marine life, and would also have an electrically driven model of the ship tracking across the Atlantic. The team worked through weekends as well as late into the evenings long after the store had closed, and they would have to navigate 'the labyrinthine by-ways'[44] of the deserted department store to find the porter to unlock the door and let them out. Max had immediately made friends with the porter – 'dear Gordon' – and the 'dear kind man … seemed to like looking after us … he used to make tea for us on Sunday afternoons & bring milk specially & little pieces of cake'.[45] Their efforts meant the map was finished five days before Wornum's deadline.

For some time Priscilla had been concerned about Max's health. After getting home he would be terribly tired and just throw himself on the bed. Several people in recent months had commented that he was thinner and looked unwell. In May Priscilla had persuaded him to see a doctor who had given him a clean bill of health, but now Max was also complaining of his throat being a 'nuisance'[46] and was having difficulty breathing deeply. Priscilla organised an appointment for him to see their doctor, Francis Leslie. An X-ray revealed two swollen 'glands' in his chest and a small operation was arranged to remove another small gland in his neck and he was also prescribed a three-week course of radiotherapy. Priscilla was horrified. She wrote: 'I stood by the door

Map of the North Atlantic in
the First Class Smoking Salon
of RMS *Queen Elizabeth*, oil on
board, 86.4 × 472.4 cm, 1946

of the shed wondering if the nightmare could be true, if this could be
the end of this happiness & this sort of life together, wondering if it
was tempting Providence to get married … I lay awake nearly all night
listening to his breathing, almost counting the breaths.'[47]

After the operation Francis asked to see Priscilla at his consulting
room where he told her the dreadful truth: Max had inoperable cancer of
the lung. He tried to be optimistic, telling her that the best-case scenario
would be that the X-ray treatment might keep it under control and that
Max 'might live for some years & perhaps fairly well, but that was the best
one could hope for'.[48] She shut her eyes – and understood the truth but
she determined then: 'He mustn't know that he was going to die.'[49]

'My secret weighed me down like a sense of guilt',[50] she wrote, and she
felt on her next visit that Max must surely find her changed. Somehow she
managed to keep the fatal diagnosis from him, only telling the immediate
family. His doctors obfuscated by telling him that he had 'glandular
plurification [*sic*]'.[51] The treatments he underwent had a profound effect:
'It took a lot to get him down but the deep x-rays did it. There were no
jokes with the nurses now, the old gaiety was gone. Food was tasteless &
he no longer wanted to smoke. There was only one thing he wanted &
that was me. He wanted me there all the time',[52] Priscilla recalled later. His
wish was impossible to fulfil. In those days, hospitals imposed draconian
visiting times and Max was only allowed three visits a week, although
Priscilla managed to obtain a special dispensation by insisting she had to

come in to deal with his business correspondence. When she sat with him, she made a herculean effort to appear strong and optimistic, chatting, reading to him, discussing his work. But outside the hospital she let her emotions run free. 'I never cried for long at a time', Priscilla wrote, 'but at odd moments suddenly I would be seized & shaken by a fierce brief fit.'[53]

When she had to go down to the cottage for a few days, she bolstered his spirits by writing him a long and heartfelt letter declaring her love, telling him that they were inseparable, and she would never leave him except by death. Nevertheless he missed her terribly: 'long time to wait till Sun. dear P. come back.'[54] By now he was having daily radiotherapy treatments and some days he did seem more lively and cheerful and they both felt encouraged.

After undergoing twenty-two sessions, he was at last allowed home: 'so happy to be out again or rather away – for back to bed as soon as we got back to 21 J.M. – but so much nicer & P. there all the time,'[55] he wrote. He told Priscilla that she 'was the only thing that keeps me alive'.[56] A week later, after seeing a little better, he suddenly relapsed and started having terrible coughing fits in the night accompanied by high temperatures and profuse sweating, hawking, struggling and gasping for breath but all with 'never a word of complaint'.[57]

His illness was momentarily forgotten in the drama of his daughter Mary's return from Rome. She arrived with Sigbert, the young singer she had fallen in love with while on the run from the Germans in Italy. Full of anticipation and excitement, Priscilla and Anne met them at Victoria and brought them straight back to the flat, knowing Max would be thrilled to see his daughter. 'Max was in bed in the dark. He switched the light on & Mary ran to him & threw herself into his arms … she said, "Isn't he lovely, isn't he exactly like himself"',[58] at which Priscilla rushed out into the corridor and collapsed in tears.

Towards the end of October Max felt well enough to venture out for the first time in nearly two months and managed to walk slowly as far as the post-box and the baker's. Priscilla was glad he felt so well and was so cheerful: '… he didn't get breathless coming back upstairs. He was gay & silly & wanted to kick people's baskets & tell people in the Baker's to queue properly.'[59] Desperate to carry on working, a bed was made up for him in the studio and somehow he found the energy to paint the pair of carved oak saints for Brightlingsea church and design the lettering for a memorial plaque.

Another X-ray at the hospital showed a significant improvement in Max's lungs so Priscilla booked a holiday in Sidmouth where Max could

convalesce in a place with clean sea air. Their hotel was directly on the seafront, easy for Max to walk on the beach where they would skim pebbles and throw sticks to a stray dog that adopted them. Four days into their stay, however, Max began to suffer bad abdominal pain – the first sign that the cancer had spread to his liver. While they were sitting in the sunshine looking out to sea, he said sadly: 'I wish it wasn't going to be over so soon, I wish it needn't end.'[60]

Back at the flat, he managed to finish painting the Brightlingsea statues with help from Mary and Priscilla. With his failing strength that was all he could do. The last batch of regimental badges for the IWGC was passed to Harold Nelson and work on three Philips' maps came to a halt – these would later be completed by Kingswell.

Knowing it would be Max's last, the family gathered for Christmas at West Wittering. It was a dismal drive in pouring rain but despite everything, Max was irrepressible. At their lunch stop Priscilla was intrigued by 'a little boy watching us with fascinated attention. I looked at Max & saw that he was screwing a penny into his eye like a monocle & then letting it drop out again. As always, his audience was captivated.'[61] On they travelled and despite a puncture at Cocking, they eventually reached West Wittering where they were eagerly welcomed by Muriel, Mary and Buster, the family dog, who greeted his old master like a long-lost friend. On Christmas Day the rest of the family arrived – Anne, John, his wife Barbara and baby Richard – and they all crammed into the tiny cottage to feast on a 'beautiful Christmas dinner with turkey & a pudding full of sixpences',[62] followed by tea and presents. All too soon the festivities were over and, with great sadness, the following day they packed the car. Unfortunately the car refused to start, and it was discovered that the petrol tank had sprung a leak. Max – not best pleased – was put on a train back to London while Priscilla – by now extremely fraught – was left behind to organise the repair of the car.

Once home, Max's pain worsened. Drugged up on 'little green chaps'[63] as he called his sleeping tablets, he needed support even to sit upright. His last outing was to the hospital where the professor shook his head and told Priscilla: 'We don't think we can help him any more.'[64] She wondered how long he would live, thinking 'about three months perhaps?' But Francis was more realistic: 'not months – oh no, no not months.'[65] Priscilla supposed he meant weeks.

Max lay in his makeshift studio bedroom with its 'high ceiling and wide view over the roofs of Chelsea … felt cut off from the world'[66] with Priscilla and Mary tending to his every need. He seemed constantly

thirsty and 'had a craving for soda water', and ate his way through 'a cornucopia of fruit'.[67] But he could no longer walk and when he tried 'he fell flat on his face … and couldn't get up'.[68] He tried to be cheerful and always thanked Priscilla for everything she did for him and wanted her with him all the time. She wrote: 'He liked me to sit in the bed behind him when he had to sit up to take things & when he was sick I … held him in my arms & he said, "It's all right because you're there". I would have been there for ever if it could have made it all right.'[69] She later told his brother Evan: 'No one can ever have had a more angelic patient to nurse, patient, brave & gay & unfailingly considerate, as he had always been, so he was to the end.'[70]

In the early hours of 14 January, he told Priscilla that he had a bad pain and 'began to make a sort of groaning sound with every breath. "I don't know why I make this silly noise," he said, "it seems easier somehow".'[71] He said to Mary: 'I'm sorry about the noise, it's so dull – monotonous – must try to vary it' – 'and gave a squeak instead …'[72] 'He used to say', said Priscilla, 'that even in his coffin he would contrive to make us laugh & I thought this came near to fulfilling his macabre prophesy.'[73] Francis came and gave Max an injection of morphia and Priscilla understood that the end was near. She knelt by his bedside 'and whispered to him to think of one of his landscapes like the background of the Italian paintings such as he used to describe to me when he wanted to soothe me. I said "Will you?" & he said "Yes". Those were our last words to each other.'[74] He quietly slipped into unconsciousness. She telephoned Muriel and Anne telling them to come. A friend called in to see Priscilla and as they were talking – at about 1 o'clock – Mary came in and said, 'I think he's dead.' Priscilla rushed into his room and tried to feel his heart and could feel nothing. 'The sound of his breathing had stopped. He was dead.'[75]

The two women both began to cry as they understood that it was all over. Priscilla later said: 'Having known that this was about to happen seemed to make little difference to its impact when it came … The shock & overpowering quality of his being really dead did not seem to be mitigated at all by the ceaseless dread of the last four months.'[76] She fell upon the bed and cried out: 'I don't know how to live without him, he's always been there, I can't do without him …'[77] and was then gripped by such a powerful emotion that she let out an extraordinary howl of grief. Mary handed her a generous glass of Max's whisky and little by little she managed to calm herself. Then Francis came with a nurse, followed by Anne and her mother Muriel.

Max's death was announced on the wireless that evening and in the newspapers the following morning. Condolences and tributes began flooding in from friends, family and acquaintances. Max's siblings were dismayed to hear of their brother's death, having not even known of his illness.

The funeral took place four days later at the tiny church at Streat near Ditchling. 'The sun was streaming down on us and the Downs in the background looked so beautiful',[78] wrote Angela, who attended along with her sister Enid and brother Cecil. One of Max's harshest critics, Cecil could not fathom why Priscilla answered his questions somewhat tersely. He told his brother Evan in a letter written shortly afterwards that 'there was no room for harsh judgements and criticism' yet followed this with words of condemnation about 'the odd make-up of the funeral procession illustrating the mad and foolish-evil complexity of Max's later life … and his real piety, wasted by an ineffectual creed …'[79] Angela, on the other hand, recalled only treasured moments of her much-loved brother, the joker and story-teller of the family:

> as I sat and waited for the rest of the people to arrive so many thoughts of dear old Max kept surging up – chiefly his gaiety, and kindness to me as a child – and many other times … we all filed out to the little graveyard … and by some curious trick of memory, as we all went so silently and solemnly, I couldn't help thinking of Max's 'Marble Clock' story and I almost heard him say, as though to all of us, 'treading quietly down the drive', 'Please, as you go down the drive, go quietly as my mare has a swollen fetlock' and although I was almost weeping, I wanted to laugh.[80]

Max would have been delighted to hear this. Like Cecil, however, Angela found it hard to believe that Muriel and Priscilla were now friends and watched in amazement when the two women left the graveyard together accompanied by both Mary and John. Anne Gill had excused herself because she was acting in a pantomime matinee that afternoon and in any case, she declared: 'she couldn't bear funerals.'[81]

The graveyard at Streat was a fitting place for Max to be buried. Situated on the south side of the church, his resting place looks towards the South Downs he loved, the hills where he had played as a child, wandered as an adult and depicted in his maps. His simple headstone and footstone were designed and carved by Joseph Cribb and inside the

church was placed a small plaque with an inscription painted by Max and given by Priscilla in his memory.

Max's gravestone carries no epitaph but perhaps the message he inscribed on the cartouche of *The Wonderground Map of London Town* can provide one:

> The laughter of the Gods is yours if you will
> As the wish of the artist is. MacDonald Gill.

Max's headstone (designed by Joseph Cribb), Streat, Sussex

POSTSCRIPT

SHORTLY AFTER MAX'S DEATH Priscilla cleared out his possessions from the Hare Court studio. Much was thrown away, a sheaf of maps was given to Max's children and everything else Priscilla deemed of importance was carefully stored away in their Sussex cottage. This collection – inherited by Priscilla's nephew – has formed the basis for *Out of the Shadows: MacDonald Gill*, a major retrospective hosted by the University of Brighton, and a series of further exhibitions which have ignited massive interest in his work.

Max's maps are now highly prized and appreciated, not only for their aesthetic qualities, but also because they illustrate events and developments in the rapidly changing world of the twentieth century: the demise of the British Empire, innovations in transport and communications technology, the abdication crisis, the rise of American influence and the devastating impact of two World Wars. Influential in their time, these maps also inspire modern artist–mapmakers such as Stephen Walter, creator of such iconic maps as *The Island*.

And what happened to those left behind after Max's death? Priscilla's novel *The Sound of Flutes* was published a few months after his death. She then immersed herself in researching and writing her best known book – a biography of her father Edward Johnston, which was published in 1959. The same year she married her second husband Tony Roworth, who predeceased her; they had no children. She maintained close friendships with Max's daughters and also with Muriel Gill, who lived out her days in West Wittering. Priscilla died at the Sussex cottage in 1983.

ACKNOWLEDGEMENTS

THIS BOOK COULD NOT have been written without the help of an enormous number of people. But I owe the greatest debt to Andrew and Angela Johnston, who have allowed me unfettered access to Max Gill's archive as well as Priscilla Johnston's journals, and provided me with endless hospitality and support in the process. Our friendship and collaborations on talks and exhibitions have enriched my life tremendously. I would also like to thank them for permission to quote from Priscilla's and Max's diaries and letters and to photograph artworks, documents and family photos in their possession. The late Priscilla Johnston also needs special mention as without the collection of items she stored after Max's death, this detailed account of Max's life would have been impossible.

My cousin Evan Quick also deserves special thanks for his support and generosity in giving me his grandfather's MacDonald Gill scrapbook, and so too does the late Mary Corell (Max's daughter), who regaled me with many family anecdotes. I would also like to thank Stewart LaBrooy, who supported my setting up of the MacDonald Gill website – this has helped promote Max to the wider world and allowed people to contact me with information.

I am also grateful to a host of others who have supported my project in many ways: supplied information and images, allowed me to photograph artworks, and permitted me to use copyrighted material. These include the late Richard Adeney, Anne Ball, Peter Barber, Rod Barron, Stephanie Bentley, Dorothy Bentley-Smith, Mark Bertram, Michael Bochmann, Susan Chick, Stephen Constantine, Oliver Corell, Joe Cribb, Ruth Cribb, Bill Debenham, Nicholas Deterding, Norman Duncan, Kitty Edwards-Jones, Howard Elliott, Julia Facey, Christopher Gaisford Lawrence, Chirlene Gama, David Gaylard, Richard Gill, Martin Graham, Peter Green, Peter Greenhill, Ted Greenway, Elizabeth Harper, Tom Harper, Anne Harvey (literary executor of Estate of Eleanor Farjeon), Andrew Haslam, John Hawkins, Benedict Heal, the late David Heal, Oliver Heal, Mark Howarth, Louis Jebb, Peter Kane (literary executor of Estate of John Farleigh), Margaret Kelly, Sir Peter and Lady Sylvia Lachmann, Robert Langmead, Anthony Lavers,

Squire de Lisle, Lawrence May, Fiona McCarthy, Timmy and Penny Norton, Ben Pearce, Jane Ridley, David Ross (creator of Map Roman, the font used for the book titles), Selina Rutherston, Ann Shealy, Father Terry Steele, Sue Taylor, Roger and Samantha Weatherby, Gary, Beverley and Hayley Widdowson, Elke Karin Wood and Adele Wright.

My gratitude also goes to the many institutions which have aided my research including All Souls' College, Oxford, the Art Workers' Guild, Balliol College, British Library, Cambridge Guildhall, Chorley's Auction House, Christ Church, Oxford, City of Westminster Archive Centre, Commonwealth War Graves Commission, Coventry Guildhall, Ditchling Museum of Art + Craft, Kelmarsh Hall, Lincoln Cathedral, Lindisfarne Castle, London Transport Museum, National Archives, National Art Library, Prints and Drawings Room at the Victoria and Albert Museum, Royal Institute of British Architects, Royal Geographical Society, Scott Polar Research Institute, Senate House, South Africa House, Tate, University of Liverpool Cunard Archive, Michael Somare Library at the University of Papua, West Sussex Record Office and the W.H. Smith Archive, Worthing Town Hall.

I would also like to thank my editor Caroline Brooke Johnson, whose encouraging comments and constructive suggestions have been invaluable, and my publisher Unicorn Publishing Group, especially Lucy Duckworth – whose enthusiasm for the project never waned, and their designer Felicity Price-Smith, who has worked tirelessly to create an attractive book worthy of Max's own artistic output.

My family too have supported and encouraged me during the research and writing of this book especially my husband who proofread the final manuscript as did Andrew and Angela Johnston. It is a great sadness to me that my mother did not live long enough to read this biography of her Uncle Max, but she would have been thrilled to know that it has finally been published.

IMAGE CREDITS

23 (top), 25 West Sussex Record Office; **40 (top)** © reproduced with permission of Southend-on-Sea Borough Council; **40** (bottom), **158 (bottom)** Evan Quick Collection, reproduced with permission; **60** St Ternan's Church, Banchory, Scotland; **74, 94** copies of original photos by Emery Walker for William Rothenstein's *Twenty four Portraits (Second Series)*, 1923, and *Twenty four Portraits (First Series)*, 1917*;* **83** © Michael Edwards Photography, reproduced with permission; **89** courtesy of Louis Jebb; **92** courtesy of Michael Bochmann; **94** reproduced with permission of *Country Life* Picture Library; **100** *Matrix* 10, 1990; **cover** detail of *By Paying Us Your Pennies* poster, whole image posters: **106, 161, 163, 194, 203**, details from posters: **107, 108, 109, 131, 165** © TfI, from the collection of the London Transport Museum, reproduced with permission; **105, 117** courtesy of Ben Pearce; **115** courtesy of Mark Howarth/Mark Bertram; **121** courtesy of Sue Taylor; **143** photo courtesy of Commonwealth War Graves Commission; **169 (top)** courtesy of Oliver Heal; **172 (bottom)** www.armaghbeds.com; **185** courtesy of Richard Gill; **201** © Chorley's Auction House, reproduced with permission; **287** reproduced with permission of Inner Temple Library; **303 (top)** © The Reverend Caroline Beckett, reproduced with permission.

ENDNOTES

Key to abbreviations used in the endnotes:
CWGC – Commonwealth War Graves Commission
IWGC – Imperial War Graves Commission
PJ – Priscilla Johnston
MG – MacDonald Gill

Chapter 1 – Brighton

1. Gill, Eric, *Autobiography*, London: Jonathan Cape, 1940, p.19.
2. Ibid. p.43.
3. Speaight, Robert, *The Life of Eric Gill*, London: Methuen & Co., 1966, p.4.
4. Gill, Donald, Letter to Evan Gill, 15 September 1961.
5. PJ, Unpublished Memoir, p.135.
6. The terrace was renamed Highcroft Villas.
7. Gill, Eric, *Autobiography*, London: Jonathan Cape, 1940, p.21.
8. Gill, Romney, Letter to parents, 8 April 1925.
9. Gill, Eric, *Autobiography*, London: Jonathan Cape, 1940, p.43–4.
10. Ibid., p.42.
11. MG, Diary, 8 June 1902.
12. Gill, Eric, *Autobiography*, London: Jonathan Cape, 1940, p.45.
13. PJ, Unpublished Memoir, p.136.
14. PJ, Diary, 26 March 1947.
15. PJ, Unpublished Memoir, p.136.
16. Gill, Eric, *Autobiography*, London: Jonathan Cape, 1940, p.61.
17. Ibid., p.58.
18. List of family members written by Arthur Tidman Gill.
19. Film pioneers G.A. Smith, Esme Collings and Alfred Darling had their works very near the Gill's home.
20. MG, Diary, 19 January 1899.
21. Gill, Eric, *Autobiography*, London: Jonathan Cape, 1940, p.38.
22. Ibid., p.46.
23. A Miss Eliza Brown is listed in Kelly's Directory of 1876 as running a boy's preparatory school at 31 Montpelier Crescent, Brighton.
24. MG, Diary, 26 July 1895.
25. Ibid., 28 June 1895.
26. Gill, Eric, *Autobiography*, London: Jonathan Cape, 1940, p.40.
27. The Gill family had already begun attending St Peter's Church in Preston. Some said his move to become an Anglican minister was to improve his prospects as church had always been considered better 'class' than chapel.
28. Gill, Cicely Rose, Letter to MG, 11 October 1903.
29. This event took place on 17 June 1896 after Nansen's failed attempt on the North Pole.

Chapter 2 – Chichester

1. Gill, Eric, *Autobiography*, London: Jonathan Cape, 1940, p.40.
2. The Prebendal School in Chichester was originally founded to provide an education for the Cathedral choristers, but was now also a grammar school for local boys.
3. MG, Diary, 17 November 1897
4. Ibid., 4 July 1899.
5. Ibid., 11 April 1899.
6. Ibid., 16 July 1898.
7. Corell, Mary, interview with author, 2011.
8. Ibid., 30 April 1898.
9. Ibid., 29 November 1898.
10. Gill, Eric, *Autobiography*, London: Jonathan Cape, 1940, p.92.

Chapter 3 – Bognor

1. St John the Baptist was demolished in 1972 although the mother church of St Wilfrid's still stands.
2. Bognor would not gain the suffix 'Regis' until 1930 after a visit by George V in 1929.
3. MG, Diary, 26 June 1898.
4. The building was converted into flats and renamed Streete Court.
5. Ibid., 31 May 1900.
6. Ibid., 8 December 1900.
7. Gill, Eric, *Autobiography*, London: Jonathan Cape, 1940, p.92.
8. Gill, Romney, Letter to L. Williams, 9 July 1936.
9. Ibid
10. Ibid., 1 February 1901.
11. MG, Diary, 4 February 1901.
12. Ibid., 23 January 1902.
13. Gill, Romney, Letter to MG, 10 January 1904.
14. MG, Diary, 22 August 1901.
15. The Yeomanry was the mounted arm of volunteers and militia who protected the British Isles when regular troops were abroad. Units have been absorbed into the modern-day Territorial Army.
16. Gill, Romney, Letter to MG, 16 September 1906.
17. MG, Diary, 2 March 1902.
18. Ibid., 10 June 1902.
19. MG Diary 18 June 1902.
20. Ibid., 22 June 1902.
21. Ibid., 23 June 1902.
22. Ibid., 27 June 1902.

23. Ibid., 12–20 August 1902.

24. Decades later Romney refers to this event as in the year he commenced work for the Rev. Eden, but he mistakenly writes 1901 rather than 1902.

25. MG, Diary, 11 February 1903.

26. Ibid., 22 February 1903.

Chapter 4 – The Early Years

1. MG, Diary, 23 February 1903.

2. Ibid.

3. Pevsner, Nikolaus, 'Goodhart-Rendel's Roll Call', *Architectural Review*, 138, no. 824, October 1965, p.263.

4. MG, Diary, 27 April 1903.

5. Ricardo and William de Morgan were partners in a firm making hand-made glazed tiles.

6. MG, Diary, 29 July 1903.

7. Eric Gill, Letter to Romney Green, 23 July 1940

8. Gill, Romney, Letter to MG, 22 February 1903.

9. MG, Diary, 12 July 1903.

10. Gill, Eric, *Autobiography*, London: Jonathan Cape, 1940, p.118.

11. Johnston, Priscilla, *Edward Johnston*, London: Faber & Faber, 1959, p.17–18.

12. Ibid., p.99.

13. Ibid., p.96.

14. The first woman to be admitted to the guild was the wood-engraver Joan Hassall in 1964.

15. Johnston, Edward, Letter to Greta, 1901.

16. Gill, Cicely Rose, Letter to MG, 9 March 1903.

17. Gill, Cicely Rose, Letter to MG, 26 February 1903.

18. Gill, Cicely Rose, Letter to MG, *c.* 1903/1904.

19. Gill, Cicely Rose, Letter to MG, 26 February 1903.

20. Gill, Arthur Tidman, Letter to MG, 23 March 1903.

21. PJ, Unpublished Memoir, p.156.

22. Ibid., 26 April 1903.

23. Gill, Cicely Rose, Letter to MG, 28 June 1906.

24. MG, Diary, 27 April 1903.

25. Ibid., 17 April 1903.

26. This was probably for the Bournemouth branch which was installed under Max's supervision in December 1904.

27. Ibid., 19 October 1904.

28. Ibid., 23 July 1903.

29. Ibid., 27 March 1904.

30. McCarthy, Fiona, *Eric Gill*, London: Faber & Faber, 1989, p.90.

31. Gill, Romney, Letter to MG, 10 May 1904.

32. Gill, Romney, Letter to MG, 1 February 1903.

33. Gill, Romney, Letter to MG, 23 August 1903.

34. MG, Diary, 6 August 1904.

35. Ibid., 22 July 1905.

36. MG, Letter to Vernon Gill, early December 1910.

37. MG, Diary, 17 April 1906.

38. Chelsea Football Club, Letter to MG, 17 November 1906.

39. This is in St Wilfrid's Church, Bognor Regis.

40. Gill, Romney, Letter to MG, 23 May 1905.

41. Gill, Arthur Tidman, Letter to MG, 2 November 1906.

42. Ibid., 2 August 1906.

43. Catalogue, 8th Arts & Crafts Exhibition, 11 January–17 March 1906.

44. Ibid.

45. Gill, Cicely Rose, 25 March 1906.

46. MG, Diary, 16 April 1906.

47. Ibid., 20 August 1906.

48. Ibid., 24 August 1906.

49. Gill, Cicely Rose, Letter to MG, 28 April 1906.

50. Gill, Romney, Letter to MG, 18 March 1906.

51. MG, Diary, 8 May 1907.

52. Gill, Arthur Tidman, Letter to MG, 28 April 1907.

53. MG, Diary, 24 December 1907.

54. Gill, Cicely Rose, Letter to MG, 6 April 1908.

55. Ibid.

Chapter 5 – Independence: The First Year

1. MG, Diary, 4 May 1908.

2. Gill, Cicely Rose, Letter to MG, *c.* late 1908.

3. MG, Diary, 15 June 1908.

4. Ibid., 24–5 July 1908.

5. Gill, Vernon, Note with photo, Scrapbook.

6. MG, Diary, 27 April 1908.

7. Ibid.

8. Ibid., 29 July 1908.

9. Ibid.

10. Luigi Gatti, who would run the *A La Carte* restaurants on the SS *Olympic* and SS *Titanic*, lost his life in the Titanic sinking in 1912.

11. Holland, Scott, Canon, *The Ground of Our Appeal*, Oxford: Christian Social Union, 1904, quoted in Bliss (ed.), The (English) Christian Social Union, p.205.

12. MG. Ledger, 1908, entry no. 29.

13. Ibid., 18 August 1908.

14. Gill, Cicely Rose, Letter to MG, 13 August 1908.

15. MG, Diary, 16 July 1908.

16. Ibid., 22 September 1908.

17. MG, Lecture on 'Calligraphy' given to Junior Art Workers' Guild, 21 January 1909.

18. Johnston, Priscilla, Unpublished Memoir, p.142.

19. MG, Lecture given at the Society of Calligraphers, 24 October 1908.

20. Ibid.

21. MG, Lecture on 'Calligraphy' given to Junior Art Workers' Guild, 21 January 1909.

22. Ibid.

23. 'The Modern Revival of Handwriting', *The Cheltenham Ladies' College Magazine*, o. LIX, Spring 1909, p.135.

24. A version of this talk was presented to the Society of Calligraphers in 1908.

25. MG, Diary, 28 April 1909.

Chapter 6 – Lutyens and the First Painted Map

1. Worthington, Hubert, 'Reminiscences on Lutyens', *Architectural Association Journal*, 74, 1959, p.233.

2. Sitwell, Osbert, *Great Morning*, 1948 pp.19–20.

3. Ridley, Jane, *The Architect & His Wife*, London: Chatto & Windus, 2002, p.24.

4. James, Mrs William Dodge, quoted in Jane Ridley, *The Architect and His Wife,* 2002, p.157.

5. MG, Diary, 31 August 1909.

6. MG, Diary, 17 October 1909.

7. Ibid., 26 October 1909.

8. Ricardo, Harry, *Memories and Machines: The Pattern of my Life*, London: Constable, 1968, p.30.

9. Ibid.

10. *The Times*, 21 December 1909.

11. MG, Diary, 11 December 1909.

12. *The Times*, 21 December 1909.

13. Therese's second husband was Walter Sickert.

14. Ricardo, Harry, *Memories and Machines: The Pattern of my Life*, London: Constable, 1968, p.244.

15. MG, Diary, 20 December 1909.

Chapter 7 – From Justice to Punch and Judy

1. Rothenstein, William, *Men and Memories*, vol. 1, New York: Tudor Publishing Co., 1920, p.202.

2. MG, Diary, 23 December 1909.

3. Galsworthy, John, *Justice*, London: Duckworth & Co., 1910.

4. Howe, *The Repertory Theatre: A Record & a Criticism*, London: Martin Secker& Co., 1910.

5. Beerbohm, Max, 'Justice', *Saturday Review*, 5 March 1910.

6. Ibid.

7. Howe, *The Repertory Theatre: A Record & a Criticism*, London: Martin Secker & Co., 1910.

8. Rothenstein, William, *Men and Memories*, vol. 1, New York: Tudor Publishing Co., 1920, p.202.

9. One of the founders of the Parliamentary Labour Party, Ramsay MacDonald would in 1924 become the first Labour prime minister.

10. Boulter, Ben, Letter to Evan Gill, 2 May 1954.

11. MG, Diary, 16 May 1910.

12. Ibid., 14–15 May 1910.

13. Boulter, Ben, Letter to Evan Gill, 2 May 1954.

14. MG, Postcard to Vernon Gill, 21 May 1910.

15. In the late 1890s Andrew Usher, a whisky distiller, donated £100,000 to build a concert hall in Edinburgh. The winning entry was by Stockdale Harrison & Howard H. Thomson of Leicester.

16. *The Builders' Journal*, 29 June 1910.

17. MG Diary, 11 September 1910.

18. Ibid., 18 November 1910.

19. Gaisford St Lawrence, Christopher, correspondence with the author, 27 November 2007.

20. MG, Letter to Vernon Gill, 12 December 1910.

21. MG, Diary, 22 July 1911.

22. Only four pilots completed the course. The winner was Lieutenant de Vaisseau Conneau, who landed back at Brooklands in his Blériot XI monoplane four days later, with a flight time of just under thirty hours.

23. Spalding, Francis; www.tate.org.uk/art/artists/roger-fry-1129, accessed 10 September 2019.

24. Fry, Roger, 'Vision of Art' in *Art & Socialism*, 1972.

25. *The Athenaeum,* 23 September 1911, p.366.

26. Woolf, Virginia, *Roger Fry – A Biography*, London: The Hogarth Press, 1940.

27. Ibid., 3 March 1911.

28. Peter Stansky, *On or about December 1910: Early Bloomsbury and Its Intimate World*, Harvard University Press, Cambridge, Massachusetts, London, England, 1997, p.234

29. Fry, Roger, *Letters of Roger Fry* (introduction by Denys Sutton), London: Chatto & Windus, 1972, p.48.

30. During the First World War Albert Rothenstein, brother of William Rothenstein, changed his name to Rutherston to disassociate himself from his German origins.

31. Fry, Roger, *Letters of Roger Fry* (introduction by Denys Sutton), London: Chatto & Windus, 1972, p.48-49.

32. *The Times*, 19 September 1911, p.9.

33. *Evening Standard*, September 1911.

34. *The Athenaeum,* 23 September 1911.

35. *National Review*, September 1911.

36. Fry, Roger, no. 318: Letter to Lady Fry, 9 November 1911, in *Letters of Roger Fry* (introduction by Denys Sutton), London: Chatto & Windus, 1972, p.353.

37. Packer, Frederick, Letter to Mary Chamot, 15 Jan 1954 (Tate Archive ref. TG 15/7).

38. *The Times*, 19 September 1911, p.9.

39. MG, Letter to Vernon Gill, 17 November 1911.

40. Gill, Eric, Diary, 6 September 1911.

41. Gill, Eric, letter to H S 'Jim' Ede, 27 March 1931, Tate Archive collections

42. MG, Letter to Vernon Gill, 17 December 1911.

43. MG, Diary, 16 October 1911.

44. MG, Letter to Vernon Gill, 17 December 1911.

45. Quoted by Cecil Baring's daughter. Pollen, Daphne, *I Remember, I Remember* (1983), privately published 2008, p.77.

46. MG, Letter to Vernon Gill, 17 December 1911.

47. Ibid.

48. Ibid.

Chapter 8 – Hare Court, North End and the North-East

1. MG, Letter to Vernon Gill, 1 September 1912

2. Ibid..

3. Ibid.

4. Ibid.

5. Boulter, Ben, Letter to Evan Gill, 2 May 1954.

6. MG, Diary, 12 August 1912.

7. MG, Letter to Vernon Gill, 1 September 1912.

8. Gill, Arthur Tidman, Letter to MG, 15 April 1912.

9. Gill, Arthur Tidman, Letter to MG, 29 September 1911.

10. MG, Diary, 31 July 1912.

11. Gill, Eric, *Autobiography*, London: Jonathan Cape, 1940, p.197.

12. Strachey, Lytton, in Brown, Jane, *Lutyens and the Edwardians*, London: Viking, p.119.

13. MG, Diary, 18 November 1912.

14. Gill, Cicely Rose, Letter to MG, 23 November 1912.

15. Ibid.

16. MG, Diary, 7 December 1912.

17. Galsworthy, John, entry in notebook, quoted in Marrot, H.V., *Life & Letters of John Galsworthy*, London: Heinemann, 1935.

18. MG, Diary, 12 December 1912.

19. MG, Letter to Romney, 27 February 1913.

20. Gill, Cicely Rose, Letter to Evan Gill, 13 May 1913.

21. Ibid.

22. MG, quoted in quoted in letter to Evan Gill from Cicely Rose Gill, 13 May 1913 (ibid.).

23. Ibid.

24. Gill, Romney, quoted in letter to Evan Gill from Cicely Rose Gill, 13 May 1913 (ibid.).

25. Deterding, Nicholas, correspondence with the author, 22 September 2010.

26. When asked about the tiny holes in the map, Deterding's grandson Nicholas told the author (see endnote 243) that his father and cousin – when boys – had used the panel as a dartboard and when the damage was discovered they were thrashed so hard by Henri Deterding that they were unable to sit down for days.

Chapter 9 – The Wonderground Map of London Town

1. MG, Workbook 1910–13, 22 July 1913.

2. Johnston, Priscilla, Edward Johnston, London: Faber & Faber, 1959, p.191.

3. MacCarthy, Fiona, 'Design on the line', *Manchester Guardian Weekly*, 29 Aug 1968, p.19.

4. Johnston's alphabet was finally produced in 1916. Later he also designed the familiar 'bull's eye' roundel.

5. Warde, Beatrice, *The Monotype Recorder,* vol. 41, no. 3, Autumn 1958, p.14.

6. Pick, Frank, quoted in Green, O, *Frank Pick's London*, London: V&A, 2014, p.27.

7. MG, Diary, 18 March 1914.

8. MG, Diary, 23 October 1913.

9. Smith, Dorothy Bentley, *Past Times of Macclesfield Vol. IV*, Stroud: Amberley Publishing, 2017, pp.91–92.

10. MG, Diary, 21 February 1914.

11. Ibid., 13 January 1914.

12. Ibid., 9 March 1914.

13. *The Times*, 21 March 1914.

14. *Daily Sketch*, 21 March 1914.

15. *Evening Standard*, 21 March 1914.

16. *The Times*, 21 March 1914.

17. MG, Decorative Maps, *The Studio*, December 1944, p.166.

18. *Evening Standard*, 21 March 1914.

19. Barber, Peter, *Magnificent Maps: Power, Propaganda and Art*, London: British Library, 2010, p.134.

20. The first pilot to perform this feat was Lt. Pyotr Nikolaevich Nesterov, a Russian army pilot at Kiev on 9 September: www.thosemagnificentmen.co.uk/ aerobat, accessed 13 May 2014.

21. The 'Begarez Hog' is an obscure Gill family joke which crops up in correspondence between the siblings.

22. *Daily Sketch*, May 1914.

Chapter 10 – The Bladen Estate and the End of a Romance

1. MG, Diary, 14 May 1914.

2. Ibid., 27 June 1914.

3. Ibid., 13 June 1914

4. Ibid., 12 May 1914.

5. Ibid., 13 March 1914.

6. Ibid., 7 May 1914.

7. Ibid., 24 January 1914.

8. Ibid., 2 January 1914.

9. Ibid., 3 January 1914.

10. Ibid., 3 January 1914.

11. Ibid., 5 January 1914.

12. Ibid., 2 Jan 1914.

13. Ibid., 14 February 1914.

14. Ibid., 10 March 191

15. Ibid., 19 March 1914

16. Max uses various spellings 'Turner's Puddle', 'Toners Puddle' and most commonly, 'Tonerspuddle'. Even locals today cannot agree on the correct spelling. Unless in a quotation, the last version will be used.

17. Nash, John. Letter to Anne Hill, 11 March 1968.

18. MG, Diary, 20 March 1914.

19. 'Concrete and Thatch in Dorset', *Country Life*, 10 May 1919, p.38.

20. Visitor leaflet, Bladen Estate, 1929.

21. 'Concrete and Thatch in Dorset Pt.1', *Country Life*, 3 May 1919, p.507.

22. Ibid.

23. Ibid.

24. MG, Diary, 8 June 1914.

25. Ibid., 28 May 1914.

26. Ibid., 27 June 1914.

27. Ibid., 7 May 1914.

28. Ibid., 12 May 1914.

29. Ibid., 21 May 1914.

30. Ibid., 22 May 1914.

31. Ibid., 13 June 1914.

32. Ibid., 25 June 1914.

33. Ibid., 28 June 1914.

34. After the death of Bishop Creighton, Mary's mother moved into a spacious grace-and-favour apartment at Hampton Court.

35. MG, Diary, 19 July 1914.

36. Ibid., 21 July 1914.

37. Ibid., 22 July 1914.

38. Ibid.

39. Ibid., 14 August 1914.

40. Ibid., 4–5 August 1914.

41. Ibid., 31 August 1914.

42. Ibid.

43. Ibid., 14 November 1914.

44. Ibid., 6 October 1914.

45. Ibid.

46. Ibid., 2 November 1914.

47. Ibid., 7 November 1914.

Chapter 11 – An Old Flame

1. MG, Letter to Cecil Gill, 2 November 1938.
2. Later referred to as Sissinghurst.
3. MG, Diary, 28 February 1915.
4. Ibid., 24 March 1915.
5. Ibid., 14 April 1915.
6. MG, Letter to William Rothenstein, 12 August 1915 (courtesy of the Houghton Library).
7. MG, Letter to William Rothenstein, 6 August 1915 (courtesy of the Houghton Library).
8. Nash, John, Letter to Anne Hill, 11 March 1968.
9. MG, Letter to William Rothenstein, 6 August 1915 (courtesy of the Houghton Library).
10. Ibid.
11. MG, Letter to William Rothenstein, 12 August 1915 (courtesy of the Houghton Library).
12. Told to the author by Ben Boulter's grandson in 2019.
13. Ibid.
14. MG, Diary, 27 January 1915.
15. Ibid., 16 October 1915.
16. MG, Letter to Romney Gill, 4 April 1939.
17. Farjeon, Eleanor, *Edward Thomas: The Last Four Years*, Oxford: Oxford University Press, 1958, p.168.
18. Ibid., p.167.
19. Thorp, Joseph, 'MacDonald Gill: Designer', *Overseas: The Monthly Journal of the Overseas Club & Patriotic League,* vol.V, no. 52, May 1920, p.43.
20. Betjeman, John, quoted in *Daily Echo,* 9 June 2001.

Chapter 12 – Eric Comes to Dorset

1. For details of classifications, see the Military Service Act 1916.
2. Gill, Eric, Diary, 29 May 1917.
3. Ibid.
4. Ibid., 25 August 1918.
5. Ibid., 14 August 1918.
6. Additional names were carved in July 1919 by Albert Leavey, another of Eric's pupils.
7. Greenhill, Peter and Brian Reynolds, *The Way of the Sun,* Claremont, Ontario: True to Type Books, 2010, p.6.
8. Ibid.
9. Hunter, Eileen, *The Profound Attachment*, London: André Deutsch, 1969, p.79.
10. *Country Life,* 15 March 1924.

Chapter 13 – An Alphabet to Remember

1. Kenyon, Sir Frederick, *War Graves how the Cemeteries abroad will be designed*, His Majesty's Stationery Office: London, 1918.
2. Weaver, Lawrence, 'Memorials & Monuments', *Country Life*, 1915, p.338.
3. Thorp, Joseph, 'MacDonald Gill: Designer', *Overseas: The Monthly Journal of the Overseas Club & Patriotic League*, vol.V, no. 52, May 1920, p.42.
4. MG, quoted in note written by Vernon Gill on an IWGC leaflet.
5. Kenyon, Sir Frederick, *Kenyon Report Pt 2*, IWGC, 24 January 1918.
6. Minutes of IWGC Headstone Committee, 17 February 1919, CWGC, ADD 1 February 1983.
7. MG, Letter to J.E. Talbot, IWGC, 2 Oct 1919, CWGC 1/1/5/13.
8. Lutyens, Sir Edwin, Letter to J.E. Talbot, 24 September 1919, CWGC 1/1/5/13.
9. Kenyon, Sir Frederick, *War Graves: how the Cemeteries abroad will be designed.* London: HM Stationery Office, 1918.
10. Ibid.
11. Gill, Eric, Diary, 7 January 1919.
12. Gill, Eric, Letter to *The Burlington Magazine,* April 1919, vol. XXXIV, no. 193, in *Letters of Eric Gill,* ed. by Walter Shewring, Jonathan Cape, 1947, p.130.
13. Ibid., p.128.
14. Ibid. p.132.
15. Minutes of IWGC Headstone Committee, 17 February 1919, Commonwealth War Graves Commission, ADD 1 February 1983.
16. Whether this offer was taken up is unknown.
17. Gill, Arthur Tidman, Letter to MG, 25 October 1918.

Chapter 14 – The Post-War Years

1. Gill, Arthur Tidman, Letter to MG, 25 June 1919.
2. MG, Letter to Vernon Gill, 17 November 1919.
3. Ibid.
4. MG, Letter to Romney Gill, 29 August 1923.
5. Ibid.
6. Ibid.
7. Ibid.
8. MG, Letter to Romney Gill, 26 September 1923.
9. Mary Corell in conversation with the author, 2007.
10. MG, Letter to Romney Gill, 20 April 1924.
11. Ibid.
12. www.sussexparishchurches.org/spc_V31/west-sussex/23-west-sussex-c-d/421-chichester-st-bartholomew-without-mount-lane. Accessed 3 November 2014.
13. In 1959 the church became the college chapel and then a drama studio for Chichester University though its future use at the time of writing is undecided.
14. Jackson, The Rev Cyril, Letter to Principal of Chichester Theological College, 21 October 1959 (West Sussex Record Office).
15. Principal of Chichester Theological College, Letter to The Rev. Cyril Jackson, 5 November 1959 (West Sussex Record Office).
16. PJ, Unpublished Memoir, pp.175–6.
17. Ibid.
18. Ibid.
19. Thorp, Joseph, 'MacDonald Gill: Designer', *Overseas: The Monthly Journal of the Overseas Club & Patriotic League,* vol.V, no. 52, May 1920 p.43.
20. Power's map panel was bequeathed to the nation in his will and is now on permanent display to the public at the City of Westminster Archives.
21. 'Romance from a London Bus Stop', *Daily News,* 14 November 1920.
22. Ibid.

23. Kenneth Gill married Louise Cullen a few months before his death in October 1918.
24. *Daily Telegraph*, 1923.

Chapter 15 – Promoting the Empire
1. Brochure, *British Empire Exhibition*, 1924.
2. MG, Letter to Romney Gill, 20 April 1924.
3. Ibid.
4. Ibid.
5. Ibid.
6. Ibid.
7. Gill, Cecil, Letter to Romney Gill, 20 January 1924.
8. MG, Letter to Romney Gill, 20 April 1924.
9. *General Handbook*, British Empire Exhibition 1924.
10. Constantine, Stephen, *Buy & Build: The Advertising Posters of the Empire Marketing Board*, Public Record Office: London, 1986, p.2.
11. Ibid., p.3.
12. 'Is the World a Semi-circle', *Daily Herald*, 1 January 1927.
13. *The Spectator*, 28 May 1929.
14. 'Poster Holds Up Traffic', *Eastern Daily Press*, 1 January 1927.
15. Lt. Col. S. Smith, according to papers in the Empire Marketing Board file CO 758/60/5, claimed the projection was his design and accused the EMB of breaching copyright.
16. Constantine, Stephen, *Buy & Build: The Advertising Posters of the Empire Marketing Board*, London: HM Stationary Office, 1986, p.8.
17. Ibid.
18. Ibid, p.17.
19. Ibid., p.11.
20. www.hillarys.co.uk/back-in-my-day/, accessed 18 September 2019.

Chapter 16 – A House and a Home
1. MG, Letter to Romney, 22 April 1924.
2. David Heal in conversation with the author, *c.* 2008.
3. Mortimer, John, *Clinging to the Wreckage: a part of life*, London: Penguin Books, 2010, p.31, copyright © Advanpress Ltd, 1998 (one hundred and ninety-three (193) word extract in the English language licensed from Penguin Books).
4. MG, Letter to Romney, 22 April 1924.
5. Ibid.
6. Ibid.
7. Ibid.
8. Ibid.
9. 'The Lesser Country Houses of Today: Darwell Hill', *Country Life*, 3 March 1928, p.318.
10. Ibid.
11. MG, Letter to Romney Gill, 15 November 1927.
12. Ibid.
13. Gill, Evan, Letter to Romney Gill, 28 February 1927.
14. MG, Letter to Romney Gill, 15 April 1927.
15. Richard Adeney in telephone conversation with the author, 20 April 2010.

16. Ibid.
17. MG, Letter to Romney Gill, 15 April 1927.
18. The name 'Duncannon' was given to the early Class B2 4-4-0 steam locomotives that ran on the London Brighton and South Coast Railway in the 1890s.
19. MG, Letter to Romney, 15 April 1927.
20. Ibid.
21. PJ, Unpublished Memoir, p.144.
22. Author interview with Mary Corell and conversation with a Gill cousin Helen Mary Skelton.
23. Andrew Johnston in note to the author, July 2019.
24. Susan Stiff (née Gill, daughter of Evan Gill) in conversation with the author, 2006.
25. PJ, Unpublished Memoir, p.139.

Chapter 17 – Maps and Murals
1. Decades later Tree's ex-wife, the interior designer Nancy Lancaster wrote about the map, but misattributed the work to Colin Gill, who was Max and Eric's cousin and a mural painter of some note and is now best known for painting the extraordinary eyes on the ceiling at Blenheim Palace.
2. This outline setch has previously been attributed – erroneously – to Edward S. Prior on the basis that he has written his name and address on the paper. The style and lettering show that the artist was certainly MacDonald Gill, who also painted the full colour drawing. The idea of The Creation mural was, however, conceived by Prior.
3. Farleigh, John, *Graven Image – An Autobiographical Textbook,* London: Macmillan, 1940, pp.177–8.
4. The mural was repainted in the 1980s but it is deteriorating badly so that whole sections at the east end have vanished. This is due to the salt-saturated north-easterly winds from the North Sea which hit this end of the church.
5. The British Society of Poster Designers was set up in 1926 with the aim of improving the relationship between client and designer.
6. PJ, Diary, 13 August 1939.
7. PJ, Diary, 13 August 1939.
8. Gill, Romney, Letter to MG, 19 December 1929, Michael Somare Library, University of Papua New Guinea.
9. *Sussex Daily News*, 8 August 1929.
10. Gill, Romney, Letter to MG, 19 December 1929

Chapter 18 – A Financial Crisis
1. Gill, Romney, Letter to MG, 17 October 1931, Michael Somare Library, University of Papua New Guinea.
2. Ibid.
3. PJ, Unpublished Memoir, p.135.
4. PJ, Diary, 8 July 1931.
5. PJ, Unpublished Memoir, p.143.
6. Ibid.
7. Ibid., p.147.
8. Ibid.
9. Ibid., p.148a.

10. PJ, Diary, 10 July 1931.
11. In 2019 this sold at auction for £50,000.
12. Lovett, Patricia, www.patricialovett.com/macdonald-gills-westminster-maps, accessed 12 October 2019.
13. *Manchester Dispatch*, 18 October 1932.
14. Ibid.
15. Gill, Romney, Letter to MG, 6 October 1932, Michael Somare Library, University of Papua New Guinea.

Chapter 19 – A Chance Encounter
1. MG, Diary, 4 February 1933.
2. Ibid., 15 February 1933.
3. PJ, Letter to Edward Johnston, 19 January 1933.
4. H. Lawrence Christie, calligrapher and one of Johnston's early pupils.
5. PJ, Diary, 18 January 1933.
6. PJ, Unpublished Memoir, p.153.
7. Johnston, Edward, letter to Greta Johnston, 18 May 1903.
8. Ibid.
9. Ibid.
10. Ibid., pp.154.
11. PJ, Diary, 8 February 1933.
12. Ibid., 16 February 1933.
13. Ibid.
14. Ibid.
15. PJ, Unpublished Memoir, p.157.
16. Ibid., 14 March 1933.
17. MG, Letter to PJ, 30 March 1933.
18. Designed by Charles Cowles-Voysey.
19. MG, Letter to PJ, 8 April 1933.
20. MG, Letter to PJ, 21 August 1933.
21. PJ, Letter to MG, 5 April 1933.
22. PJ, Letter to MG, 6 October 1933.
23. MG, Letter to PJ, 30 March 1933.
24. Ibid.
25. PJ, Letter to MG, 9 August 1933.
26. PJ, Letter to MG, 13 August 1933.
27. PJ, Letter to MG, 18 November 1933.
28. PJ, Letter to MG, 13 July 1933.
29. MG, Letter to PJ, 21 August 1933.
30. PJ, Unpublished Memoir, 157.
31. PJ, Letter to MG, 24 October 1933.
32. Ibid.
33. PJ, Unpublished Memoir, p.158.
34. Ibid.
35. MG, Letter to PJ, 26-7 December 1933.
36. Ibid.
37. PJ, Diary, 22 September 1933.

Chapter 20 – Cambridge: Painting the Poles
1. PJ, Unpublished Memoir, p.161.
2. Ibid., p.163.
3. PJ, Diary, 16 May 1934.
4. Ibid., 22 June 1934.
5. Ibid., 19 June 1934.
6. MG, Letter to PJ, 30 April 1934.
7. PJ, Unpublished Memoir, p.167.

8. Ibid., p.168.
9. Ibid.
10. Shortly after this John Gill became a tomato grower in the West Wittering area.
11. MG, Letter to PJ, July 1934
12. PJ, Diary, 10 July 1934.
13. PJ, Diary, 28 September 1935.
14. Ibid., 20 April 1937.
15. PJ, Unpublished Memoir, p.184.
16. Ibid.
17. PJ, Diary, 15 February 1935.
18. Ibid.
19. Ibid.
20. Ibid., 16 February 1935.
21. Ibid.
22. *The Times*, 19 September 1934, p.12.
23. PJ, Diary, 22 December 1934.
24. Ibid., 5 January 1935.
25. Ibid., 29 December 1934.
26. Ibid., 14 February 1935.
27. Angela Johnston in a note to the author, November 2019.
28. PJ, Letter to MG, 14 January 1935.
29. PJ, Diary, 25 February 1935.
30. Designed by George Grey Wornum.
31. PJ, Diary, 22 February 1935.
32. Ibid.
33. Ibid.
34. Ibid., 4 May 1935.
35. Ibid., 18 May 1935.

Chapter 21 – A Mural for a Queen
1. Shipbuilding Minutes of Meeting, 8 February 1932, Cunard Archive, University of Liverpool.
2. PJ, Diary, 27 February 1935.
3. Shipbuilding Minutes of Meeting, 27 May 1935, Cunard Archive, University of Liverpool.
4. This is believed to be the last commission undertaken by the interior design firm founded by architects Charles Mewés (1860–1914) and Arthur Davis (1878–1951), which had designed the interiors for the Ritz and liner *Aquitania*.
5. PJ, Diary, 28 August 1935.
6. PJ, Unpublished Memoir, p.175.
7. Ibid.
8. Ibid p.180.
9. Ibid.
10. Ibid.
11. PJ, Diary, 2 January 1936, and PJ, Unpublished Memoir, p.180.
12. PJ, Unpublished Memoir, p.182.
13. Ibid.
14. Ibid.
15. Ibid.
16. PJ, Diary, 10 January 1936.
17. PJ, Unpublished Memoir, p.176.
18. Ibid., p.183.
19. PJ, Unpublished Memoir, 2nd version, p.183.
20. PJ, Diary, 5 February 1936.
21. PJ, Unpublished Memoir, 2nd version, p.181.

22. MG, letter to PJ, 12 June 1936.
23. PJ, Diary, 1 April 1936.
24. Ibid., 8 April 1936.
25. Ibid., 24 May 1936.
26. Ibid.
27. Ibid.
28. Ibid., 27 May 1936.
29. Ibid.
30. Ibid.
31. Ibid.
32. Breitenbach, Margaret, letter to her cousin Susan Stiff, 10 April 1989.
33. Ibid.
34. PJ, Diary, 8 August 1936.
35. Ibid., 21 August 1936.
36. Ibid.
37. Ibid., 22 August 1936.
38. Ibid., 1 September 1936.
39. Ibid., 8 September 1936.
40. Ibid.
41. Ibid. 20 September 1936.
42. Ibid.
43. Ibid.
44. Ibid.,17 November 1936.
45. Ibid., 1 December 1936.
46. Ibid., 6 December 1936.

Chapter 22 – Paris and the Glass Maps

1. Ibid., 18 January 1937.
2. *Hackney Gazette*, 5 May 1937.
3. PJ, Diary, 20 February 1937.
4. Ibid.
5. Ibid., 1 July 1937.
6. Ibid., 19 May 1937.
7. PJ, Diary, 11 February 1937.
8. Ibid., 15 February 1937.
9. Ibid., 25 February 1937.
10. Ibid., 16 March 1937.
11. Ibid., 16 April 1937.
12. Ibid., 17 April 1937.
13. Ibid., 4 April 1937.
14. Ibid.
15. Ibid., 2 April 1937.
16. Ibid., 9 April 1937.
17. Ibid.
18. Ibid., 13 April 1937.
19. Ibid.
20. PJ, Unpublished Memoir, 2nd version, p.200.
21. Ibid., 8 June 1937.
22. Adshead was unable to do the map herself as she was having a baby.
23. PJ, Diary, 21 May 1937.
24. Ibid., 28 May 1937.
25. Ibid., 3 June 1937.
26. PJ, Unpublished Memoir, p.203.
27. MG, Letter to PJ, 17 August 1937.
28. Ibid.
29. Ibid.
30. PJ, Diary, 25–26 August 1937.
31. Gill, MacDonald, 'Decorative Maps', *The Studio*,

December 1944, p.169.
32. PJ, Unpublished Memoir, p.203.
33. Ibid.
34. PJ, Diary, 6 June 1937.
35. Ibid., 17 June 1937.
36. Ibid., 28 October 1937.
37. Ibid., 18 September 1937.
38. Ibid., 4 November 1937.
39. Ibid.
40. Ibid.
41. Ibid.
42. Ibid.
43. Ibid., 13 November 1937.
44. Ibid.
45. PJ, Diary, 10 December 1937.
46. Ibid., 30 December 1937.
47. Ibid.
48. Ibid., 31 December 1937.

Chapter 23 – This Is Our Year

1. Ibid., 7 January 1938.
2. Ibid., 10 January 1938.
3. Ibid., 28 March 1938.
4. Ibid., 3 February 1938.
5. Ibid., 28 February 1938.
6. Ibid., 1 November 1937.
7. MG, Letter to PJ, 28 March 1938.
8. PJ, Diary, 21 January 1938.
9. Veronica Whall, daughter of the stained-glass master, Christopher Whall, had made a stained-glass window for St Michael & All Angels in Bude Haven.
10. Ibid., 17 February 1938.
11. Ibid., 8 February 1938.
12. Ibid., 17 March 1938.
13. Ibid.
14. PJ, Unpublished Memoir, p.224A.
15. Ibid.
16. Several of this talented group would carve out respectable careers for themselves in the world of art: Edmund Nelson became a well-known portrait painter while Bernard Hailstone and Johnny Worsley both made their names as Second World War artists. Worsley, a talented portrait and seascape artist and illustrator for *The Eagle* comic, became famed for his creation of Albert RN, a life-size dummy of a British soldier which hoodwinked the German guards in Marlag-O prison camp near Bremen. (John Worsley, Obituary, *Daily Telegraph*, 7 October 2000)
17. PJ, Unpublished Memoir, p.224C.
18. PJ, Unpublished Memoir, p.225A.
19. Ibid.
20. PJ, Diary, 21 April 1938.
21. Ibid., 24 April 1938.
22. PJ, Unpublished Memoir, p.225C.
23. PJ, Diary, 28 April 1938.
24. PJ, Unpublished Memoir, p.224D.
25. *Architect's Journal*, 30 June 1938.
26. *Sunday Graphic & Sunday News*, 8 May 1938.
27. PJ, Diary, 8 May 1938.
28. Ibid., 10 May 1938.

29. Ibid., 15 June 1938.
30. MG, Letter to PJ, 4 July 1938.
31. MG, Letter to PJ, 20 July 1938.
32. PJ, Diary, 21 July 1938.
33. Ibid., 28 July 1938.
34. Ibid.
35. Ibid., 29 July 1938.
36. Ibid.
37. Ibid.
38. Ibid.
39. Madeline Gill, Letter to MG, 15 March 1939.
40. Cecil Gill, Letter to MG, 19 October 1938.
41. Eric Gill, Letter to Romney Green, 23 July 1940.
42. Eric Gill, Letter to MG, 20 November 1938.
43. PJ, Diary, 16 December 1938.
44. Ibid.
45. Edward Johnston, Letter to PJ, 7 December 1938.

Chapter 24 – New Beginnings

1. PJ, Unpublished Memoir, 2nd version, p.208.
2. MG, Letter to PJ, 18–19 January 1939.
3. MG, Letter to PJ, 2 November 1938.
4. Note written to the author by Andrew Johnston, July 2019.
5. PJ, Unpublished Memoir, 2nd version, p.206.
6. Ibid., 21 November 1938.
7. Ibid., 20 October 1938.
8. PJ, Diary, 5 December 1938.
9. PJ, Unpublished Memoir, 2nd version, p.208.
10. PJ Diary, 4 December 1938.
11. PJ, Diary, 10 October 1938.
12. Ibid., 24 November 1938.
13. Ibid.
14. PJ Diary, 23 December 1938.
15. Ibid.
16. PJ, Diary 25 December 1938.
17. Ibid.
18. Ibid., 29 December 1938.
19. Ibid.
20. Ibid., 10 July 1939.
21. Ibid., 14 July 1939.
22. Ibid., 26 January 1939.
23. PJ, Unpublished Memoir, 2nd version, p.232.
24. Ibid., p.236.
25. Ibid., p.238.
26. PJ, Diary, 1 July 1939.
27. PJ, Unpublished Memoir, 2nd version, p.246–7.

Chapter 25 – Wartime Worries

1. PJ, Diary, 18 October 1939.
2. Ibid., 16 September 1939.
3. PJ Diary, 6 December 1938.
4. Ibid., 25 October 1939.
5. MG, Diary, 15 December 1939.
6. PJ, Diary, 12 December 1939.
7. Ibid.
8. Ibid.
9. Ibid.
10. Ibid., 14 December 1939.
11. PJ, Unpublished Memoir, 2nd version, p.259.
12. Ibid.
13. Ibid. p.247.
14. Huxley, G., in Rappaport, E., *A Thirst for Empire: How Tea Shaped the Modern World*, p.269.
15. Gill, Evan, Letter to Romney Gill, December 1940.
16. Ibid.
17. Ibid.
18. MG, Diary, 21 November 1940.
19. PJ, Diary, 21 November 1940.
20. Green, Oliver, *Frank Pick's London*, V&A Publishing, 2013, p.124.
21. The MOI Film Unit was headed by Jack Beddington, former publicity director of Shell, whose mentor at Balliol had been Sir Stephen Tallents.
22. PJ, Diary, 9 December 1940.
23. PJ, Unpublished Memoir, p.257.
24. MacLagan, Eric, Letter to Sir Frederick Kenyon, 1 December 1939, Headstone & Badge Designs For 1939–1946, CWGC/1/2/A/18.
25. MacLagan, Eric, Letter to Sir Frederick Kenyon, 20 February 1940, Headstone & Badge Designs For 1939–1946, CWGC/1/2/A/18. Also Headstone Committee, note 15. March 1940, CWGC/1/2/A/18.
26. Ware, Sir Fabian, Note 9, 14 March 1940, CWGC/1/2/A/18 Headstone & Badge Designs For 1939–1946.
27. Minutes of Meeting of Headstone Committee, 2 April 1940, Headstone & Badge Designs For 1939–1946, CWGC/1/2/A/18.
28. Ibid.
29. PJ, Unpublished Memoir, 2nd version, p.259.
30. PJ, Diary, 5 February 1942.
31. Ibid., 20 October 1942.
32. PJ, Diary, 22 September 1942.
33. PJ, Diary, 14 October 1942.
34. Ridley, Jane, *The Architect and his Wife: A Life of Edwin Lutyens*, London: Chatto & Windus, 2002, p.408.
35. PJ, Diary, 14 May 1942.
36. Ibid., 18 May 1942.
37. *Time & Tide* was a political magazine set up in 1920 by its editor Margaret Lady Rhondda and staffed mainly by women.
38. MG, Letter to Frederick Philips, 9 October 1942.
39. Ibid.
40. *The Time & Tide Map of the Atlantic Charter*, Promotion leaflet, George Philips & Sons, 1942.
41. Meynell, Francis, quoted in PJ, Diary 14 December 1942.
42. *Headway*, Journal of the League of Nations Union, 1942.
43. PJ, Diary, 11 September 1943.
44. Ibid., 27 May 1944.
45. Ibid., 29 May 1944
46. Ibid., 5 June 1944.
47. Ibid., 18 June 1944.
48. Corell, Mary, *In Love and War: A Letter to my Parents*, London: Short Books, 2001.
49. PJ, Diary, 26 October 1943.
50. Ibid., 28 November 1944.

51. Ibid.
52. Ibid., 3 November 1944.

Chapter 26 – Endings

1. McWilliams (née Brown), Mary, Letter to Evan Gill, 17 November 1946.
2. PJ, Diary, 1 November 1944.
3. Ibid., 30 October 1946.
4. PJ, Diary, 15 Sept 1944.
5. Ibid., 3 August 1945.
6. Ibid., 11 August 1945.
7. Ibid., 8 September 1945.
8. Ibid., 9 September 1945.
9. Ibid., 30 September 1945.
10. Ibid., 8 October 1945.
11. Ibid., 24 December 1945.
12. Ibid., 30 December 1945.
13. Ibid., 31 December 1945.
14. Ibid., 28 January 1946.
15. Ibid.
16. Ibid., 14 March 1946.
17. Ibid., 12 March 1946.
18. Ibid., 27 October 1945.
19. All Saints' Church in Brightlingsea commemorates its parishioners who have died at sea with painted tiles displayed in a frieze around the nave.
20. Ibid., 1 April 1946
21. Alec Clunes, who died in 1970, was father of actor Martin Clunes.
22. Ibid., 26 February 1946.
23. Ibid., 29 December 1945.
24. Ibid., 16 March 1946.
25. Ibid., 2 March 1946.
26. Ibid., 8 March 1946.
27. MG, Diary, 9 March 1946.
28. Izzard, Brian, *Sabotage: The Mafia, Mao and the Death of the Queen Elizabeth*, Stroud: Amberley Publishing, 2012.
29. Ibid., 4 May 1946.
30. Ibid.
31. Ibid.
32. Ibid.,
33. Ibid.
34. MG, Diary, 15 May 1946.
35. Ibid.
36. PJ, Diary, 25 May 1946.
37. Ibid., 1 June 1946.
38. Ibid.
39. Ibid.
40. Ibid.
41. MG, Diary, 1 June 1946.
42. PJ, Diary, 11 July 1946.
43. MG, Diary, 10 August 1946.
44. PJ, Unpublished Memoir, p.277.
45. Ibid.
46. MG, Diary, 27 August, 1946.
47. PJ, Diary, 31 August 1946.
48. Ibid., 9 September 1946.
49. PJ, Unpublished Memoir, p.278.
50. Ibid., p.279.

51. MG, Diary, 28 September 1946.
52. PJ, Unpublished Memoir, p.279.
53. PJ, Diary, 10 September 1946.
54. MG, Diary, 12 September 1946.
55. Ibid., 2 October 1946.
56. PJ, Diary, 19 September 1946.
57. Ibid., 14 October 1946.
58. Ibid., 17 October 1946
59. Ibid., 23 October 1946.
60. Ibid., 22 November 1946.
61. Ibid., 23 December 1946 and PJ, Unpublished Memoir, p.282.
62. PJ, Diary, 25 December 1946.
63. Ibid., 5 January 1947.
64. Ibid., 8 January 1947.
65. Ibid., 9 January 1947.
66. PJ, Unpublished Memoir, p.281.
67. PJ, Diary, 10 January 1947
68. Ibid.
69. Ibid., 8 January 1947.
70. PJ, Letter to Evan Gill, 16 January 1947.
71. PJ, Diary, 14 January 1947.
72. Ibid.
73. PJ, Unpublished Memoir, p.283.
74. PJ, Diary, 14 January 1947.
75. Ibid.
76. PJ, Unpublished Memoir, p.283.
77. Ibid.
78. Gill, Angela, Letter to Evan Gill, 21 January 1947
79. Gill, Cecil, Letter to Evan Gill, 21 January 1947.
80. Skelton, Angela, Letter to Evan Gill, 21 January 1947.
81. PJ, Diary, 18 January 1947.

INDEX